The Persistence of the Soul in Literature, Art and Politics

Delphine Louis-Dimitrov • Estelle Murail
Editors

The Persistence of the Soul in Literature, Art and Politics

palgrave
macmillan

Editors
Delphine Louis-Dimitrov
Catholic University of Paris
Paris, France

Estelle Murail
Catholic University of Paris
Paris, France

ISBN 978-3-031-40933-2 ISBN 978-3-031-40934-9 (eBook)
https://doi.org/10.1007/978-3-031-40934-9

© The Editor(s) (if applicable) and The Author(s), under exclusive licence to Springer Nature Switzerland AG 2024

This work is subject to copyright. All rights are solely and exclusively licensed by the Publisher, whether the whole or part of the material is concerned, specifically the rights of translation, reprinting, reuse of illustrations, recitation, broadcasting, reproduction on microfilms or in any other physical way, and transmission or information storage and retrieval, electronic adaptation, computer software, or by similar or dissimilar methodology now known or hereafter developed.

The use of general descriptive names, registered names, trademarks, service marks, etc. in this publication does not imply, even in the absence of a specific statement, that such names are exempt from the relevant protective laws and regulations and therefore free for general use.

The publisher, the authors, and the editors are safe to assume that the advice and information in this book are believed to be true and accurate at the date of publication. Neither the publisher nor the authors or the editors give a warranty, expressed or implied, with respect to the material contained herein or for any errors or omissions that may have been made. The publisher remains neutral with regard to jurisdictional claims in published maps and institutional affiliations.

Cover illustration: William Blake, "The Soul Hovering over the Body", 1805. Illustration to Robert Blair's "The Grave", watercolour (16.0 x 22.7 cm). Source: https://blakearchive.org/copy/butwba10.1?descId=butwba10.1.wc.09

This Palgrave Macmillan imprint is published by the registered company Springer Nature Switzerland AG.
The registered company address is: Gewerbestrasse 11, 6330 Cham, Switzerland

Paper in this product is recyclable.

Acknowledgements

The idea for this book followed from the international conference on "Persisting Souls" which we organized in 2018 at the Catholic University of Paris with the LARCA research centre of the Université Paris Cité. We would like to give special thanks to Pr. Sara Thornton who played a major role in initiating the project and co-organizing the conference with us. She also gave us invaluable advice along the way and kindly proofread our manuscript. The late Pr. François Brunet, who gave us funding and encouraged us as head of the LARCA, is also in our thoughts. We would like to express our gratitude to Pr. Anne Banny, Pr. Cécile Roudeau, and Pr. Thomas Constantinesco for supporting this project. We thank our keynote speakers, Pr. Joseph Urbas, Pr. Ann Braude, and Pr. Christopher Moreman, for their enriching contributions to our reflection on the concept of the soul, as well as all the colleagues who participated in the conference, many of whom also contributed to this volume. We are grateful to the Catholic University of Paris and the LARCA research centre of the Université Paris Cité for their support in organizing and funding our project throughout its development, and to all the wonderful team at Palgrave who helped us through the editing process.

Contents

1 Introduction. Rewriting the Soul: The Persistence of a Concept 1
Jacques Arènes, Delphine Louis-Dimitrov, and Estelle Murail

Part I Writing the Soul 27

2 Egyptian Souls in Victorian Minds: The Transmigration of the "Ka" in Egyptianising Fiction 29
Nolwenn Corriou

3 E. S. Dallas's Literary Theory: The "Hidden Soul" and the Workings of the Imagination 49
Thalia Trigoni

4 "You Haven't Let Me Call My Soul My Own": Soul, Psyche and the Thrill of Nothingness in May Sinclair's *Mary Olivier: A Life* 67
Leslie de Bont

5 Spectrality and Narrative Form in George Saunders's *Lincoln in the Bardo* 83
Stefanie Weymann-Teschke

6	Forging in the Smithy of David Foster Wallace's Postmodern Soul Béatrice Pire	101

Part II	The Aesthetics of the Soul	117

7	Transmutations of the Soul: *Anima* and Her Heart in Christopher Harvey's *School of the Heart* (1647) Émilie Jehl	119
8	Let Us Go Forward: The Soul, Spiritualism, and the Funerary Commemoration of Richard Cosway, Dante Gabriel Rossetti, and Evelyn De Morgan Cherry Sandover	137
9	"Dancing the American Soul: Secular and Sacred Motifs in the Choreographic American Renaissance" Adeline Chevrier-Bosseau	155
10	Casting the Soul: Antony Gormley's Sculptures Coralie Griffon	177
11	Sweet Soul Music Adrian Grafe	197

Part III	The Ethics and Politics of the Soul	211

12	Colliding Circles: Ralph Waldo Emerson's Concept of the Soul Between Spiritual Self-Realization and Materialistic Expansion Olga Thierbach-McLean	213
13	"Souls on Board": A Counter-History of Modern Mobility Susan Zieger	229

14 African American Women's Literary Renaissance:
 A Template for Spiritual Fiction in the Twenty-First
 Century? 243
 Claude Le Fustec

15 Persisting Souls in a Persisting Myth: Appropriation
 and Transmigration in Ahmed Saadawi's *Frankenstein
 in Baghdad* (2013) 259
 Claire Wrobel

Index 275

Notes on Contributors

Jacques Arènes is a clinical psychologist and psychoanalyst, as well as a Professor Emeritus at the Catholic University of Paris. He holds a doctorate in fundamental psychopathology and psychoanalysis and specializes in psychoanalysis and the anthropology of religions. He has authored numerous books in these fields, including *Le psychanalyste et le bibliste* (Bayard, 2007), *La quête spirituelle hier et aujourd'hui*, and *Croire au temps du dieu fragile* (Ed. du Cerf, 2011 and 2012), *Nos vies à créer* (Ed. du Cerf, 2014), *Les assises du monde. L'autorité et la chair du social* (Parole et Silence, 2014), and *La Fabrique de l'intime* (Ed. du Cerf, 2017). His latest work focuses on the question of transmission: *L'art secret de faire des enfants. Essai sur les tourments contemporains du temps et de la filiation* (Éditions du Cerf, 2021).

Adeline Chevrier-Boisseau is a senior lecturer in American Literature and Dance Studies in Sorbonne Université and a junior member of the IUF (Institut Universitaire de France). She is the author of *Emily Dickinson du côté de Shakespeare, modalités théâtrales du lyrisme* (PUBP, 2020), and has directed the Special Issue of peer-reviewed journal *Cahiers Elizabéthains* on Shakespeare and Dance. Her research focuses on the dialogue between literature and dance; in addition to the publication of several peer-reviewed articles, she has choreographed "Instincts for Dance, A Choreographic Translation of Emily Dickinson's Poetry", which premiered in Seville in July 2022.

Nolwenn Corriou is a teaching fellow at Université Paris 1 Panthéon-Sorbonne. Her work explores the archaeological motif in Victorian and

Edward popular fiction and particularly the representation of Egyptian mummies in the imperial and scientific context at the turn of the century. It also considers the psychoanalytical implications of the representation of archaeology as an excavation of the deepest recesses of the imperial mind. Her recent work focuses on Henry Rider Haggard's depictions of Egypt and contemporary reinterpretations of the motif of the mummy in films and graphic novels.

Leslie de Bont teaches English for psychology, British literature, and literary translation at the University of Nantes in Western France. She has authored various essays on May Sinclair, Ford Madox Ford, Stella Benson, and Sylvia Townsend Warner, as well as a monograph entitled *Le Modernisme singulier de May Sinclair* (Presses de la Sorbonne Nouvelle, 2019). She will edit Sinclair's *Far End* for the forthcoming Complete Works of May Sinclair (Edinburgh UP), and her research interests include intertextuality, place-identity, and gender roles in intermodernist fiction.

Adrian Grafe has a BA Hons (Oxon) and is an English professor at Université d'Artois in France. He has written broadly on poetry, literature, spirituality, and popular music, and the links between them. His novel *The Ravens of Vienna* (2022) came out in paperback and Kindle versions in 2023. With Andrew McKeown, he is co-editing *Dancing About Architecture: Rock and Roll Writing* (forthcoming from Bloomsbury) and working on a new novel, *The Power of the Dog*.

Coralie Griffon is a PhD student at Jean Moulin Lyon 3 University, Lyon, France. Her thesis deals with British sculpture and, more particularly, with Antony Gormley's works. Her research focuses on the representation of the human body in sculpture. She also teaches English at the University of Technology of Compiègne (UTC) in Compiègne, France. In 2020, she wrote an article entitled "Antony Gormley's Refusal of Exception: The Universal Figure of the Artist" in the online journal *Polysèmes*.

Émilie Jehl works as an English teacher for non-specialist students in the Language Resources Centres of Strasbourg University. She completed a PhD in English literature on The Motif of the Heart in Seventeenth-Century English Devotional Emblematics under the supervision of Professor Jean-Jacques Chardin and defended her thesis in December 2018. She is a member of the SEARCH (Savoirs dans l'Espace Anglophone: Représentations, Culture, Histoire) research unit.

Claude Le Fustec is Professor of American Literature at Rennes 2 University (France). She authored a monograph on Toni Cade Bambara entitled *Toni Cade Bambara: entre militantisme et fiction* (Belin, 2003). In 2015, she wrote *Northrop Frye and American Fiction*, a study of the relationship of six canonical American novels to transcendence, using Frye's theory of the relationship between the Bible and Western literature in *Words with Power* (1990). She is the co-founder of an international and transdisciplinary network working on the academic theory of the spiritual (*Theorias*, www.theorias.org).

Delphine Louis-Dimitrov is a senior lecturer at the Catholic University of Paris and a research fellow at the LARCA research centre of Université Paris Cité. She studied at the École Normal Supérieure in Paris and holds a doctorate in American literature from the Sorbonne Nouvelle University. Her doctoral dissertation, which is about to be published, dealt with Mark Twain's vision of history. She has written several peer-reviewed articles, book chapters, and collections of essays dealing with nineteenth- and early-twentieth-century American literature, with a special interest in cultural transfers. Her research mostly focuses on the interplay of individuality with history and politics in fiction and autobiographical writings. Spirituality is central to her reflection on literary representations of individual and collective identities.

Estelle Murail is a senior lecturer at the Catholic University of Paris and a research fellow at the LARCA research centre of Université Paris Cité. She gained her jointly supervised PhD in English Literature from Université Paris Cité and King's College London. Her thesis, entitled "Beyond the *Flâneur*: Walking, Passage and Crossing in London and Paris in the Nineteenth Century", examined the evolution of this cosmopolitan walking figure in both capitals. She has authored several articles on *flânerie* and the city in nineteenth-century literature, and co-edited the volume *Dickens and the Virtual City Urban Perception and the Production of Social Space* (Palgrave, 2017). She co-runs the "Victorian Persistence" and "Environmental Humanities" seminars for the LARCA. Her research focuses on urban spaces, the environment, crossings and networks, and the notion of persistence.

Béatrice Pire is a senior lecturer in American Literature at University of Sorbonne Nouvelle, Paris. She is the author of *Hart Crane l'Ame extravagante* (Belin 2003), *Figures de la décomposition familiale dans le roman*

américain contemporain (Houdiard 2018), *David Foster Wallace: Presences of the Other* (ed. with P. L. Patoine, 2017), and *Contemporary American Fiction in the Embrace of the Digital Age* (ed. with P.L. Patoine and Arnaud Regnauld, 2021). She has authored numerous articles, book chapters, and book reviews on contemporary American fiction.

Cherry Sandover is a lecturer in Contextual Studies at the University Centre: South Essex; and self-supporting priest in the Church of England since 2015. Her PhD thesis was entitled "The Triumph of Fame over Death: The Commemorative Funerary Monument of the Artist in 19th-century Britain as Signifier of Identity". Her works include "The Dome of His Mausoleum: Commemorating the 18th-Century Artist" (2000) for the Romney Society's annual journal *Transactions* and conference papers such as "Delivering Down Their Name in Glory: The Significance of the Palette and Brushes Motif on Funerary Commemoration" (2009) and "Painter's Corner: Paying Respect to Departed Genius" (2020).

Olga Thierbach-McLean is an independent scholar, journalist, and translator. She earned her doctorate in American Studies at the University of Hamburg, where she has also taught as a lecturer. She is the author of numerous academic and journalistic publications on US popular and political culture, with her main research interests being in the intellectual history of liberalism, American Transcendentalism, and in particular in the impact of Emersonian individualism on contemporary American discourses on personal rights and social reform.

Thalia Trigoni is a senior lecturer and Serra Hunter Fellow in English Cultural Studies at Rovira i Virgili University. She has held positions at the University of Cambridge, the University of Athens, the Hellenic Open University, and the American College of Greece and has a Postdoctoral Research Fellowship at the University of Cyprus. Her research focuses on the unconscious, emotions, animal studies, and travel writing. She has written on D.H. Lawrence, William James, Salvador Dalí, Emily Dickinson, and Thomas De Quincey. Her first book *The Intelligent Unconscious in Modernist Literature and Science* was shortlisted for the Modernist Studies Association First Book Prize as well as for the 2021 British Society for Literature and Science Book Prize.

Stefanie Weymann-Teschke studied English and American Studies at the University of Freiburg and English at King's College London, before receiving her doctoral degree from Heidelberg University. While her

doctoral work explored the city in contemporary American novels, she is also interested in questions of spectrality and the narration of absence. Weymann-Teschke is the author of *The City as Performance: The Contemporary American Novel and the Power of the Senses* (2018), and she teaches English and American literature at the University of Jena, having previously taught at Heidelberg University and Kiel University.

Claire Wrobel is a senior lecturer in English at Paris-Panthéon-Assas Université and a member of VALE (Sorbonne Université). Her research focuses on the novel, with a particular interest in law and literature, surveillance, and rewritings of the Gothic canon. Her recently published works include "Underground Manchester as Urban Palimpsest in Jeanette Winterson's *Frankissstein: A Love Story* (2019)" (Angles 15, 2022). She is the author of *Roman noir, réforme et surveillance en Angleterre (1764–1842)* (Classiques Garnier, 2022) and co-editor of *Law, Surveillance, and the Humanities*, to which she contributed a chapter on gender and surveillance in Margaret Atwood's novels (2023).

Susan Zieger is Professor of English at the University of California, Riverside. She wrote *Inventing the Addict: Drugs, Race, and Sexuality in Nineteenth-Century British and American Literature* (2008) and *The Mediated Mind: Affect, Ephemera, Consumerism* (2018). She co-edited *Assembly Codes: The Logistics of Media* (2021) and *The Aesthetic Life of Infrastructure* (2022); her project is a cultural history of logistics, forthcoming from the University of California Press.

List of Figures

Fig. 7.1	The first emblem of *The School of the Heart*. © British Library Board (Hazlett/I 203; Wing/H183). Image published with permission of ProQuest. Further reproduction is prohibited without permission	120
Fig. 7.2	The Tilling of the Heart. © British Library Board (Hazlett/I 203; Wing/H183). Image published with permission of ProQuest. Further reproduction is prohibited without permission	122
Fig. 7.3	The Sacrifice of the Heart. © British Library Board (Hazlett/I 203; Wing/H183). Image published with permission of ProQuest. Further reproduction is prohibited without permission	123
Fig. 7.4	The Humiliation of the Heart. © British Library Board (Hazlett/I 203; Wing/H183). Image published with permission of ProQuest. Further reproduction is prohibited without permission	124
Fig. 7.5	The Hardnesse of the Heart. © British Library Board (Hazlett/I 203; Wing/H183). Image published with permission of ProQuest. Further reproduction is prohibited without permission	125
Fig. 7.6	Embleme 20. © British Library Board (Hazlett/I 203; Wing/H183). Image published with permission of ProQuest. Further reproduction is prohibited without permission	126
Fig. 7.7	The Oppression of the Heart. © British Library Board (Hazlett/I 203; Wing/H183). Image published with permission of ProQuest. Further reproduction is prohibited without permission	128

Fig. 7.8	The full engraving of Embleme 33. © British Library Board (Hazlett/I 203; Wing/H183). Image published with permission of ProQuest. Further reproduction is prohibited without permission	131
Fig. 8.1	Richard Cosway by Charles Picart; after Richard Westmacott © National Portrait Gallery, London	142
Fig. 8.2	Tomb of Dante Gabriel Rossetti, Birchington on Sea, © Miss Jennie Burgess. Source: Historic England Archive	146
Fig. 8.3	Tomb of William (1839–1917) and Evelyn De Morgan (1855–1919), Brookwood Cemetery (victorianweb.org) Photograph by Robert Friedus	149
Fig. 10.1	Antony Gormley, *Body and Soul I*, 1990. Etching on 300 gsm Somerset TP textured paper. 50 × 58.1 cm. © the artist	178
Fig. 10.2	Antony Gormley, *Learning to See*, 1993. Lead, fibreglass, plaster, and air. 197 × 53 × 36 cm. © the artist	180
Fig. 10.3	Antony Gormley, *Field for the British Isles*, 1993. Terracotta. Variable size: approx. 40,000 elements, each 8–26 cm tall. Arts Council Collection, Southbank Centre, London, England. Installation view, Irish Museum of Modern Art, Dublin, Ireland. © the artist	182
Fig. 10.4	Antony Gormley, *Another Place*, 1997. Cast iron. 189 × 53 × 29 cm (100 elements). Permanent installation, Crosby Beach, Merseyside, England. © the artist. Photography by Stephen White & Co.	183
Fig. 10.5	Antony Gormley, *Lock I*, 1994. Lead, fibreglass, plaster, steel, and air. 92 × 59 × 127 cm. Museum Voorlinden, Wassenaar, the Netherlands. © the artist. Photograph by Stephen White & Co	186
Fig. 10.6	Antony Gormley, *Dawn*, 1988. Lead, fibreglass, plaster, and air. 65 × 194 × 210 cm. © the artist	187
Fig. 10.7	Antony Gormley, *Connect*, 2015. Cast iron. 192.5 × 70 × 51 cm. Installation view, "Sight," Delos, Greece, 2019. © the artist. Photograph by Oak Taylor Smith	189
Fig. 10.8	Antony Gormley, *Signal II*, 2018. Cast iron. 189 × 51.8 × 35.5 cm. © the artist. Photograph by Stephen White & Co.	190
Fig. 10.9	Antony Gormley, *Station XIX*, 2014. Cast iron. 193.8 × 48.9 × 35.5 cm. © the artist. Photograph by Stephen White & Co.	191
Fig. 10.10	Antony Gormley, *Feeling Material I*, 2003. 3.25 mm square section rolled mild steel hoops of various diameters. 205 × 154 × 128 cm. The SCHAUWERK Sindelfingen Collection, Sindelfingen, Germany. © the artist. Photograph by Stephen White & Co.	193

CHAPTER 1

Introduction. Rewriting the Soul: The Persistence of a Concept

Jacques Arènes, Delphine Louis-Dimitrov, and Estelle Murail

The soul has long been exiled from humanities studies. The term itself is often considered as obsolete and rarely employed by critics when literature, art, history, or politics are at stake. Scholars who have recently studied the concept of the soul take note of the climate of mistrust or hostility that it generally encounters in academia (Goetz and Taliaferro 2011, 1; Le Fustec et al. 2015, 7; Cheng 2016, 11–12; Le Fustec et al. 2022)—if not of its "eclipse" from academic discourse, including from some dictionaries of theology (Bossi 2003, 1–2). In his letters on the soul (*De l'âme*), French writer and academician François Cheng nonetheless makes a claim for the relevance of the concept of the soul, understood as a life-giving, unifying principle defining an individual's identity through time and circumstances, as opposed to the alterable nature of both body and mind (Cheng 2016,

J. Arènes • D. Louis-Dimitrov (✉) • E. Murail
Catholic University of Paris, Paris, France
e-mail: j.arenes@icp.fr; d.louisdimitrov@icp.fr; e.murail@icp.fr

© The Author(s), under exclusive license to Springer Nature Switzerland AG 2024
D. Louis-Dimitrov, E. Murail (eds.), *The Persistence of the Soul in Literature, Art and Politics*,
https://doi.org/10.1007/978-3-031-40934-9_1

27). Far from being restricted to the religious sphere, the soul stands for the unity of consciousness and is often apprehended as an expression of individuality.

For all the academic reticence that it encounters, the idiom of the soul persistently irrigates cultural productions, from literary texts and artworks to philosophical, historiographical, and political essays. The word now most commonly refers to "the spiritual or immaterial part of a person considered in relation to God and religious or moral precepts" (OED, "soul", II.7.a), but it has a rich history and a variety of meanings. In line with the ancient notion of the original breath animating living beings, the soul (*psyche/anima*) has been understood as the principle of life accounting for animate existence. The term also designates the principle of thought and action defining an individual's spiritual (as opposed to corporeal) nature, or the seat of emotions and sentiments in an individual. In different ways, representations of the soul convey a sense of persistence which turns out to be central to the concept. To persist—from the Latin *persistere*, to stand firmly—is to consistently continue in a particular course in spite of opposition; hence the idea of pursuing one's existence in time (OED, "persistence", 1, 2.a). Inherent to representations of the soul is a sense of resistance, insistence, and ability to stand against obstacles. From a metaphysical perspective, the persistence of the soul refers to the notion that the soul may survive beyond the boundaries of individual life—whether detached from bodily existence or through reincarnation or metempsychosis. From a psychological stance, it refers to the ability of the soul, within the timespan of human existence, to act as a unifying principle defining individual identity beyond considerations of change and potential fragmentation of the self. As a principle of resistance and determination, the persistence of the soul may also account for an individual's capacity to overcome obstacles while pursuing a course of action, whether in individual life or in the fields of history and politics.

Although the philosophical and theological understandings of the soul have often been examined, its presence in cultural productions has largely remained unexplored.[1] In *Soul and Form* (first published in Hungarian in 1910), György Lukács laid the groundwork for a reconsideration of the soul by exploring metaphysical, existential and ethical significance of aesthetic forms (Lukács 2010, 16–34). In the wake of this seminal work, the present volume analyses how writers, artists and thinkers have apprehended the persistence of the soul and given shape to their metaphysical object, making it seizable by the senses and the intellect. Combining literary, aesthetic, ethical, and political considerations of the soul in texts and

works of art spanning cultures and schools of thought, this collection of essays emphasizes the enduring presence of the soul as concept and idiom in a selection of literary, artistic and theoretical works which rely on, and sometimes bring together, distinct frames of interpretation—the various mythological, religious, philosophical and psychological frameworks within which the concept is set. This book examines how literary and artistic representations of the soul have contributed to the understanding of individuality and subjectivity, and how the soul was endowed with collective significance expressing the ethos of a particular nation, culture, and time, or responding to history as an idiom of resistance and political or ethical action. While theories of the soul shape the apprehension of the individual, of history and of politics, literary and artistic works reinterpret and extend the meaning of the term, sometimes bridging some of its seemingly divergent dimensions. This collection of essays thus sheds light on the historicity of the soul as idiom, understood as its capacity to traverse time through literary and artistic forms, and to relate to history and specific cultures. The volume focuses on the Western world and more specifically on British and American cultures, but through intertextual networks and influences Eastern and Middle-Eastern interpretations of the soul also come into play.

The Metaphysical Vision of the Soul

Belief in the persistence of the soul dates back to time immemorial and unfolded in religious and mythological frameworks before becoming an object of philosophical discussion. The Old Testament, as well as Egyptian, Greek, and Latin mythologies, provide a rich breeding ground for further developments. Philosophical inquiry into the nature of the soul and its persistence through time started developing with the Presocratics. While some early Greeks, such as the proponents of Orphism, still had "prephilosophical, unexamined, and uncritical beliefs about the persistence of the soul after death" (Sisko 2019, 8), Presocratic thinkers opened metaphysics to rational discussion and laid the groundwork for subsequent reflections. Early philosophical theories addressing the question of the persistence of the soul at that time delineate two opposite fields, "mortalism" and "immortalism" (Sisko 2019, 9). Mortalism refers to the belief that the soul does not subsist beyond corporeal death. Immortalism, which defends the opposite view, is embraced by most philosophers who posit immaterial/material dualism (Sisko 2019, 14) and falls into three

categories: "weak immortalism" (the idea that the soul is long-lived but not eternal), "strong immortalism" (belief in its eternal subsistence), and "conferred immortalism" (the belief that the annihilation of the soul is metaphysically possible but that a divine being, possessing immortality, confers it to the soul) (Sisko 2019, 13). They also elaborate on distinct modes of soul persistence, including reincarnation—survival of the soul in a new body—and metempsychosis—the transmigration of the soul among the bodies of different species (Sisko 2019, 8)—, which both imply that the soul outlasts the body without it necessarily being eternal. Metempsychosis, which originates from Orphic mysteries, if not from Egyptian cults, was a prominent belief in the early poetic and religious traditions of ancient Greece (Sisko 2019, 26). The doctrine subsisted in Presocratic metaphysics and was embraced by such thinkers as Empedocles and most notably Pythagoras (Sisko 2019, 10).

With Plato, the metaphysics of the persistence of the soul became grounded in an ontology of the soul: establishing its nature was considered to be a condition for further discussions on its duration (Sisko 2019, 23). Plato understood the soul (*psyche*) not just as a principle of life—imparting life to the body—but also as a principle of philosophical wisdom. Since it belongs in the world of eternal and immaterial Ideas and strives to contemplate them, the soul is immortal (*Phaedo* 79b–80b). The body therefore stands as a prison for the soul (*soma-sema*) (Plato 1925, *Phaedrus* 250c) and as an obstacle to the knowledge and contemplation of Ideas (*Phaedo* 64d–e). Short before drinking the hemlock, Socrates affirms that while his body will perish, he—meaning his soul—will live on in the world of eternal Forms. Yet Plato also writes that the soul will later return to the world of the living (Plato 2001, *Phaedo* 70c–72e), in coherence with the belief in reincarnation which was widespread in ancient times (Goetz and Taliaferro 2011, 8–9).

Like Plato, Aristotle refers to the soul as an active principle of life—the first principle of living beings (Aristotle 1902, *De Anima* 17). He considers the soul to inform and animate all things in nature, including animals and plants, with yet a hierarchical distinction between three entities (Aristotle 1902, *De Anima*). The "nutritive soul", common to human beings, animals, and plants, sustains biological life understood as something which must "be given to everything that grows and dies" (Aristotle 1902, *De Anima* 138). The "sensitive soul", which accounts for the faculty of sensory perception—distinguishes animals from plants (Aristotle 1902, *De Anima* 56) and includes the nutritive one. The "rational soul", which

contains the souls of the lower levels, is specific to human beings and sustains the faculty of thinking (Aristotle 1902, *De Anima* xxvii). Contrary to Plato, he claims that the soul does not exist independently from the body that it informs. It is the individual in terms of both a soul and a body who experiences sensations and thoughts (Goetz and Taliaferro 2011, 22–23).

From classical antiquity onwards, the apprehension of the soul went hand in hand with the understanding of its disorders, hence the use of the expression "disease of the soul" in philosophy. Such questions were at the heart of ancient psychopathology. In the wake of Stoicism, the "passions" were also defined as diseases of the soul. According to the classical Stoics, no exterior physician could be called upon to cure diseases of the soul (unlike those of the body). For Pigeaud, this meant that "ultimately, the disease of the soul, whatever its definition, was the responsibility of the individual, and that the only possible doctor [wa]s oneself" (2006, 538). This notion of the "disease of the soul" put a real emphasis on interiority and on the subject's responsibility, which the Stoics themselves foregrounded in their work on the passions.

However, this understanding of the diseased soul as the responsibility of the individual was not shared by the physicians of antiquity, who obviously developed a vision in which their intervention played a more significant role. The Hippocratic-Galenic doctrine, which dominated medical thought until the seventeenth century, insisted that the soul depended on the body, and more particularly on the brain. Diseases of the soul were then considered to be stemming from damage to the brain or other organs (Gourevitch 2004). Galen's theory of temperaments—sanguine, phlegmatic, choleric, and melancholic—was based on the predominance of one of the four humours (blood, phlegm, yellow bile, or black bile) in the individual. For Galen, diseases of the soul were caused either by direct damage to the brain, or (by sympathy) by damage to other organs affecting the brain. The Galenic model was based on physiology, which implied that any diseased soul required medical intervention (through diet, pharmacopoeia, or surgery).

Christian thinkers initiated a new stage in the reflection on the soul which nonetheless drew on previous theories. While considering the soul in the light of their religious faith, St. Augustine and St. Thomas Aquinas were strongly influenced by Plato and Aristotle respectively (Goetz and Taliaferro 2011, 30). St. Augustine made a claim for the substantiality of the soul, defining it as "a special substance, endowed with reason, adapted to rule the body" (*Greatness of the Soul* 13.22, quoted by Goetz and Taliaferro 2011, 33). He developed the idea of self-awareness of the soul

which would later be further developed by Descartes (Goetz and Taliaferro 2011, 34). His vision of the soul relies on three superior faculties—memory, intelligence and will—which also remain relevant to the modern understanding of individuality. Reinterpreting the Augustinian vision of superior faculties, Cheng, for instance, sees the soul as the locus of desire, memory, and heart intelligence (Cheng 2016, 44–45). St. Thomas Aquinas, like Aristotle, distinguished between different kinds of souls (nutritive, sensitive, and rational) and claimed that the soul informs the body. To account for its subsistence beyond bodily death, he argued that the soul may be maintained in existence by God (Goetz and Taliaferro 2011, 49–50, 60). In mediaeval thought, the Aristotelian-Thomist conception of the soul was subdivided into three distinct planes or levels of perfection. It made it possible to account for the differences between humans, animals and plants—the former only being endowed with a rational soul. Rational beings are distinguished from other animate beings through their spirituality and their capacity to transcend matter. This three-tiered conception of the soul would later recur in some secular theories of interiority (including Freud's psyche).

The rationalistic turn that took place with the Enlightenment brought about a new understanding of the soul which did not depend on religious faith and contributed to ground the modern conception of the self. In his *Meditations*, Descartes rationally establishes the existence of the soul and its independence as substance from the body (Descartes 1967. For him, the "I" is the soul ("[…] this 'I'—that is, the soul by which I am what I am—[…]", Descartes 1985, I, 127), which he also equates with the mind (Descartes 1967, I, 141). It is "a thing that thinks" (*res cogitans*), which is aware of its own existence (Descartes 1967, I, 135), and which is united to the body without being located in space and without "exist[ing] in any one of its parts to the exclusion of the others", as he explains in *The Passions of the Soul* (Descartes 1967, I, 345). The soul, as he understands it, is distinct from the body, yet interacts with it and experiences "passions" that are no longer considered as a disease.

THE SECULARIZATION OF THE SOUL AND THE EMERGENCE OF THE PSYCHIC SUBJECT

With the decline of religion and metaphysics in the Western world that followed from the Enlightenment, the soul underwent a gradual process of subjectivation and secularization which culminated in the twentieth

century (Arènes 2011, 2012). In *The Disenchantment of the World*, Marcel Gauchet writes about this gradual fading away of religion as a structuring system of Western society. For him, this waning of religious power has led individuals to shape their beliefs on their own: the contemporary world is now culturally structured around a separation between the subjective dimension of belief and the absence of religion (Gauchet 1999, 162–190). Gauchet situates belief at the heart of the believer's subjectivity, as psychologist William James had already done a century before him.[2] One may think about the subjectivation and psychologization of the soul as stemming from the rational, scientific discourse which emerged in the eighteenth and nineteenth centuries, but this process started as early as the seventeenth century both within and without the religious discourse. It was already visible in Rembrandt's paintings, as Georg Simmel remarked. Talking about religious figures painted by Rembrandt, Simmel noted that piety was an individual phenomenon produced from the deepest well of each soul: "People are no longer in an objectively pious world, but rather they are, as subjects, pious in an objectively indifferent world" (Simmel 2005, 115).[3]

From the nineteenth century onwards, the journey of the soul away from organized Christian religion and towards the realms of psychology and psychotherapies contributed to rewriting its meaning over time. Although one might understand this journey as one of secularization, religious and metaphysical understandings of the soul heavily influenced the field of psychology. Freud himself spoke of the *soul* (he used the word *Seele*), which also remained central to Jung's theory. There is an interesting circularity to the history of the term, since the development of psychology leads us back to the ancient Greek *psyche*. The soul has crossed boundaries, moving between mythology, philosophy, religion, and modern science.

The history of the move of belief towards subjectivity, and towards a more psychological understanding of the soul, is not linear. The alliance between ancient traditional spiritual healing techniques, romantic expressiveness, rationalism, and positivism gave birth to the continuum of psychotherapies which shapes our current understanding of the soul as psyche.

For centuries, in Christian Europe, the soul had been the preserve of theologians such as St. Augustine or St. Thomas Aquinas. However, belief slowly started moving "inward"—towards each individual's own subjectivity—and towards something resembling psychology within religious discourse itself, as with the "cure of souls" (*Seelsorge*), also known

as "pastoral care", a form of pastoral therapy based on speaking which was very influential in the Protestant world. Within this tradition or "technique", the minister cares for the faithful (Arènes 2011, 151–153). Penance is not just a recognition of one's past sins, but it is also a remedy against one's present and future sins. During the seventeenth and eighteenth centuries, within pietist movements, "the cure of souls" progressively became a form of therapy for the soul. Pietism was a Protestant movement which greatly stressed the importance of interiority within one's faith. This movement contributed to building the idea of the original subject's own "psychology", born out of his or her own individual journey. This movement, which gave "psychological" attention to "diseased souls", was poised between direction (influence) and shared conversations. "The pietist tradition insists on the necessity of the personal bond between the soul healer and the faithful, the faithful being an individual or a small group. Ministers exert their influence through their own words, be it through a conversation or a sermon. Progressively, however, the focus moves towards the accounts of the faithful, especially in biographies, accounts of conversions, or spiritual narratives" (Mengal 2000, 37), in which each individual narrates their own singular journey towards God. The soul healer denounces the illusions of the ego and guides the diseased soul towards the love of God. Within the "cure of souls" tradition, Protestant ministers were considered to be endowed with a spiritual gift that enabled them to obtain the confession of "troubling secrets" from distressed souls (Ellenberger 77). Though they were not bound by the rules of professional secrecy, as Catholic priests were, these ministers were extremely attentive to secrecy. This theme of the "pathogenic secret" clearly fell into much more secular hands, especially when the first hypnotists came about at the end of the eighteenth century. It also became a central theme of a certain type of literary production. Nathaniel Hawthorne's *The Scarlet Letter* (1850) and Henrik Ibsen's *The Lady from the Sea* (1888), which also evokes a pathogenic secret, both come to mind. It has become a pivotal idea for therapeutic thinking, even today in its contemporary developments with, for instance, the current fascination with transgenerational therapy and repressed secrets. The theme of the "pathogenic secret" also influenced the development of "dynamic psychotherapy" (Ellenberger 1994, 80). Oskar Pfister, a pietist minister from Zurich and "curer of souls", came into contact with psychoanalysis in 1908 through his extensive correspondence with Freud. With him came the transition between the cure of

souls and psychoanalysis. Throughout his life, he remained keenly interested in pathogenic secrets, certain aspects of which were compatible with Freudian catharsis.

Michel Foucault analysed these ancient religious confession techniques, especially through the angle of spiritual guidance and confession, and saw them as closely linked to Christianity as original forms and practices of subjectivation. These ancient religious confession techniques were therefore also at the root of other secularized practices. This religious interest in what was later called "psychology" fostered the rise of psychotherapies at the end of the nineteenth century. Seen through this historical lens, the modern psyche appears as a direct descendant of the soul.

The very term "psycho-therapeutic" was coined by an English physician, Daniel Tuke, in 1872. The word primarily designated the influence of the patient's mind over his or her own physical ailments (Tuke 1884, xv). The meaning then spread to mental conditions needing medical treatment. Hippolyte Bernheim, one of the founders of medical hypnosis, took up Tuke's ideas, and introduced the term "psychotherapy" on the continent, while stressing the role of imagination as therapeutic. Bernheim borrowed the words "hypnotism", "suggestion", and "psychotherapy" and amplified them to oppose them to an "organicist"[4] definition of human beings, rooted in positivism (Carroy 2000, 11). As a result, a new type of therapeutic relation and a new psychological culture emerged in the nineteenth century. This new culture created a space for the technique of suggestion, which is built on the idea that the patient is an ally whose words are acknowledged as relevant, whose symptoms are interpreted in psychological terms, and whose collaboration is called upon. The relationship between this new culture, these new therapies, and religious (or spiritual) matters, is complex. If Freud advocates cleansing psychoanalysis from any direct religious or hypnotic association (Freud 1970), French psychologist Pierre Janet, on the other hand, does not break away from previous forms of therapy, be they magnetic, religious or hypnotic (Janet 1983). In France, these therapies are seen as psychological, and nothing other than psychological, and are more and more "secularized" and cleansed from religious references. In Great Britain and the United States, the nascent field of psychology is much more accepting of the religious experience, as is the case for William James, for instance.

Some aspects of the philosophy of nature and romantic philosophy also contributed to creating the idea of the modern psyche. Certain themes of

Christian anthropology, such as that of the tripartite view of humankind (mind, body, and soul) were echoed in philosophy, as for instance in von Schubert's philosophy of nature (Ellenberger 1994, 235–237). Some para-religious vitalist principles, such as the idea of an absolute unconscious being, the very substance of the universe, were also at the root of Eduard von Hartmann's *Philosophy of the Unconscious* (1869). These ideas, which were imbued with spiritualism, were an essential aspect of the cultural background in which psychoanalysis was created and "secularized". The continuations and breaks between these different movements were numerous. Jung saw himself as following in the footsteps of von Hartmann or von Schubert, while Freud tried to differentiate his theory of the unconscious from that of his romantic predecessors.

The nineteenth century was also the period during which the question of the "psychic subject" emerged. This subject emerged at the very moment when, on the one hand, the notion of "culture" was becoming more prominent and, on the other hand, individualism was becoming an ideology. Theories about "the social being" or "the psychic being" were based on a systematization which was no longer supported by a transcendent subject. These theories became mutually reinforcing just as the notion of religion as all-encompassing was disappearing and as interiority was becoming secularized. The nineteenth century became the century of "the ages of life", in which human developmental stages were scientifically analysed from conception to death. It fostered the interest in the process of psychological development and in identifying certain key stages, such as adolescence (Caron 2003). Psychology—and psychoanalysis—emerged from this secular model of an interior space, which was in conflict with the previously prevalent spiritual model. On the one hand, exterior reality had become devoid of the presence of the gods, and on the other hand, interiority, having become the only place for believers, was becoming inventoried by a scientific discourse whose aim was to objectivize mental processes. The psychic person became quantifiable, and was the culmination of a process of deconstruction of philosophical and metaphysical discourses. During the second half of the nineteenth century, the boundaries between the soul and the psyche became blurred. Historian and philosopher Hippolyte Taine, for instance, defended the psychological value of a discourse about the soul, which he defined as observable inner life (Taine 1883).

During that same period, conscience and the soul became medicalized. In the first half of the nineteenth century, as religion was seen as having

the potential to save souls, chaplains would routinely go to asylums, where secularized religious practices were also common. The following decade constituted a turning point in the medicalized approach of religious practices. The medical argument penetrated to the very heart of the Church. In that period, the physician progressively took the place of the priest and became an expert of the soul and a director of conscience (Guillemin 2006, 11). The very fierce debate about hypnotism was at the heart of conflicts about matters of the soul. Besides, the role of the brain and memory in the analysis of psychopathological difficulties was discussed at length at the end of the nineteenth century and became linked with the debate about the place of the soul. This debate deeply transformed our current understanding of the soul, as Ian Hacking points out: "A feature of the modern sensibility is dazzling in its implausibility: the idea that what has been forgotten is what forms our character, our personality, our soul" (Hacking 1998, 11). In this context, the notion of the soul is not an essence, a spiritual anchorage point which upholds the subject. It is a more modest concept, which "stands for the strange mix of aspects of a person that may be, at some time, imaged as inner" (Hacking 1998, 6).

As a result of this shift towards medicalization in the second half of the nineteenth century, religions started to look at the emerging practices of psychoanalysis and modern psychotherapies to reject some, validate others, and form an empirical relationship with them, trying to share the territory between spiritual guidance and the healing of souls. This dialogue between theology and psychology is ongoing to this day: in his 2016 book, Peter Tyler argues that the soul "is a call to hold theology and psychology together" (Tyler 2016, 181). However, in contemporary society, real power over the psyche—or the soul—has largely come to rest in the hands of medical doctors, more specifically in those of psychiatrists and neuroscientists. These doctors' relationships with psychologists and psychotherapists can go from outright hostility to close collaboration.

Postsecular Souls

With contemporary society's move away from religion, the soul has become a much more fluid, polymorphous concept. It is even now being redefined by society's renewed interest in spirituality, which has resurfaced in a much secularized, and indeed postsecular Western culture as something rooted in the quest for the self. Personal identity is now seen as unstable and is constantly being constructed and deconstructed.

The entrance into the postmodern era in the mid-twentieth century largely affected the understanding of the subject. Historically speaking, postmodernity consists in the breakdown of temporal frameworks and the dismissal of references to tradition and progress. Postmodernity does not believe in metanarratives anymore. It is grounded in doubt, enhanced references to subcultures and personal ethics rather than the collective construction of meaning, while reason is no longer called upon as a universal paradigm (Freitag and Bonny 2002, 45–94). The postmodern subject accordingly is a disunified, fragmented one. As Kathryn Hume points out, previous conceptions of the soul had preserved the unified vision of the self: the Christian concept of a soul "guaranteed the self as a unitary being—all of the soul was saved or damned, not parts of it", and Freud's studies of the unconscious opened complex possibilities which did not yet contradict the notion of a subject's unity (Hume 2020, x). However, in the postmodern period, "theorists talk[ed] about multiple subjectivities with no underlying unity" (Hume 2020, x), which called for remodelled frames of representation. Though "multiple subjectivities have found an answering resonance in some properties of polytheistic myth" (Hume x), such as the Egyptian notion of a plurality of souls, the understanding of the soul as a unifying principle persisted in cultural representations, often pervading them in a diffuse manner.

The persistence of the notion of the soul in literary and artistic works and in the political thought of the second half of the twentieth century is an expression of the postsecular turn that took place in post-World War II secular societies as part of the ontological, epistemological, and aesthetic questioning of the postmodern era. As a sociological concept notably developed by Habermas, the "postsecular" refers to the persistence of religion within increasingly secular environments, and to the coexistence, interactions, and reshaping of religious and secular mentalities (Habermas 2008, 111–112). The concept has subsequently been used to refer to the resurgence of the religious in non-institutional forms within secular societies after the second World War. In the field of literature, postsecularism more specifically hints at expressions of spirituality in contemporary fiction, especially postmodern, by such novelists as Thomas Pynchon, Don DeLillo, Toni Morrison, Alice Walker, Charles R. Johnson, Leslie Marmon Silko, Gloria Naylor, Toni Cade Bambara, or Louise Erdrich. In *Partial Faiths, Postsecular Fiction in the Age of Pynchon and Morrison* (2007), John A. McClure has shown that postsecular works explore new forms of spirituality and invent religiously inflected modes of being that remain

partial and open-ended. Bringing the soul centre stage, these works take the form of a quest for transcendence and dramatize processes of conversion that disrupt secular structures of reality while being at odds with dogmatic forms of religiosity (McClure 2007, ix, 3). Such texts also articulate spiritual practices with progressive political projects sustaining "self-transformation" and "collective empowerment". Postsecular spirituality consequently is "not just personally but politically enabling"; it is "a valuable resource in the community's ongoing struggle to survive" (McClure 2007, 105).

Building on McClure's analysis of the postsecular in literature, Amy Hungerford has suggested in *Postmodern Belief. American Literature and Religion since 1960* (2010) that the "syncretic and personalized spiritualism" (137) that thrives in the second half of the twentieth century is to be found in works imagining "nonsemantic aspects of language in religious terms" (xiii), as can be seen for instance in texts by Allen Ginsberg, James Baldwin, Cormac McCarthy and Don DeLillo. Such uses of language bring about a new approach of the soul. They make literary works a condition for the persistence of spiritual expression in a (post)secular time and reveal the "religious valence of the literary in the secular context of twentieth-century America" (Hungerford 2010, xiii). Though such forms of spiritual expression are essentially to be found in the second half of the twentieth century, McClure and Hungerford have shown that postsecular spirituality has roots among the Romantics and modernists (McClure 2007, 3; Hungerford 2010, xiii). For instance, the Bible was the primary source of inspiration for pre-Romantic artist and writer William Blake. He created a highly idiosyncratic mythology despite his strong opposition to organized religion. Blake's "The Soul Hovering over the Body, Reluctantly Parting with Life", an engraving he made to illustrate Robert Blair's poem "The Grave" in 1813, and which is reproduced on the front cover of this book, clearly shows his indebtedness to the Christian concept of the soul. However, Blake contests the idea of the separateness of body and soul in his 1790 work *The Marriage of Heaven and Hell*: "Man has no Body distinct from his Soul; for that call'd Body is a portion of Soul discern'd by the five Senses, the chief inlets of Soul in this age" (Blake 1906, 9). Postsecular spirituality also has roots in transcendentalist thought, which resolutely opposed theological dogmas and institutional forms of religion.

Spirituality in modern and postmodern times was reshaped through the fusion of different influences, including that of ancient and Eastern religions. To give but one example, Buddhist concepts such as Atman

(individual soul) and Brahman (universal soul) have become some of the tools with which people explore their interiority. This form of modern spirituality also contains certain elements of modern psychotherapies, especially those centred on personal development. Spirituality in contemporary Western culture provides a private space for the creation of individual belief, while sacred collective rites have become less visible. It may be seen as an attempt to respond to the anguished concerns of subjectivity. It is both in opposition and in collusion with the world of psychotherapies.

Apprehending the Soul and Its Persistence

This collection of essays attempts to capture understandings of the soul across literature, art, and politics. It does not mean to conduct an exhaustive study of the significance of the concept of the soul to literature, art, and politics—which would be a vain endeavour anyway; it rather seeks to open new perspectives that may pave the way for further inquiries. The book moves across disciplines, taking the literary form as its point of departure in the first section, "Writing the Soul". From there, it investigates the confluence of categories such as the visible and the invisible, the mind and the spirit, and life and death. In the second section, "The Aesthetics of the Soul", it reflects on how the soul is apprehended and expressed in poetry, prose, and other art forms, such as music, dance, and sculpture. The third and final section, "The Ethics and Politics of the Soul", interrogates how such understandings of the soul shape action, particularly in the social and political realms.

Writing the Soul

The first part of this collection, "Writing the Soul" shows that literature plays an active role in both reflecting and shaping the changes that affect the construction of the soul from the nineteenth century to the present. Focusing on soul persistence within and across literary texts, the five essays of this chapter take the soul beyond the boundaries of the individual mind and explore the intertextual correspondences and echoes that connect seemingly distant souls together. They highlight the echoes and continuities in the representation of the soul across time, texts, and cultures, from antiquity to modernity through the romantic and Victorian periods. They

underline the soul's palimpsestic nature, the persistence of which precisely stems from these multi-layered borrowings from other texts and cultures.

In "Egyptian Souls in Victorian Minds: The Transmigration of the 'Ba' and the 'Ka' in Archaeological Fiction", Nolwenn Corriou focuses on the discovery of the ancient Egyptian conception of the soul as formed of the "Ka" (double) and the "Ba" (soul), and its influence on Edwardian and Victorian literature. As the traditional understanding of the link between the body and the soul shaped by Christian beliefs was starting to be questioned by the findings of geologists and archaeologists, more and more thinkers were paradoxically drawn to the occult and supernatural answers to the mysteries science could not quite explain. Many occult orders, including the Hermetic Order of the Golden Dawn, were widely influenced by the discoveries of Egyptology and by forms of worship inspired by ancient Egypt. The idea of the transmigration of the soul offered fascinating possibilities in a world in which magic seemed to be vanishing. A number of Victorian and Edwardian writers explored the Gothic possibilities offered by the motif of the haunting of the Victorian mind by an ancient Egyptian soul. Bram Stoker in *The Jewel of Seven Stars* (1903), Henry Rider Haggard in "Smith and the Pharaohs" (1913) and Algernon Blackwood in *The Wave* (1916), among others, imagined the devastating effects of the awakening of an Egyptian soul within a modern character. In these texts, the archaeological work undertaken by Egyptologists to excavate the buried past of ancient Egypt soon becomes an archaeology of the modern psyche: a psyche haunted by the return of the archaic and imperial repressed, which often takes the terrifying form of the mummy.

Thalia Trigoni offers further insight into the construction of the modern subject in "E. S. Dallas's Literary Theory: The 'Hidden Soul' and the Workings of the Imagination". As stated earlier in the introduction, from the 1850s onwards, the budding field of psychology slowly started replacing the "soul" with the "mind" or "consciousness" as its object of study. However, psychology as a discipline was not only shaped by scientists. Questions about the mind and soul were also propagated and discussed in the popular press and literary fiction of the period. This essay sheds light on the pivotal role of literary critic and writer E.S. Dallas, whose work is representative of the tectonic shift in the way contemporary thinkers and psychologists thought about the human mind. Within a period of fourteen years, there was a shift away from the metaphysically imbued "soul" discussed in Dallas's *Poetics* (1852) to a theory that turned from the divine realm of spirituality to the inner, physiological workings of the mind in

The Gay Science (1866). Dallas theorized that human nature is a conjunction of two souls, one conscious and familiar, and the other "hidden" and unconscious. Dallas, whose terminology found its way into numerous literary works, became one of the most respected and prolific critics of the period. He participated in the nineteenth-century shift from the metaphysics of the soul and its cognitive components to psychology.

In the early twentieth century, literature became a site for the philosophical and psychological investigation of the soul. In "'You haven't let me call my soul my own': Soul, Psyche and 'the thrill of nothingness' in May Sinclair's Fiction", Leslie de Bont examines May Sinclair's philosophical understanding of the soul and its influence on her fiction. She shows that in her philosophical essay, *A Defence of Idealism* (1917), May Sinclair refers to dreams as "experiments with the soul that is to be" and thus clearly challenges the notion of a transition between soul and psyche. Indeed, her philosophical system, which she later called "New Idealism" (1922), is built on her idiosyncratic combination of idealist philosophy, Spinoza's monism, animism, mysticism, and Jung's analytical psychology. Leslie de Bont explores Sinclair's understanding of the "soul", which proves central to her reflections on consciousness, individuation, identity, the absolute, ultimate reality, sublimation, and the libido. After attempting to reconstruct Sinclair's theoretical approach to "souls", she studies the way Sinclair represents this notion in her fiction. Indeed, Sinclairian souls always seem to refer to the irreducible individuality of female characters and involve an active spiritual quest that relies on mystical visions, sensory keenness, and rebellion against the Anglican religion. Sinclair's *Bildungsromane* often focus on the protagonists' gradual discoveries, explorations, and eventual reappropriations of their souls. However, the final pages of *Mary Olivier* (1919) depict the "thrill of nothingness" experienced by the heroine's "stripped soul", indicating that the advent of the soul is also an ambiguous "adventure" or "risk" that elicits emptiness and significant sacrifices.

In her essay on "Spectrality and Narrative Form in George Saunders's *Lincoln in the Bardo*", Stefanie Weymann-Teschke reflects on the literary construction of the persistence of the soul in a postmodern context. In this 2017 novel, recently deceased Willie Lincoln, the son of President Abraham Lincoln, finds himself in a strange place: while his lifeless body is interred in a Georgetown cemetery, Willie "tarries" in a realm between, no longer part of the living, but not quite ready to depart either. Saunders's construction of the souls haunting the cemetery results from a complex

entanglement of different influences, including that of traditional ghost stories, Christian religion, and Tibetan Buddhism. The author reads the novel as a narrative exploration of the state of in-betweenness and focuses on the challenge of narrating spectrality. While quotes from historical sources and the Buddhist concept of bardo provide the narrative backbone, she argues that it is the dialogic form of Saunders's novel that captures the disembodied, haunting presences inhabiting the cemetery as a liminal space. She highlights the hybridity of the soul as a literary construction while examining how literary form can reflect the fluidity of ghostly souls.

Although recent criticism has argued for the emergence of the "new atheist novel" over the claims of religion, Stephen Burn writes that "much post-postmodern fiction seems to yearn for at least a partial return to religion and spirituality" and that "a distillation of this impulse is also palpable in the heightened resonance the word 'soul' carried in much post-postmodern fiction." Béatrice Pire, in "Forging in the Smithy of David Foster Wallace's Postmodern Soul" studies this postsecular "return of the soul" in recent fiction by focusing on David Foster Wallace's "metaphysical ache", including his several attempts to convert to Catholicism, the revisitation of *Hamlet*'s ghost in the burlesque creation of a filmmaker wreath in *Infinite Jest*, and an "underworld" dialogue with James Joyce. She focuses on Wallace's short story "The Soul Is Not a Smithy", a parody of *A Portrait of the Artist as a Young Man* based on Lacan's reading of Joyce in Seminar 23 and playing with St. Thomas Aquinas' influence on Joyce's fiction. Following Joyce's "forging" and "uncreating" of the Irish soul, she eventually examines the return of traditional narrative technique and conventional subject matter in post-postmodern novels as mostly exemplified in Jonathan Franzen's major "Great American novels". She shows how they illustrate John W. De Forest's 1868 definition of the Great American Novel as a work meant to capture "the American soul", close to Ernest Renan's 1882 definition of a nation as "a soul, a spiritual principle" (Renan 1990).

The Aesthetics of the Soul

The second part of this collection, "The Aesthetics of the Soul", deals with the challenge of representing the soul and its persistence through various art forms, from seventeenth-century religious emblems to sculpture, architecture, paintings, drawings, music, and dance. The

contributors to this chapter examine how these art forms give a material or sensory expression to the invisible, explore the link between body and soul, or convey the idea of the persistence of the soul beyond bodily existence.

Religious emblems stand at the crossroads of art and religion. In "Transmutations of the Soul: Anima and her Heart in Christopher Harvey's *School of the Heart* (1647)", Emilie Jehl studies the representation of the soul in emblem books, a literary and pictorial genre that was born in sixteenth-century Europe and relies on the semiotic codes of both texts and images. She looks at a few emblems of the heart, a category of emblematic literature which proposes to observe the soul's travails via the symbolism of the heart, with a focus on the English collection *Schola Cordis*, by Christopher Harvey (1647). She shows how Catholic images are re-used by an author affiliated to the English established Church. These representations stage a series of operations performed by Christ on the heart: it is assaulted by arrows of love shot by Christ-Cupid, who engraves its flesh with divine law, and also distended, crowned with thorns, or crushed with a hammer. Heart emblems postulate a relationship between the material and the spiritual. Spiritual processes thus find a material expression in the space of the book; but it is also through the body and its manifestations that the soul becomes tangible, and spiritual progress possible.

Like emblem books, funerary monuments closely depend on—yet remodel—religious representations. In her essay entitled "Let us go Forward: The Soul, Spiritualism and the Funerary Commemoration of Richard Cosway, Dante Gabriel Rossetti, and Evelyn de Morgan", Cherry Sandover reflects on the profusion of funerary monuments to dead artists that began to populate the churches, cathedrals, and new cemeteries of England during the nineteenth century. The styles of these commemorative monuments mirrored the myriad of religious ideas that were to be found at the time. These were informed by the celebration of the individual as promulgated during the previous century, alongside the impact of further scientific discoveries and experimentation casting doubt where there had been certainty. They might also have been influenced by the peculiarly English historical arguments over doctrine and other issues of religious practice. Cherry Sandover considers the ways in which the funerary monuments erected in respect of three nineteenth-century painters, Richard Cosway (d.1821), Dante Gabriel Rossetti (d.1882) and Evelyn de Morgan (d.1919), came to be influenced by the growth in esoteric notions

of the soul as the root of spiritual love, and its persistence into the afterlife. That each memorial was either designed, or commissioned, by a "soulmate" or with one in mind, adds further interest in the exploration of the designs with reference to the Victorian soul as the key to an unbreakable connection despite death.

In contrast to such memorials which consider the soul as separate from the body, dance may lend it a bodily representation. In "Dancing the American Soul: Modern Dance and the Persistence of American Founding Myths", Adeline Chevrier-Bosseau shows how dance can convey not just the individual soul, but also the soul of a nation—the American soul. Her essay explores the quest for genuine, organically American movement in the works of dance pioneers such as Isadora Duncan, Loïe Fuller, Ruth Saint Denis, Ted Shawn, but also George Balanchine, Agnes De Mille, and Martha Graham. What is notable in their works is the persistence of the folklore that came to be known as "Americana", but also of the founding myths of American society—such as Manifest Destiny and the pioneer spirit—as well as references to the literature of the American Renaissance, in a prolonged search for the American artistic identity and cultural independence. She examines how American choreographers have attempted to "dance the American soul", to capture Americanness through movement while also exploring the transcendent, divine dimension of the soul. She considers these choreographers' engagement with the divine soul in the light of their fascination for Eastern philosophy and spirituality, especially Brahmanism.

If dance is liable to capture the soul, so is sculpture, which "in stillness, can transmit what may not be seen" (Gormley 1987). In "Casting the Soul: Antony Gormley's sculptures", Coralie Griffon explores the presence of the soul as a principle of life in Gormley's body cases and reflects on suggestions of its immortality. Departing from the dualistic dichotomy of body and soul, Gormley considers the body and the senses as "windows" and "gateways" to the soul. By resorting to specific techniques previously used by other artists to go beyond the materiality of the body and of artworks, he aims to open up a metaphysical dimension in his sculptures and symbolically convey the articulation of body and soul. Coralie Griffon shows how the tensions between the visible and the invisible, the inside and the outside are poetically intertwined in Gormley's works, insufflating the breath of life in seemingly abstract statues.

Of all artforms, music is the medium most often associated with the soul, and soul music most explicitly expresses this link. In "Sweet Soul

Music", Adrian Grafe examines its palimpsestic roots and polyphonic characteristics and reflects on what gives soul music its soul. Reaching back to the origin of its name, he delves into the works of some of the artists associated with the genre: Wilson Pickett, Sam and Dave, Billie Holiday, Etta James, Sam Cooke, Al Green, Stevie Wonder, Motown artists like The Four Tops, the Temptations, and Diana Ross and the Supremes, among others. While strongly relying on Gospel spirituality and imagery, soul music serves primarily as a language of feelings, but it is also a vehicle for expressing political and social consciousness.

The Ethics and Politics of the Soul

The final part of the collection, "The Ethics and Politics of the Soul", focuses on the soul understood in its capacity to convey values and principles of action relating to the collective sphere, whether to give shape to cultural and national identities or on the contrary to bring forth counter-discourses as well as patterns of resilience, resistance, or dissidence.

Ralph Waldo Emerson (1803–1882), the "Bard of Concord" and founder of the American transcendentalist movement, developed a metaphysics of the soul—or "Over-Soul"—understood as a principle of unity in nature. Placing the soul at the core of the universal "song of laws and causes" (Urbas 2016), he defined it as the causal, ontological principle of the universe—the "cause" and "life by which things exist" ("Self-Reliance"). He saw it as a principle of eternal causation in nature (Urbas 2020) as well as the "causal power on the stage of human history" (Urbas 2016, 24). In her essay entitled "Colliding Circles: Ralph Waldo Emerson's Concept of the Dynamic Soul and its Political Ambiguities", Olga Thierbach-McLean reflects on how Emerson's concept of the soul brings together its transcendental essence and a practical dimension unfolding in the historical sphere. She points out that while readings of his work long remained dominated by the image of the withdrawn "Bard of Concord" whose quest for spiritual truths unfolded beyond the world of politics, more recent scholarship has underscored his role as an active social reformer and major figure in the emergence of a distinctly American political mentality. As part of this scholarly approach, she analyses the continuing resonance of Emersonian tenets in American culture and demonstrates that his concept of the soul, which is central to his individualistic philosophy, is a cornerstone of the dualism whereby, in Stanley Cavell's words, Americans are still a "half-Transcendental, half-pragmatic

people." Emerson described the soul as a divine spiritual essence, but at the same time as a decidedly practical force calling for real-world application. She relates his vision of the soul's dynamic nature to his assertion that "our life is an apprenticeship to the truth, that around every circle another can be drawn" (Emerson 1983, 403). This statement casts the process of self-realization as a perpetual aspiration to more—a deeply idealist vision of ongoing personal growth, but also as a paradigm of unrestrained materialistic expansion. Her essay investigates the resonance of Emerson's ideal of the soul in contemporary U.S. culture and politics and explores the inherent tensions between spirituality and materialism, personal freedom, and public interest; it also interrogates the premise of abundance in a socioeconomic reality characterized by dwindling resources and ecological crisis.

While accounting for a nation's particular ethos and historical identity, the idiom of the soul also gives access to a counter-history, one that investigates the ghostly existence of those who were counted as "souls" while their very humanity was denied. In "Souls on Board: A Counter-History of Modern Mobility", Susan Zieger investigates the maritime custom of counting the enslaved as "souls on board"—a practice that airplane captains still use to enumerate the number of living individuals on their crafts. Her essay considers how invocations of the soul framing different kinds of voyages—that of the enslaved, the tourist, the immigrant, the soldier—inflect the word across an ethical and political range. Officially deprived of their names, made to suffer in the cramped ship's hold on the Middle Passage, tortured on deck, and often thrown overboard when ill, the enslaved—though counted as "souls"—were dehumanized. Yet Zieger shows that in the bonds they forged with each other, and in their resistance to oppression, lie roots of African American culture, especially the idiom of the "soul" as expressing sadness or poignancy.

The Negro Spirituals, the "sorrow songs" which W.E.B. Du Bois perceived as an expression of the soul (Du Bois 2007, 167–177), bear testimony to this legacy while also relying on the soul as a principle of inner resistance and resilience. The idiom of the soul has retained much of this significance in African American culture. The literature of the African American women's Renaissance of the 1970s and 1980s in particular relies on the soul to express dissident claims related to gender and race. Claude Le Fustec's essay on "Spiritual Rebirth in African American Women's Fiction" considers the spiritual upsurge of African American writers such

as Toni Cade Bambara and Alice Walker on the literary scene, under the aegis of Toni Morrison. Her analysis relies on *Soul Talk: The New Spirituality of African American Women* (2001) by African American critic Akasha Gloria Hull, which argues that the 1970s–1980s were a time of spiritual maturation "as preparation for grappling with social issues on a more profound level" (Hull 2001, 24), radically departing from the generally held view that this was a time of regress in the light of the political ferment so active in the sixties. Hull notes that an upsurge of spirituality developed around 1980 in the wake of the Civil Rights movement and of the early ferment of the feminist movement. Building on Hull's work, Le Fustec's essay focuses on the literary expression of spiritual resilience in fictional writings of the period, in relation with gender and politics. She argues that beyond militant political action, these works convey a quest for unity and for higher global spiritual consciousness, with the potential to impact political action.

Just as in the slavery and civil rights context, the notion of "soul" has acquired political meanings in the colonial, postcolonial and decolonial contexts. Scholars have taken up the term to adapt its meaning, defining it for instance as a political tool used to control colonial subjects. In her essay "Three Women's Texts and a Critique of Imperialism", Gayatri Spivak describes the imperialist project as "soul making" (Spivak 1985, 236–237). According to her, "soul-making" is "the imperial project cathected as civil-society-through-social-mission" (Spivak 1985, 236–237). In this case, the colonialist project goes as far as trying to shape the very soul of the colonial subjects, who are supposedly devoid of one.

This postcolonial lens is at the heart of Claire Wrobel's essay, which examines the political stakes of the persistence of the soul through the reflection on national unity in *Frankenstein in Baghdad* (2013, transl. 2018), a novel by Ahmed Saadawi which received the International Prize for Arabic Literature in 2014. Claire Wrobel is interested in the rewriting of the myth of Frankenstein in a different cultural context. In "Persisting Souls in a Persisting Myth: Appropriation and Transmutation in *Frankenstein in Baghdad*", she shows that through the treatment of the soul, Saadawi's satirical rewriting of Shelley's novel metaphorically explores how national unity and a collective destiny may emerge out of a fragmented body politic here represented by the creature. *Frankenstein in Baghdad* appropriates various meanings of the soul—its common understanding as a principle of life, as well as religious, Islamic interpretations— to convey a reflection on national unity. Just as the principle of life

supposedly unifies the monster's body which is made of parts from diverse backgrounds (ethnicities, tribes, and social classes), the soul here becomes the principle that turns a country into a nation; but it is also a principle of potential chaos and political fragmentation. The paradigm of the soul thus proves liable to express political anxieties and to unsettle national representations.

In all its different guises, it seems that the soul has from the start been a peculiarly fluid concept. It has never lost its significance and relevance, even as it has become further and further removed from its origins in Greek philosophy or Christian theology. This elasticity, which has opened the door to reinterpretations of all sorts by thinkers and artists as well as appropriations within popular culture, may well be the source of its singular longevity and resilience. The distinct categories of literature, art, and politics around which the book is structured should not occult the permeability of their boundaries and the ability of the concept of the soul to traverse different disciplinary fields. This exploration of the soul hopes to shed light on the epistemological richness of a long-neglected concept, on its ability to bring together seemingly distant or antagonistic disciplines, and on its enduring relevance to humanities studies and to the modern world.

Notes

1. A few scholars have recently reconsidered the soul from a literary, artistic, or political perspective. Among them, see for instance Abe Davies (2021), who examines the literary representation of the soul from the tenth century to the age of Shakespeare specifically; see Le Fustec et al. (2015) for an exploration of the links between spirituality, arts and sciences, and Le Fustec et al. (2022) for a study of the links between the soul and social sciences.
2. William James defined religion in terms of individual experience and thought doctrines, while for him religious institutions were of secondary importance (James 1917).
3. See for instance Rembrandt van Rijn, *The Supper at Emmaus*, 1628, oil on canvas, 39 × 42 cm, Jaquemart-André Museum, Paris, France. The disciple facing the viewer is privately experiencing the awe of divine revelation while the servant busy in the back room, who is unaware that Christ has revealed himself, represents the "objectively indifferent world" Simmel talks about.
4. This organicist positivism sees the brain as being the first cause of psychological or mental disorder.

Works Cited

Arènes, Jacques. 2011. *La quête spirituelle hier et aujourd'hui. Un point de vue psychanalytique*. Paris: Edition du Cerf.

———. 2012. *Croire au temps du dieu fragile. Psychanalyse du deuil de Dieu*. Paris: Edition du Cerf.

Aristotle. 1902. *Aristotle's Psychology; a Treatise on the Principles of Life (De Anima and Parva Naturalia)*. Translated by William Alexander Hammond. London: Swan Sonnenschein & Company, Limited; New York: The Macmillan Company.

Blake, William. 1906. *The Marriage of Heaven and Hell* [1790]. Boston: John W. Luce and Company.

Bossi, Laura. 2003. *Histoire naturelle de l'âme*. Paris: Presses Universitaires de France.

Caron, Jean-Claude. 2003. De l'anonymat à l'avant-scène. Évolution de la notion d'adolescence aux XIXème et XXème siècles. In *L'Adolescence dans la psychanalyse*, ed. François Marty, 49–68. Paris. In Press.

Carroy, Jacqueline. 2000. L'invention du mot de psychothérapie et ses enjeux. *Psychologie Clinique* 9: 11–30.

Cheng, François. 2016. *De l'âme*. Paris: Albin Michel.

Davies, Abe. 2021. *Imagining the Soul in Premodern Literature*. London: Palgrave Macmillan.

Descartes, René. 1967. *The Philosophical Work of Descartes*, vols. I–II. Translated by E.S. Haldane, and G.R.T. Ross. Cambridge: Cambridge University Press.

———. 1985. *The Philosophical Writings of Descartes*, vols. I–II. Translated by J. Cottingham, R. Stoothoff, and D. Murdoch. Cambridge: Cambridge University Press.

Du Bois, W.E.B. 2007. *The Souls of Black Folk* [1903]. New York: Oxford University Press.

Ellenberger, Henri F. 1994. *Histoire de la découverte de l'inconscient*. Paris: Fayard.

Emerson, Ralph Waldo. 1983. *Essays and Lectures*. New York: Library of America.

Freitag, Michel, and Yves Bonny. 2002. *L'Oubli de la société. Pour une théorie critique de la postmodernité*. Rennes: Presses Universitaires de Rennes.

Freud, Sigmund. 1970. Les voies nouvelles de la psychothérapeutique psychanalytique. In *La Technique psychanalytique*, 131–141. Paris: Presses Universitaires de France.

Gauchet, Marcel. 1999. *The Disenchantment of the World: A Political History of Religion*. Translated by Oscar Burge. Princeton: Princeton University Press.

Goetz, Stewart, and Charles Taliaferro. 2011. *A Brief History of the Soul*. Oxford: Wiley-Blackwell.

Gormley, Antony. 1987. *Five Works*. London: Serpentine Gallery.

Gourevitch, Danielle. 2004. La psychiatrie de l'Antiquité gréco-romaine. In *Nouvelle histoire de la psychiatrie*, ed. Jacques Postel and Claude Quétel, 3–23. Paris: Dunod.

Guillemin, Hervé. 2006. *Diriger les consciences. Guérir les âmes.* Paris: La découverte.
Habermas, Jürgen. 2008. *Between Naturalism and Religion: Philosophical Essays* [2005]. Translated by Ciaran Cronin. Cambridge: Polity Press.
Hacking, Ian. 1998. *Rewriting the Soul: Multiple Personality and the Sciences of Memory.* Princeton: Princeton University Press.
Hull, Akasha Gloria. 2001. *Soul Talk: The New Spirituality of African American Women.* Rochester: Inner Traditions.
Hume, Kathryn. 2020. *The Metamorphoses of Myth in Fiction since 1960.* New York, London: Bloomsbury.
Hungerford, Amy. 2010. *Postmodern Belief. American Literature and Religion since 1960.* Princeton, Oxford: Princeton University Press.
James, William. 1917. *The Varieties of Religious Experience: A Study in Human Nature Being the Gifford Lectures on Natural Religion Delivered at Edinburgh in 1901–1902.* New York: Longmans, Green, and Co.
Janet, Pierre. 1983. *Les Médications psychologiques.* Paris: Société Pierre Janet.
Le Fustec, Claude, Françoise Storey, and Jeff Storey. 2015. *Théoriser le Spirituel. Approches transdisciplinaires de la spiritualité dans les arts et les sciences/ Theorizing the Spiritual. Transdisciplinary Approaches of Spirituality in the Arts and Sciences.* Bruxelles: Editions Moludaires Européennes.
Le Fustec, Claude, Myriam Watthee-Delmotte, Eric Vinson, and Xavier Gravend-Tirole, eds. 2022. *Le Spirituel. Un Concept opératoire en sciences humaines et sociales.* Louvain: Presses Universitaires de Louvain.
Lukács, György. 2010. *Soul and Form* [1910]. New York: Columbia University Press.
McClure, John A. 2007. *Partial Faiths, Postsecular Fiction in the Age of Pynchon and Morrison.* Athens, London: University of Georgia Press.
Mengal, Paul. 2000. D'une parole à l'autre. Le retournement rhétorique dans l'histoire de la psychothérapie. *Psychologie Clinique* 9: 31–42.
Pigeaud, Jacky. 2006. *La maladie de l'âme. Étude sur la relation de l'âme et du corps dans la tradition médico-philosophique antique.* Paris: Les Belles Lettres.
Plato. 1925. Phaedrus. In *Plato in Twelve Volumes*, vol. 9. Translated by Harold N. Fowler. Cambridge: Harvard University Press.
———. 2001. In *Plato's Phaedo*, ed. Richard Stanley Bluck. London: Routledge.
Renan, Ernest. 1990. "What is a nation?" (A lecture delivered at the Sorbonne, 1882). In *Nation and Narration*, ed. Homi K. Bhabha. London: Routledge.
Simmel, Georg. 2005. *Rembrandt: An Essay in the Philosophy of Art.* New York: Routledge.
Sisko, John. 2019. *Philosophy of Mind in Antiquity: The History of the Philosophy of Mind.* Vol. 1. New York: Routledge.
Spivak, Gayatri Chakravorty. 1985. Three Women's Texts and a Critique of Imperialism. *Critical Inquiry* 12:1 (Autumn), 235–261.

Taine, Hippolyte. 1883. *De l'intelligence* [1870], 2 volumes. Paris: Librairie Hachette & Cie.
Tuke, Daniel Hack. 1884. *Illustrations of the Influence of the Mind on the Body in Health and Disease, Designed to Elucidate the Action of the Imagination* [1872]. London: J. & A. Churchill.
Tyler, Peter. 2016. *The Pursuit of the Soul: Psychoanalysis, Soul-making and the Christian Tradition.* London: Bloomsbury.
Urbas, Joseph. 2016. *Emerson's Metaphysics: A Song of Laws and Causes.* New York: Lexington Books.
———. 2020. *The Philosophy of Ralph Waldo Emerson.* New York: Routledge.

# PART I

Writing the Soul

CHAPTER 2

Egyptian Souls in Victorian Minds: The Transmigration of the "Ka" in Egyptianising Fiction

Nolwenn Corriou

In Bram Stoker's novel *The Jewel of Seven Stars* (1903), the fictional Egyptologist Abel Trelawny exposes at great length the ancient Egyptian concept of the soul, basing his explanations on the research of the Victorian archaeologist Wallis Budge:

> First there is the 'Ka', or 'Double', which, as Doctor Budge explains, may be defined as 'an abstract individuality of personality' which was imbued with all the characteristic attributes of the individual it represented, and possessed an absolutely independent existence. It was free to move from place to place on earth at will; and it could enter into heaven and hold converse with the gods. Then there was the 'Ba', or 'soul', which dwelt in the 'Ka', and had the power of becoming corporeal or incorporeal at will; 'it had both substance and form […]. It had power to leave the tomb […]. It could revisit the body in the tomb […] and could reincarnate it and hold converse

N. Corriou (✉)
Paris 1 Panthéon Sorbonne University, Paris, France
e-mail: nolwenn.corriou@univ-paris1.fr

© The Author(s), under exclusive license to Springer Nature Switzerland AG 2024
D. Louis-Dimitrov, E. Murail (eds.), *The Persistence of the Soul in Literature, Art and Politics*,
https://doi.org/10.1007/978-3-031-40934-9_2

with it.' Again there was the 'Khu', the 'spiritual intelligence', or spirit. It took the form of 'a shining, luminous, intangible shape of the body.'... Then, again, there was the 'Sekhem', or 'power' of a man, his strength or vital force personified. These were the 'Khaibit', or 'shadow', the 'Ren', or 'name', the 'Khat', or 'physical body', and 'Ab', the 'heart', in which life was seated, went to the full making up of a man. (Stoker 2008, 174–175)

One can immediately see the appeal for fiction writers of this conception of a soul divided into multiple parts, capable of leaving and re-entering the dead body at will as well as susceptible of occupying other bodies. The growing knowledge about the ancient Egyptian notions concerning the body and the soul at the turn of the twentieth century was contemporary with a certain sense of disenchantment brought about by the scientific positivism which characterised the second half of the century. As the Christian tradition was increasingly called into question by the findings of geologists, naturalists or archaeologists, Victorians were increasingly drawn to the occult and to supernatural answers to the mysteries science could not explain satisfactorily—the link between the body and the soul in life, but mostly after death, being one of those unresolved mysteries. In this context, Egyptian concepts of the soul provided an appealing model by offering the hope of multiple rebirths and the eternity of the soul. Occult societies, such as the Hermetic Order of the Golden Dawn, were widely influenced by the discoveries of Egyptology and by the iconography and beliefs of Ancient Egypt. The ideas of reincarnation and the transmigration of the soul, in particular, offered fascinating possibilities in a world from which magic seemed to be vanishing, defeated by scientific progress. A number of Victorian and Edwardian writers also realised what rich imagination could be derived from the motifs of reincarnation, survival of the Ka in the present day and invasion and haunting of a Victorian mind by an ancient Egyptian soul, in romantic as well as in Gothic tales.

Egyptianising fiction[1] has broadly used the motif of reincarnation as a trope pointing to the eternal character of an ancient Egypt that survives in the present through the migration of Egyptian souls into Victorian bodies. Among the texts concerned, Bram Stoker's *The Jewel of Seven Stars* (1903) and Henry Rider Haggard's "Smith and the Pharaohs" (1913) are part of the genre described as mummy fiction. By locating ancient Egypt within imperial dynamics of exploitation and domination, this genre echoes what Patrick Brantlinger has defined as imperial Gothic, the mummy standing for a figure of the colonised that rebels against the archaeologist's imperial

rule. As a consequence, ancient Egyptian magic—and the power of the ancient Egyptian soul to free itself from the body and circulate at will—may be read as a Gothic motif expressing the threat represented by an empowered colonised population. Indeed, in *The Jewel of Seven Stars*, the soul of Queen Tera's mummy fights back by invading the body of Margaret Trelawny, the archaeologist's daughter, and using her voice to obtain what she wants. In "Smith and the Pharaohs," the eponymous character, himself a reincarnated ancient Egyptian, has to face his own criminal transgression when accused by a jury of revived mummies. However, not all Egyptianising fiction pertains to imperial Gothic fiction and a novel like Algernon Blackwood's *The Wave* (1916) may be analysed alongside Stoker's and Haggard's work insofar as it also stages, albeit in a very different vein, the immortality and the transmigration of antique souls and the devastating effects of the awakening of an Egyptian soul within a modern character. In these texts, the archaeological work undertaken by Egyptologists to excavate the buried soul of ancient Egypt can become an archaeology of the modern psyche, a psyche haunted by the return of an archaic and imperial repressed that comes back to life in the shape of the Egyptian Ka.

Reincarnation and the Quest for Identity

Mummy fiction—and, more broadly, Egyptianising fiction—is most of the time focused on the notion of return, as the persisting soul of ancient Egyptians returns in various ways, through the rebirth of an ancient Egyptian soul within a modern body or the awakening of an ancient body revived by its Ka. This return can take many shapes and is exploited in different veins by authors of popular fiction.

Most of the time, the return of an ancient soul is accompanied by the return of a body identical to the ancient one. In Henry Rider Haggard's *She* (1887), Leo Vincey, the reincarnation of the Egyptian queen Ayesha's lover, Kallikrates, comes back to life in Victorian Britain and is drawn to walk in the footsteps of his ancestor (or first incarnation) by travelling to South Africa to find the place where Ayesha has rebuilt a society hidden from the world. The rather moronic Leo Vincey, however, is a pale copy of his original incarnation. Just like the Sherd of Amenartas, which relates his family history, has become damaged by travelling through time to eventually reach him, the soul of Kallikrates appears to have been degraded by time so that only his body has been perfectly preserved. In *The Ancient*

Allan (1920), Haggard represents the link that exists between the different incarnations of a same soul. Travelling in time by breathing in the magic smoke of *taduki* leaves, Allan Quatermain is surprised to recognise himself in a man who looks nothing like him. His soul, however, has remained the same, and Quatermain is therefore able to recall and relive past experiences. His companions in ancient times turn out to be the same ones with whom he still shares adventures in the present day, testifying to the permanence of the soul.

This is also what the novella "Smith and the Pharaohs," another of Haggard's works that relies on the notion of reincarnation,[2] emphasises: in this story, the eponymous character is quite unaware of his ancient identity as Horu, an Egyptian sculptor who was the lover of Queen Ma-Mee and was punished for this unlawful passion. However, the sight of a bust of Queen Ma-Mee at the British Museum reawakens his passion for the long-dead queen and prompts him to become an Egyptologist so that he can search for the tomb of his beloved. His understanding of ancient Egypt and the instinct that helps him to locate the ancient tomb pertain more to personal memory than to scientific knowledge, and the track he follows eventually leads him to discover his antique self and to realise that the soul of Horu still lives in him. His dormant ancient Egyptian soul is then returned to a certain consciousness by his meeting with ancient Egyptian monarchs, who come back to life for a single night inside the museum of Cairo.

A more intricate instance of a persisting soul returning to a reborn body is presented by Bram Stoker in *The Jewel of Seven Stars*. In this novel, the discovery of Queen Tera's tomb coincides with the death of the archaeologist's pregnant wife. The child, Margaret Trelawny, is born shortly after her mother's death. The reader is made to assume that the child also died before being revived by the soul of the mummy[3]—and is therefore born twice of a dead mother/mummy, once in the flesh and once by receiving her soul. As a consequence, Margaret looks exactly like the Egyptian queen, and, as the novel gradually reveals, the possession of her mind by Tera's Ka subjugates her increasingly to the mummy's will as the living soul of the Egyptian queen circulates between the mummified body and the young British woman. Paradoxically, Margaret also has a mind of her own but, as her name suggests,[4] she is the repository of Tera's soul so that both Margaret's mind and the Queen's Ka vie for the control of the young woman's body.[5]

The motif of the returning soul, in these different texts, can be used to serve either a romantic or a Gothic plot. In *The Ancient Allan*, Allan Quatermain discovers his love for Lady Ragnall in the shape of the ancient priestess of Isis, Amada, while in "Smith and the Pharaohs," Smith tries again to claim the love of the woman he could not possess in Antiquity. The idea of an eternal soul is accompanied by the motif of eternal love, a love that lasts beyond death. However, in *The Jewel of Seven Stars*, the persisting soul of Queen Tera appears rather ominous as the narrator, in love with Margaret, observes the changes that come from the possession of her soul by the mummy's Ka and describes his concerns that her "other individuality was of the lower, not of the better sort" (Stoker 2008, 209).

In other texts, the leitmotif of the eternal Egyptian soul gets a rather more comedic treatment. These texts play with the equation between ancient Egypt and the return of a glorious past through the eternity of the soul. As it turns out in a short story such as "The Mummy of Thompson Pratt," written in 1904 by C.J. Cutcliffe Hyne, the return of an ancient soul can be quite a disappointment for the modern archaeologist. In this story, the eponymous Thompson Pratt appears to be the descendant of Menen-Ra whose mummy has just been discovered. An attempt is made to revive the mummy so that "the old boy may let slip something in the natural science line which is strange to us to-day" (Cutcliffe Hyne 2008, 153). However, the major scientific breakthrough which may have helped to understand the secrets of the soul and the atavistic links which bind Menen-Ra and Thompson-Pratt together (their bodies bear the exact same birthmark), delineating the missing link between the body and the soul, comes to a rather ludicrous end when the revived mummy turns out to be unable to provide any meaningful information. Instead, the archaeologist who "had looked for a dissertation on history" complains he was only "getting *chroniques scandaleuses*" (Cutcliffe Hyne 2008, 156):

> Again and again Gargrave tried to lead this wanderer from a long-forgotten past on the more weighty matters of state, and time after time he got back to talk about cockfights, and dicing bouts, and ape-racing on the dry Nile banks; or else he would speak to us of Chloe and his other loves with a freedom which is quite obsolete to-day. He brimmed with these reminiscences. But he had no others of a graver sort. (Cutcliffe Hyne 2008, 157)

This passage makes it clear that if the soul of Menen-Ra did persist and was successfully brought back to his body, it may not have been a soul

worth salvaging from the past. Tired of the mummy's bawdy stories, the archaeologist sends his soul away, thus silencing the ancient Egyptian.

Finally, the leitmotif of the survival of Egyptian souls became such a systematic trope of Egyptianising fiction that it came to be used paradoxically by Sax Rohmer in his novel *She Who Sleeps* (1928). Baffled by the affinity he feels with Zalithea, an apparently revived mummy, and by the memories he seems to have of her, the young hero of this romance naturally jumps to the conclusion that he is obviously the reincarnation of an ancient Egyptian and that "She has slept, miraculously, living on; but he had died, in the ordinary way, and was now reborn—in the ordinary way!" (Rohmer 1928, 198). The assumption that the transmigration of an ancient Egyptian soul into a modern American body is "the ordinary way"[6] ironically underlines the intertextual iteration of this trope throughout the genre of mummy fiction and more generally in all texts that take ancient Egypt as their subject.

This overview of the varied representations of the returning soul in Egyptianising fiction points to one common feature of this trope: the discovery of the transmigrating Ka is akin to a quest for identity, an attempt to return to one's own origins, buried under the sands of Egypt. Indeed, the interest of the authors of Egyptianising fiction in the motif of reincarnation or the return and transmigration of ancient souls cannot only be assigned to the popular fascination of Victorians for the occult and for supernatural happenings. It has to be replaced in the scientific context of the late nineteenth century. By opening up new spatial as well as temporal dimensions, the work of relatively new disciplines such as geology or archaeology challenged and even shattered the biblical tales that justified the origins of humanity as well as the ability of the soul to transcend materiality after death. The search for an origin appeared, therefore, as a real scientific concern in a period when natural sciences opened up as many questions as they answered. The narrative appeal of such questioning is obvious in the many stories that hinge on the search for a personal or collective missing link and the discovery of an ancient civilisation or ancestor that justifies the existence of modern characters. In short, by attempting to rationalise the universe and explain it as rigorously as possible, the scientific positivism of the nineteenth century is paradoxically responsible for opening a space for imagination and magic, a space where the soul plays an important part. The missing link scientific research was striving to identify was, in fiction, repeatedly discovered in fantastic tales in the guise of a persisting soul that had travelled across history.

Egyptianising fiction—and mummy fiction in particular—often takes the shape of a quest for an origin by staging Egyptological research, a quest that binds the modern British character with ancient Egypt through the transmigration of the soul. Of the characters mentioned so far, many are orphans, deprived of either both their parents or at least their mother. In *She*, Leo has lost both his parents and is brought up by his guardian, Horace Holly; in *The Jewel of Seven Stars*, Margaret Trelawny is born of a mother who is already dead while Smith in Haggard's "Smith and the Pharaohs" only has a godfather while no mention is made of his parents. Their broken families reflect the broken link between them and their past—a link they attempt to rebuild through the work of archaeology, thus mirroring a collective attitude suggested by the work of natural sciences. In those tales, the attempt to discover a historical origin in Egypt merges with the search for a personal origin, so that the quest for a mother figure often leads to the finding of a "mummy," underlining the paramount importance of a symbolic maternal anchorage in the narratives considered. The Egyptian souls that persist or return to life are the link that confirms the characters' genealogy, taking them back to ancient Egypt. The continuity of Leo Vincey's genealogy is materialised through the Sherd of Amenartas that tells of the travels of Leo's ancestors from Egypt to Britain, via ancient Greece, ancient Rome and medieval France. In "The Mummy of Thompson-Pratt," the eponymous character has a very similar genealogy, as the character of Gargrave asserts he has "worked out the chain of descent in Egypt, Italy, France, England, Scotland and England again without a break" (Cutcliffe Hyne 2008, 153).

In the imperial context of turn-of-the-century Britain,[7] the quest for an origin can have certain political undertones. In Egyptianising fiction, archaeological activities often serve as a metaphor for the colonial exploitation of Egypt. As a consequence, the discovery of one's ancient origins in Egypt may be used to vindicate the occupation of modern Egypt as much as the appropriation of its past. Egypt is constructed as a motherland the British characters return to and claim for themselves as their legitimate historical inheritance—one they received by right along with an Egyptian soul.

Invasion of the British Body: Transmigration and Reverse Colonisation

Despite the comedic or parodic treatment of the motif of the persisting Egyptian soul, the imperial context which saw the emergence of mummy fiction—and Egyptian-themed fiction more broadly—can also suggest a

darker undertone to the circulation of ancient souls and their penetration of modern British bodies. The outcome of the quest for an origin, by unearthing ancient souls and ancient vengeful bodies, may also threaten the modern character, the soul becoming the instrument of an imperial Gothic narrative.

In *Rule of Darkness*, Patrick Brantlinger explains that the genre of imperial Gothic fiction is characterised by narratives which show the invasion of western civilisation by occult forces originating in the colonial territories' past and beliefs. In the Orientalist context of Egyptianising fiction, the supernatural beliefs of ancient Egyptians as well as the superstitions linked to ancient sites for the country's modern population suggest to fiction writers the occult forces that may threaten British civilisation through the archaeologist who is the first to encounter these forces. Through his activities, the archaeologist may be interpreted as an agent of the Empire, invading the colonised country in order to appropriate its (historical) resources through the exploitation of the local workforce. In this context, the excavation of mummies and their treasures can be considered a transgression both as a form of looting and as a mark of disrespect for the ancient culture and its dead. This is an opinion expressed by Henry Rider Haggard in his memoirs, *The Days of My Life* (1926) when he writes:

> I dwelt upon the wholesale robbery of the ancient Egyptian tombs and the consequent desecration of the dead who lie therein. It does indeed seem wrong that people with whom it was the first article of religion that their mortal remains should lie undisturbed until the Day of Resurrection should be haled forth, stripped and broken up, or sold to museums and tourists. (Haggard 1926, vol. 2, 158)

Haggard also reminds his reader that

> Nothing in the world was so sacred to the old Egyptian as were his corpse and his tomb. In the tomb slept the body, but according to his immemorial faith it did not sleep alone, for with it, watching it eternally, was the Ka or Double, and to it from time to time came the Spirit. This Ka or Double had, so he believed, great powers, and could even wreak vengeance on the disturber of the grave or the thief of the corpse. (Haggard 1926, vol. 1, 259)

This imagination surrounding Egypt can explain why the mummy becomes, in many short stories and a few novels written at the turn of the century, an instance of a colonial monster bent on destroying the imperial

archaeologist. This monster is revealed through archaeological research before it is brought to England to be displayed in a museum from which the curse can strike. However, the mummy itself—in the sense of the preserved dead body—is rarely actually responsible for all the mysterious and dramatic events that follow the transgression entailed by the violation of the tomb and the displacement of its contents. In *The Jewel of Seven Stars*, in spite of the repeated attacks on the archaeologist Abel Trelawny and the disappearance of various objects, the mummy of Queen Tera is never described in movement; she only ever appears lying, perfectly motionless, in the mummy chamber or in the archaeologist's bedroom, unable, it seems, to perpetrate any of the attacks of which she is suspected. Instead, the reader is given to understand that Margaret, the archaeologist's daughter and Queen Tera's lookalike, may be responsible for most of the bloody incidents reported in the narrative. It appears, however, that Margaret is not aware of what she is doing and that her actions are directed by the mummy's Ka, which travels at will between Tera's body and Margaret's. In other words, the curse of the mummy is actually the curse of the mummy's soul, the mummy simply waiting for the return of the Ka to be reanimated.

The lack of incarnation is precisely what makes the mummy's Ka such a powerful and terrifying monster. The very fact that it can live and travel without a body gives it great power and makes it invincible: it cannot be seen, it cannot be killed, but its capacity to act on reality seems almost endless. *The Jewel of Seven Stars*, in particular, shows the concerning effects of the Ka on the British people who inhabit the house. Throughout the novel, the narrator, Malcolm Ross, underlines the detrimental effects of the influence of Tera's Ka on his beloved Margaret. At first, however, the transformation of Margaret caused by her possession by Tera's Ka appears mostly positive. The new woman who emerges is described in laudatory terms:

> Her noble words, flowing in musical cadence and vibrant with internal force, seemed to issue from some great instrument of elemental power. Even her tone was new to us all; so that we listened as to some new and strange being from a new and strange world. (Stoker 2008, 179)

Margaret describes the occupation of her own mind by the mummy's soul as a joyful merging of their beings which gives a voice to the ancient Egyptian queen as she imagines the land where she might be reborn:

> Where there might be some one kindred spirit which could speak to hers through mortal lips like her own; whose being could merge with hers in a sweet communion of soul to soul, even as their breaths could mingle in the ambient air! I know the feeling, for I have shared it myself. I may speak of it now, since the blessing has come into my own life. I may speak of it since it enables me to interpret the feelings, the very longing soul, of that sweet and lovely Queen, so different from her surroundings, so high above her time! (Stoker 2008, 178)

This happy communion of the souls, however, soon leads Margaret to struggle with a form of schizophrenic personality, as she hovers between her old and her new self. The narrator also expresses his doubts regarding his fiancée: "I never knew whether the personality present was my Margaret—the old Margaret whom I had loved at the first glance—or the other new Margaret, whom I hardly understood, and whose intellectual aloofness made an impalpable barrier between us" (Stoker 2008, 204). This "dual existence" (Stoker 2008, 209) eventually seems to end in the denouement of the novel as a result of the Great Experiment meant to reconcile Tera's body with her Ka. In the second ending of the novel (written in 1912), as the mummy's body disappears mysteriously, it is unclear what happened to her Ka, and whether it vanished with her once and for all or settled definitely in Margaret. It would seem quite likely, considering Margaret's "far-away eloquent dreamy look" (Stoker 2008, 250) and last words,[8] that the Ka has finally taken full possession of Margaret's spirit, silencing her "old self" once and for all, as she now speaks in the queen's voice.

In its capacity to penetrate the body at will, without being seen, and to change the person affected radically—as is the case with Margaret Trelawny—there is something pathological in the representation of the Egyptian soul. Indeed, like a disease, the Ka can contaminate the Victorian body with variable effects. The motif of the virus can be found in a number of Egyptianising novels, echoing the turn-of-the-century fear of degeneration and contamination by the imperial territories. This is most clear in the novel *Pharos the Egyptian* by Guy Boothby (1899), in which the British protagonist, Cyril Forrester, is repeatedly the victim of phenomena which seem akin to spiritual possession at the hands of Pharos, a reborn ancient Egyptian who seeks vengeance for the looting of his tomb and the theft of his mummy. The point of these episodes of possession remains unclear until it is revealed that Forrester has been inoculated with

the plague while he was unconscious—a virus he then carries with him through Europe, contaminating countless people, as per Pharos's plan.

The inability to locate the soul, to understand or seize it, as well as its devastating effects on the modern body it occupies, locates the representation of the soul in the realm of Gothic or, more precisely, imperial Gothic fiction, as the imperial context needs to be taken into account to understand why the occupation or invasion of a British body by an ancient Egyptian soul may be significant at the turn of the century. Indeed, by entering and occupying a Victorian mind without consent and then exploiting the body it thus gets to control, the Egyptian soul reproduces and inverts the colonial dynamics of domination, transferring them from the imperial territory to the imperialist body. In that sense, one can see an echo, in the motif of spiritual possession in Egyptianising fiction and in *The Jewel of Seven Stars* in particular, of the notion of reverse colonisation identified by Stephen Arata in his study of *Dracula*. Arata analyses Dracula's move to Britain as well as his vampiric activities as a form of reverse colonisation through which the colonised subject reverses imperial power dynamics. Dracula asserts his power through symbolic invasions, from the city where he settles to the body of the woman whose blood he drinks. The contamination of Margaret Trelawny's mind by the Ka of Queen Tera echoes the vampiric contamination of the blood of Lucy Westenra and Mina Murray in *Dracula*. The "Egyptian contamination" may be perceived in the fact that many characters discover their own Egyptian blood, like Smith in Haggard's "Smith and the Pharaohs" or Leo Vincey in *She*. But it can also take a visual appearance: in *The Jewel of Seven Stars*, Abel Trelawny, the owner of Queen Tera's mummy, is himself gradually converted into what looks very much like a mummy, with his arm wrapped in bandages that mirror the mummy's wrapping. Trelawny, like Tera, is compared to a statue, as he lies unconscious, with his face "as white as a marble monument" (Stoker 2008, 47). Tera's skin is similarly compared to marble but also to ivory, as she is described lying in her tomb or in Trelawny's house. Both the archaeologist and the mummy appear deprived of their souls as their bodies turn into motionless statues, while Margaret is struggling with the invasion of her own mind by the queen's Ka.

In the case of the eponymous Smith in Haggard's "Smith and the Pharaohs," reincarnation also appears as a form of reverse colonisation, his ancient soul returning to his modern body to reveal his former identity to him. In this process of transmigration of the soul, Smith is left quite wrecked as the end of the novella shows him obsessively striving to

understand his experience to determine whether or not he dreamed his encounter with revived Egyptian mummies. The form of madness that comes from the return of an ancient soul echoes the pathological contamination one can observe metaphorically in *The Jewel of Seven Stars* or literally in *Pharos the Egyptian*.

The reverse colonisation that is achieved by Egyptian souls penetrating British minds and manipulating or transforming the bodies they control can be read in the imperial context as expressing some of the fears which marked Victorian society at the turn of the century: the fear of seeing the colonies turning on the coloniser and claiming independence, the fear of degeneration through contact with indigenous populations and the fear of miscegenation. In this sense, Egyptianising fiction anticipates the invasion novel of the early twentieth century.

The freedom and the power of the Egyptian Ka, such as it is represented in Egyptianising fiction, make it a perfect metaphor for an inversion of positions between the coloniser and the colonised—with the devastating consequences this reversal can have. In the original ending of *The Jewel of Seven Stars*, Margaret is eventually destroyed by Queen Tera, along with all her companions, except for the narrator. The 1912 ending, which seems to suggest the victory of the Queen's Ka over the young woman's mind, appears rather ominous.

From the Soul to the Mind: An Archaeology of the Psyche

The notion of the return of a soul from the past that upsets and sometimes even destroys a modern mind has obvious psychoanalytical echoes in a corpus that was written at the time when Freud was developing his psychoanalytical methods and theory of the layered mind. By invading the British mind, the buried Ka uncovered by archaeology can, in certain texts, reveal a haunted modern mind.

The parallels between archaeology and psychoanalytical work were underlined on several occasions by Freud as he attempted to circumscribe the mission and the methods of the psychoanalyst:

> His [the analyst's] work of construction, or, if it is preferred, of reconstruction, resembles to a great extent an archaeologist's excavation of some dwelling-place that has been destroyed and buried or of some ancient edifice. The two processes are in fact identical, except that the analyst works

under better conditions and has more material at his command to assist him, since what he is dealing with is not something destroyed but something that is still alive—and perhaps for another reason as well. But just as the archaeologist builds up the walls of the building from the foundations that have remained standing, determines the number and positions of the columns from depressions in the floor and reconstructs the mural decorations and paintings from the remains found in the débris, so does the analyst proceed when he draws his inferences from the fragments of memories, from the associations and from the behaviour of the subject of the analysis. (Freud 1964, 259)

By considering his work as an archaeology of the psyche, Freud constructs the mind as a vertical structure made up of successive layers, the deepest of which are both the most ancient and the most strongly repressed. The discovery of a personal origin through archaeological work in Egyptianising fiction may be interpreted as the unearthing of the most primitive and ancient bases of the mind as well as the repressed content that has been rejected in the deepest pits of the mind.

Collectively, the corpus of mummy fiction—and Egyptianising fiction in general—can be read as a case study demonstrating the obsessions and the repressed anxieties of the late-Victorian and Edwardian psyche (about the decline of the Empire, of the British "race," and so on). However, the metaphorical power of archaeology as a signifier of psychoanalytical work is only explicitly emphasised in Algernon Blackwood's novel, *The Wave: An Egyptian Aftermath* (1916). The text is, from the opening, announced as a narrative construction illustrating Freud's theory of dreams and notions of the unconscious mind, memory and repression. The main principles of Freud's method are exposed in the first few pages by the father of Tom Kelverdon, the central character. Presented as a disciple of Freud, he attempts to analyse his son's dreams so as to understand what is troubling the child. The whole novel can be read as a narrativised psychoanalytical process that eventually reveals what Tom has been repressing. The story develops around the interpretation of a recurring dream Tom has had since his childhood: in this vision, he sees a wave that threatens to submerge him, while he also perceives the presence of angry blue eyes and Oriental black eyes, accompanied by a light smell. A link is quickly established between certain elements of the dream and ancient Egypt as Tom identifies the "Whiff" from his dream as an Egyptian scent he discovers in his father's desk. As the novel unfolds, the reader is given a demonstration

of the displacement of Tom's Oedipal complex onto his friend Lettice, who stands for a mother figure, and his cousin Tony, who becomes a hated father figure. As this unconscious part of the mind is gradually revealed, Tom's repressed thoughts are given a narrative representation as a forgotten Egyptian past. The repressed feelings that appear in his dreams are described as memories from a former incarnation. It takes a trip to Egypt for the past of the three protagonists to return and for their former Egyptian souls to reawaken. They remember that they were entangled in a similar love triangle in a remote antique past they all shared and had forgotten. The return of her ancient soul is perceived by Lettice as a division of her mind:

> Some part of her, long hidden, had emerged in Egypt, brought out by the deep mystery and passion of the climate, by its burning, sensuous splendour: its magic drove her along unconsciously. There were two persons in her. (Blackwood 2012, 170)

In this passage, as in the whole novel, the repressed past of the characters takes the form of an Egyptian soul that persisted through time and reasserts itself thanks to the process of reincarnation. The Ka of their ancient Egyptian self has become part of their modern mind, one that has been repressed and buried under layers of time and consciousness, but one that can always break through when the memories of Egypt are reactivated by a holiday in that country.

The discovery of an ancient soul at the bottom of the mind in Blackwood's novel reveals a layered conception of the personality whereby the stratified construction of the mind is seen as a historical process—at the level of the individual as well as at a collective level. In the metaphorical history of the mind proposed by Blackwood, ancient Egypt stands for the most remote past, the childhood of the soul but also that of humanity. The modern mind, as a consequence, is built on the foundation of this ancient soul that may return and is ever present in the individual. In Blackwood's novel, the interpretation of dreams serves to reactivate the memory and bring to light what has been hidden by time. In *The Wave*, the oneiric dimension is represented by the constant repetition of the same conversations which fail to make sense as soon as they fade from Tom Kelverdon's memory. Just like a dream, his experience can only be interpreted after a thorough analysis of what he has chosen to bury in the depths of his consciousness.

Similarly, the dream-like experience of Smith in "Smith and the Pharaohs" is guided by Smith's apparent memory of the queen he has been trying to find through his work as an Egyptologist. As the dream unfolds, Smith, like Tom Kelverdon, reaches the most ancient part of history and discovers his own former identity as an Egyptian from Antiquity. The closing lines of the novella show Smith struggling with this newly discovered soul and trying to determine what he can make of his oneiric experience.

Blackwood's image of the soul is linked to his notion of history and time as a stratified structure. Indeed, time is seen not as a continuous line but as a spiral that offers the possibility to look back on events. This is the theory Tom exposes to his companions:

> 'I say,' Tom began with a sudden plunge, 'you know a lot about birds and natural history—biology too, I suppose. Have you ever heard of the spiral movement?'
> [...] 'I mean the idea—that evolution, whether individually in men and animals, or with nations—historically, that is—is not in a straight line ahead, but moves upwards—in a spiral?'
> 'It's in the air,' replied Tony vaguely, yet somehow as if he knew a great deal more about it. 'The movement of the race, you mean?'
> 'And of the individual too. We're here, I mean, for the purpose of development—whatever one's particular belief may be—and that this development, instead of going forwards in a straight line, has a kind of—spiral movement—upwards?' [...]
> 'I mean—a movement that is always upwards, always getting higher, and always looking down upon what has gone before. That, if it's true, a soul can look back—look down upon what it has been through before, but from a higher point—do you see?' (Blackwood 2012, 46)

To Freud's idea of a layered mind, Blackwood adds the idea of a historically layered soul, which reflects the spiral of time. At both the individual and the collective levels, there is a sense of constant progress, the current time representing—for now—the apex of civilisation. This goes against the idea of a possible decline of Western civilisation in the imperial context while presenting the modern man as the sum of former civilisations (as is the case of Leo Vincey, in *She*, for instance) that are all contained within his soul. This vision of the soul echoes another concept which anticipated Freud's theories: that of the mind as a palimpsest formed of many layers that can be restored to the consciousness through a form of archaeology

of the mind. Thomas de Quincey develops this image in *Suspiria de Profundis*:

> What else than a natural and mighty palimpsest is the human brain? Such a palimpsest is my brain; such a palimpsest, oh reader! is yours. Everlasting layers of ideas, images, feelings, have fallen upon your brain softly as light. Each succession has seemed to bury all that went before. And yet, in reality, not one has been extinguished. (De Quincey 1965, 510)

Tom Kelverdon's soul is such a palimpsestic structure insofar as his ancient Egyptian past is never erased but can, on the contrary, be observed and revisited from a higher position in the time of the "Egyptian aftermath" of the title. This position, at the top of the spiral, as it were, is frequently suggested by the impression felt by Tom of perceiving events through a sort of veil. The vagueness of his perception underlines the superposition of events as opposed to the linearity of experience and is repeatedly represented in the novel in the shape of a déjà-vu:

> And the sense of familiarity became suddenly very real: he knew what she was going to say, how he would answer, why they had come together. It all flashed near, yet still beyond his reach. He almost understood. They had been side by side like this before, not in this actual place, but somewhere—somewhere he knew intimately. Her eyes had looked down into his own precisely so, long, long ago, yet at the same time strangely near. There was a perfume, a little ghostly perfume—it was the Whiff. It was gone instantly, but he had tasted it... A veil drew up... He saw, he knew, he remembered—almost... (Blackwood 2012, 74)

In his vision of former selves living the same events, Tom appears himself as a palimpsestic being whose reincarnations each contain the traces and the memories of former incarnations thanks to the transmigration of a same living soul. The sense of continuity involved by this understanding of the soul is analysed by Josephine McDonagh in her study of the figure of the palimpsest in de Quincey's work: "As history is inscribed on the lower layer of a palimpsest the past becomes the origin of the present and the future, the missing link that restores the unity of all time" (1987, 212). This is to say that Blackwood, in *The Wave*, like Haggard in *She* or in "Smith and the Pharaohs," uses the Egyptian past to picture a lost origin that can be found again, through the work of archaeology—or archaeology of the mind. Unlike other authors, however, Blackwood uses the

motif of the return of an Egyptian soul to locate the modern individual and the nation in a spiral of continuity that is synonymous with progress and elevation rather than decline and collapse.

Born of late-nineteenth-century Egyptomania, Egyptianising fiction—and mummy fiction in particular—also stems from a moment of great epistemological doubt paradoxically caused by scientific progress. As the knowledge of the body and the material world developed, the Victorians turned to the soul, the immaterial and the occult to try and make sense of the world and fight a certain sense of disenchantment. The appeal of ancient Egyptian notions of the Ka is obvious in the genre of imperial Gothic. By using the motifs of reincarnation and the return of antique souls, the texts considered present an archaeology of the mind, where the Ka stands for the archaic part of the conscience. Through archaeology—or psychoanalysis as an archaeology of the psyche—this hidden, repressed part of the soul may be retrieved, sometimes with devastating consequences. Indeed, the Egyptian repressed is, for the most part, an imperial repressed that points to the decline of the British mind as well as the British Empire, while the body becomes vulnerable to the return of the repressed Ka. Paradoxically, the quest for an origin that can be read in the motifs of reincarnation and the return of the ancient Egyptian soul serves to unearth the revelation of an impending end. Just as ancient Egypt eventually disappeared in the sands of time, it seems that imperial Britain may follow the same path. The revelation of the Egyptian soul contained within the British mind proleptically announces the always-growing spiral of time and consciousness which eventually buries the past. However, the return of the ancient Egyptian soul may also be read as a sign of hope, suggesting the future persistence and the progress of the modern soul in the eternal spiral of time described by Blackwood:

> Nations rise and fall, equally with the fortunes of a family. History repeats itself, so does the tree, the rose: and if a man live long enough he recovers the state of early childhood. There is repetition everywhere. But while some think evolution moves in a straight line forward, others speculate fancifully that it has a spiral twist upwards. At any given moment, that is, the soul looks down upon a passage made before—but from a point a little higher. Without living through events already experienced, it literally lives them over; it sees them mapped out below, and with the bird's-eye view it understands them. (Blackwood 2012, 37)

Notes

1. I use the phrase proposed by Maria Fleischhack to describe literature that depicts or refers to ancient Egyptian culture (Fleischhack 2015).
2. Haggard was interested in the theory of reincarnation, although he admitted having strong doubts about its possibility. Instead, he believed in a form of atavistic sense that would explain the "fact that some men have a strong affinity for certain lands and periods of history, which, of course, may be explained by the circumstance that their direct ancestors dwelt in those lands and at those periods" (Haggard 1926, 255, vol. 1).
3. "The dead child! Was it possible that the child was dead and was made alive again? Whence then came the animating spirit—the soul? Logic was pointing the way to me now with a vengeance!—If the Egyptian belief was true for Egyptians, then the "Ka" of the dead Queen and her "Khu" could animate what she might choose. In such case Margaret would not be an individual at all, but simply a phase of Queen Tera herself; an astral body obedient to her will!" (Stoker 2008, 206).
4. As many studies have noted, Margaret's name contains the name of the Egyptian queen spelled backwards: MargARET.
5. In the first ending of the novel written in 1903, Tera appears to triumph, and Margaret dies of the struggle between the two souls. The second ending, published in 1912, is somewhat more ambiguous, as Margaret survives the Great Experiment meant to revive Queen Tera. Her last words, however, suggest that the queen's Ka may have definitely settled in her body, as the young woman seems to convey the ancient Egyptian's thoughts to her husband.
6. The rational solution to this mystery (the fact that "Zalithea" is a young actress posing as a mummy) comes as a surprise for the reader as much as for the character of Barry Cumberland, who is convinced of being part of a supernatural plot naturally suggested by the ancient Egyptian context. See Corriou.
7. In many of the works pertaining to mummy fiction or Egyptianising fiction, the awakening of an Egyptian soul represents a curse for modern Britain, evoking one of the criteria given by Patrick Brantlinger to define the genre of imperial Gothic: "an invasion of civilization by the forces of barbarism and demonism" (Brantlinger 1988, 230).
8. "Do not grieve for her! Who knows, but she may have found the joy she sought? Love and patience are all that make for happiness in this world, or in the world of the past or of the future, of the living or the dead. She dreamed her dream, and that is all that any of us can ask!" (Stoker 2008, 250).

Works Cited

Arata, Stephen. 1996. *Fictions of Loss in the Victorian Fin de Siècle*. Cambridge: Cambridge University Press.

Blackwood, Algernon. 2012. *The Wave: An Egyptian Aftermath* [1916]. Maryland: Wildside Press.

Boothby, Guy. 1899. *Pharos the Egyptian*. London: Ward, Lock & Co. Limited.

Brantlinger, Patrick. 1988. *Rule of Darkness: British Literature and Imperialism, 1830–1914*. Ithaca: Cornell University Press.

Corriou, Nolwenn. 2019. 'Birmingham Ware': Ancient Egypt as an Orientalist Construct. *Journal of History and Cultures* 10: 45–66.

Cutcliffe Hyne, C.J. 2008. The Mummy of Thompson Pratt [1904]. In *Out of the Sand: Mummies, Pyramids and Egyptology in Classic Science Fiction and Fantasy*, ed. Chad Arment. Landisville: Coachwhip Publications.

De Quincey, Thomas. 1965. Suspiria de Profundis: Being a Sequel to the Confessions of an English Opium-Eater. In *Confessions of an English Opium-Eater* [1845]. London: MacDonald.

Fleischhack, Maria. 2015. *Narrating Ancient Egypt. The Representation of Ancient Egypt in Nineteenth-Century and Early-Twentieth-Century Fantastic Fiction*. Frankfurt: Peter Lang.

Freud, Sigmund. 1964. Constructions in Analysis. In *The Standard Edition of the Complete Psychological Works of Sigmund Freud*, vol. XXII. London: The Hogarth Press and the Institute of Psycho-Analysis.

Haggard, Henry Rider. 1887. *She*. London: Longmans.

———. 1920a. Smith and the Pharaohs. In *Smith and the Pharaohs and Other Stories*. London: J.W. Arrowsmith.

———. 1920b. *The Ancient Allan*. London: Cassell and Company.

———. 1926. *The Days of My Life: An Autobiography*. Vol. 1. London: Longmans.

McDonagh, Josephine. 1987. Writings on the Mind: Thomas De Quincey and the Importance of the Palimpsest in Nineteenth Century Thought. *Prose Studies* 10: 207–224.

Rohmer, Sax. 1928. *She Who Sleeps: A Romance of New York and the Nile*. New York: Doubleday.

Stoker, Bram. 1997. *Dracula* [1897]. New York: Norton.

———. 2008. *The Jewel of Seven Stars* [1903]. London: Penguin Classics.

CHAPTER 3

E. S. Dallas's Literary Theory: The "Hidden Soul" and the Workings of the Imagination

Thalia Trigoni

In the early 1800s, psychology was considered as a science of the soul rather than of the mind, and it was expected "to reinforce important religious beliefs" (Reed 1997, 3). The spiritual and religious view, however, did not automatically imply the rejection of a secular material basis for psychology (Reed 1997, 5; Dixon 2003, 9). The term "psychology" started becoming widespread in the 1850s, but its field of inquiry was not clearly delineated yet (Smith 2004, 82). As psychology replaced the "soul" with the "mind" or "consciousness" as its object of study, it migrated from a focus on spirituality as the source of mental processes to a material, physiological basis for cognition, marking a shift from metaphysics to physiology. The discipline was not shaped solely by scientists. Rather, "questions about body and mind, spirit and soul … were also widely aired in the popular press and fiction of the period" (Matus 2007, 1260). In fact, it is primarily in the periodical press that we find the "*shaping* of an area of discourse, known as psychology" (Smith 2004, 82). As one of the

T. Trigoni (✉)
Rovira i Virgili University, Tarragona, Spain
e-mail: thalia.trigoni@urv.cat

© The Author(s), under exclusive license to Springer Nature Switzerland AG 2024
D. Louis-Dimitrov, E. Murail (eds.), *The Persistence of the Soul in Literature, Art and Politics*,
https://doi.org/10.1007/978-3-031-40934-9_3

most respected critics of the day who wrote during the 1850s and 60s for *The Times*, and at least a dozen more periodicals, E.S. Dallas was placed right at the heart of this debate, whilst his terminology found its way into a number of contemporary literary works, shaping, to a significant extent, the period's literary production. He was very influential in literary circles of the time, and it was Dallas who wrote reviews in *The Times* of such monumental works as *Adam Bede* (1859), *The Mill on the Floss* (1860), *Silas Marner* (1861), *Great Expectations* (1861) and *Romola and Felix Holt* (1866). His work is representative of the tectonic shift in the way contemporary thinkers and psychologists thought about the human mind, as within a period of 14 years, we may observe a turn from the metaphysically imbued "soul" of his *Poetics* (1852) to a theory in *The Gay Science* (1866) that turns from the divine realm of spirituality to the inner, physiological workings of the mind. What is particularly distinctive and tantalising about Dallas's work is that he theorised that human nature is in fact a conjunction of two souls, one conscious and familiar, and the other hidden and unconscious. The name he gave to the latter kind of soul is "hidden soul" as a means to suggest that just as the soul is a cognate for the conscious mind, the hidden soul refers to the existence of a hidden or unconscious mind.

Dallas's Scientific Criticism: At the Borders of the Hidden Soul and the Poetic Imagination

Dallas's formulation of the theory of a hidden soul was probably inspired by various strands of thought and scientific enquiry that were pervading contemporary thought, like dreams, intoxication, insanity as well as the new vogue of the time—spiritualism, mesmerism and hypnotism. A distinctive feature common to all these states was that the unconscious exhibited characteristics similar to those of consciousness. Previous theories of the unconscious viewed them as instances of God's acting through the individual. John Stuart Mill (1806–1873) is often seen as a pioneer responsible for a turn against this tide by postulating the existence of reasoning processes within the unconscious mind (Reed 1997, 131). The same shift was identified in the works of German psychologists in the 1850s and 1860s, in the works of Hermann von Helmholtz (1821–1894) and Wilhelm Wundt (1832–1920), and in the concept of "unconscious inference" (Reed 1997, 118). E.S. Dallas stands tall among these figures

inasmuch as he provided the first book-length exposition on the cognitive abilities of the hidden soul, whilst associating it with the imagination and the need to arrive at a literary theory that incorporates the science of psychology. His critical theory, developed in *Poetics* and *The Gay Science*, represents the first major attempt to use contemporary theories of the unconscious as the basis for poetic imagination in order to formulate what he referred to as "scientific" literary criticism.

Dallas sought to develop a theory of the imagination based upon the "best scientific account," drawing on contemporary psycho-physiological discourse. His work is part of a general tendency during the Victorian era to establish a scientific mode of criticism (Morgan 2017, 75–80). His books should thus be treated in the context of the Victorian belief that literary studies should borrow methodologies from the sciences in order to strengthen their epistemological claims and, as a consequence, their "scientific" status (Dekkers 1998, 4–133). More specifically, he was one of the pioneers of physiologically oriented literary criticism along with Alexander Bain (1810–1877), G. H. Lewes (1817–1878) and James Sully (1842–1923) (Stiles 2019, 370). The book is an attempt "to settle the first principles of criticism," whilst he laments the lack of science in literary theory (Dallas 2011, I: v).

His earliest attempts at arriving at what he terms "science of criticism" stretch back to his *Poetics*, where Dallas sets out to discover "the laws of operative power in literary works" so as to deconstruct the belief that "Criticism is not commonly considered the work of a science" (Dallas 1852, 3). Here, Dallas advocated the idea that the immediate end of poetry is pleasure. *The Gay Science* complements and supplants *The Poetics* inasmuch as in this more mature work Dallas aims at providing the "best scientific account" because "At the stage which criticism has now reached there is nothing so much wanting to it as a correct psychology" (2011, I: 42). He aspired to create a science of criticism that can study the arts through a focus on their source—the mind in general and the imagination in particular. The central principle around which his overarching thesis revolves is that "criticism cannot advance a step without first understanding what imagination is" (2011, I: xii). The only complete criticism for him is an inclusive criticism that must comprise "the science of the laws and conditions under which pleasure is produced" (2011, I: 91). Dallas turns to the burgeoning science of psychology because "the great fault of criticism is its ignorance—at least its disregard of psychology" (2011, I: 57). He relates the state of criticism to the "neglect of the science of the

mind" (2011, I: 47). The resulting "science of criticism" will "resolve itself into something like a science of reason—a logic—a science of science" (2011, I: 10). Thus, he wants to make clear that he puts his "work forward, not as a science, but as a plea for one, and as a rude map of what its leading lines should be" (2011, I: 71).

Dallas places the study of pleasure at the cornerstone of his scientific criticism, referring to it as "the science of pleasure, the Joy Science, the Gay Science" (2011, I: 93). Having identified imagination as the source of pleasure, he asserts that imagination itself has nevertheless not been properly analysed. It remains an unknown agent despite the recognition of its immense importance. Since "criticism cannot advance a step without first understanding what Imagination is," (2011, I: xii), Dallas embarks on an "inquiry into the nature of this power—the acknowledged potency of Imagination" (2011, I: 180). The cognitive processes taking place in the imagination take a form that "can only be defined by reference to its spontaneity, or by reference to its unconsciousness" (2011, I: 308). Dallas imaginatively provides a topography of these processes, which occur "in the dusk of unconsciousness" (2011, I: 265). For Dallas, this topography is capacious, allowing for "the free, unconscious play of thought" (2011, I: 305). In contrast to consciousness, which is by nature "partial and concentrated in points," imagination includes a "wholeness of thinking," it involves the mind as a whole—"the play of reason, the play of memory, the play of the whole mind with all its powers at once; in one word, the play of thought" (2011, I: 305, 272). Imagination in Dallas's theory is not treated as one of the instruments of the conscious mind. Rather, it forms a network of cognitive relations that involve "the entire mind in its secret working" (2011, I: 196). Involuntary thinking, then, taking place in the imagination, draws on the entire mind, in contrast to voluntary or deliberate thought: "the mind in free play works more as a whole than in conscious and voluntary effort" (2011, I: 305). The pleasure that imagination triggers in a reader of poetry is, accordingly, what Dallas referred to as "hidden pleasure," one that erupts within us whilst we are unaware, as if it were an automatic effect. The name he chose to refer to the imagination in order to capture its cognitive reach is the "Hidden Soul."

From the outset, he presents a view of the unconscious as "a secret flow of thought" that is "so like the conscious intelligence," on the caveat that the hidden soul, or the imagination, is more whole and expansive (2011, I: 199–200). Unconscious thinking is presented as superior to conscious thinking: "Outside consciousness there rolls a vast tide of life, which is,

perhaps, even more important to us than the little isle of our thoughts which lies within our ken" (2011, I: 207). Dallas's model of the mind includes "two concentric worlds of thought,—an inner ring, of which we are conscious, and which may be described as illuminated; an outer one, of which we are unconscious, and which may be described as in the dark" (2011, I: 207). The relation between these two cognitive systems is dynamic, thoughts within the one system flying into the other and vice versa, without our being conscious of this dynamic exchange of thoughts. To showcase the cognitive powers of the unconscious mind, Dallas draws a replicating symmetry between the faculties of each soul only to move on to an account according to which each of these faculties is more intimately connected to the hidden soul where it is allowed more free play: "At present, what we are to keep in view is this, that as the conscious soul may be roughly divided into faculties of memory, of reason, and of feeling, so the unconscious or hidden soul may be divided in the same manner, and may be considered as memory, as reason, and as feeling" (2011, I: 209). Memory is found to be even more related to hidden thought than to the conscious mind, as evidenced, for example, by the spontaneous recovery of buried knowledge and its emergence in consciousness. This becomes particularly clear when "we become aware that we are seeking for something which we know not; and there arises the strange contradiction of a faculty knowing what it searches for, and yet making the search" (2011, I: 210). The existence of a separate thinking mechanism testifies to the inherent contradiction that we are more likely to successfully recall a forgotten name when we are otherwise engaged and have abandoned our initial attempts to remember it (2011, I: 210). Dallas parades before his readers an array of cases that illustrate the theory of the hidden soul. These include the Countess of Laval, who spoke during sleep a language no one understood, only to discover that it was the language her nanny spoke to her in infancy (2011, I: 211). Through multiple anecdotes, Dallas demonstrates that "there is knowledge within us of which we see nothing, know nothing, think nothing" (2011, I: 217). The processes taking place in our unconscious knowledge storehouse "invest all objects of thought with a halo of mystery, which is but the faint reflection of forgotten knowledge" (2011, I: 221). To support his overarching argument, Dallas evokes the authority of Wordsworth, who writes in his "Ode on Intimations of Immortality" that "Our birth is but a sleep and a forgetting;/ The soul that rises with us, our life's star, / Hath elsewhere its setting, / And cometh from afar;/ Not in entire forgetfulness" (2011, I: 220). According

to Dallas, all great artists, poets and inventors possess "great memory—their unconscious memory being even greater than that of which they are conscious" (2011, I: 222). This unconscious process has a will of its own and remains hidden "until its work is achieved and the effect of it is not to be resisted. We see the finished result; of the process we know nothing" (2011, I: 222).

The ability to perform reasoning processes is also characteristic of the hidden soul, and it encompasses "judgment, invention, comparison, calculation, selection, and the like movements of thought, forethought and afterthought" (2011, I: 223). In every mental operation, multiple thinking processes operate simultaneously, most of which take place without our awareness. An example Dallas provides is that of a piano player: for a beginner, each note that s/he strikes requires a distinct thought, but with practice s/he is able to "grasp whole handfuls of notes in quick succession with greater ease," and in time s/he can use both hands to strike eight separate notes, lift the pedal to give fullness to sound, read the music-book bars that follow and even hold a conversation whilst performing all these operations (2011, I: 223). A similar process can be observed during the act of reading. "There are indeed," Dallas notes, "well attested cases of readers overtaken with sleep and continuing to read aloud, although thus overpowered" (2011, I: 224). In reading during sleep, textual consumption is less a matter of conscious construal than of unconscious absorption. The hidden soul leads a distinct life, it "has languages, it has music at command of which when wide awake it has no knowledge … through dreams it helps us to facts" (2011, I: 230). The reasoning powers of the hidden soul can also be evidenced in our ability to solve a problem upon waking up, even though it might have seemed impossible to tackle the day before. Dallas describes the phenomenon in these terms: "the mind, though it seemed to be otherwise engaged, was really brooding in secret over its work, and mechanically revolving the problem, so that it was all ready for solution at peep of dawn" (2011, I: 226). Through this common experience, Dallas is led to the conclusion that the phenomenon will "flash upon us unexpectedly when we are lost in other cares" (2011, I: 226). It is a phenomenon commonly known as the "eureka moment." As he recalls the famous story, "Archimedes was in the bath when he jumped to the shout of Eureka" (2011, I: 227). Taken together, these anecdotes illustrate the hidden soul's ability to "remember, brood, search, poise, calculate, invent, digest, do any kind of stiff work for us unbidden, and always do the very thing we want" (2011, I: 227). In a nutshell, the hidden soul

thinks logically and independently of the conscious mind. In fact, certain tasks are impossible to perform when we put conscious effort into them. Mozart's advice regarding the creative process, Dallas claims, is characteristic of the need to relinquish conscious thinking in order to allow for the imagination, or the hidden soul, unconstrained creative activity: "If you think how you are to write, you will never write anything worth hearing. I write because I cannot help it" (2011, I: 229). The final category of phenomena that exemplify the reasoning unconscious is where it thrives the most, where the hidden soul operates unobstructed, that is, in sleep, and particularly in cases of sleepwalking or somnambulism: "The sleepwalker seldom takes a wrong step, or sings a wrong note" (2011, I: 235). Although both the hidden soul and the soul, the unconscious and the conscious, are similar in terms of their cognitive abilities, the chasm that separates the two modes of reasoning is nevertheless deep. They are "as distinct as parallel lines that have no chance in meeting" (2011, I: 235). Dallas posits here a real distinction between the two souls, each one functioning independently of the other.

In a final twist of thought, Dallas turns to passion, feeling, sympathy, instinct and intuition as attributes of the hidden soul. Commonly recognised as poetical and identified with imagination, these "are processes which never fairly enter into consciousness, which we know at best only in a semi-consciousness, and less in themselves than in their results" (2011, I: 237). The essence of sympathy is that "We imitate without knowing that we imitate" (2011, I: 239). As an act of the hidden soul, it is essentially an unconscious imitation: "One man smiles, and another without knowing it repeats the action" (2011, I: 239). Instinct, too, which may seem to be a mechanical reaction, involves unconscious reasoning processes. These range from physiological alterations in the function of our lungs and the beating of our heart depending on the stimulus with which we are confronted, to the eye that often assumes the office of an arithmetician: "when we behold red colour the retina pulsates at the rate of 480 billions of times between every two ticks of a clock" (2011, I: 243). The hidden soul is also manifested when "the mere thought of her child fills the mother's breast with milk … In numerous facts like these there is evidence of a hidden life of thought working with a constant energy in our behalf in the economy of the bodily frame" (2011, I: 244).

The starting point of Dallas's scientific literary theory is Hamilton's definition of pleasure, which, although "the most complete that has yet been put forth," nevertheless "excludes the marvellous phenomenon of

hidden pleasure," or what he alternatively referred to as "the unconsciousness of pleasure" (2011, II: 13, 109, 124). Tracing the characteristics of poetic imagination, Dallas turns to the etymology of "imagination" (sensibility to images), going on to note that it can take the "simplest form of similitude to the most complex form of metaphor and symbol" (2011, I: 266). That said, Dallas argues, the ability to draw comparisons, whether simple or complex, is not idiosyncratic to the imagination, but every act of thought involves a comparison. As he assertively concludes, "No comparison, no thought" (2011, I: 266). The difference between the comparisons taking place in the imagination and the comparisons drawn in conscious thought processes is that "the former are automatic, and that those of the latter are the result of conscious effort" (2011, I: 268). More importantly, imagination is a "love of wholes, its wonderful power of seeing the whole, of claiming the whole, of making whole" (2011, I: 268–69). Poetic comparisons, in particular, working primarily on the imagination, "assert resemblance of wholes" (2011, I: 269). Here, "in the freedom of unconsciousness, the mind acts more as a whole, and takes more to wholes" (2011, I: 270). By contrast, the conscious mind is more acroscopic in its thought process. The unconscious mind, the imagination or the hidden soul "is never content with a part; it rushes to wholes" (2011, I: 291). Here, in the freedom of the hidden soul, where the imagination is allowed to perceive wholes instead of parts, lies for Dallas the creative talent of literary writers who produce great art:

> when a dramatist or novelist raises before us a great complex character, finely moulded and welded into a consistent whole, we attribute his work to imagination, because it has been devised in unconsciousness, and neither he nor we can follow the process. It is not imagination in the sense of a special faculty that does the work, but imagination in the sense of the hidden soul, the ordinary faculties engaged in free, unconscious play (2011, I: 303).

Expanding on the processes taking place during the act of literary creation, Dallas analyses the ways in which authors try "to establish a connection with the unconscious hemisphere of the mind, and to make us feel a mysterious energy there in the hidden soul" (2011, I: 316). The great artist is able to sense, albeit intuitively, the ability of the unconscious to reason and to recognise "the existence within us of a double world of thought" (2011, I: 316). The artist is therefore faced with the difficult task of expressing, through conscious thought, the recesses of the

unconscious (2011, I: 316). To this end, "subtle forms, tones, words, allusions, associations" are used to appeal to the hidden soul (2011, I: 316). What is intuited or felt remains enigmatic to the conscious mind and ever-elusive. The value of art does not rest on explaining the known and providing new, fixed knowledge (this is the territory of science), but in "suggesting something which is beyond and behind knowledge, a hidden treasure, a mental possession whereof we are ignorant" (2011, I: 318). Great literature is produced in and appeals to the hidden soul, the cognitive judgements of which burst into consciousness in forms whose semantic content cannot be conceptually arrested. Unconscious memory processes come into play to "to render up their dead" and unconscious reasoning associations "set innumerable trains of thought astir in the mind" only to "fill us with their suggestiveness" (2011, I: 318). The feelings triggered during the workings of the hidden soul "charm us with an indefinable sense of pleasure" (2011, I: 318). And so Dallas concludes with the following remark: "The object of art is pleasure—a sensible possession or enjoyment of the world beyond consciousness. We do not know that world, yet we feel it chiefly in pleasure" (2011, I: 313).

In Wordsworth's poetic language, Dallas found a rich laboratory to test and experiment with his ideas on the hidden soul's workings. One of the examples he provides is "Tintern Abbey," where the poet writes: "I have felt / A presence that disturbs me with the joy / Of elevated thoughts; a sense sublime / Of something far more deeply interfused" (2011, I: 320). Nature, for Dallas, acts upon the hidden soul of the speaker in such a way as to expand his cognitive and experiential horizons and enable him to witness and undergo an aesthetic phenomenon that resists conceptual fixity. The poem intimates "the world which art and poetry are ever pointing and working towards," without ever allowing for conceptual specificity (2011, I: 321). Nature arouses in the speaker "a treasure trove which is not in the consciousness proper" (2011, I: 321). Dallas finds in Wordsworth a keen spirit that articulates poetically his conviction in the impossibility of capturing or pinning down this cognitive and aesthetic "treasure": "What that treasure, what that presence is, it would pose Wordsworth or any one else to say. All he knows is that nature finely touches a secret chord within him, and gives him a vague hint of a world of life beyond consciousness" (2011, I: 321). Working on the hidden soul, the chief effects of Wordsworth's poetry point to the presence of a phenomenon that cannot be captured by means of conscious reasoning.

Critics found Dallas's application of his theory on poetry to be dissatisfactory. Roellinger dismissed Dallas on the basis of the fact that "He does not succeed in defining the mysterious effect of poetry" (1941, 662). However, we should be reminded that it would have been a contradiction of terms for Dallas to define the mysterious effect of poetry because the force of this effect, of this sublime effect to use Wordsworth's vocabulary, rests exactly in the failure of any attempt to define it. To define the contents of the sublime is to efface them and render them no longer sublime. The experience of the sublime remains whole only in the poetic imagination, in the hidden soul, for, in contrast to conscious thought, it has the power to create wholes. Once it erupts into consciousness, it becomes fragmented, resisting any attempt to be recreated and reproduced in its wholeness in the conscious soul. Unconscious memory is also at play within this context, as it becomes the poem's intellectual and aesthetic well, into which the poet dips in order to recollect the sublime experience he had undergone. What the poet provides to his readers is the recollection of that experience, which he brings to the fore only in a state of tranquillity. This experience could not have been recollected from within the conscious soul's memory apparatus, for there rest only parts, fragments and concepts that sit comfortably within the symbolic order of understanding and signification. The sublime experience however, the contents of which resist the symbolic order, can only be recollected from the hidden soul, however tenuously and obscurely. For Roellinger, Dallas's argument is straightforward and consistent: "poetic effects which most defy analysis are the responses of the unconscious, the 'hidden soul'" (1941, 2). Elisha Cohn appears to hold a similar view inasmuch as she argues that Dallas "proposes a radical scepticism about what the analysis of art can yield; his attractive endorsement of nescience invites us to adopt the paradoxical position of reading closely and attentively to find what is *not* revealed" (2016, 24). Indeed, the cognitive and experiential contents which poetry evokes in the hidden soul may remain elusive in their wholeness to the conscious mode of thinking, but something does erupt in consciousness, a "presence" in Wordsworth's language, which for Dallas is subject to analysis. This presence may never be fully comprehended by the conscious mind for our intellectual efforts and reflections can only deal with its fragments. The chief poetic effects of any great literary work rest, according to Aristotle and Longinus, for example, in the fact that they will always cause readers to "add something as an agreeable extra." (Aristotle 1995, 17–18). Dallas's notion that we will never be able to capture, in

their wholeness, the signifying properties of poetic imagination is akin to this classical literary theory, according to which the elusiveness of the cognitive and experiential contents triggered by a literary work does not point at the end of analysis. Rather, it taps into the reasons why we keep, and we will keep, analysing a literary work, for something will always remain unsaid.

According to Dallas, the words that we use to arrest the "creature moving about in worlds not realized" trigger in us "a set of pleasant associations, and stimulate our imaginations" (2011, I: 322–23). These pleasant associations fuel our attempts to interpret the literary work at hand in order to attain the satisfaction of complete understanding. The process of analysis has therefore begun. However, "as soon as we try to dissect and analyze them, to distinguish between the form of expression and the sense which it is intended to convey, we fail altogether" (2011, I: 323). As long as we receive pleasant feelings from poetic imaginations, we will never cease to interpret and analyse them, not in an attempt to ever efface and reduce the sublime to a bedrock concept, but in order to explore and appreciate on the level of reflection, the fragments or ruins of a felt presence that lies whole in the hidden soul. This failure, therefore, does not mark the end of critical analysis. It facilitates and sustains it. The poet "brings back upon us strange memories, and through memory surprises us with a momentary sense of the hidden life" (2011, I: 324). Although this sense is indeed for Dallas momentary, emerging in consciousness like "a sudden gleam as of a falling star that comes we know not whence, and is gone ere we are conscious of having seen it," we nevertheless cannot help but chase that falling and vanishing star through intellectual and interpretive efforts (2011, I: 324). Quoting Wordsworth once again, Dallas describes this process as an "abiding sense of a mystery surrounding human life and thought, of an energy which is ours, and yet is separate from conscious possession" (2011, I: 324). Something *is* revealed, an abiding sense or a presence which tingles readers into analysing it as a means to recapture it in its wholeness. For Dallas, this is perhaps most obvious in music: "The glory of music is to be more intimately connected than any other art with the hidden soul; with the incognisable part of our minds, which it stirs into an activity that at once fills us with delight and passes understanding" (2011, I: 327). Much of the delight we find in art rests in the failure to fully capture this delight's wholeness in language, and the suspension of the fulfilment of ever being able to do so perpetuates the delight and, by extension, the interpretive/analytical efforts. This is what Dallas refers to as the "mental gifts" that poets impart to us,

"which, without the key supplied by the theory of the Hidden Soul, are to most readers a perfect riddle" (2011, I: 325). We are not so much placed in a rather uncomfortable and paradoxical position of reading attentively in order to find what is not revealed, for if it were possible to reduce a literary work to a single statement, to an identifiable and monolithic revelation, then we would assimilate art into science: it "is poetry so long as it remains the know-not-what, and ceases to be poetry when it is defined into knowledge and becomes an item of science" (2011, I: 325). Poetry's value resides precisely in its "far-away suggestions, glimpses of another world," which "crowd upon the uttermost rim of consciousness" (2011, I: 328). During this process and "Through the splendid collision of facts, we learn to catch at something which is not in the facts; from the conquered world of knowledge we sidle into the unconquered world of hidden thought" (2011, I: 328).

It is tantalising to observe that Dallas's overarching theory of the poetic imagination anticipates the theory of cultural and literary theorist Roland Barthes (1915–1980). In *The Responsibility of Forms* (1985), Barthes argues that the chief effects of a work of art are communicated to audiences primarily at an unconscious level. During the act of reading, we listen to an inner voice that seizes upon "a general 'signifying' no longer conceivable without the determination of the unconscious" (1985, 246). As in Dallas's literary theory, here we have a phenomenon whereby the unconscious erupts within consciousness to guide our intellectual efforts to stabilise the semantic contents of the work before us. However, what we discover is the elusiveness of meaning as conceptual clarity and fixity collapse before what Barthes calls the *signifying*:

> what is listened to here and there (chiefly in the field of art, whose function is often utopian) is not the advent of a signified, object of a recognition or of a deciphering, but the very dispersion, the *shimmering* of signifiers, ceaselessly restored to a listening which ceaselessly produces new ones from them without ever arresting their meaning: this phenomenon of shimmering is called *signifying [signifiance]*, as distinct from signification (1985, 259).

Barthes identifies the workings of the signifying on our unconscious during the act of reading poetry as "the most extreme pleasure (all poetry—the whole of the unconscious—is a return to the letter)" (99). This "return to the letter" implicates readers–listeners in a perennial quest to decipher its meaning, a task that is rendered impossible as the "letter"

remains enigmatic and elusive: its signifying properties can never be arrested and interpretively fixed or stabilised in their wholeness. The letter "tirelessly releases a profusion of symbols … it releases an imagery vast as a cosmography" (98). The cognitive mechanism responsible for this tireless explosion of symbols and meanings is unconscious, locking the conscious mind in an endless quest for a cognitive relief or release through semantic revelation: "doubtless animated by an unconscious irritation against the words which were familiar to me and of which I consequently felt myself to be a prisoner" (119). The promise of release from the endophonic semantic explosion is never realised, as the unconscious, via its various forms of cognitive processes, persistently rejects the "Law which prescribes direct, unique listening," a type of listening that satisfies the logocentric law of semantic determination and the fixity of the signifier: "listening includes in its field not only the unconscious in the topical sense of the term, but also, so to speak, its lay forms: the implicit, the indirect, the supplementary, the delayed: listening grants access to all forms of polysemy, of overdetermination, of superimposition, there is a disintegration of the Law which prescribes direct, unique listening; by definition, listening was *applied*; today we ask listening to *release*" (258).

Dallas's Influence on Literary Authors

Dallas was well-respected and well-known in the literary circles of the time, and his words had considerable impact on the literary scene (Eliot 1885, III: 64; Trollope 1905, 114, 133; Dallas 1865, 6; Dickens 1965, XI: 83). As the primary book reviewer for *The Times* and other periodicals, he published a vast number of essays and reviews during the 1850s and 1860s on literary and social subjects and was thus an immensely influential writer in the mid-century literary milieu. His analysis of the imaginative potential of the unconscious, for instance, anticipates Robert Louis Stevenson's "A Chapter on Dreams." In this essay, Stevenson recounts the beneficent nature of his dreams, explaining how they inspired him with ideas for the *Strange Case of Dr Jekyll and Mr Hyde* (1886) and "Olalla." He describes his conscious self when asleep as the audience at a play, entertained by "the little people who manage man's internal theatre" and provide inspiration for his tales (Stevenson 2005, 99). He confesses, "how often have these sleepless Brownies done him honest service, and given him, as he sat idly taking his pleasure in the boxes, better tales than he could fashion for himself" (100). Stevenson locates in this way the source

of literary inspiration in cognitive processes that lie outside of his conscious control. There is no doubt in Stevenson's mind that unconscious creative processes are active not only during sleep, but also when awake (103). Literary inspiration clearly springs up from unconscious depths to the surface of consciousness. Similarly, Dallas's unconscious bears the transformative powers we find in fairy tales and continues to operate "independent of our care" in wakefulness and sleep (2011, I: 224). In both Dallas's and Stevenson's theories of imagination, the involuntary thinking processes may be performed unconsciously but they emerge in consciousness as inspiration.

At the cornerstone of Dallas's criticism, we find what he referred to as "hidden pleasure," one that emerges from our hidden soul. "We do not know that world, yet we feel it chiefly in pleasure," Dallas writes, and turns his two-volume work into an exploration of this world to systematise "the science of pleasure, the Joy Science, the Gay Science" (2011, I: 93). Stevenson's analysis of imagination as the source of pleasure strikingly recalls Dallas's conceptualisation of "the unconsciousness of pleasure" (2011, II: 13, 109, 124).

In his essay, Stevenson attributes the unconscious with knowledge and imagination that lie beyond surface consciousness. The unconscious imaginative processes are embodied as workers that "labour all night long, and all night long set before him truncheons of tales upon their lighted theatre" (100). Stevenson explicitly stresses the ingenuity that characterises this work: "I speak of the little people as of substantive inventors and performers" (102). And explicitly dissociates his conscious self (referred to in the third person) from his hidden mind: "It was not his tale; it was the little people's! And observe: not only was the secret kept, the story was told with really guileful craftsmanship" (102).

Stevenson's terminology reflects Dallas's own, encouraging us to suspect that, although Stevenson does not acknowledge Dallas explicitly, he nevertheless does so implicitly: Stevenson evokes Dallas's analysis of "hidden thought," which is explained in terms of stories from traditional folklore: "The hidden efficacy of our thoughts, their prodigious power of working in the dark and helping us underhand, can be compared only to the stories of our folklore, and chiefly to that of the lubber-fiend who toils for us when we are asleep or when we are not looking" (2011, I: 201). Both Dallas's "unknown and tricksy worker" and Stevenson's "little people" perform all the work while the conscious mind receives all the

acknowledgement. The complete dissociation of the unconscious and conscious mind even creates for Stevenson a sense of guilt, as he confesses:

> Here is a doubt that much concerns my conscience. For myself—what I call I, my conscious ego…—I am sometimes tempted to suppose he is no storyteller at all, but a creature as matter of fact as any cheesemonger or any cheese, and a realist bemired up to the ears in actuality; so that, by that account, the whole of my published fiction should be the single-handed product of some Brownie, some Familiar, some unseen collaborator, whom I keep locked in a back garret, while I get all the praise (103).

Stevenson's essay not only provides a context to understand the imaginative development that Stevenson underwent in the composition of *The Strange Case of Dr Jekyll and Mr Hyde*; it also gives important insight into dissociation while revealing his anxiety over the ownership or authorial control of his creative writing.

More than any other novelist of her time, George Eliot was immersed in the mid-to late-nineteenth century burgeoning sciences of mind and consciousness. In his 1881 essay "George Eliot's Art," published in *Mind*, the psychologist James Sully described her as "touched by the scientific spirit of her age" (1881, 393). Sully emphasised the central place of mid-nineteenth-century theories of mind in George Eliot's fiction, especially concepts of unconscious mental action. Eliot was closely related to key figures in the emerging sciences—George Henry Lewes was her spouse and Herbert Spencer, a long-time friend. Eliot and G.H. Lewes were also personally acquainted with the Darwins, Thomas Huxley, and John Tyndall. George Eliot's engagement with contemporary views on the workings of the mind also came through the writings of her friend and reviewer, E.S. Dallas. In *Adam Bede*, Eliot describes unconscious processes using a strikingly similar metaphor to Dallas's: "Our mental business is carried on in much the same way as the business of the State: a great deal of hard work is done by agents who are not acknowledged…Possibly there was some such unrecognized agent secretly busy in Arthur's mind at this moment…The human soul is a complex thing" (2008, 157). Dallas's "unknown and tricksy worker[s]" in Eliot become "unrecognised agents." Like Dallas, she is preoccupied by the lack of recognition as these "agents who are not acknowledged," secretly perform important work. Dallas's terminology also appears in Eliot's fiction. In *Middlemarch*, for example,

Rosamond's singing and playing lead Lydgate into mistaken assumptions about her character and "hidden soul" (2000, 103).

Dallas's influence on the literary circles of his time was followed by a period of oblivion, from which the poet and dramatist John Drinkwater attempted to salvage him in 1932. In his essay, he characteristically comments on the discovery of *The Gay Science*: "I was astonished to find myself under the spell of a quite remarkable intelligence" (1932, 202). Credit for Dallas's revival must also go to the Scottish poet Hugh MacDiarmid. His 1950 essay is an important intervention due to MacDiarmid's stature as one of the principal forces behind the Scottish Renaissance and his lasting impact on the modern Scottish culture and tradition. In his prose work *Aesthetics in Scotland*, MacDiarmid writes about an "important and far too little known Scottish writer" whom he revives because, as he confesses, "I am one of that very few and far between sort of Scotsman sufficiently interested in theories of art to look for and read all I can lay my hands on in this connection" (1984, 55). MacDiarmid characterises the *Gay Science* as a rare and serious attempt at a systematic theory of literary criticism. He also praises Dallas's acuity in arguing for the importance of the "unconscious mind" for the imaginative process and maintains its central position in pre-Freudian ideas on the unconscious. Although Dallas was a well-known critic of the time and extracts from his books are included in anthologies of nineteenth-century literary criticism, his literary theory can only be traced in scattered references in critical works of the past few decades (Caramagno 1987, 21–33; Hughes 1985, 1–21; Roellinger 1941, 652–664).

Dallas's work is transitory, participating in the shift of the time from the metaphysics of the soul and its cognitive components to psychology. His theory is rooted in an adaptation of aspects from contemporary findings in the field of psychophysiology, findings that would later be developed in varied ways to articulate the intelligent forms of cognition that occur unconsciously and affect our behaviour and conscious modes of thinking. He came to apply this overarching theory to the field of appreciating, evaluating and understanding literary works in order to establish the basis of a scientific type of criticism, not in the sense of arriving at scientific, monolithic statements about the meaning of a literary piece of writing, but in the sense of establishing a framework potent enough to explain the cognitive processes that underpin our interpretive efforts during the act of reading. His work also anticipates the "cognitive revolution" in literary studies in its deployment of cognitive science as providing objective

grounds upon which to interpret literary texts with increasing exactitude in terms of how they emerge from and correspond to cognitive capacities. Despite the historical ambiguities of the term "science," it was also Dallas's objective to examine the first principle of art, that is, the doctrine of pleasure. He places pleasure at the cornerstone of his scientific criticism, which analyses the psychological mechanisms by which poetry produces pleasure in a reader. Through his two works on criticism, *Poetics* and *The Gay Science*, he attempted to provide "the first theory of art and literature … arguing that a kind of hidden self often guided artistic creation" (Reed 1997, 142–43). Based on phenomena like involuntary memory, dreams, intuition and delirium, which were the objects of focus of contemporary psychologists and physiologists, Dallas formulated what he referred to as "correct psychology" of the hidden soul, which was essential in his attempt to establish a "science of criticism."

Works Cited

Aristotle. 1995. *Poetics*. Translated by Stephen Halliwell. Cambridge: Harvard University Press.

Barthes, Roland. 1985. *The Responsibility of Forms: Critical Essays on Music, Art, and Representation*. Translated by Richard Howard. New York: Hill and Wang.

Caramagno, Thomas C. 1987. The Psychoanalytic Aesthetics of Eneas Sweetland Dallas. *Literature and Psychology* 33 (2): 21–33.

Cohn, Elisha. 2016. *Still Life: Suspended Development in the Victorian Novel*. New York: Oxford University Press.

Dallas, Eneas Sweetland. 1852. *Poetics: An Essay on Poetry*. London: Smith, Elder, and Co.

———. 1865. *Our Mutual Friend*. *Times*, November 29.

———. 2011. *The Gay Science*, 2 volumes. Cambridge: Cambridge University Press.

Dekkers, Odin. 1998. Part 1: Victorian Scientific Criticism. In *Rationalist and Literary Critic*, ed. J.M. Robertson, 94–133. Brookfield: Ashgate.

Dickens, Charles. 1965. *The Letters of Charles Dickens*. Vol. 11. Oxford: Clarendon.

Dixon, Thomas. 2003. *From Passions to Emotions: The Creation of a Secular Psychological Category*. Cambridge: Cambridge University Press.

Drinkwater, John. 1932. Eneas Sweetland Dallas. In *The Eighteen-Sixties*, ed. John Drinkwater, 201–223. Cambridge: Cambridge University Press.

Eliot, George. 1885. *George Eliot's Life as Related in Her Letters and Journals*, 3 volumes, ed. J. W. Cross. New York: Harper & Brothers.

———. 2000. In *Middlemarch: An Authoritative Text, Backgrounds, Criticism*, ed. Bert G. Hornback, 2nd ed. New York; London: Norton.

———. 2008. In *Adam Bede*, ed. Carol A. Martin. Oxford: Oxford University Press.
Hughes, Winifred. 1985. E. S. Dallas: Victorian Poetics in Transition. *Victorian Poetry* 23 (1): 1–21.
MacDiarmid, Hugh. 1984. In *Aesthetics in Scotland*, ed. Alan Bold. Edinburgh: Mainstream.
Matus, Jill L. 2007. Victorian Framings of the Mind: Recent Work on Mid-Nineteenth Century Theories of the Unconscious, Memory, and Emotion. *Literature Compass* 4 (4): 1257–1276.
Morgan, Benjamin. 2017. *The Outward Mind: Materialist Aesthetics in Victorian Science and Literature*. Chicago: Chicago University Press.
Reed, Edward. 1997. *From Soul to Mind: The Emergence of Psychology from Erasmus Darwin to William James*. New Haven: Yale University Press.
Roellinger, Francis X. 1941. E. S. Dallas on Imagination. *Studies in Philology* 38 (4): 652–664.
Smith, Roger. 2004. The Physiology of the Will: Mind, Body, and Psychology in the Periodical Literature, 1855–1875. In *Science Serialized: Representations of the Sciences in Nineteenth-Century Periodicals*, ed. Geoffrey Cantor and Sally Shuttleworth, 81–110. Cambridge: The MIT Press.
Stevenson, Robert Louis. 2005. In *The Strange Case of Dr. Jekyll and Mr. Hyde*, ed. Martin A. Danahay, 2nd ed. Plymouth: Broadview.
Stiles, Anne. 2019. Brain Science. In *Routledge Companion to Victorian Literature*, ed. Dennis Denisoff and Talia Schaffer, 368–377. New York: Routledge.
Sully, James. 1881. George Eliot's Art. *Mind* 6 (23): 378–394.
Trollope, Anthony. 1905. *Autobiography of Anthony Trollope*. New York: Dodd, Mead & Co.

CHAPTER 4

"You Haven't Let Me Call My Soul My Own": Soul, Psyche and the Thrill of Nothingness in May Sinclair's *Mary Olivier: A Life*

Leslie de Bont

May Sinclair (1863–1946) produced over twenty novels and six collections of short stories. With a writing career spanning over five decades, she is both central and peripheral in the literary canon. Celia Marshik and Allison Pease note that "from about 1910 to 1920, Sinclair was considered the foremost British woman novelist, a mantle that was taken up by Woolf in the subsequent decade" (Marshik and Pease 2018, 30). Laurel Forster adds that Sinclair "had built a reputation for being a writer who tackled difficult issues concerning women's lives" and that she is now mostly remembered for her depictions of fictional female consciousness (Forster 2019, 274).

L. de Bont (✉)
Nantes Université, Nantes, France
e-mail: leslie.debont@univ-nantes.fr

© The Author(s), under exclusive license to Springer Nature Switzerland AG 2024
D. Louis-Dimitrov, E. Murail (eds.), *The Persistence of the Soul in Literature, Art and Politics*,
https://doi.org/10.1007/978-3-031-40934-9_4

However, Sinclair's work has recently "gained critical legitimacy" (Raitt 2016, 23) and her fiction, her non-fiction as well as her many engagements have attracted academic interest. Between 1908 and 1913, she was involved with the Suffragettes and wrote several pamphlets for women's rights. As her biographers suggest, Sinclair was also a friend and collaborator of many avant-garde figures, including Ford Madox Ford, Ezra Pound, H.D. and T.S. Eliot (Raitt 2000, 7; Boll 1973, 95). Additionally, Isabelle Brasme reminds us that "Sinclair's voice could be often heard in avant-garde literary reviews, where she steadily championed the more innovative writers" (Brasme 2018, 1). Her critical voice innovatively challenged disciplinary boundaries, and most modernist studies mention that she was the first to apply William James' concept of "stream of consciousness" to literary criticism. Her interest in psychology, and in Jungian psychoanalysis in particular, was thoroughly documented (Boll 1962; Raitt 2004; Martindale 2004; Mosimann 2015, 198–203; de Bont 2016). By contrast, if her many essays on philosophical idealisms contributed to her election to the Aristotelian Society, her expertise in philosophy has only very recently attracted academic interest (Thomas 2019; Jones 2021; Moravec 2022). For example, Emily Thomas showed that Sinclair "became a 'British idealist' at a time when idealism was slowly dying out in Britain, superseded by 'new realism'" (Thomas 2019, 137).

Troy and Kunka demonstrated that Sinclair's fiction and non-fiction "eluded easy categorization" (2006, 3), and Bowler and Drewery hold that Sinclair's "interdisciplinarity has very likely contributed to the traditional neglect of her writing" (2016, 1). In this essay, I will argue that interdisciplinary interests are probably one of the most innovative dimensions of both her fiction and her non-fiction. In other words, a remarkable aspect of her two dozen essays and of most of her novels and short stories is that they engage in a sustained and challenging dialogue with her psychology studies, her philosophical idealism, her interest in feminism and her questionings on the mystical.

Sinclair's triangulation of disciplines is actually the centrepiece of her philosophical system, which she called "New Idealism" (as the title of her 1922 essay indicates), and which relies on her idiosyncratic combination of idealist philosophy, Samuel Alexander's realist philosophy, psychology and a specific interest in pantheism (Thomas 2019, 137). That is why when she writes about Spinoza's monist system, she recurrently refers to Jung's analytical psychology (and to his concept of the libido, which is much closer to Bergson's *élan vital* than to Freud's psychosexual theory)

as well as to Schopenhauer's Will. Equally significant is her reference to dreams as "experiments with the soul that is to be" (Sinclair 1917a, 293) in *A Defence of Idealism*. In this 1917 philosophical essay, she clearly challenges the notion of a transition or divide between soul and psyche while re-appropriating Jung and "Freud's propositions that dreams are a piece of the conquered life of the childish soul" (Jung 1916/2019, 27).

In each of her essays, as she developed an interdisciplinary approach to consciousness, identity, the absolute, sublimation and the libido, the word "soul" is central (it appears more than 200 times) and yet it is never properly defined. In this chapter, I will thus first try to map out the Sinclairian theories of the soul, and compare them to other Sinclairian concepts, before examining how souls are represented in her fiction, and more particularly in her largely autobiographical 1919 *Künstlerroman Mary Olivier: A Life*. By means of conclusion, I aim to explore two ambiguous scenes in which "the soul" is associated with what Sinclair calls "the thrill of the adventure" into nothingness.

Theorising the Soul

According to Lucia Bortoli, May Sinclair was fluent in German and read Freud before A. A. Brill's famous first translation, *The Interpretation of Dreams* (1914), and before Ernest Jones, James and Alix Strachey and Joan Riviere translated Freud's *Collected Papers* and started to publish the *Standard Edition* in 1924 (Bortoli 1998, 146). That is why her philosophical work is somehow in keeping with Bruno Bettelheim's 1983 revaluation of the mistranslations of Freud's works into English. In *Freud and Man's Soul*, Bettelheim focuses on the use of the German word *die Seele* (the soul) as a key part of man's psychical apparatus and reminds his readers that psychic apparatus is "quite frequently" referred to as "seelischen Apparats" in Freud's original text (*Interpretations of Dreams*), terms which "have even more exclusively spiritual meanings than the word 'soul' has in present-day American usage" (Bettelheim 1983, 71). He adds that Freud did not use the adjective "geistig, which refers mainly to the rational aspects of the mind" (Bettelheim 1983, 76), and accordingly stresses the semantic proximity of "psyche" and *Seele*. As he claims that "by soul Freud meant the psyche" (Bettelheim 1982, 52), I would like to argue that so did Sinclair, even if her understanding and theoretical background are somehow different; for one, her understanding of the unconscious departs from Freud's psychosexual theory (Sinclair 1917a, 10–12).

In his study of the philosophical origins of Freud's theories and following Bettelheim, Matt Ffytche highlighted that "psychology in Freud's Vienna was not a natural science but a 'science of the spirit', 'deeply rooted in German idealist philosophy'" (Ffytche, 236). This transdisciplinary approach is in line with Sinclair's spiritual and pantheistic interests, which paradoxically sought to emphasise the overarching and all-encompassing influence of consciousness, with the soul indeed being its main instrument.[1] In her idealist essays, Sinclair constantly sought to articulate the soul, with other emerging concepts and contemporary notions. But, however rich and transdisciplinary her theories may be, they are particularly idiosyncratic and necessary details are sometimes missing. Thus, in order to grasp the issues at stake in Sinclair's understanding of the concept of soul, definitions of her most frequently used terms are needed, namely consciousness, "ultimate Reality," Will and the libido.

A Defence of Idealism opens with the commonly used metaphor: "a self is, in plain language, a soul" (Sinclair 1917a, 3). However, Sinclair gives us her first definition of the soul as people's "psychical dispositions"[2] (Sinclair 1917a, 80). If her focus is indeed rather on people's mental and emotional or cognitive and affective capacities but also on immaterial or spiritual inclinations, her understanding of consciousness is, however, distinct. Sinclair is an Absolute idealist. "The world," she tells us, "arises in consciousness, through consciousness, and is of that stuff, with no independent existence apart from it" (Sinclair 1922, 111). Like many others before her, she distinguished between primary (i.e. sense perception), secondary (i.e. "reflective thoughts") and "ultimate consciousness" (Sinclair 1922, 45), which, as Thomas explains, is "an Absolute consciousness. [Sinclair] identifies this Absolute with the universe. As she also identifies the Absolute with God, her system is a kind of pantheism" (Thomas, 138). So when Sinclair referred to the soul as "the unique ground for the unity of consciousness" (Sinclair 1917a, 109), she diverges from her very influential literary essay on the stream of consciousness (published two years earlier), in which she examined the notion of the stream (i.e. the continuity of cognitive and emotional activities) as the indicator of the unity of consciousness. In other words, for Sinclair, the soul, because of the many powers it holds, is a more convincing concept than the notion of stream when one tries to define both self-identity and the core principle of her pantheistic system.

In *The Other World*, Janet Oppenheim notices that at the end of the nineteenth century, "whether dubbed mind, soul, spirit, or ego, such an

entity distinct from brain tissue was requisite to rescue man from a state of virtual automatism, a mere bundle of physical and chemical properties" (Oppenheim 1985, 205). As a neo-idealist, Sinclair really fits into this tendency and, like pioneer psychologist William McDougall, she also equates the soul with Schopenhauer's concept of Will and chose to defend her idealist system against contemporary Realist philosophies. She thus repeatedly referred to McDougall's *Body and Mind: A History and a Defence of Animism* (1911), who wrote that "the difference between instinct and will similarly rests on the fact that while the former arises in the body, the will belongs to the soul itself" (McDougall 1911, 52). However, drawing from McDougall and in keeping with C. G. Jung, she also really sought to explore the many interactions between body and soul (as in the following graph curiously illustrating Sinclair's criticism of Parallelists conceptions of the mind-body problem).

(Sinclair 1917a, 104)

The soul is thus an all-powerful human attribute in Sinclair's essays. This proposition is further refined in her main argument that "the soul itself may figure as a phenomenon or aspect of the underlying Reality"[3] (Sinclair 1917a, 77). But what is "underlying Reality" for Sinclair? The expression refers to transcendental or sublimated experiences in which "ultimate consciousness" is at play. It is…

> […] the moment that the human soul becomes conscious of itself in God. […] Lovers and poets and painters and musicians and mystics and heroes know them: […] moments when things that we have seen all our lives without truly seeing them, the flowers in the garden, the trees in the field, change to us in an instant of time, and show the secret and imperishable life they

harbour; moments of danger that are sure and perfect happiness, because then the adorable Reality gives itself to our very sight and touch. (Sinclair 1917a, 379)

"Ultimate Reality" is thus reached when the soul becomes aware of its divine powers. This happens via intense, sensual and psychical activities and leads to non-verbal epiphanies (as the expression "perfect happiness" suggests). Unsurprisingly, Bertrand Russell was not convinced. In 1917, he famously wrote: "She says: 'Raise either psychic energy or physical energy to their highest pitch of intensity and you get Spirit'. I confess I cannot understand what this means. Does it mean that if an express train were to go really fast it would acquire a soul?—for that certainly is what it *seems* to say" (Russell 1917, 383).

So what *does* Sinclair mean? Her theory of ultimate reality is actually derived from philosopher T. H. Green, one of Sinclair's most-quoted references, who wrote that "the eternal consciousness […] reproduces itself in the human soul" (Green 1906, 207). However, Sinclair did not fully agree with several of his arguments, including "faith based on revelation" (Raitt 2000, 48–50[4]), and added a psychological dimension to Green's eternal consciousness: for Sinclair, it can only be reached through the intense experiences of "lovers and poets and painters and musicians and mystics and heroes," as she describes them in her essays. Following Sinclair's terminology, what these experiences have in common is that they are instances of sublimated libido, which "holds, the high interacting parties, body and soul, together" (Sinclair 1917a, 110). But Sinclair's understanding of the term libido is again extremely idiosyncratic. As she herself reckons, her work is overall much closer to that of C. G. Jung than of Freud's sexual theory. The Sinclairian libido draws from C. G. Jung's desexualised libido but it clearly is a new approach: "the Libido has many of the attributes of God. It is eternal, indestructible, pure in its essence, infinite in its manifestations, of which the sexual impulse is only one" (Sinclair 1916, 44). What Sinclair's original argument really suggests here is that souls and bodies are connected via the libido: "the libido […] is transferred from a human and bodily object to a divine and spiritual one" (Sinclair 1917a, 257).[5] As her unpublished psychoanalytical essay suggests, the Sinclairian libido can have two forms: it is either unsublimated or sublimated (Sinclair 1915). Unsublimated libido simply refers to the necessary energy to fulfil one's immediate, physical needs (among which are nutrition and sexuality), while sublimated libido, a combination of

instinct and of her understanding of Schopenhauer's will, implies that the individual has been able to redirect his life energy towards the higher, more productive goal of ultimate consciousness. Her list of the many aspects of the Libido is thus particularly interesting: "primal need, want, Will-to-live, desire, wish, liking, affection, interest, love and will" (Sinclair 1915, 136). Where D. H. Lawrence's 1921 essay, *Fantasia and the Unconscious*, focused on the creative dimension of psychic energy, Sinclair emphasises the versatility of the libido, which can lead to artistic creations but also to mystical experiences. To simplify her argument and to refer back to Freud's image, we could say that the sublimated libido is an instrument that enables the soul to "be conscious of itself in God."

But Sinclair also adds an intriguing *caveat*: the soul can also be potentially dangerous for certain mystics because it contains darkness and secret recesses. She goes as far as to argue that looking into your soul could induce dissociation, a pathology first studied by Pierre Janet (whose works she had read and quotes extensively in both her novels and her essays):

> The mystic look is essentially an inward one. The mystic seeks God, for the most part, not in the outer world of art and science and action, but in the darkest and most secret recesses of his own soul. And it is precisely this darkness and secrecy that the psychoanalyst has the most reason to mistrust. […] The mystic consciousness presents in a marked degree the pathological phenomena of "dissociation." Monsieur Janet's account of the matter leaves us no doubt. (Sinclair 1917a, 258–9)

Sinclair's theory thus postulates that we should not search for God within our souls; instead, she argues that we should enable our soul to reach God by sublimating our libido. For Sinclair (and unlike Jung for instance), sublimation is indeed the result of a partly conscious, disciplining effort. So how do we avoid that inward look that causes dissociative disorders? How do we sublimate our libido to make our souls conscious of themselves in God? In an unpublished psychoanalytical essay, Sinclair actually considers five "ways": through a practice of religion that is open to the world, via scientific research, "concrete activities" (which resembles, *mutatis mutandis*, Miháli Csziksentmihalyi's concept of Flow (1975)), with heroic behaviour (and it is worth noting that Sinclair wrote most of her essays during and immediately after World War One), and through Art. "Art," she writes, "is behaving precisely as the psychoanalyst who is also the soul-healer and the soul-builder" (Sinclair 1915, 69).

The Sinclairian soul is a particularly rich construct that is intertwined with a wide range of notions and concepts. To put it very simply, for Sinclair, the soul is the defining evidence of the divine powers contained in each of us. However, these powers can only be reached through action and interaction with the world around us. Let us now see how Sinclair transfers these constructs to her own fiction.

SOULS, *BILDUNGSROMAN* AND FEMALE EMPOWERMENT

Sublimating one's libido and enabling one's soul are central issues in most of Sinclair's *Bildungsromane*. The largely autobiographical novel *Mary Olivier: A Life* (1919) depicts the life of Mary, the heroine, who experiences illuminating mystical visions and eventually becomes a mystic poet. In the novel, even secondary characters argue about souls. Indeed, when Aunt Lavvy tells Mary's father, Emilius, "You haven't let me call my soul my own" (Sinclair 1919, 106), she argues about her religious and philosophical freedom, which her brother had decided to ban from his home as a means to make sure that Lavvy stayed an obedient member of the Anglican Church.

In Sinclair's novels, the soul becomes political. As Truran notes, "for Sinclair, 'resisting the pressure of life' means forging intellectual and, emotional and spiritual freedom via self-awareness and individual will" (Truran 2016, 80). In *Mary Olivier*, reclaiming one's soul becomes synonymous with individual autonomy, which amounts to a very specific kind of personal freedom, one that was traditionally reserved to men, the conscious and informed, intellectual love of God. As Battersby demonstrates (Battersby 2002), Sinclair's experimentation with the *Bildungsroman* thus differs from other more canonical modernist texts (Abel et al. 1983; Gordon 2016) precisely because her appropriation of the *Bildungsroman* formula innovatively emphasises the heroine's voyage towards spirituality and mysticism as the key hallmark of her individuation.

Lavvy's claim implies that her soul is a centrepiece of her personal identity, and it is no coincidence that, in the novel, she is the only positive model for Mary, whose spirituality and mystical visions stem from her dreams, "the experiments with the soul that is to be" (Sinclair 1917a, 293) (or to quote Freud, translated by Bettelheim: "the dream is the result of the activity of our own soul," Bettelheim 1983, 71). Aunt Lavvy's claim can be contrasted with a taunting remark made by Mary's mother, who, upon discovering that Mary was reading philosophical books instead of

learning bible excerpts, exclaims, "You're destroying your soul, Mary" (Sinclair 1919, 275). Here, Mary's mother supposedly refers to Mary's Christian soul, which she is supposedly destroying as she reads an impressive series of philosophical essays. Mary is indeed a voracious reader and cannot resist immersing herself in volumes by Hume, Spinoza, Kant and Hegel, which works as a key step in her individuation process, as in the following example where she reads the article on Spinoza in the *Encyclopaedia Britannica*:

> "God is the immanent"—indwelling—"but not the transient cause of all things" [...] Thought and Extension are attributes of the one absolute substance which is God, evolving themselves in two parallel streams, so to speak, of which each separate body and spirit are but the waves. Body and Soul are apparently two, but really one and they have no independent existence: They are parts of God [...]. Were our knowledge of God capable of present completeness we might attain to perfect happiness but such is not possible. (Sinclair 1919, 99)

This passage reads like an actual illustration of Sinclair's essays, in which, for example, she quotes from Wilhelm Wundt's 1874 *Principles of Physiological Psychology*: "body and soul are, for our immediate knowledge, one being, not different" (Sinclair 1917a, 82). Yet, as this has been shown elsewhere (de Bont 2016), Sinclair's fiction often goes beyond mere illustrations and consistently complicates, completes, or even contradicts the theoretical background it is supposed to refer to. In our passage, the use of the expression "perfect happiness" (a phrase that Sinclair repeatedly used in both novels and essays to describe the effects of the soul's consciousness of itself in God) is particularly significant. In the extract above, the expression directly refers to a hypothesis or a theoretical approach, and there cannot be any "perfect happiness" for Mary just yet. With this expression, we see how the novel is actually constructed as a dialogical tool, full of experiments, works-in-progress, contradictions and hesitations.

Interestingly, there is a similar dialogic approach when Mary eventually experiences that "perfect happiness":

> A queer white light everywhere, like water thin and clear. Wide fields, flat and still, like water, flooded with the thin, clear light; grey earth; the high trees, [...]. She saw the queer white light for the first time [...]. She saw Five Elms for the first time. [...] The drawing-room at the back was full of the

queer white light. [...] Her mother sat at the far end of the room. [...] [Mary] ran to her and hid her face in her lap. [...] It was that miracle of perfect happiness, with all its queerness, its divine certainty and uncertainty. The Christians knew at least one thing about it; they could see it had nothing to do with deserving. But it had nothing to do with believing, either, or with being good and getting into heaven. It *was* heaven. It had to do with beauty, absolutely un-moral beauty, more than anything else. (Sinclair 1919, 49–50)

The intensity of the experience makes Mary see her familiar environment "for the first time." The images of both the tree and the light are clear echoes to the examples used in the essays (such as Sinclair 1917a, 379 commented above). Mary's soul has become conscious of itself in God, and she emerges from this experience as a changed girl. The many repetitions and the anaphora in "she" stress how important this experience is. Also crucial is Mary's relationship to nature. Through her visions, she is building a privileged, pure and unmediated relationship with the world, which stands out from the codified society of her parents. At that stage, her experiences seem to bring her closer to her mother, who will prove to be a rather manipulative and very authoritarian woman. However, at the end of the third book, entitled "Adolescence," Mary's mystical visions eventually help her see her mother's hidden agenda, as if the novel suggested that the heroine had achieved sublimation—a prospect that is somehow in line with the masculine example in the essay: "this triumph of the individual would be impossible if the Will-to-live were incapable of sublimation [...]. Adolescence must break the child's habit of dependence if it is ever to become man-hood" (Sinclair 1917a, 6).

It is also worth noting that in the *Bildungsroman*, the soul is given a strong affective dimension—a possibility that is barely mentioned, in passing, in the essays.[6] In the following extract, Mary, now a young woman, describes her fiancé's best qualities as follows: "He had the soul of Shelley and the mind of Spinoza and Immanuel Kant" (Sinclair 1919, 226). Unfortunately, Mary has been jilted[7] and pounders on her feelings for Maurice:

No. She had *not* loved him with her soul, either. Body and soul; soul and body. Spinoza said they were two aspects of the same thing. *What* thing? Perhaps it was silly to ask what thing; it would be just body *and* soul. Somebody talked about a soul dragging a corpse. Her body wasn't a corpse; it was strong and active; it could play games and jump; it could pick Dan up and carry him round the table; it could run a mile straight on end. It could

excite itself with its own activity and strength. It dragged a corpse-like soul, dull and heavy; a soul that would never be excited again, never lift up against in any ecstasy. (Sinclair 1919, 225–6)

With the chiasma "body and soul; soul and body," built on Sinclair's philosophical rhetoric, we see how the heroine experiences duality and challenges the theoretical intertexts (Genette 1982). After her failed relationship, her body becomes "strong and active" while her soul is "corpse-like" (because it has been deceived) and reveals the moral, affective and intimate, but also potentially misleading, dimensions of Sinclairian souls—another perspective that is not fully considered in the essays and that I would like to study in the final section of this chapter.

The Thrill of Nothingness?

The final page of the novel is indeed particularly ambiguous. As many feminist critics have noted, inconclusive endings are particularly frequent in early modernist prose written by female novelists. Marianne Hirsch for one analyses them as an actual strategy designed to explore new modes of creation that would fit feminine experiences while challenging masculine norms (Hirsch 1989, 93). If Woolf's and Richardson's reflections on the feminine prose are the most notable examples (Woolf 1923, 73; Richardson 1990, 431), Sinclair's experimentations fit with this approach but the ambiguity is both diegetic and theoretical, with many contradictory theoretical intertexts both referenced and challenged. In the final chapter of *Mary Olivier*, Mary is lying on her bed, alone; she has turned down a marriage proposal and has chosen to remain in her mother's home, which she describes as her prison. Following many other Sinclairian characters (Schyllert 2016), she has sacrificed her well-being for the intense and risky visions, or experiences of nothingness:

> She saw that the beauty of the tree was its real life, and that its real life was in her real self and that her real self was God. […] All her life she had gone wrong about happiness. […] *Letting go had somehow done the trick*. I stripped my soul; I opened all the windows and let my ice-cold thoughts in on the poor thing; it stood shivering between certainty and uncertainty. I tried to doubt away this ultimate passion, and it turned my doubt into its own exquisite sting, the very thrill of the adventure. Supposing there's nothing in it, nothing at all? That's the risk you take. (Sinclair 1919, 378–9)

The tree (a recurring symbol in Sinclair) indicates yet another vision. Yet, the soul is "stripped," it becomes "the poor thing" and it "shivers," which paradoxically points to its materiality. Similarly, the lexis used echoes the "clearness and hardness of her soul," a recurring phrase in *The Tree of Heaven* (1917b; see also Hutchinson-Reuss 2010, 119) that shows a clear connection with "the ideals of the Imagist aesthetic", as Hutchinson-Reuss suggested in her dissertation (2010, 118). Quite interestingly, the focus on the materiality of the soul leads to negative suppositions and induces the dangerous "thrill" of self-annihilation. Nothingness seems to get the upper hand and all possible creations, if not all possibility of actions, seem to have vanished.

Is this the "pathological inward look" that Sinclair described in her essays? I am tempted to argue otherwise because this scene is constructed as a pivotal moment, be it only because of the use of the pronoun "I," a very rarely used pronoun in the novel. This shift in pronouns is a recurring device in Sinclair and a significant tool in modernist *Bildungsromane* indicating that agency is indeed at stake. The repetition of the adjective "real" (l.1–2) echoes Sinclair's essays on "ultimate reality" and the statement "her real self was God" does seem to be an extension of a passage quoted in the first section of this essay ("It is the moment that the human soul becomes conscious of itself in God..."). Quite ambiguously, Mary's supposition that her mystical visions may have led her nowhere complicates her theory of sublimation. Her situation could, however, echo another of her thesis statements, namely that "the individual [...] may have to die that the Self may live" (Sinclair 1917a, 375). Sinclair claims that the individuality must be sacrificed so that "the Self" (the manifestation in man of ultimate consciousness, according to Sinclair's terminology) may live. What Mary might be experiencing here, is a new ecstasy, the thrill of ambiguity, of risk-taking or of nothingness that may lead to illumination and creation, as if the inward look into the soul, the pathological dissociation, evoked in the essay, could also produce art and creation. As she approaches a more complex depiction of both sublimation and soul than the essays, Mary is here in the uncharted territory of Sinclairian souls.

One of the earliest occurrences of the word "soul" in Sinclair's fiction, more precisely in her first novel, *Audrey Craven* (1897), is worth mentioning in this context:

> She felt him as something illuminating and intensifying her consciousness. She heard the vicar's voice like a fine music playing in the background. [...]

Now it was no longer a fugue of sounds—it was a fugue of all sensations [...]. Her individuality that had swum with the stream became fluent and coalesced with it now, *soul flooded with sense, and sense with soul*. She came to herself exhausted and shivering with cold. (Sinclair 1897, 217. Italics mine)

This early example somehow announces Sinclair's philosophical system: intense bodily sensations leading to non-verbal epiphanies while simultaneously depicting a highly intimate and spiritual stream-like experience. Even more remarkably, Sinclair's fictional experimentations with souls enabled her to explore the thrill of a feminine adventure towards mysticism—even if it remains limited in Audrey Craven's case. Reconsidering Sinclair's fiction within the specifically Sinclairian theoretical framework and its immediate context, as well as developing new scholarship on Sinclair's philosophical, psychological and feminist theorisations might thus give us important insight on the reception of her work and help us revalue her place among modernist authors as well as female scholars of mysticism.

In May Sinclair's theoretical texts, conceptualisations and representations of souls are very diverse and relate to her keen interest in both their philosophical and psychological aspects. However, her fiction more clearly demonstrates her constant and open-ended questioning on the subject. While the essays relied on general principles and theories, Sinclair seems to have chosen to represent her own doubts and questions in her novel, which investigates the challenging aspects of feminine pathologies, physiology, creativity and spirituality. More than her other works, *Mary Olivier* embodies her relentless effort to explore the powers of the human mind, consciousness and soul. Sinclair's aim, like her heroine Mary's, was indeed to "go on without ever having to stop thinking" (Sinclair 1919, 89).

Notes

1. Freud repeatedly refers to the psyche as an [...] 'instrument' [of the soul] (*Seeleninstrument*) (Ffytche 2011, 235) and Sinclair, as we shall see, refers to the libido as an instrument of the soul.
2. "Psychical dispositions are but a substitute for a soul" (Sinclair 1917a, 80).
3. Sinclair never fully explores the alternative between aspect and phenomenon.
4. Another line of contention lies on her consistent emphasis on the libido and the body, which makes her thus closer to Spinoza's dual system than to Green's idealism.

5. Sinclair also seems to adapt her own terminology when she writes that "the neurotic cannot sublimate his Will-to-Live", (Sinclair 1917a, 9) instead of using the term libido.
6. In her essays, Sinclair reckons passion as one of the soul's attributes but does not give us any detail on its scope and nature, e.g. the quest for ultimate reality is as much a necessity of thought as it is a passion of the soul" (Sinclair 1917a, 246).
7. "She [Miss Laura] thought it was a good thing to be jilted; for then you were purified [...]. Your soul was set free" (Sinclair 1919, 223). True to Sinclair's dialogic approach, the novel seems to articulate various definitions of the word soul, ranging from the critique of the too-restrictive Christian soul to Sinclair's own complex and unstable representation.

WORKS CITED

Abel, Elizabeth, Marianne Hirsch, and Elizabeth Langland. 1983. The Voyage. In *Fictions of Female Development*. London: University Press of New England.
Battersby, Christine. 2002. In the Shadow of His Language: May Sinclair's Portrait of the Artist as Daughter. *New Comparison* 33 (4): 102–120.
Bettelheim, Bruno. 1982. Freud and the Soul. In *The New Yorker*, March 1, 52–53.
———. 1983. *Freud and Man's Soul*. New York: Alfred A. Knopf.
Boll, Theophilus. 1962. May Sinclair and the Medico-Psychological Clinic of London. *Proceedings of the American Philosophical Society* 106 (4): 310–326.
———. 1973. *Miss May Sinclair: Novelist*. Cranbury: Associated University Presses.
Bortoli, Lucia, 1998. May Sinclair's Modernist Experience: A Political Revision of Female Subjectivity and Autobiographical Writing. PhD diss., Notre-Dame (Notre-Dame, Indiana).
Bowler, Rebecca, and Claire Drewery. 2016. *May Sinclair: Re-thinking Bodies & Minds*. Edinburgh: Edinburgh University Press.
Brasme, Isabelle. 2018. May Sinclair's Literary Criticism: A Commitment to Modernity. *E-rea* 15: 2. http://journals.openedition.org/erea/6178.
Csikszentmihalyi, Mihály. 1975. *Beyond Boredom and Anxiety*. San Francisco: Jossey-Bass Publishers.
de Bont, Leslie. 2016. The Ambiguous Influence of Freud on May Sinclair's Novels. In *May Sinclair: Re-thinking Bodies & Minds*, ed. R. Bowler and C. Drewery, 59–78. Edinburgh: Edinburgh University Press.
Ffytche, Matt. 2011. *The Foundation of the Unconscious: Schelling, Freud and the Birth of the Modern Psyche*. Cambridge: Cambridge University Press.
Forster, Laurel. 2019. May Sinclair, Magazine Writer: Exploring Modernisms through Diverse Journals. In *Women, Periodicals and Print Culture in Britain, 1890s–1920s: The Modernist*, ed. Faith Binckes. Edinburgh University Press.
Genette, Gérard. 1982. *Palimpsestes: La Littérature au second degré*. Paris: Seuil.

Gordon, Victoria. 2016. Identity-Construction and Development in the Modernist *Bildungsroman*. PhD diss., Lesley University.
Green, Thomas. 1906. *Prolegomena to Ethics* [1883]. 5th edition. Oxford: Clarendon Press.
Hirsch, Mariane. 1989. *The Mother/Daughter Plot*. Bloomington: Indiana University Press.
Hutchinson-Reuss, Cory Bysshe. 2010. Mystical Compositions of the Self: Women, Modernism, and Empire. PhD diss., Lesley University.
Jones, Charlotte. 2021. *Realism, Form, and Representation in the Edwardian Novel*. Oxford: Oxford University Press.
Jung, Carl Gustav. [1916/2019]. *Psychology of the Unconscious*. Translated by B Hinkle. New York: Moffat Yard.
Lawrence, David Herbert. [1921/1991]. *Psychoanalysis and the Unconscious and Fantasia of the Unconscious*. Harmondsworth: Penguin.
Marshik, Celia, and Allison Pease. 2018. *Modernism, Sex, and Gender*. London: Bloomsbury.
Martindale, Philippa. 2004. 'Against All Hushing and Stamping Down': The Medico-Psychological Clinic of London and The Novelist May Sinclair. *Psychoanalytical History* 62: 177–200.
McDougall, William. 1911. *Body and Mind: A History and a Defense of Animism*. Boston: Beacon Press.
Moravec, Matyáš. 2022. Taking Time Seriously: The Bergsonism of Karin Costelloe-Stephen, Hilda Oakeley, and May Sinclair. *British Journal for the History of Philosophy* 31 (2): 331–354.
Mosimann, Elizabeth. 2015. Postwar New Feminism: May Sinclair and Colette. In *1922: Literature, Culture, Politics*, ed. J.-M. Rabaté, 196–208. Cambridge: Cambridge University Press.
Oppenheim, Janet. 1985. *The Other World: Spiritualism and Psychical Research in England, 1850–1914*. Cambridge University Press.
Raitt, Suzanne. 2000. *May Sinclair, A Modern Victorian*. Oxford: Oxford University Press.
———. 2004. Early British Psychoanalysis and the Medico-Psychological Clinic. *History Workshop Journal* 58: 63–85.
———. 2016. 'Dying to Live': Remembering and Forgetting May Sinclair. In *May Sinclair: Re-thinking Bodies & Minds*, ed. R. Bowler and C. Drewery, 21–38. Edinburgh: Edinburgh University Press.
Richardson, Dorothy. 1990. Foreword to *Pilgrimage* [1938]. In *Gender of Modernism*, edited by B. K. Scott, 429–432. Bloomington: University of Indiana Press.
Russell, Bertrand. 1917. Metaphysics: Review of May Sinclair *A Defence of Idealism*. *The English Review* 25: 381–384.

Schyllert, Sanna. 2016. Why British Society Had to "Get a Young Virgin Sacrificed": Sacrificial Destiny in *The Tree of Heaven*. In *May Sinclair: Re-thinking Bodies & Minds*, ed. R. Bowler and C. Drewery, 178–193. Edinburgh: Edinburgh University Press.

Sinclair, May. 1897. *Audrey Craven*. London: Blackwood.

———. [1915]. *The Way of Sublimation*. University of Pennsylvania: Kislak Center for Special Collections, Rare Books and Manuscripts, Box 23.

———. 1916. Clinical Lecture on Symbolism and Sublimation—II. *The Medical Press and Circular* 153:142–145. August 16.

———. 1917a. *A Defence of Idealism: Some Questions and Conclusions*. New York: Macmillan.

———. 1917b. *The Tree of Heaven*. New York: Macmillan.

———. [1919/1982]. *Mary Olivier: A Life*. London: Virago.

———. 1922. *The New Idealism*. New York: Macmillan.

Thomas, Emily. 2019. The Idealism and Pantheism of May Sinclair. *Journal of the American Philosophical Association* 5 (2): 137–157.

Troy, Michelle, and Andrew Kunka. 2006. *May Sinclair: Moving Towards the Modern*. Aldershot: Ashgate.

Truran, Wendy. 2016. Feminism, Freedom and the Hierarchy of Happiness in the Psychological Novels of May Sinclair. In *May Sinclair: Re-thinking Bodies & Minds*, ed. R. Bowler and C. Drewery, 79–97. Edinburgh: Edinburgh University Press.

Woolf, Virginia. Review of *Revolving Lights* [1923/1990]. In *The Feminist Critique of Language*, edited by D. Cameron, 72–73. London: Routledge.

CHAPTER 5

Spectrality and Narrative Form in George Saunders's *Lincoln in the Bardo*

Stefanie Weymann-Teschke

George Saunders's *Lincoln in the Bardo*, published in 2017, is a haunted book, a novel in which characters, stories and memories are caught in a continuous process of disappearing, while exhibiting at the same time the curious power of persistence, of going on. A stylistic hybrid, the novel thereby moves freely between different genres and forms to tell the story of a little boy who has recently died and a father mourning this unfathomable loss. Just like it never fully commits to one form or genre, instead bearing the echoes of each equally, Saunders's novel operates in the interstices, in the space between life and death, past and present, absence and presence. Approaching the novel via Jacques Derrida's concept of hauntology, this chapter will trace on both the story level and the level of narrative discourse the polyphony of voices and forms haunting the eerie and

S. Weymann-Teschke (✉)
Friedrich Schiller University Jena, Jena, Germany

Kiel University, Kiel, Germany
e-mail: stefanie.weymann-teschke@uni-jena.de

© The Author(s), under exclusive license to Springer Nature Switzerland AG 2024
D. Louis-Dimitrov, E. Murail (eds.), *The Persistence of the Soul in Literature, Art and Politics*,
https://doi.org/10.1007/978-3-031-40934-9_5

astoundingly moving world of *Lincoln in the Bardo* before considering the novel's most haunting presence of all: the soul.

Derrida and Hauntology

"To haunt," Derrida writes famously in *Specters of Marx*, "does not mean to be present, and it is necessary to introduce haunting into the very construction of a concept. Of every concept, beginning with the concepts of being and time. That is what we would be calling here a hauntology. Ontology opposes it only in a movement of exorcism. Ontology is a conjuration" (2006, 202). Hauntology in the Derridean sense is thus a gesture of incorporation, albeit an incorporation that is necessarily incomplete. Instead of suggesting a simple extension in which the concept of being or presence is treated as complementary to its opposite, hauntology here necessitates the inclusion of one in the other, of tracing the convergence of being and non-being, presence and absence. Without dealing in absolutes, hauntology thereby always implies an Other, a potentiality realised in the form of a trace.

It is this renunciation of absolutes in favour of 'always already' and 'already no longer' that makes hauntology a valuable concept for studying literary texts as it demands awareness of what lies in-between. Colin Davis therefore points out that "[h]auntology is part of an endeavour to keep raising the stakes of literary study, to make it a place where we can interrogate our relation to the dead, examine the elusive identities of the living, and explore the boundaries between the thought and the unthought" (2005, 379). In this exploration of what lies between presence and absence, life and death, here and there, the figure of the spectre plays a very prominent role. To quote Derrida once more:

> [T]he specter is a paradoxical incorporation, the becoming-body, a certain phenomenal and carnal form of the spirit. It becomes, rather, some "thing" that remains difficult to name: neither soul nor body, and both one and the other. For it is flesh and phenomenality that give to the spirit its spectral apparition, but which disappear right away in the apparition, in the very coming of the *revenant* or the return of the specter. (2006, 5)

Supernatural phenomenality: what Derrida here describes is a continuous process of coming and going, an apparition that already bears the terms of its disappearance. Above all, the spectre enacts a complex

interplay of absence and presence. Instead of an either/or, it announces the presence of one in the other: neither here nor there but both; neither soul nor body but both. In fact, the spectre is an absence made flesh, the making visible of invisibility as a trace or an echo. As a text, *Lincoln in the Bardo* is haunted by such present absences, by forms and voices that are not completely *there* but whose echoes and traces lastingly inform the *here* of narration. In the first step, this textual haunting will be traced at the level of narrative form.

Tracing Form

In his review of the novel, Ron Charles calls the book, among other things, "an extended national ghost story" (2017) and judging from the novel's plot, characters and setting, there is sufficient evidence to support his claim. *Lincoln in the Bardo* is set in a Georgetown cemetery, where numerous dead characters have not quite moved on: not ready or willing to leave the earthly realm, they are stuck as spectral forms in a strange place in-between, not completely gone but no longer present either. On a day in February 1862, while the Civil War is raging in the country, these present absences become aware of a new arrival who turns out to be none other than President Abraham Lincoln's eleven-year-old son. Willie Lincoln, having recently died of typhoid fever, does not simply pass on, but lingers in this intermediate realm, caught between life and death. His persistent presence worries the population of Oak Hill Cemetery because "[t]hese young ones are not meant to tarry" in this place (Saunders 2017, 31). Alarmed by what will happen to the boy should he remain any longer, several of the cemetery's inhabitants try to convince Willie Lincoln to leave, an endeavour that is seriously complicated by President Abraham Lincoln's repeated visits to the crypt. Eventually, Willie Lincoln departs from this strange place in-between and as many of the other spectral forms follow suit, the novel ends on a somewhat hopeful note for the mourning father, too: having eventually taken leave of his son's remains, Abraham Lincoln in the final scene of the novel rides off into the night, determined to bring the Civil War to an end. Crucially, as he is about to exit the cemetery, the spectral form of a former slave slips into the body of the President and leaves with him, a symbolic union to brace for the struggle that lies ahead.

Dead characters haunting the narrative from their graves, a greyish hue wafting through the cemetery, its chapel and the crypt, all this makes for a

perfect ghost story. But *Lincoln in the Bardo* is not just that. While the supernatural element is unmistakable, the novel's form gestures towards something more. This 'something more' is signalled by the fact that, as Hari Kunzru in his review for *The Guardian* rightly points out, the dead characters in Saunders's novel strictly speaking are not ghosts (2017): *Lincoln in the Bardo* is not a classical tale of ghostly visitations that scare or console the living because the dead characters in Saunders's novel do not *appear* to any of the living characters; to them, they do not materialise in a distinct shape or form. In their corporeal incorporeality, they approach Derrida's definition of the spectre, which is distinguished from the spirit or ghost by "a supernatural and paradoxical phenomenality, the furtive and ungraspable visibility of the invisible" (Derrida 2006, 6). The spectre, "not present, itself, in flesh and blood" (Derrida 2006, 126), therefore lingers in this indeterminacy, a visible invisibility that is capable of seeing without itself being seen.

A seemingly minor detail, the exact nature of the supernatural in *Lincoln in the Bardo* lastingly shapes the spatial and temporal parameters of the novel: here, the spectre introduces not only a temporal disruption—blending a past presence into a present absence—but also a spatial one by creating two separate realms for the dead and the living. These two realms coexist, for the most part, independently. Even on those few but momentous occasions when the dead characters attempt to breach the present of the living by entering the mind and body of those that are still alive, the moments of "co-habitation" (Saunders 2017, 173) often affect the dead more than the living. While exchange between these two realms tends to be monodirectional, the spectral presence of the dead is all the more powerful, presenting as a visible invisible and an audible inaudible. On the level of narrative discourse, the reader of *Lincoln in the Bardo* is thus confronted with a narrative impossibility: how to signify the visible invisibility of a spectral form without betraying its shapeless phenomenality? While the ghost story as a literary tradition informs *Lincoln in the Bardo*, it does not materialise in full-fledged form. Instead, the novel takes an experimental turn.

Responding to the representational challenge of making visible and audible that which is essentially invisible and inaudible, Saunders makes use of a form which can perhaps best be described as approaching dramatic narration. *Lincoln in the Bardo* is presented predominantly as monologues and dialogues that flow across the page without quotation marks to anchor them, a typographical setup that Corina Selejan in her reading of the novel

initially associates with a play rather than a novel (2019, 109). Indeed, the only device that identifies the chunks of text as direct speech is an attribution inserted after each utterance, revealing the name of the speaker. The closeness to drama is thus unmistakable, but in contrast to the conventional layout of plays, it is the speech acts themselves, instead of the speaker's name, that take precedence in *Lincoln in the Bardo*: similar to drama but not quite the same.

On the other hand, dialogic structures are, of course, hardly new to narrative texts either. But in this respect, too, Saunders's novel represents a distinct form. Due to the unique layout of the page, the monologic or dialogic utterances are not embedded in a conventional narrative frame. Lacking an extradiegetic narrative centre or anchor, these utterances constantly defer the narrative focus, shifting quickly from one speaker to the next. The result of this focal fluidity is indirection: in lockstep with the repeated shifts in narrative focus, the reader also sees with each of the principal speakers changes in the degree of narrative involvement. Here, speakers can be seen to repeatedly absent themselves from the narrated events and take on the role of I-as-witness, thereby shifting the narrative focus outward. The following exchange is an ample case in point. In this excerpt, the voices of Hans Vollman and the Reverend Everly Thomas, two dead characters whose bodies are presently decomposing in their graves, recount the arrival of Willie Lincoln at Oak Hill Cemetery:

> A newcomer? said the Reverend.
> I believe we have the honor of addressing a Mr. Carroll, Mr. Bevins said.
> The lad only looked at us blankly.
> <div align="center">hans vollman</div>
>
> The newcomer was a boy of some ten or eleven years. A handsome little fellow, blinking and gazing cautiously about him.
> <div align="center">the reverend everly thomas</div>
>
> Resembling a fish who, having washed ashore, lies immobile and alert, acutely aware of its vulnerability.
> <div align="center">hans vollman</div>

(Saunders 2017, 28–29)

The interlacing of direct speech with reported speech at first glance reduces the immediacy of narration in this scene. The shift from absent to

present voice, here illustrated with the example of the Reverend Everly Thomas, directs the narrative focus outward while also pushing it onwards. At the same time, this deferral reinforces the inherent logic of the book, in which narrative presence is undercut by the fundamental absence at its core: the voices of the dead in their orchestrated multitude produce an undeniable vocal presence; a presence, however, which these spectres in their corporeal absence can never fully incorporate. This approximation to dramatic form—the foregrounding of voices floating across the pages— here mirrors the disembodied state the characters find themselves in, enacting presence in absence.

Notably, the one element that tends to momentarily interrupt the play of voices is the attribution inserted after each utterance. The naming and subsequent authorisation of each utterance briefly anchors them by tying them to a definitive source. It is, however, only that: a momentary pause in a whirl of voices. The polyphony that George Saunders unleashes may render the absent present, may make the inaudible audible, but the moment of giving voice is punctuated by an absence that cannot be denied. Here, the persistent avoidance of capitalisation in the attributions themselves may be seen as a precaution against mistaking a temporary being-there for being: "Hans Vollman" and "the Reverend Everly Thomas" are identity markers that are informed by temporal stability, whereas "hans vollman" and "the reverend everly thomas" are provisional forms that claim a presence they can never inhabit.

The issue of authorisation, in fact, haunts another aspect of form. For in addition to its proximity to the ghost story and the unmistakable traces of dramatic form, the novel is also a work of historical fiction (as per the book's front matter). In his discussion of past and present tense in narration, Gérard Genette in *Narrative Discourse Revisited* comments briefly on the "so-called historical narrative (of fiction)" (1990, 80). "The term," he writes,

> is certainly very indefinite, or at least here I think it has to be taken in the broadest possible sense, as covering every type of narrative (a) that is explicitly placed (even by only one date) in a historical past, even a very recent one, and (b) whose narrator, on the basis of that single piece of information, sets himself up more or less as a historian and therefore (if I may attempt this very slight oxymoron) as a *subsequent witness*. (1990, 80)

Lincoln in the Bardo fits this description on all counts. Apart from the presence of historical figures that root the novel firmly in 1860s America,

the historical dimension is particularly palpable in those chapters that interrupt the passages of direct discourse. These sections consist entirely of quotes from historical sources—real and invented—about the Lincoln family, their very private tragedy and the Civil War. One might consider the collection of quotes part of what Merritt Moseley terms Saunders's "use of fragmentation as another tool in his project of challenging and displacing the traditional and conventional historical novel's assumption of verisimilitude, wholeness, and self-consistency" (2019, 96). In any case, this medley of historical perspectives counterbalances the multitude of voices emanating from the cemetery to provide the factual body to a narrative that is otherwise characterised by fluidity and indirection. What is more, these quotes from history books, diaries, logbooks or letters root the story in time: they evoke a historical present to which none of the characters presently roaming Oak Hill Cemetery have access. The historical voices bear witness to the visible, gruesome reality of the Civil War and infuse the narrative with a sense of time passing.

As markers of a historical past, the voices echoing from these chapters take on the role of "*subsequent witness*" (Genette 1990, 80) in a particular manner. For one, the historical testimonies are each followed by bibliographic details to signal factual accuracy. In contrast to the passages of direct speech discussed earlier, the bibliographic information is provided with capitalisation of names and titles, thereby setting the textual snippets apart from the oral discourse taking place among the dead. Enacting a return to realism and verisimilitude, the historical voices, secondly, do not tell a consistent history of the United States during the Civil War. Instead, the quotes set in motion a continuous rewriting of the past.

In one instance, the novel thus combines several conflicting reports about something as minor as the weather conditions that prevailed on the evening before Willie Lincoln's death:

> There was no moon that night and the sky was heavy with clouds.
> Wickett, op. cit.
>
> A fat green crescent hung above the mad scene like a stolid judge, inured to all human folly.
> In "My Life," by Dolores P. Leventrop.
>
> The full moon that night was yellow-red, as if reflecting the light of some earthly fire.
> Sloane, op. cit.

(Saunders 2017, 19)

Other than pointing to differences in perception and recollection, these conflicting accounts hardly raise questions of reliability. Since they are positioned in a seemingly random order, each of them authorised in their own right, the different perspectives converge in a complex image that is fortified further by the multifarious voices it combines. The same effect is produced when it comes to accounts of President Lincoln, both as a politician and as a grieving father. Exemplary of a wide range of quotes and comments, the following two examples highlight the role of "*subsequent witness*" (Genette 1990, 80). The first is an account of President Abraham Lincoln's outer appearance, while the second is a damning take on the President's role in the Civil War:

> Oh, the pathos of it!—haggard, drawn into fixed lines of unutterable sadness, with a look of loneliness, as of a soul whose depth of sorrow and bitterness no human sympathy could ever reach. The impression I carried away was that I had seen, not so much the President of the United States, as the saddest man in the world.
> Browne, op. cit.
> (Saunders 2017, 201)

> The people have, for nineteen months, poured out, at your call, sons, brothers, husbands & money.—What is the result?—Do you ever realize that the desolation, sorrow, grief that pervades this country is owing to you?—that the young men who have been maimed, crippled, murdered, & made invalids for life, owe it to your weakness, irresolution, & want of moral courage?
> Tagg, op. cit., letter from S. W. Oakey.
> (Saunders 2017, 233)

As opinions, perspectives and experiences clash, as in these two excerpts, the different voices gather around the only solid presence in the novel. The lynchpin of these accounts, President Abraham Lincoln represents simultaneously the embodiment of sorrow as well as the very cause of it. In these two seemingly irreconcilable expressions of grief, the personal merges with the public to write a multi-layered history of suffering: the grief reaching deep into the soul of one mourning father translates onto the national scale, where an entire country bears the scars of conflict. While the spectre of history here counters the novel's timeless whirl of dead voices, it also reinforces the overwhelming sense of absence, of intense loss, at the heart of the novel.

Tracing Religion

A potential countermeasure that Saunders offers to reinscribe this absence with presence, to gesture beyond the immediacy of loss towards a point of possible reconciliation, comes from the vantage point of religion. Another haunting echo in a novel that already hovers somewhere between ghost story, dramatic narration and historical fiction, religion is used as a sounding board to further explore the vicissitudes of human suffering. The most immediate reference to religion is thus presented in the novel's title. Bardo, as discussed in the *Tibetan Book of the Dead*, denotes in Tibetan Buddhism several states of existence: the intermediate state of living, the intermediate state of dreams, the intermediate state of meditative concentration, the intermediate state of the time of death, the intermediate state of reality and the intermediate state of rebirth (2006, 32–33). While the very concept of Bardo thus alludes to a complex spiritual journey, the novel's reference to it is really just that: an allusion. Instead of engaging openly with the notion of Bardo and related Buddhist practices, the novel relies on intertextual innuendo.

Throughout the novel, then, there are aspects that may be connected to certain elements of Tibetan Buddhist practice. There is, for one, the portrayal of the dead characters in *Lincoln in the Bardo*. While the characters themselves do not want to acknowledge their status as deceased until very late in the narrative—Hans Vollman, for instance, refers to his coffin and the cemetery as a "sick-box" located in "this hospital-yard" (Saunders 2017, 6)—the reader is soon led to understand that these characters are no longer living. Having arrived at the cemetery just recently, it is Willie Lincoln who provides an I-as-witness account of the cemetery's population. The first resident of Oak Hill Cemetery he sees features "several sets of eyes All darting to and fro Several noses All sniffing" (Saunders 2017, 27), whereas the aforementioned Hans Vollman is characterised as follows:

> The other man (the one hit by a beam) Quite naked Member swollen to the size of Could not take my eyes off
> It bounced as he
> Body like a dumpling Broad flat nose like a sheep's …
> willie lincoln
>
> (Saunders 2017, 28)

The breaks in Willie Lincoln's report signal the unnatural setup of a novel carried by voices that effectively can no longer be heard. What is more, the hesitation in his account also underlines the grotesqueness of these sights. In fact, the disfigured forms grow even more grotesque as the novel progresses, with characters manifesting as different shapes and figures.

Within the context of intermediate states in Tibetan Buddhism, the characters' condition finds, perhaps, an echo in the intermediate state of rebirth. In the *Tibetan Book of the Dead*, this state sees the rising of a body described in the tantras as "*[h]aving the bodily form of one's past and emergent existences, / Complete with all sense-faculties, and the power of unobstructed movement. / Endowed with miraculous abilities derived from past actions, / Visible to those similar in kind and through pure clairvoyance*" (2006, 274). What in this religious context signals the final stage prior to rebirth and therewith the final chance to exit cyclic existence and attain Buddhahood (2006, 267), in *Lincoln in the Bardo* has become a condition that some of the characters have known for several years: here, the novel's description of the grotesque forms, with a notable emphasis on sense-faculties, marks a past that cannot be shed.

In Saunders's novel, prolonged persistence in this intermediate realm is thereby predicated on the dead characters withstanding several temptations as they are visited on a regular basis by visions that, in the guise of loved ones, try to convince them to move on. "Come with us," whispers one such temptation to a character at one point, "[h]ere it is all savagery and delusion. You are of finer stuff. Come with us, all is forgiven" (Saunders 2017, 93). These enticing messages are occasionally successful. Whenever a dead character is ready to let go of the "delusion" and face the reality of their state, their departure is accompanied by a sudden eruption of light. This "familiar, yet always bone-chilling, firesound associated with the matterlightblooming phenomenon," as it is marked in the novel (Saunders 2017, 96), bears some likeness to the moment of attaining Buddhahood described in *The Tibetan Book of the Dead* as "*dissolv[ing] inseparably within the lights and buddhabodies*" (2006, 267).

For all the links that may be established between the narrative and *The Tibetan Book of the Dead*, the novel suspends these intertextual references mid-air so as not to allow for a reading that would root the narrative firmly in religious practice. As such, it remains unclear whether the departure of dead characters signals the attainment of Buddhahood or the beginning of another cycle of existence by rebirth. While the novel thus

repeatedly—and explicitly as far as the novel's title is concerned—gestures towards Tibetan Buddhism as a possible frame, these references effectively resemble faint echoes drifting over the eerie grounds of Oak Hill Cemetery.

Alongside echoes of Tibetan Buddhism, the novel includes nods to other religions as well. With the Reverend Everly Thomas, the narrative features a priest whose presence introduces elements of Christian eschatology to the story. Unlike the other characters who are in denial about their current situation, the Reverend Everly Thomas has no illusions about being dead. What is more, he has already caught a glimpse of the afterlife, having previously moved on from the cemetery to face his personal Day of Judgment. In his detailed account of it, the Reverend is met by Christ seated at "a diamond table" flanked by two beings "tall, thin, luminous, borne on feet of sun-yellow light" who determine his fate based on his life's record (Saunders 2017, 189). Anticipating eternal damnation, Everly Thomas turns around in panic and runs before Christ can send him to hell—a place that in the novel is illustrated rather graphically as a tent, where a horrifying feast is taking place: "on long tables inside, numerous human forms were stretched out, in various stages of flaying; the host was no king, no Christ, but a beast, bloody-handed and long-fanged, wearing a sulfur-colored robe, bits of innards speckling it" (Saunders 2017, 191–192).

His sudden escape from the diamond building housing Christ, accompanied by "whips of fire" urging him to "[*t*]*ell no one about this. Or it will be worse upon your return*," plunges the Reverend into desperation: "We are shades, immaterial, and since that judgment pertains to what we did (or did not do) in that previous (material) realm, correction is now forever beyond our means. Our work there is finished; we only await payment" (Saunders 2017, 193). A different account of the afterlife that introduces notions of reward and punishment, these eschatological revelations here pose an imminent threat: to the Reverend Everly Thomas, having come face to face with a likely future in hell, persistence in this immaterial realm signals the evasion of "payment." What is more, it gestures beyond the intermediate realm to a definitive, horrible end. Whereas the other characters, judging from the life stories they tell each other, are much too attached to their lives and seem to anticipate a return from the sick-boxes to their former states, the Reverend Everly Thomas fears the certainty of a future in endless damnation: "[*Y*]*ou shall not be allowed to linger here forever. None of us shall. We are in rebellion against the will of our Lord, and in time must be broken, and go*" (Saunders 2017, 194). As the Reverend's

sudden escape from the celestial palace suspends final sentencing indefinitely, the eschatological vision haunts the narrative, turning fictional Oak Hill Cemetery into a waiting room before the spectral forms must, indeed, "*be broken, and go.*"

Finding the Soul

In terms of narrative form, then, *Lincoln in the Bardo* is a veritable *tour de force*, drawing liberally on the supernatural, drama, history and religion to frame a plot that ultimately cannot be framed. For all the fluctuation between narrative forms and intertextual echoes, there is one haunting presence throughout Saunders's novel that is particularly persistent. In between the historical and religious references, the polyphony of voices merges at the novel's very centre to present *sotto voce* a moving commentary on the human soul. True to form, the subject is broached only obliquely. In fact, throughout the novel, the word 'soul' appears a meagre seven times. This relative, nominal absence, however, only betrays the soul's omnipresence. For while it is never referred to as such, the concert of voices that the novel presents in its paradoxical audibility always already points to that which remains inaudible. In their inexplicable thereness, these voices bear the traces of that which cannot be heard, that which cannot even be named properly: in making audible the inaudible, in making visible the invisible, these spectral forms tell of the persistence of the soul.

In *Lincoln in the Bardo*, the closest that the narrative ever comes to expressing the ultimate visible-invisible, audible-inaudible is captured beautifully in two of the novel's most moving scenes. In the first, Abraham Lincoln returned to Oak Hill Cemetery to mourn his son. Standing in the crypt that holds Willie's coffin, Lincoln is so overcome with grief that he opens the coffin to look at his son's lifeless body once more. As the mourning father tries to convince himself to let go, the palpable absence in the presence of the child's bodily remains becomes almost unbearable:

> (... *Look down.*
> *At him.*
> *At it.*
> *What is it? Frankly investigate that question.*
> *Is it him?*)
> *It is not.*
> (*What is it?*)

> It is that which used to bear him around. The essential thing (that which was borne, that which we loved) is gone. Though this was part of what we loved (we loved the way he, the combination of spark and bearer, looked and walked and skipped and laughed and played the clown), this, this here, is the lesser part of that beloved contraption. Absent that spark, this, this lying here, is merely— ...
> (Absent that spark, this lying here, is merely—
> Say it.)
> Meat. ...
> <div align="right">hans vollman</div>
> (Saunders 2017, 245–246)

Transmitted indirectly by Hans Vollman in another instance of "cohabitation" (Saunders 2017, 173), President Lincoln's attempt to separate body and soul, the material from the immaterial, reflects an important stage in the process of mourning. Critically, Willie's absence is here explained as a loss of essence, a lack of weight—"that which was borne" (Saunders 2017, 245). As Abraham Lincoln looks down at his son's body, this essence is displaced, freed and no longer bound to Willie's remains. On Oak Hill Cemetery, however, in this strange place in-between, the child's soul—his essence, his spark—persists. Here, it is localised temporarily in spectral form, which to the living may be inaudible and invisible but certainly not impalpable: "*Love, love, I know what you are*" (Saunders 2017, 246)—with these words, Abraham Lincoln finally takes leave of his son forever only to find him again.

That Willie Lincoln can, indeed, be found again, even beyond the boundaries of Oak Hill Cemetery, is shown in another narrative transfer of presence onto absence that takes place in the cemetery's chapel, after Abraham Lincoln has closed his son's coffin and returned it to its place. Here, Willie 'enters' his father. During this moment, the child understands that he is really dead and that his father is mourning an irreversible absence (Saunders 2017, 296). This recognition initiates Willie Lincoln's definitive departure from Oak Hill Cemetery:

> I am Willie I am Willie I am even yet
> Am not
> Willie
> Not willie but somehow
> Less
> More

> All is Allowed now All is allowed me now All is allowed light-lightlight me now ...
> Whatever that former fellow (willie) had, must now be given back (is given back gladly) as it never was mine (never his) and therefore is not being taken away, not at all!
> As I (who was of willie but is no longer (merely) of willie) return
> To such beauty.
> willie lincoln
>
> (Saunders 2017, 301)

The dissolution of Willie's spectral form has wide-ranging effects. For one, his realisation causes a mass exodus from the cemetery with tormented characters left and right finally accepting death and vanishing into flashes of light. When it comes to Willie's own disappearance, however, it is suggestively framed as a return. The moment that Willie's spectral form disperses, he becomes less—"Not willie but somehow"—while returning at the same time as something more; something that is no longer bound to an I, who "is no longer (merely) of willie," but expands beyond it. Casting off all matter—"[w]hatever that former fellow (willie) had"—and substance—fading from "Willie" to "Not willie"—the return to "such beauty" here collapses absence into presence.

One might read into this moment of ascension, of the individual returning to "such beauty," traces of transcendental philosophy. One might detect in this moment of liberation and departure into "light-lightlight" reverberations of Tibetan Buddhism. In the fictional realm of Oak Hill Cemetery, in any case, the echo of Willie's disappearance and subsequent return pierces the world of the living, too. Here, the sudden eruption of light transforms Willie's bodily absence into a presence in spirit that is no longer bound to a locale. Attesting to the omnipresence of the soul, President Lincoln's thoughts, recorded by three dead characters whom he passes through on his way out of the chapel, indeed revolve around the idea of placelessness:

> His boy was gone; his boy was no more.
> hans vollman
>
> His boy was nowhere; his boy was everywhere.
> roger bevins iii

> There was nothing here for him now.
> hans vollman
>
> His boy was no more *here* than *anyplace else,* that is. There was nothing special, anymore, about *this* place.
> roger bevins iii
>
> (Saunders 2017, 303)

As Willie is nowhere and everywhere simultaneously, felt in the traces of memory and love, he remains a present absence to his father and the other characters alike: "In *our* mind," reports Roger Bevins III later, "the lad stood atop a hill, merrily waving to us, urging us to be brave and resolve the thing" (Saunders 2017, 309). To be sure, this acceptance of loss does not end Lincoln's suffering, but it makes him recognise—and here the novel moves from the personal to the national level once more—that sorrow is a universal experience. With his own personal loss connecting him to an entire nation waiting for their President to "resolve the thing" that is the Civil War, Lincoln leaves the cemetery with renewed determination, spurred on by the continued presence in absence of his son Willie.

The Past in the Present

Tellingly, the President, as mentioned above, does not leave Oak Hill Cemetery on his own. As the novel draws to a close and the soul of Willie Lincoln, his essence, is released into the gruesome reality of Civil War America, Saunders's tale *returns,* as spectral forms do, to the ghost story tradition.

> A key role played by ghosts in many cultural traditions is precisely to bring to light travesties of justice that dispute the official record. The story the ghost bears is often one of violence and exclusion, and the narrative associated with it therefore often functions as a form of cultural critique calling into question the completeness or truthfulness of the "official record." American ghost stories function in this capacity not only in relation to indigenous people, but other historically disenfranchised groups as well, including women and persons of colour. (Weinstock 2018, 209)

The final voice that the reader of *Lincoln in the Bardo* hears on the record belongs to Thomas Havens, an African American and a former slave whose story is indeed marked by sorrow and exclusion, even in death. Throughout the narrative, Thomas Havens has been persisting with all the

other African Americans in the cemetery in "the mass grave on the other side of the fence" (Saunders 2017, 213). Thus segregated, he does not form part of the main chorus for a substantial portion of the novel. In the final scenes of *Lincoln in the Bardo*, however, Thomas Havens effectively changes the tune of the chorus. As President Lincoln passes through him on his way to the front gate, Thomas Havens's spectral form in one decisive move enters the President's body and leaves the cemetery with him: "I began to feel afraid, occupying someone so accomplished. And yet, I was comfortable in there. And suddenly, wanted him to *know* me. My life. To know *us*. Our lot" (Saunders 2017, 311). Performing an incorporation, literally, the voice of the former slave merging with the body of the President here carries Thomas Havens's testimony beyond the cemetery. As he calls to mind the sufferings and hardships endured by those he has known, Thomas Havens likewise gestures ahead to the future: "Sir," he implores the President, "if you are as powerful as I feel that you are, and as inclined toward us as you seem to be, endeavor to *do* something for us, so that we might do something for ourselves" (Saunders 2017, 312). Commenting on spectrality and temporality, Katy Shaw writes in *Hauntology*: "The appearance of the specter, a thing from the past in the present moment, marks a burden of the past on the present, and opens up the present to the many possibilities of that which came before" (Shaw 2018, 8). In this, the novel's final scene, the burden of the past is literally brought to bear on the present as the future takes shape in their union.

Joining for one final time a presence with an absence, infusing the timeless intermediate realm with historical momentum, *Lincoln in the Bardo* closes on a note of hope. It can do so because the traces of the dead inscribe themselves in the narrative present, urging the living onward. Willie is gone, but his presence is still felt. Thomas Havens has left, but his voice still rings as he and the President ride "forward into the night, past the sleeping houses of our countrymen" (Saunders 2017, 343). In the novel's back-and-forth between absence and presence, perhaps it is this, finally, that persists: it may be called the soul, the spark, or the essence of a person, but it is always that which is felt even after the body is gone, that which is heard even after the voice has fallen silent.

Works Cited

Charles, Ron. 2017. 'Lincoln in the Bardo' Arises from a Tragic Footnote in American History. Review of *Lincoln in the Bardo*, by George Saunders. *Washington Post*, February 6, 2017. https://www.washingtonpost.com/entertainment/books/lincoln-in-the-bardo-a-long-awaited-novel-by-george-saunders/2017/02/06/473568b4-e98f-11e6-b82f-687d6e6a3e7c_story.html.

Davis, Colin. 2005. Hauntology, Spectres and Phantoms. *French Studies* 59 (3): 373–379. https://doi.org/10.1093/fs/kni143.

Derrida, Jacques. 2006. *Specters of Marx: The State of the Debt, the Work of Mourning and the New International*. Translated by Peggy Kamuf. New York: Routledge.

Genette, Gérard. 1990. *Narrative Discourse Revisited*. Translated by Jane E. Lewin. Ithaca: Cornell University Press.

Kunzru, Hari. 2017. Extraordinary Story of the Afterlife. Review of *Lincoln in the Bardo*, by George Saunders. *Guardian*, March 8, 2017. https://www.theguardian.com/books/2017/mar/08/lincoln-in-the-bardo-george-saunders-review.

Moseley, Merritt. 2019. *Lincoln in the Bardo*: 'Uh, NOT a Historical Novel'. *Humanities* 8 (2): 96. https://doi.org/10.3390/h8020096.

Saunders, George. 2017. *Lincoln in the Bardo*. New York: Random House.

Selejan, Corina. 2019. Fragmentation(s) and Realism(s): *Has* the Fragment Gone Mainstream? *Anglica Wratislaviensia* 57: 103–112. https://doi.org/10.19195/0301-7966.57.8.

Shaw, Katy. 2018. *Hauntology: The Presence of the Past in Twenty-First Century English Literature*. Cham: Palgrave Macmillan.

The Tibetan Book of the Dead. 2006. Composed by Padmasambhava. Revealed by Terton Karma Lingpa. Translated by Gyurme Dorje. Edited by Graham Coleman and Thupten Jinpa. London: Penguin.

Weinstock, Jeffrey Andrew. 2018. The American Ghost Story. In *The Routledge Handbook to the Ghost Story*, ed. Scott Brewster and Luke Thurston, 206–214. New York: Routledge.

CHAPTER 6

Forging in the Smithy of David Foster Wallace's Postmodern Soul

Béatrice Pire

Speaking of the soul in the time of Modernism or, worse, in the age of Postmodernism and Post-postmodernism seems paradoxical or outdated. Yet, James Joyce ended his *Portrait of the Artist as a Young Man* with Stephen Dedalus' following exclamation and creative project: "Welcome, O life! I go to encounter for the millionth time the reality of experience and to forge in the smithy of my soul the uncreated conscience of my race" (Joyce 1958 [1916], 257). Almost less than a century later, David Foster Wallace, in turn, made reference to this penultimate page and vision of the soul as an Hephaistian smithy, even to negate it, in one of the short stories collected in *Oblivion*, "The Soul Is Not a Smithy" (Wallace 2004, 67–113). Recent critical work in the field of David Foster Wallace studies has come to address this question of the soul, namely Jamie Redgate in *Wallace and I: Cognition, Consciousness and Dualism* in *David Foster Wallace's fiction*. And before him, Stephen Burn, the doctoral supervisor of this study, had already raised the seemingly obsolete issue of body and soul in the age of neuroscience, in this groundbreaking statement:

B. Pire (✉)
Sorbonne-Nouvelle University, Sorbonne-Nouvelle, France

© The Author(s), under exclusive license to Springer Nature Switzerland AG 2024
D. Louis-Dimitrov, E. Murail (eds.), *The Persistence of the Soul in Literature, Art and Politics*,
https://doi.org/10.1007/978-3-031-40934-9_6

a deep metaphysical ache [...] lies at the heart of post-postmodern fiction, a yearning to achieve some transcendent spiritual meaning presumed to be absent from the postmodern world. Although recent criticism has argued for the emergence of the "new atheist novel" [...], much post-postmodern fiction seems to yearn for at least a partial return to religion and spirituality [...]. Such a return is anecdotally apparent in biographical fragments—say, David Foster Wallace's several attempts to convert to Catholicism—but a distillation of this impulse is also palpable in the heightened resonance the word *soul* carries in much post-postmodern fiction. (*in* Peacock and Lustig 2013, 45–46)

"There Is Actually No Such Thing as Atheism"

As early as 1993, in the famous interview conducted by Larry McCaffery for the *Review of Contemporary Fiction*, Wallace used words such as "redemptive," "illuminate," "joy" and "charity" or "angelic" to circumscribe the tasks of good fiction, and stated that "language and linguistic intercourse is, in and of itself, redeeming."[1] His most obviously nonfiction text imbued with religious language, however, remains *This is Water*, the commencement speech given at Kenyon College in 2005 and posthumously published with the added subtitle *Some Thoughts, Delivered on a Significant Occasion, about Living a Compassionate Life* (Wallace 2009 [2005]). The speech is based on two parables, the fish parable where an older fish asks two younger ones how water is, to which they reply and wonder "what the hell water is," and the second one, called the Eskimo parable:

> There are these two guys sitting together in a bar in the remote Alaskan wilderness. One of the guys is religious, the other is an atheist, and the two are arguing about the existence of God with that special intensity that comes after about the fourth beer. And the atheist says: "Look, it's not like I don't have actual reasons for not believing in God. It's not like I haven't ever experimented with the whole God and prayer thing. Just last month I got caught away from the camp in that terrible blizzard, and I was totally lost and I couldn't see a thing, and it was fifty below, and so I tried it: I fell to my knees in the snow and cried out 'Oh, God, if there is a God, I'm lost in this blizzard, and I'm gonna die if you don't help me.'" And now, in the bar, the religious guy looks at the atheist all puzzled. "Well then you must believe now," he says, "After all, here you are, alive." The atheist just rolls his eyes.

"No, man, all that happened was that a couple Eskimos happened to come wandering by and showed me the way back to the camp.

Used like a little story in an edifying sermon addressed to a young and possibly immature crowd, it mostly serves to demonstrate the necessity to exercise one's "capacity for basic human empathy and compassion and caring," already equated in "The Depressed Person" to the "soul" (Wallace 1999, 68). One should shift lenses, avoid what Wallace calls "blind certainty," "close-mindedness that amounts to an imprisonment" and find a midway between self-centeredness and "other-directness."[2] Turning the classical interface of body and soul into a conflict between mind and soul, Wallace calls for awareness and attention to "what is around us" instead of what is only inside us in order to put an end to "the constant monologue inside your own head" or mind, "a terrible master" that enslaves us and that suicides usually shoot to free themselves.[3] "It is not the least bit coincidental that adults who commit suicide with firearms almost always shoot themselves in: the head. They shoot the terrible master," he claims. Well-adjusted people, on the other hand, are able to live before death and freely which involves "attention and awareness and discipline and being able truly to care about other people and to sacrifice for them over and over." Paying attention allows one to experience what Wallace calls "a situation as not only meaningful, but sacred, on fire with the same force that made the stars: love, fellowship, the mystical oneness of all things deep down." To which he also adds, "there is actually no such thing as atheism. There is no such thing as not worshipping."

Much has been said about this speech that soon became, after Wallace's suicide, a guidebook for education and good life on American campuses, a claim for the reintroduction of humanity in a post-postmodern and post-human fiction or the articulation of a "pragmatic spirituality," as thoroughly detailed by Robert Bolger, the editor of a collection of essays on Wallace and philosophy (Bolger and Korb 2014). Bolger reads this speech as Wallace's "spiritual philosophy of life" (32), itself strongly influenced by the tenets of the AA program and Williams James' *Varieties of Religious Experience*. For him, the speech articulates a theology in three parts, following the three steps of sin, conversion and salvation or the progress of the soul from a fallen state to the city of God: it begins with an account of human selfishness, then gives tools to overcome our wretched condition to eventually recognise the divine in the world (Bolger and Korb 2014, 33). Interpreting it as a "modern account of the mystical path to God"

(33), Bolger nonetheless underlines the essentially pragmatic dimension of Wallace's mysticism: it is "a spiritual point of view that involves an active choice to look on reality in a certain way [...] not a religion of believing certain propositions; it is not doctrinal and not metaphysical. It is an interpretative spirituality, a sort of 'seeing-as' (following Wittgenstein)" (48).

Often read, indeed, in the light of Wittgenstein or French existentialist philosophers, Sartre and Camus, another theoretical framework to understand Wallace's godless theology could have been Emmanuel Levinas. Levinas' foregrounding of "sanctity" could very well apply to Wallace's understanding of holiness as inter-human and his paradoxical vision of God not as transcendent but as an attention paid by man to his suffering neighbour or as a compassionate and careful responsibility towards the vulnerable other.[4] For both Wallace and Levinas, compassion is the "supreme ethical principle" and the "nexus of human subjectivity."[5]

THE GHOST OF THE SYSTEM

But Wallace's fiction has rather been discussed so far from a dualist or platonic tradition where the body is conceived as the locus of suffering, a cage or a prison, and following the famous play on words made by Socrates in Cratylus (*soma/sema*) a "tomb for the soul" (Plato 1921, section 400 b). In *Infinite Jest*, most bodies ache, are wounded, disabled or deformed and, as a somewhat logical consequence, heads are detached from bodies, as spirit from matter, while one of the central characters of the novel is a ghost. The title refers to Yorick's qualities, "a fellow of infinite jest and excellent fancy," whose skull is now detached from the dead body and is held by Hamlet in the churchyard scene. Similarly, the main character's father, Jim Incandenza, commits suicide by solely putting his head in a microwave and returns as a wreath to "converse" with Don Gately, lying wounded on a hospital bed in an emergency room. If American literature written at the end of the twentieth century seems to have been obsessed with angels, as Harold Bloom accounts in his insightful essay entitled *Fallen Angels*,[6] the era seems to have been equally "haunted," so to speak, by ghosts. Bloom understands this "turn of the millennium" obsession as a "mask for the American evasion of the reality principle, that is, the necessity of dying" (Bloom 2007, 64). For him, a fallen angel—but this could equally be said of a ghost—is the metaphor of our mortal condition, the awareness of one's mortality, "the dilemma of being open to transcendental longings even as we are trapped inside a dying animal" (63). This

awareness would grow in reading and decline in the visual media where we should eventually drown if we stop reading (preferably Shakespeare and Milton). Brian McHale, who has extensively written about Postmodernism,[7] takes on Harold Bloom to analyse the ghost of *Infinite Jest* (McHale 2017, 41–42).[8] This ghost is the erring soul of Jim Incandenza, the suicide and director of the video cartridge entitled *Infinite Jest* that literally entertains its viewers to death. Those become so absorbed in it, unable to take their eyes off it that they "dehydrate and starve themselves to death, later to be discovered stone dead in front of their televisions" (McHale 42). McHale consequently connects the ghost with reality's preemption by entertainment: he symbolises a reality deficit, the displacement of an actual lived reality by simulacra and ersatz experience. But the opposite interpretation could equally be given: the ghost would not come to confirm the evacuation of reality in an age of simulation but to provide consolation in an age haunted by apocalyptic and millennial fears of death and grounded in an ever-growing vision of man as merely material. He can be read as a reminder of man's mortal condition in the age of information and conversely as a compensation for living in a hyper-materialistic and post-secular time where man is only brain and matter. He can be seen as a denial of memento mori, like TV as Wallace defines it:

> One thing TV does is help us deny that we're lonely. With televised images, we can have the facsimile of a relationship without the work of a real relationship. It's an anesthesia of "form." The interesting thing is why we're so desperate for this anesthetic against loneliness. You don't have to think very hard to realize that our dread of both relationships and loneliness, both of which are like sub-dreads of our dread of being trapped inside a self (a psychic self, not just a physical self), has to do with angst about death, the recognition that I'm going to die, and die very much alone, and the rest of the world is going to go merrily on without me. (Wallace *in* Burn 2013, 32)

Like TV, the ghost makes us forget about mortality and "amuses us to death," following Neil Postman's expression. But as a "vanitas-like" figuration (like Yorick's skull) and "intimation of immortality," he opens up the possibility of an afterlife since he stands between life and death and never really dies.

Infinite Jest consequently examines a postmodern humanity that either grows ever more unreal, as a "pure mind," or increasingly mere matter, ghost without machine or machine without ghost, to use Gilbert Ryle's

words in his grounding book *The Concept of the Mind*, which exposes Descartes' dualism as a dogma, a myth or a mistake and demonstrates that mental processes cannot be separated from physical processes. Wallace, on the other hand, as Jamie Redgate recently demonstrated, would have revived a "dualist approach to the mind-body problem" which is "one of the main drivers of his critique of Postmodernism" (Redgate 2019, 5). "Descartes' outdated model [would be] the foundation upon which [his] characters are built" (61). Indeed, almost every character of *Infinite Jest* is either a mindless body or a disembodied mind as the opening sentence of the almost 1200-page novel prepares the reader for: "I am seated in an office, surrounded by heads and bodies" (*IJ*, 3). As stated before, the central figure of *Infinite Jest* is a wreath, a revisitation of Hamlet's dead father or of his surrogate father, Yorick the jester. Following the haunting influence of Shakespeare's play in Wallace's writing, another parodic vision of the mind "shuffling off his mortal coil" (*Hamlet*, III, 1, 68) appears in the middle of the novel, after the death of one minor character, Lucien Antitoi, the owner of an entertainment store:

> Lucien finally dies, [...] shed his body's suit [...] and newly whole, clean and unimpeded, and is free, catapulted home over fans and the Convexity's glass palisades at desperate speeds, soaring north, sounding a bell-clear and nearly maternal alarmed call-to-arms in all the world's well-known tongues. (*IJ*, 488–489)

Comically named Antitoi, "Anti-you" in French, as a form of counter-self, Lucien, leaving his physical garment behind, to return home freely, recalls Plato's vision of the soul rather than Descartes' *Meditations*. Several dialogues such as *Phaedrus*, *Phaedo*, *The Republic* and *Timaeus* represent the soul exiled within the confines of a body over the span of a human life, but returning after death, and flying back to its original and eternal condition, envisioned as the divine realm of Truth, Goodness and Beauty.[9] The soul, metaphorized as a chariot of two winged horses conducted by a charioteer, is divided into three separate parts, reason, spirit and appetite, which are now read from a more contemporary perspective by scholars who no longer read Wallace's world as a Cartesian or Platonician world, but as a neurocultural world and find, in his fiction, testimonies of his interest in cognitive science. Stephen Burn, for example, finds the division within the Incandenza family into three brothers as reflective of the three separate functions or modules of the brain. The tripartite representation of

the brain into reptilian (basic fears and reproductive urges), paleomammalian (emotional responses) and neomammalian (cognitive responses) would respectively correspond to the characters of Orin, the passionate and sexually obsessed football player, Mario, the disabled and moving one, and Hal, the most autobiographical character of the three, the smart tennis player (Burn *in* Boswell & Burn 2013, 68–69).

In the course of one decade from the release of *Infinite Jest* (1996) to the short story collection *Oblivion* (2004) and the posthumous publication of *The Pale King* (2011) after Wallace's suicide in 2008, the representation of the ghost and Wallace's approach to dualism also seems to have evolved or taken a different turn. As painful as it can be, one must admit that the ghost changed places from character ("the wraith") to narrator and eventually author. In *Oblivion* indeed, one short story entitled "Good Old Neon" is narrated from beyond the grave by Neal, a former classmate of David Wallace who voluntarily kills himself in a car accident and later imagines that he must have appeared to "David Wallace" as someone with a "seemingly almost neon aura around him," "an actual living person instead of the dithering, pathetically self-conscious outline or ghost of a person David Wallace knew himself to be" (Wallace 2004, 180–181). As for Wallace the man, he killed himself before his last book was edited and published and consequently gave the impression that the novel meaningfully entitled *The Pale King*, in reference once again to Hamlet's dead father, has itself been released by the ghost of the writer or written by a ghost writer.

OF MINDS AND SOULS: WALLACE-THE-SINTHOME

If dualism remains a vivid question, sometimes apprehended through medical or psychoanalytical lenses to expose Wallace's schizophrenic narration or his melancholy style where the self or "ego" dissolves itself in "the shadow of the object," the dead and lost one (Freud 1955 [1917] 248), the conflict between body and mind seems to have been added as a third element in late Wallace who rather explores the contradiction between mind and soul than body and soul. The philosopher François Cheng in a recent book entitled *De l'âme* explains that the "body-soul-spirit triad is perhaps the most ingenious intuition of the first centuries of Christianity" later forsaken in favour of dualism. "A contradiction may exist between body and soul or body and mind, but the major and most fruitful dialectical play stands between soul and spirit… (Cheng 2016, 67

[my translation])." It is no coincidence that Wallace delivered his most theological speech *This is Water* in an academic context where, he says, "the mind is a terrible master" antagonising a list of different virtues that could very well characterise the soul, even though the word itself is not mentioned. It is however mentioned in the title of the short story set in the identical context of a school ruled by a terrible master, "The Soul Is Not a Smithy" (Wallace 2004, 67–113). The story is the following: told in retrospect by an unnamed narrator, it recounts the day when a crazed substitute teacher, while giving a Civics class to 4th grades on the American Constitution started to write "KILL THEM ALL" in capital letters on the black board and suffered a psychotic breakdown which resulted in a hostage crisis. The narrator was oblivious to the scene at the front of the classroom as he was focusing on the small spaces of a window screen used as various panels to create a cartoon narrative. The story is interpreted in different ways: as a representation of a "child's fear of the adult world," of "boredom," as an exploration of "solipsism" or the divided self, a representation of entrapment inside one's head and escape from one's body felt as a liberation from suffering to reach the state of "an unbound disembodied consciousness."[10] But read in the light of the Kenyon Speech, it can also be viewed as a confrontation between the master mind and the soul of the artist at work. The reference to Joyce may underline the way Postmodernism writes in the shadow of Modernism, seized or not by the anxiety of its influence[11]; the classroom crisis indeed recalls Stephen Dedalus' various painful confrontations with the school institution and its punishments. And in the same way as *The Portrait* is a *Künstlerroman*, this story may well be a *Künstlerstory*, describing the artist's soul creating against the terrifying and deadening forces of mastery, in keeping with the etymological definition of the soul, as *anima*, breath or life principle. The sentence that precedes Stephen Dedalus' plan of forging "in the smithy of [his] soul" is an address to life. As for the metaphor of the soul as a smithy, it may just have been brought by a linguistic glissando from one language to another, common in Joyce's writing, the verb "to forge" in English meaning "smithy" as a noun in French ("une forge"). In a similar way, it seems that "soul" is not only brought by the idea of life ("O life!") but the exclamation that precedes it ("Amen") which almost sounds like "âme" (*soul* in French), a pun on which Cheng ends his book writing "âme-aum. Amen" (153): "Mother is putting my new secondhand clothes in order. She prays now, she says, that I may learn in my own life and away from home and friends what the heart is and what it feels. Amen. So be it.

Welcome, O life!" (*Portrait*, 257). The short story can consequently be analysed as a conflict between the mind and consciousness or head and reason even (the master) and the power of artistic imagination that Wassily Kandinsky in *On the Spiritual in Art* conceives as "a power, so strong and full of purpose that it serves the refinement of the soul. It is its language which speaks to the soul" (Kandinsky 1946, 93). Had Jacques Lacan still been alive and taken interest in Wallace as he did in Joyce, he may have asked the same question he set for the Irish writer in his meditation on the relation between genius and madness: "was [Wallace] mad? […] Isn't there in [his] writings what I shall call the *hint* that he is, or is turning himself into, what in his language he terms a *redeemer*?" (Lacan 2016 [1976], 62–64). Like Joyce interpreted by Lacan, Wallace may have prevented the precipitation of schizophrenia caused by the foreclosure of what Lacan calls "the-Name-of-the-Father" by writing and making a name for himself through his writing:

> His desire to be an artist who would have a hold on everyone, in any case as many people as possible, is this not the compensator for this fact that, let us say, his father had never been for him a father?" […] "Is there not here something like I would call a compensation for this paternal resignation?" […] "It was by wanting a name for himself that Joyce compensated for the paternal lack." "[T]he art of Joyce is something so particular, that the term sinthome is indeed what is, what is appropriate to it. (Lacan 2016, 73–76)

Written with the earlier spelling of the French medieval word for symptom, *sinthome* hints at both sanctity (Saint Homme/Saint Man) and Saint Thomas Aquinas (Saint Thom/as), a major influence on Joyce's writing. It describes the psychical prosthesis constructed by Joyce to keep body and soul together, avoid depersonalization or out-of-body experience, psychotic collapse or the devastating effects of madness: a fourth element or consistency, which, in Joyce's case, is a work of art, holding the three subjective elements of the Real, the Symbolic and the Imaginary that otherwise would not be knotted together. It is a repair or remedy sometimes called "supplementation," as a "supplement of soul."[12] The soul may not be a smithy, but Wallace who envisioned fiction as redeeming and remedying may have described in this metafictional short story "The Soul Is Not a Smithy" the very way an author (himself?) as narrator/character stabilises psychotic troubles by creating a work of art and thus restores the paternal function, that is dead, ghost or failing (the figure of the terrible

master) but called for, as in *The Portrait*'s ending sentence immediately following the one cited in Wallace's title: "*April 27*. Old father, old artificer, stand me now and ever in good stead."

As "sinthome" or "saint man," but also a child of his time, Wallace must have finally, more than any other writer of his generation, "expressed the spirit of his age" which, according to Kandinsky's vision of art, is "composed from the message of the epoch and the language of the nation, as long as the nation continues to exist" (Kandinsky 1946, 55). No doubt Wallace's work and *Infinite Jest* in the first place was later recognised as a Great American Novel, in keeping with John W. De Forest's 1868 definition of the GAN as a work meant to capture "the American soul" (Buell 2014, 24). Jonathan Franzen, himself the author of GANs written in the same era, declared after Wallace's death that he was "a national treasure." And didn't he, even ironically, say that he was/we were to mourn "the loss of a great and gentle soul"?

> People who had never read his fiction, or had never even heard of him, read his Kenyon College commencement address in the *Wall Street Journal* and mourned the loss of a great and gentle soul. A literary establishment that had never so much as short-listed one of his books for a national prize now united to declare him a lost national treasure. Of course, he *was* a national treasure [...]. The people who knew David least well are most likely to speak of him in saintly terms. (Franzen 2011)

If Wallace fashioned his creation in the very smithy of that soul, he may very well, like Joyce and following Lacan's definition of *sinthome*, also have forged there "a book of himself."[13]

Notes

1. "That instead of a satanic way of transcending it, there's an angelic way of transcending it"; "But if a piece of fiction can allow us imaginatively to identify with characters' pain, we might then also more easily conceive of others identifying with our own. This is nourishing, redemptive." "Really good fiction could have as dark a worldview as it wished, but it'd find a way both to depict this dark world *and* to illuminate the possibilities for being alive and human in it." "What's engaging and artistically real is how is it that we as human beings still have the capacity for joy, charity, genuine connections, for stuff that doesn't have a price?" *Conversations with David*

Foster Wallace, ed. Stephen Burn (Jackson: University Press of Mississippi, 2013), XV, 22, 26, 27, 33.
2. The blindness, imprisonment and master/slave imagery recall Andrew Marvell's identical vision of the soul entrapped within the body in the opening stanza of the poem "A Dialogue Between the Soul and the Body" (I underline).

 "SOUL
 O who shall, from this dungeon, raise
 A soul **enslav'd** so many ways?
 With bolts of bones, that fetter'd stands
 In feet, and manacled in hands;
 Here **blinded** with an eye, and there
 Deaf with the drumming of an ear;
 A soul hung up, as 'twere, in **chains**
 Of nerves, and arteries, and veins;
 Tortur'd, besides each other part,
 In a vain head, and double heart."

 Stephen Burn makes reference to this poem but in relation to *The Unnamed* by Joshua Ferris in "Mapping the Syndrome Novel," 46.
3. In the second stanza of Marvell's poem, it is the suffering body that tries to liberate itself from the tyrannical soul.
 BODY
 O who shall me **deliver** whole
 From **bonds** of this **tyrannic** soul?
4. Levinas' sanctity should be distinguished from Schopenhauer's foregrounding of asceticism that also serves as a reference to analyse Wallace's mysticism in *The Pale King*. The character of levitating Shane Drinion who finds bliss in boredom is compared by Andrew Bennett to "Schopenhauer's ascetic saint." "Inside David Foster Wallace's Head: Attention, Loneliness, Suicide, and the Other Side of Boredom," in Bolger and Korb, *Gesturing*, 83. In this case, asceticism, holiness and self-renunciation are a denial of the "Will-to-Live." See Schopenhauer, "On the Doctrine of the Denial of the Will-to-Live" in *The World as Will and Representation* (New York: Dover, 1958), 603–634.
5. William Edelglass. "Levinas on suffering and compassion." *Sophia* 45 (2006): 43–59.
6. To mention a few: *Angels* (1983) by Denis Johnson, *Angels in America* (1991) by Tony Kushner, *Ring of Brightest Angels around Heaven* (1995) by Rick Moody. Harold Bloom. *Fallen Angels*. New Haven: Yale University Press, 2007.

7. *Postmodernist Fiction.* New York: Routledge, 1987. *Constructing Postmodernism.* New York: Routledge, 1992. *The Cambridge Introduction to Postmodernism.* Cambridge: Cambridge University Press, 2015. *The Cambridge History of Postmodern Literature* (with Len Platt). Cambridge: Cambridge University Press, 2016.
8. For an extensive list of all interpretations regarding the ghost, see Jamie Redgate, *Wallace and* I, chapter 2 "He's a ghost haunting his own body: Cartesian dualism in David Foster Wallace's Ghost Stories," 51–87 and specifically note 9, 85.
9. On the soul and the chariot allegory, see in particular *Phaedrus (245c-254e)*, translated by B. Jowett, Boston: Actonian Press, 2010. "All soul is immortal, for she is the source of all motion both in herself and in others. Her form may be described in a figure as a composite nature made up of a charioteer and a pair of winged steeds. The steeds of the gods are immortal, but ours are one mortal and the other immortal. The immortal soul soars upwards into the heavens, but the mortal drops her plumes and settles upon the earth." […] "I told you about the charioteer and his two steeds, the one a noble animal who is guided by word and admonition only, the other an ill-looking villain who will hardly yield to blow or spur. Together all three, who are a figure of the soul, approach the vision of love. And now a fierce conflict begins."
10. Steve Paulson in his conversation with Wallace on the short story reads it as "a child's fear of the adult world" while Wallace rather sees it as an "inverted Kafka" piece with "a narrator partly narrating as a child and partly as an adult" on "soul-level boredom." In *Conversations with David Foster Wallace*, 127–128. Following Wallace's interpretation, Marshall Boswell interprets the story as "a beautifully stylized depiction of bourgeois boredom that is itself deadly dull," but also, like other stories in the collection, as an exploration of solipsism and beyond: "*Oblivion* looks beyond mere solipsism to explore the multiple ways in which his characters are not only alone inside their heads but also controlled to the point of madness, by the layered, nested, entropic workings of their interiors." "The Constant Monologue Inside Your Head: *Oblivion* and the Nightmare of Consciousness," in *A Companion to David Foster Wallace Studies*, 165, 151. David Hering reads the story as "a literal disembodiment, an escape from the body itself as a liberation from suffering" and "a move from 'earthly phenomenality' to an unbound, disembodied consciousness." In *Cambridge Companion to David Foster Wallace*, ed. Ralph Clare (Cambridge: Cambridge UP, 2018), 100, 107.
11. Greg Carlisle envisions the story as a genuine contradiction of Joyce's metaphor: "Wallace's title suggests that a smithy is not an accurate metaphor of the soul, given that we cannot control–and sometimes are not even

consciously aware of–the way our experiences shape our personalities." *Nature's Nightmare. Analyzing David Foster Wallace's* Oblivion (Los Angeles: Sideshow Media Group Press, 2013), 33.

12. See Daniel Bristow. *Joyce and Lacan: Reading, writing and Psychoanalysis.* New York: Routledge, 2017.

 Colette Soler asserts that Joyce became "the father of his own name. It is a button tie that is not a metaphor, but it is a button tie all the same that short-circuits the Oedipus complex and that nevertheless supplements it." *Lacan Reading Joyce*, transl. Devra Simiu (New York: Routledge, 2018), 209.

13. "*The Portrait*, the portrait that he completed at the time, the one I evoked in connection with the *uncreated conscience of his race*, in connection with which he invokes the *artificer* par excellence which his father is supposed to be; while it is he who is the *artificer*. That it is he who knows, who knows what he has to do. Who believes that there is an uncreated conscience of some race or other. Which is where there lies a great illusion. That he also believes that there is a *book of himself*. What an idea to make oneself be a book!" Lacan, *Sinthome*, 56.

Works Cited

Bennett, Andrew. 2014. Inside David Foster Wallace's Head: Attention, Loneliness, Suicide, and the Other Side of Boredom. In *Gesturing Toward Reality: David Foster Wallace and Philosophy*, ed. Robert K. Bolger and Scott Korb. New York: Bloomsbury.

Bloom, Harold. 2007. *Fallen Angels*. New Haven: Yale University Press.

Bolger, Robert K., and Scott Korb, eds. 2014. *Gesturing Toward Reality: David Foster Wallace and Philosophy*. New York: Bloomsbury.

Boswell, Marshall. 2013. The Constant Monologue Inside Your Head: *Oblivion* and the Nightmare of Consciousness. In *A Companion to David Foster Wallace Studies*, ed. Marshall Boswell and Stephen Burn. New York: Palgrave Macmillan.

Bristow, Daniel. 2017. *Joyce and Lacan: Reading, Writing and Psychoanalysis*. New York: Routledge.

Buell, Lawrence. 2014. *The Dream of the Great American Novel*. Cambridge: Harvard UP.

Burn, Stephen, ed. 2013a. *Conversations with David Foster Wallace*. Jackson: University Press of Mississipi.

———. 2013b. "Webs of Nerves Pulsing and Firing": *Infinite Jest* and the Science of the Mind. In *A Companion to David Foster Wallace Studies*, ed. Marshall Boswell and Stephen Burn. New York: Palgrave Macmillan.

———. 2018. Mapping the Syndrome Novel. In *Diseases and Disorders in Contemporary Fiction: The Syndrome Syndrome*, ed. James Peacock and Tim Lustig. New York: Routledge.

Carlisle, Greg. 2013. *Nature's Nightmare. Analyzing David Foster Wallace's Oblivion*. Los Angeles: Sideshow Media Group Press.

Cheng, François. 2016. *De l'âme*. Paris: Albin Michel.

Edelglass, William. 2006. Levinas on Suffering and Compassion. *Sophia* 45: 43–59.

Franzen, Jonathan. 2011. Farther Away. Robinson Crusoe, David Foster Wallace, and the Island of Solitude. *New Yorker*, April 11. https://www.newyorker.com/magazine/2011/04/18/farther-away-jonathan-franzen.

Freud, Sigmund. 1955 [1917]. Translated by James Strachey. *Mourning and Melancholia* (1917). *The Standard Edition of the Complete Psychological Works of Sigmund Freud, Volume XIV*. London: Hogarth Press.

Hering, David. 2018. Oblivion. In *Cambridge Companion to David Foster Wallace*, ed. Ralph Clare. Cambridge: Cambridge UP.

Joyce, James. 1958 [1916]. *A Portrait of the Artist as A Young Man*. London: Alden Press.

Kandinsky, Wassily. 1946. *On the Spiritual in Art*. New York: Solomon R. Guggenheim Foundation.

Lacan, Jacques. 2016 [1975–1976]. *The Sinthome—Seminar XXIII*. Translated by Adrian R. Price. Malden: Polity Press.

McHale, Brian. 1987. *Postmodernist Fiction*. New York: Routledge.

———. 1992. *Constructing Postmodernism*. New York: Routledge.

———, ed. 2015. *The Cambridge Introduction to Postmodernism*. Cambridge: Cambridge University Press.

———. 2017. Angels, Ghosts and Postsecular Visions. In *American Literature in Transition 1990–2000*, ed. Stephen Burn. Cambridge: Cambridge University Press.

McHale, Brian, and Len Blatt, eds. 2016. *The Cambridge History of Postmodern Literature*. Cambridge: Cambridge University Press.

Peacock, James, and Tim Lustig. 2013. *Diseases and Disorders in Contemporary Fiction: The Syndrome Syndrome*. New York: Routledge.

Plato. 1921. *Cratylus*. Cambridge: Harvard University Press.

———. 2010. *Phaedrus (245c-254e)*. Translated by B. Jowett. Boston: Actonian Press.

Postman, Neil Postman. 1985. *Amusing Ourselves to Death: Public Discourse in the Age of Show Business*. London: Viking.

Redgate, Jamie. 2019. *Wallace and I: Cognition, Consciousness and Dualism in David Foster Wallace's Fiction*. New York: Routledge.

Ryle, Gilbert. 1949. *The Concept of the Mind*. Chicago: University of Chicago Press.

Schopenhauer, Arthur. 1958. *The World as Will and Representation*. New York: Dover.

Wallace, David Foster. 1996. *Infinite* Jest. New York: Little, Brown and Co.
———. 1999. *Brief Interviews with Hideous Men*. New York: Little, Brown and Co.
———. 2004. *Oblivion*. New York: Little, Brown and Co.
———. 2009 [2005]. *This is Water*. New York: Little, Brown and Co. https://fs.blog/2012/04/david-foster-wallace-this-is-water/.

PART II

The Aesthetics of the Soul

CHAPTER 7

Transmutations of the Soul: *Anima* and Her Heart in Christopher Harvey's *School of the Heart* (1647)

Émilie Jehl

In Christopher Harvey's version of the *Schola Cordis*, the first emblem opens on the depiction of Eve standing next to the Tree of Knowledge in the Garden of Eden. Above her head, the serpent coils around a branch, murmuring into a large heart from which smaller snakes seem to be squirming. The emblem's Latin title, situated right beneath the *pictura*, states that what we are witnessing here is the "contagion of the heart" (*Contagio Cordis*, Harvey 1647, 4): like a rotten apple, the organ has been infected by the serpent's seductive rhetoric. The animal's coaxing words are to be found in the following pages: their juxtaposition with the visual scene that we have just alluded to animates the *pictura*, giving a voice to its still characters. And yet one would be unfair in calling such an image mute. Indeed, Eve's figure is twisted: while her face is turned to the left of the engraving, seemingly averting her gaze from the snake, her waist and feet are oriented

É. Jehl (✉)
Language Resources Centres of Strasbourg University (SEARCH EA 2325), Strasbourg, France

© The Author(s), under exclusive license to Springer Nature Switzerland AG 2024
D. Louis-Dimitrov, E. Murail (eds.), *The Persistence of the Soul in Literature, Art and Politics*,
https://doi.org/10.1007/978-3-031-40934-9_7

towards the right. With her hesitant *contrapposto*, the image prefigures the twist that the dialogue stages—a reluctant and obedient Eve succumbing to the serpent's seduction and persuasion. The *pictura* already contains, *in nuce*, what the words of the text will tell us (Fig. 7.1).

Such is the nature of the emblem: it is a pictorial and poetic artefact that appeared for the first time in the 1530s before seizing Europe with what some authors have considered to be a "craze" for the combined power of the visual and the textual (Manning 2003, 16; Bath 1994, 7; Daly 1986). Generally, the aim of an emblem was to instruct their reader/spectator while maintaining an enjoyable visual appeal: emblem pictures are notoriously enigmatic, intriguing, or singular; they resort to symbolism,

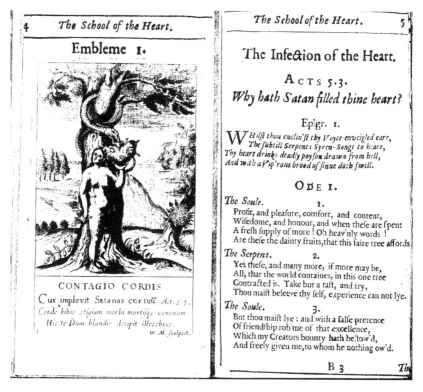

Fig. 7.1 The first emblem of *The School of the Heart*. © British Library Board (Hazlett/I 203; Wing/H183). Image published with permission of ProQuest. Further reproduction is prohibited without permission

sometimes to an extent that defies interpretation. Those pictures hold a message that is only accessible to the reader/spectator who is willing to decipher or "work" on them. They are, therefore, images that can "say" something to the mind attuned to their symbolism; they are often called "speaking pictures" (Bath 1994). The texts that accompany them may help the reader/spectator to grasp the meaning of the emblem, but may also participate in the enigmatic character of the whole, or complicate its implications and connotations. They often underline the necessity to "look", "see", and "behold": they are "texts that show". All in all, an emblem presupposes an active reader/spectator who is ready to tread the path outlined by the texts and images offered by the book.

If the first emblems mainly featured figures taken from classical mythology, an entire subgenre of emblematics started to emerge at the beginning of the seventeenth century: those emblems took the human heart as their main focus. It stood as a metonymy for man's interiority.[1] Heart emblems were religious works which sought to involve their reader/spectator in prayer and devotion, to encourage them to dive into the depths of their own self and to improve their soul. *The School of the Heart*, composed by Christopher Harvey and first published in 1647, is such a collection. As was common in English emblematics, the poet took engravings from a continental work, that of the Benedictine monk Benedictus van Haeften (1635). He then appended to those pictures texts that translated the Latin from van Haeften's book and poems that Harvey himself composed.

The School of the Heart stages various interactions between a male and a female figure, both child-like, or rather, juvenile. *Amor divinus* is an allegory of Christ, and he is shown repeatedly acting upon the heart of *Anima*, the Soul (Figs. 7.2, 7.3, 7.4, and 7.5).

The Soul's cooperation in this enterprise is not immediate: if one reads the emblems in the order in which they appear, the Soul goes through an authentic pilgrimage that takes her from turning away from Christ to taking part in his Passion, thus following the traditional mystical way of illumination, purgation, and union (Höltgen 1975; Lottes 1975; Scholz 1997). The journey, one might add, does not exactly amount to leisure travelling: *Anima*'s heart undergoes a variety of operations, some of them rather unpleasant, as it is thrown away, compressed, hammered, circumcised, pounded, crushed, burnt (on an altar and in a furnace), engraved, tilled, enlarged, … Those torture-like operations definitely belong to the material realm. How can they be related to the Soul, Man's spiritual

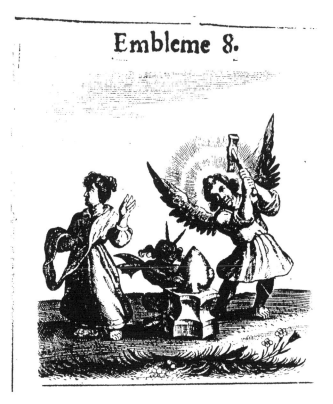

Fig. 7.2 The Tilling of the Heart. © British Library Board (Hazlett/I 203; Wing/H183). Image published with permission of ProQuest. Further reproduction is prohibited without permission

essence? My attempt in this essay is to show how the heart is used to depict the Soul's perfectioning through the action of Christ. My concern with the link between the material/physical and spiritual/transcendental will lead me to consider how the book's rhetoric aims at allowing the reader/spectator to improve their soul. The first part of this essay is dedicated to showing how emblems of the heart materialise the invisible. Its second part explores how these emblems encourage their reader/spectator to commit their senses and their body to a spiritual exercise. It concludes by suggesting that heart emblems depict an alchemy of the soul.

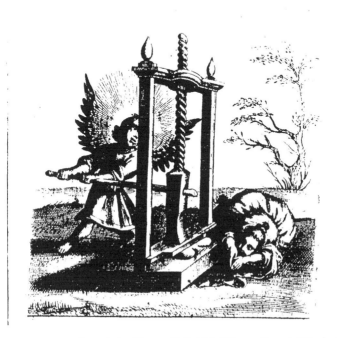

Fig. 7.3 The Sacrifice of the Heart. © British Library Board (Hazlett/I 203; Wing/H183). Image published with permission of ProQuest. Further reproduction is prohibited without permission

Harvey's emblems provide a material, visible representation of phenomena that is usually restricted to discursive expression. They provide their reader/spectator with a material, visual description of the *invisibilia*, that is to say the mysteries of Christian faith. To a reader familiar with the biblical corpus, the images included in *The School of the Heart* will clearly recall recurring scriptural metaphors of the heart. This motif occupies indeed a significant place in the biblical texts: Robert A. Erickson has thus counted more than 850 mentions of the word "heart" in the King James Version (1997, 26). The heart is depicted as the centre of what we now call "the individual". Most obviously and familiarly to us, it is the subject's

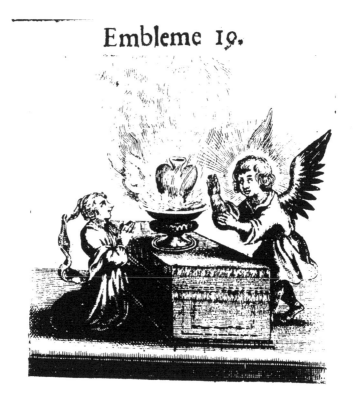

Fig. 7.4 The Humiliation of the Heart. © British Library Board (Hazlett/I 203; Wing/H183). Image published with permission of ProQuest. Further reproduction is prohibited without permission

affective centre: "And among these nations shalt thou find no ease, neither shall the sole of thy foot have rest: but the Lord shall give thee there a trembling heart, and failing of eyes, and sorrow of mind" (Deuteronomy 28:65); "My heart panted, fearfulness affrighted me" (Isaiah 21:4); "Jacob's heart fainted, for he believed them not" (Genesis 45:26). Its orientation betrays its owner's desires and allegiance: "Now therefore put away, said he, the strange gods which are among you, and incline your heart unto the Lord God of Israel" (Joshua 24:23). Above all, it is the privileged locus of the interaction between Man and God: thus God places ethical values in the believer's heart, "I, behold, […] in the hearts of all

7 TRANSMUTATIONS OF THE SOUL: *ANIMA* AND HER HEART... 125

Fig. 7.5 The Hardnesse of the Heart. © British Library Board (Hazlett/I 203; Wing/H183). Image published with permission of ProQuest. Further reproduction is prohibited without permission

that are wise hearted I have put wisdom, that they may make all that I have commanded thee" (Ex 3:6), and will measure its worth by weighing it: "Every way of a man is right in his own eyes: but the Lord pondereth the hearts" (Proverbs 21:2) (The Bible 2008). Harvey's emblems fully acknowledge their sources: the presence of the Biblical text (in Latin below the engraving and translated on the right-hand page (Fig. 7.6)) provides the scriptural antecedent of each emblem's symbolism, thus legitimising it or, in the words of Albrecht Schöne, guaranteeing its facticity (Schöne 1964; Daly 1979, 40; Bath 1994, 5). What Harvey's emblems offer, then, is a visual rendering of the Biblical narrative of how God

communicates with His creature's Soul, and how Man reacts to the divine presence, be it in a negative or positive way. Observing an emblem thus activates the memory of a pre-existing text, that in turn codifies the image, endows it with meaning. Emblems therefore also teach elements of faith: resorting to images, some authors argue, makes them accessible even to an illiterate spectator. The fantastic and striking literal rendering of a metaphor also engraves the motif in memory: it is, as Francis Bacon has argued,[2] a testament to the didactic and mnemonic power of visual representations (Fig. 7.6).

Yet one might be surprised to find an author affiliated with the reformed Church of England engaging with the seductiveness of the image.[3]

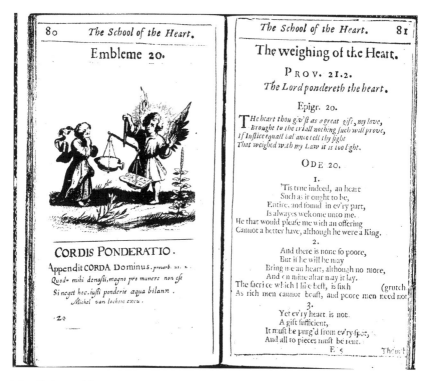

Fig. 7.6 Embleme 20. © British Library Board (Hazlett/I 203; Wing/H183). Image published with permission of ProQuest. Further reproduction is prohibited without permission

Reformed authors therefore constantly justified the use of images by dwelling on the meaning they wanted to stress, and, contrary to Catholic authors, avoided emphasising their sensual and aesthetic qualities (Diehl 1986). The role of the text, especially in Harvey's emblems, is to frame the reader/spectator's reception of the image, and to carefully provide them with what they should see in them and retain from their contemplation. In emblem 6, for example, the emblem's poem provides us with a detailed explanation of what is actually happening in the *pictura*:

> Monster of sins! See how th'inchanted soule
> O'rcharg'd already calls for more.
> See how the hellish skinker plies his bowle,
> And's ready furnished with store,
> Whilst cups on every side
> Planted attend the tide.
> See how the piled dishes mounted stand,
> Like hills advanced upon hills,
> And the abundance both of sea and land
> Doth not suffice, ev'n what it fills,
> Mans dropsy appetite,
> And Cormorant delight. (25)

In this passage, one might notice how the text constantly refers its reader back to the picture. The emblem's engraving is to be understood as an allegory of gluttony and as a warning to the potential sinner. The poem parcels out the whole image into a multitude of distinct signs, truly explaining (as in unfolding) the illustration: the soul's gesture, the flying demon, Christ's warning sign, and the barely visible heart, are called out one after the other by the emblem's poem, guiding the reader in an exploration that alternatively zooms in and out of the picture, and goes back and forth between its material depiction and its spiritual meaning. The emblem thus addresses both the external, physical eye, and a more internal type of sight which an author like Bishop Joseph Hall called "the spiritual eye"[4] (Fig. 7.7).

I have chosen this emblem with a different purpose in mind: when perusing its engraving, one might note that the heart is conveniently situated right in the middle, between Christ and the Soul. In this composition, the heart is situated in a mediating position between God and the believer's soul. It is through the heart, indeed, that Christ works to recover the Soul; it is through the heart that *Anima* undergoes the trials of

Fig. 7.7 The Oppression of the Heart. © British Library Board (Hazlett/I 203; Wing/H183). Image published with permission of ProQuest. Further reproduction is prohibited without permission

conversion. In the anatomical discourse of the time, the heart also occupies an intermediate space between the material and the spiritual world. The Early Modern body is conceived as a fleshly substance animated by vital spirits, which are, according to Robert Burton in *The Anatomy of Melancholy*, "first begotten in the heart" (1621, 21). Thus the heart is a source of life, and according to Burton, it is "the instrument of the soul, [which performs] all its actions". When subjected to violent passions, the heart reacts most intensely. A warm organ by nature (the conception of the heart as a source of heat dates back to the Antiquity), the heart grows even hotter when its owner experiences sorrow, or the throbs of love.

Thus threatening the balance of the body, it contracts and expands even more forcefully (which explains the lover's heartbeat when they see their beloved), sending out vapours to the eyes which, when entering in contact with air, are transformed into tears. The heart thus transforms the immaterial (an emotion) into the material (a tear) (Curelly 2005, 15–81). It is a bridge between those two layers of Christopher Harvey's world. Observing its movements, domesticating them and redirecting them is therefore the way to touch the soul, and to bring it back to God.

Heart emblems therefore address the soul via the body's central organ and its senses. They stimulate it to provoke physical transformations that will impact the spiritual.

Perusing Harvey's emblems requires from the reader/spectator that they resort to three faculties. I have already mentioned how such a combination of text and image is made to recall an element of the Christian faith or to allow the believer to retain it. These emblems rely on the faculty of memory. Their didactic aim also means that they call on the reader/spectator's understanding: each emblem illustrates, narrates, and moralises an aspect of the Christian experience. The overall metaphor of the "school" of the heart clearly indicates that the book is meant to teach. Christ is the professor, as stated in the introduction of the collection:

> Tis yet schoole time, as yet the doore's not shut.
> Harke how the Master calls. [...]
> Great searcher of the heart, [...]
> Teach it to know it selfe, and love thee more.
> Lord, if thou wilt, thou canst impart this skill:
> And for all other learning take't who will. (2–3)

The explanation of the image by the text, which I have exemplified a little earlier on, therefore consists in an analysis of the pictured motif that ensures its "proper" understanding by the believer. The text is what truly gives the picture a voice, and nowhere is it clearer than in the few emblems, in Harvey's collection, which are accompanied by a dialogue between the Soul and Christ, or, as is the case in the first emblem, between the Soul and the serpent in the Garden of Eden. By associating such a dialogue with an engraving depicting Eve leaning against the Tree of Knowledge while the evil animal whispers in her infected heart, the poet makes the scene universal: Eve becomes the Soul, and the reader/spectator understands that the woman's sin is humanity's, and therefore the

believer's. The dialogic form prompts the reader into re-enacting the scene of the original sin, that is to say, into applying the subject of the emblem onto themselves. By identifying with the emblem's subject, the reader/spectator reproduces *Anima*'s journey towards a reunion with *Amor divinus* in themselves. In other words, heart emblems seek to provoke the reader/spectator's conversion, a rekindling of their faith; they target their will. Harvey's emblems address and stimulate the three faculties which were attributed to the Soul—memory, understanding, and will—as specifically outlined in St Augustine's *De Trinitate*. The starting-point of this tripartite process is the engraving, a visual representation that is subsequently decomposed, analysed, and, in an image that was common at the time, ruminated upon. What they stage is a meditative exercise theorised by authors such as Ignatius of Loyola or Joseph Hall (Martz [1958] 1974; Hall 1637). These exercises were intended to elicit an emotional response, a renewed expression of love directed toward God from the Soul, flowing through the heart (Fig. 7.8).

Harvey's work attests to a revival, at the beginning of the seventeenth century, of the kind of affective piety that had been characteristic of mysticism. Through the motif of the heart, they underline that the relationship between God and Man is, above all, one of love. In the course of *The School of the Heart*, if *Anima* starts out as a rather unfaithful lover, she ends up reciprocating Christ's love. For example, in emblem 33, the arrows of a Cupid-like Christ purify the heart from the sickness of sin:

> Thy shafts will heale the hearts they hit,
> And to each sore its salve will fit.
> All hearts by Nature are both sick, and sore,
> And mine as much as any else, or more:
> There is no place that's free from sinne,
> Neither without it, nor within,
> And universall maladies doe crave
> Variety of medicines to have. (133)

Christ's action upon the soul is compared to a multitude of arrows that will strike the heart and awaken, in the believer, the three faculties that had been dimmed by sin. First, understanding:

Fig. 7.8 The full engraving of Embleme 33. © British Library Board (Hazlett/I 203; Wing/H183). Image published with permission of ProQuest. Further reproduction is prohibited without permission

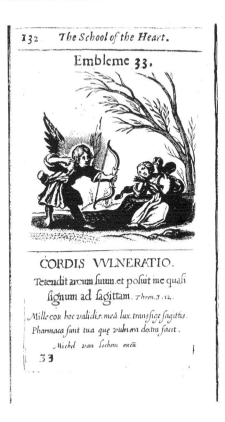

First, let the arrow of thy piercing eye,
[…] Let thy resplendent rayes of knowledge dart
Bright beames of understanding to mine heart (133)

Then, will and memory:

Next let the shaft of thy sharp-pointed pow'r
[…] Stout opposition to resigne
Its steely stubbornesse, subdue my will,
Then let that love of thine, which made thee leave
[…] Matter for an eternall story. (134)

As a result, the cured Soul is able to respond to God's love with arrows of her own:

> Then, blessed Archer, in requitall I
> To shoote thine arrowes back again will try.
> By pray'rs, and praises, sighs, and sobs,
> By vowes, and teares, by groans, and throbs,
> I'll see if I can pierce, and wound thine heart,
> And vanquish thee againe by thine own art. (135)

The Soul's reaction is a series of physical manifestations that I have mentioned earlier. It is through the body, therefore, that spiritual adhesion is manifested.

Another way of reading Harvey's emblems is to see them as attempts to design meditative exercises that allow the redirecting of passions towards a greater, sacred purpose, that of pleasing God and loving Him as one should. In that context, it is not surprising to witness the interaction of the Soul and Christ as that of a young couple engaging in a game of mutual seduction. Many of the heart metaphors that are to be found in Harvey's collection can also be retrieved in love poetry. A medieval illustration of the goddess of love submitting the lover's heart to various trials, entitled *Frau Venus und der Veliebte* and realised by Meister Casper von Regensburg (c. 1485), is a clear ancestor to Harvey's tortured heart (Slights 2002, 76). Besides, the Bible also depicted the relationship between the believer and God as that between a woman and her lover, in the *Song of Songs*. The representation of the Soul as a young woman and of Christ as a young man in emblems originated in a collection of love emblems, published in 1608 by the Dutch Otto van Veen (Veen 1608). In *Amorum emblemata*, the poet juxtaposed Eros and Anteros to signify the torments of love. As the field of emblematics had been progressively invested by religious authors, van Veen published in 1615 a collection of emblems entitled *Amoris divini emblemata*, in which he took up those two characters, this time in a more virtuous attire, and adorned with a halo (Veen 1615). Francis Quarles was the first emblematist to introduce the characters of *Amor divinus* and *Anima* in England, which then became recurring figures in emblem books (Quarles 1635). The erotic undertones of the two lovers' interactions have not completely disappeared. But perhaps it should be seen as a form of "taming of the flesh", as such representations are framed by religious authority, since they reproduce Biblical metaphors. The flesh, in a way, is sublimated.

What Harvey's emblems entail is a spiritual alchemy that takes place through the body. Alchemy is a proto-science that is now chiefly

remembered for its search for the Philosophical Stone, a magical elixir able to transform base metals into gold. But alchemy was also a philosophical discourse that taught "the restoral (*restituere*) of all fallen and infirm bodies and how to bring them back to a true balance (*temperamentum*) and the best of health" (1994, 64), as Gareth Roberts explains. Now, in Harvey's emblems, as we have seen, the heart is depicted as a malleable object, that can be pierced, pressed, and the constitution of which can be altered. These emblems then allow the apprehension of the soul as subjected to quasi-chemical repetitive operations which aim at purifying it and bringing it to a refined state. What is staged in emblems of the heart is an alchemy of the soul: as it goes through various stages of reform, cleansing, and purification, it is brought to an improved, refined, quintessential state. Such transformations are obtained thanks to the awakening of powerful emotions that will have physical manifestations. By perusing Harvey's emblems, the reader/spectator is expected to empathise with the scenes they depict and feel the regret of sin, the sorrow of unfaithfulness, and the joy of finding God again. Tears, sighs, and groans will purify the body and cleanse the soul, for true contrition will unite God and His creature again.

But to Harvey, love is also a form of poetics. His collection of emblems is concluded by a series of isolated poems that offer a form of metacommentary on *The School of the Heart*. In "The Rhetoric of the Heart", the poet underlines that his writing is nothing less than a direct transcription of his heart's content:

> MY Rethorick is not so much an Art,
> As an infused habit in mine Heart,
> Which a sweet secret Elegance Instills,
> And all my Speech with Tropes and Figures fills.
> Love is the tongues Elixir, which doth change
> The ordinary sense of words, and range
> Them under other kinds, dispose them so
> That to the height of eloquence they grow,
> E'vn in their native plainness, and must be
> So understood as liketh love and me. (193)

In these lines, love is described as a form of linguistic "elixir" that can transform and sublimate writing. The poem articulates a sort of linguistic hierarchy, in which the ordinary and the "plain" are considered inferior to

a sort of eloquence of love. Love injects figures of speech in the poet's language which will allow him to reach "the height of eloquence". Later, the poet states that "Exclamations, / Are the hearts heaven-piercing Exaltions" (194): verbal effusion is therefore described as a way to reach the transcendental. In another poem entitled "The Grammar of the Heart", the poet states: "When tongues are still, hearts will be heard above" (192). What *The School of the Heart* advocates, then, is the interiorization of the effusions of love: the language God wishes to hear does not go through the tongue, but through the heart. That is not to say that the reader/spectator of Harvey's emblems should remain mute when meditating their content rather, it seems to suggest that articulated speech is unable to translate what happens in the Soul, or what she says when she speaks to God. The only truly eloquent form of language is that of the body overcome by emotions:

> And therefore my Soul in silence moans,
> Half vowel'd sighs, and double deep thong'd groans,
> Mute looks, and liquid tears in stead of words,
> Are of the language that mine heart affords. (192)

These lines reiterate the notion that the poet's words, just like his engravings, should not be considered an end in themselves. What matters, for the reader/spectator of these emblems, is to go beyond the materiality of the visual representation, beyond that of the texts, and to seek that state of heightened, heartfelt emotion that seizes and shakes the soul.

Notes

1. Daniel Cramer seems to have initiated the movement with his 1622 collection, *Emblemata Sacra* (Cramer 1622). Johann Mannich followed from him with his 1625 *Sacra Emblemata LXXVI* (Mannich 1625). The Italian representative of the cardiomorphic trend is Francesco Pona (1645). In France, Étienne Luzvic et Étienne Binet published *Le Cœur dévot throsne royal de Jesus pacifique Salomon* (1627), which an English author called Henry Hawkins translated and published anonymously in 1634 (Hawkins was a Jesuit). Other examples of collections of heart emblems can be found in William W. E. Slights' *The Heart in the Age of Shakespeare* (2002, 59).
2. *Of the Advancement and Proficience of Learning; or, The Partitions of Sciences IX Bookes* V.v.ii, 255: "Embleme deduceth Conceptions Intellectuall to Images sensible, and that which is sensible, more forcibly strikes the

Memory, and is more easily imprinted, than that which is Intellectuall" (Bacon, [1605] 1640).
3. The reformers, as we perceive them, were numerous in disparaging altars, crosses, and icons, the visual elements of the Catholic faith. England had indeed gone through an intense period of iconoclasm, led by the most radical proponents of the Protestant faith. Harvey's book, however, is published under the reign of Charles I, who was especially fond of art, as Karl J. Höltgen underlines (1995, 223–224). The period is marked by the renewal and the flourishing of both poetic and visual production in the spiritual domain. Luther himself had acknowledged the necessity of using images in practising faith, provided any idolising of the material representation could be prevented (Helmut T. Lehmann et Conrad Bergendoff 1958, 99).
4. *The Remedy of Profaneness*, VI.321: "The carnall eye looks through God, at the world; The spirituall eye lookes through the world, at God; the one of those he seeth mediately, the other terminatively; neither is it in nature hard to conceive, how we may see two such objects, as whereof one is in the way to the other, as thorow a prospective glasse, we can see a remote mark; or thorow a thin cloud wee can see heaven" (Bath 1994, 167).

Works Cited

Bacon, Francis. 1640. *Of the Advancement and Proficience of Learning; or, The Partitions of Sciences IX Bookes*. [1605] London.

Bath, Michael. 1994. *Speaking Pictures: English Emblem Books and Renaissance Culture*. London, New York: Longman.

Burton, Robert. 1621. *The Anatomy of Melancholy*. Oxford.

Cramer, Daniel. 1622. *Emblemata Sacra*. Frankfurt.

Curelly, Laurent. 2005. *L'Alchimie des larmes dans la poésie de dévotion anglaise du dix-septième siècle*, dir. Jean-Jacques Chardin. Thèse de l'Université de Strasbourg.

Daly, Peter M. 1979. *Literature in the Light of the Emblem*. Toronto: University of Toronto Press.

———. 1986. Directions in Emblem Research. Past and Present. *Emblematica* 1 (1): 159–174.

Diehl, Huston. 1986. Graven Images: Protestant Emblem Books in England. *Renaissance Quarterly*, 39(1):49–66, Spring.

Erickson, Robert A. 1997. *The Language of the Heart (1600–1750)*. Philadelphia: University of Pennsylvania Press.

Haeften, Benedictus van. 1635. *Schola cordis, sive aversi a Deo cordis, ad eumdem reductio et instructio*. Antwerp: Joannem Meursium.

Hall, Joseph. 1637. *The Remedy of Profaneness*. London: Thomas Harper, for Nathanael Butter.

Harvey, Christopher. 1647. *Schola cordis or, The heart of it selfe, gone away from God brought back againe to him & instructed by him in 47 emblems.* London: Printed for H. Blunden.

Höltgen, Karl J. 1975. Introduction. In *The Devout Hart.* London: Scolar Press.

———. 1995. Catholic Pictures versus Protestant Words? The Adaptation of the Jesuit Sources in Quarles's *Emblemes. Emblematica* 9 (1): 223–224.

Lottes, Wolfgang. 1975. Henry Hawkins and *Partheneia Sacra.* In *The Review of English Studies, New Series,* vol. 26, (102), 144–153. Oxford University Press, May.

Luther, Martin. 1958. Against the Heavenly Prophets. In *Luther's Works, Volume 40: Church and Ministry II,* ed. Helmut T. Lehmann and Conrad Bergendoff. Philadelphia: Fortress Press.

Luzvic, Étienne, and Étienne Binet. 1627. *Le Coeur dévot throsne royal de Jesus pacifique Salomon.* Douay: Balthazar Bellere.

Mannich, Johann. 1625. *Sacra Emblemata LXXVI.* Nuremberg.

Manning, John. 2003. *The Emblem.* Londres: Reaktion Books.

Martz, Louis. 1974. *The Poetry of Meditation: A Study in English Religious Literature of the Seventeenth Century* [1958]. New Haven: Yale University Press.

Pona, Francesco. 1645. *Cardiomorphoseos sive ex corde desumpta emblemata sacra.* Verona.

Quarles, Francis. 1635. *Emblemes by Fra. Quarles.* London: G. M.

Roberts, Gareth. 1994. *The Mirror of Alchemy: Alchemical Ideas and Images in Manuscripts and Books: From Antiquity to the Seventeenth Century.* Toronto; Buffalo: University of Toronto Press.

Scholz, Bernhard F. 1997. Emblematic word-image relations in Benedictus Van Haeften's *Schola Cordis* (Antwerp, 1629) and Christopher Harvey's *School of the Heart* (London, 1647/1664). In *Anglo-Dutch Relations in the Field of the Emblem,* ed. Bart Westerweel, 149–176. Leiden: Brill.

Schöne, Albrecht. 1964. *Emblematik und Drama im Zeitalter des Barock.* Munich: Beck.

Slights, William E. 2002. *The Heart in the Age of Shakespeare.* Cambridge: Cambridge University Press.

The Bible: Authorized King James Version, with an Introduction and Notes by Robert Carroll and Stephen Prickett. 2008. Oxford; New York: Oxford University Press.

Veen, Otto van. 1608. *Amorum emblemata, figuris aeneis incisa, studio Othonis Vaenii.* Antwerp.

———. 1615. *Amoris divini emblemata studio et aere Othonis Vaeni Concinnata.* Antwerp: Ex Officina Martini Nuti & Joannis Meursi.

CHAPTER 8

Let Us Go Forward: The Soul, Spiritualism, and the Funerary Commemoration of Richard Cosway, Dante Gabriel Rossetti, and Evelyn De Morgan

Cherry Sandover

While the desire to achieve a form of immortality can be seen as a hope shared by many people across time, place, and culture, it may be said that the foundation of the Royal Academy of Arts in 1768 spurred some British artists, in pursuit of the preservation of their professional status, as well as artistic identity, to greater consideration of how they wanted to be remembered in order that their name and work persisted beyond the grave. Therefore, it was with the funeral and commemoration of the first President of the Academy, Sir Joshua Reynolds, in St Paul's Cathedral, that a tradition was instigated for many academicians, and their families and friends, to seek similar (or in the case of Reynolds' successors, the same) observances. However, the need for an immortal identity that was

C. Sandover, PhD (✉)
University Centre: South Essex, Southend on Sea, UK
e-mail: cherry.sandover@southessex.ac.uk

© The Author(s), under exclusive license to Springer Nature Switzerland AG 2024
D. Louis-Dimitrov, E. Murail (eds.), *The Persistence of the Soul in Literature, Art and Politics*,
https://doi.org/10.1007/978-3-031-40934-9_8

primarily validated by membership of the Academy began to lose impetus during the nineteenth century as many experienced greater confidence in recognition of individual genius, no doubt bolstered by increased public interest in the arts since the foundation of the Academy, as well as other cultural institutions such as the National Gallery founded in 1824.

Alongside this confidence in the potential for success during one's own lifetime, however, there can also be seen that ideas around death and immortality were complicated by a variety of aspects of nineteenth-century life in Great Britain. Amongst these—the prevalence of religious doubt expressed by public figures, as well as the diversity of ideas around Christian doctrine; enlightenment thinking putting science and empiricism in conflict with old orders of established thinking; social and political changes, as well as technological and industrial progress. All these elements helped to create a tension, which both undermined the old social order and for many, prompted a rethinking of attitudes to death, life after death, and immortality. Examining the funerary commemoration of three painters from the early nineteenth century until the Great War demonstrates that artistic endeavour and pride in achievements continued to be important. However, it can be said that all three designs were influenced by their relative experiences with esoteric spiritualism, most particularly Swedenborgian spiritualism. Furthermore, each memorial, through its design or commission, connotes the notion of the soul as the key to the unbreakable connection between soulmates beyond death.

In *The Uncanny* (1919), Freud suggested in response to the study of the motif of the double by Otto Rank (1914), that the notion of the immortal soul might have been introduced in response to the fear of death and annihilation. Freud goes on to note that in ancient Egypt, this fear of extinction after death "became a spur to artists to form images of the dead in durable materials" (Freud 2003, 142).

Therefore, it is possible that funerary commemoration, produced using long-lasting materials such as stone, bronze, marble, might also be regarded as a response to the fear of, not just death, but of loss of professional identity. As Ernest Becker states in *Escape from Evil*, "What man really fears is not so much extinction, but extinction with insignificance. Man wants to know that his life has somehow counted, if not for himself, then at least in a larger scheme of things, that it has left a trace, a trace that has meaning. And in order for anything once alive to have meaning, its effects must remain alive in eternity in some way" (1985, 212).

For those who created works of art and architecture it may be said that these creative acts were enough to ensure that their lives counted beyond death. However, for those painters whose understanding of the history of art was underpinned by their reading of Giorgio Vasari's highly influential *The Lives of the Most Excellent Painters, Sculptors, and Architects* (1558), which promulgated the cyclical nature of the arts, there may have also been a tension between faith in their genius and the knowledge that historically, painted works had proven to be less durable.[1] Therefore, one way to ensure a form of immortality was to reference their status, their artistic genius, through monuments or memorials either erected by their families or friends, or through their own wishes, such as can be seen with J.M.W Turner, who left instructions to his executors that a large sum of money was for the erection of "a monument to himself" (Thornbury 1877, 371).

It was during the nineteenth century that the styles of commemorative monuments began to broaden and, in some cases, mirror the more esoteric religious ideas that were being introduced at the time. While commemorative monuments to honour professional genius continued to be informed by the celebration of the individual. Style and placement also often reflected the impact of scientific discoveries which helped to cast doubt where there had been certainty; and perhaps further confused by arguments over doctrine, as not only Roman Catholicism continued to seem to threaten the established national Church of England, but others also broke away to join the many non-conformist groups that were achieving widespread popularity.

Richard Cosway (1742–1821) "Art Weeps. Taste Mourns, and Genius Drops Her Tear"

It was in 1771 that the painter best known for his miniatures, Richard Cosway (1742–1821), became one of the elite of the Academy by being elected a full Royal Academician. This was to enhance his reputation as one of the most sought-after artists of the city. Apart from his evident skill, which attracted many patrons to sit for him including English and French aristocrats as well as the future King George IV, Cosway seems also to have been a flamboyant and fickle character whose beliefs were shaped by whatever was fashionable amongst the social elite in London at the time. In 1781 he married the Anglo-Italian artist, Maria Hadfield, who was 20 years younger than he was, and a devout Catholic. Their marriage was not

to be conventional, and Maria spent much time travelling on the continent. Despite living separate lives for part of their marriage, they maintained a close mutual affection and Maria came home to be at his side during his final illness and death. His biographer records that she was devoted to him, and that it was, "according to Hazlitt, 'beautiful to behold'" (Williamson 1905, 57).

It is also unlikely that she shared many of his esoteric spiritual beliefs, which seemed to have been inspired by a wide range of unorthodox ideas from animal mesmerism to chiromancy as well as "the mysticism of Emanuel Swedenborg" and Cosway is recorded as having "embraced very much of his faith" (Williamson 1905, 57). It is, perhaps, not surprising that Cosway became excited by the works of Swedenborg, the Swedish scientist, theologian, and mystic who had travelled to London and died there in 1772. His writings and ideas were of interest among many intellectuals and seekers for evidence that supported the commonly held belief that there was life after death. Swedenborgian ideas were discussed in coffee houses, the print shops of the city and in other venues, such as Jacob Duché's flat at the Lambeth Asylum for orphans. One such group of devotees were brought together by the printer Robert Hindmarsh, and this later became the British Society for the Propagation of the Doctrines of the New Church (White 1868, 683). Cosway is known to have attended meetings along with his close friend, artist Philip de Loutherbourg (Rix 2007, 136). Both artists were caught up in the possibilities of communicating with the dead. Cosway often treated his friends to stories of how the great artists visited him, including Praxiteles and Apelles (Williamson 1905, 53).

As a devout Catholic, Maria probably followed the accepted teaching on the separation of the soul from body at the point of death. The soul moving to whichever realm the individual was judged to have deserved by the earthly life lived.[2] This is described as the doctrine of particular judgement and was first formally introduced in the Union Decree of Pope Eugene IV in 1439. The final general judgment, as described in the scriptures and adopted into all three creeds of the Catholic faith (and also found in the liturgy of the Church of England), will happen at the end of time and it is accepted teaching that body and soul will then be reunited before entering eternal bliss or eternal damnation (McHugh 1910).

As for his ideas around his own death and commemoration, we know that Cosway had once entertained the notion of being honoured in St Paul's or buried alongside the great masters, either "Rubens at Antwerp,

or Titian in Venice" (Williamson 1905, 57). Despite these grandiose ideas that immortality might be given a hand by his burial place being in the proximity of those whose greatness had already been guaranteed, at the end, Cosway chose instead to be buried in the newly built St Marylebone near to his home. Cunningham states, it was on "hearing a sermon from Wesley; on death and the grave" and following a funeral into the newly built church, where he was impressed by its grandeur and simplicity, that he apparently told Maria that, "I prefer this to Antwerp or St. Paul's: bury me here" (Cunningham 1842, 24).

Cosway died unexpectedly while out in his carriage on 4 July 1821, and his funeral was held at St Marylebone eight days later. It would appear that despite his enthusiasm for the unorthodox spiritualism of Swedenborg, at the end he was most likely accompanied to the grave with the liturgy of the traditional funeral rites of the Church of England, from the *1662 Book of Common Prayer*.[3]

Shortly after Cosway was laid to rest in vault no 64 under the chancel of the church, his wife commissioned a white marble wall monument for the west wall, from the sculptor, Richard Westmacott (1775–1856) who was a friend and fellow Swedenborg enthusiast.[4] The monument consists of a classically styled portrait medallion of Cosway set within a shallow niche. Classical motifs such as these were seen as invoking the grandeur and correctness of the ancient world, and suggesting a timeless quality, and perhaps here, the notion of that connection between the living and the dead, the persistence of the soul of the artist. Westmacott was in demand as a sculptor of church monuments and, as Busco points out, "he often attempted to clothe the immaterial, spiritual world with tangible form" (1994, 149) (Fig. 8.1).

Maria's devotion to her husband did not end with his death, and she commissioned Westmacott to produce a second version of the monument to be installed in the dining room of the college she had founded in Lodi, Italy. Cosway's biographer describes the room in detail, and that there was a fountain installed opposite the replica, with an added note about this purportedly from Maria, who stated it was intended, "by its bright and living movement to remind her that the tomb opposite to it only commemorated one who yet lived while he slept" (Williamson 1905, 79).

The portrait itself does not resemble the artist's many representations of himself, but rather a more natural look that may have come from the hand of his wife. It is possible that Maria, in close consultation with the sculptor, chose this to represent Cosway purified of earthly concerns and

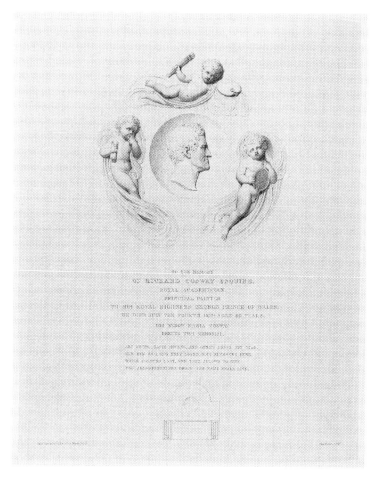

Fig. 8.1 Richard Cosway by Charles Picart; after Richard Westmacott © National Portrait Gallery, London

disappointments and readied to be accompanied to heaven by the three putti, which encircle the portrait of the artist. These symbolise the noble and timeless qualities (Art with palette and brushes, Taste represented by the scroll and Genius, holding the frame of a portrait miniature) that Cosway undoubtedly would have wanted to inform his claim for immortality.[5] Even if the portrait itself was not directly created by Maria, the composition of the whole demonstrates her commitment to him and

merges her more traditional Roman Catholic belief on the separation of the soul from the body after death, to be readied for the Last Judgement; with her husband's dalliances with Swedenborgian ideas of how married couples continue their life together when they meet after death. In *Conjugial Love* (1768) Swedenborg discusses the ways in which the bonds of love that a husband and wife develop in life continue to grow in Heaven. He saw the marital union between a man and a woman as the most perfect mirroring of divine love. "Conjugial" is a word derived from the Latin "conjugium" meaning "a union." Swedenborg used it in a very specific sense to mean the love that exists within marriage.[6]

DANTE GABRIEL ROSSETTI (1828–1882) "HONOURED AMONG PAINTERS AS A PAINTER AND AMONG POETS AS A POET"

It is well known that the Pre-Raphaelite poet and painter, Dante Gabriel Rossetti (1828–1882) lived a distinctive, dramatic, and eccentric life—underscored by his fascination with the spirit world alongside the more orthodox beliefs he was brought up with. His father was an Italian Roman Catholic immigrant, whose interest in esoteric philosophies and study of the work of the poet, Dante Alighieri, evidently was to have a great impact on his youngest son. His mother was a devout Anglican, however, and with her daughters Christina and Frances, she was to come under the influence of the Anglo-Catholic tradition when the family began attending Christ Church, Albany Street, not long after it was consecrated in 1837. The incumbent, William Dodsworth, tasked with the development of a new church which was to be inspired by the Oxford Movement, was known for his eloquent preaching and soon there was congregation which reflected the artistic and literary sensibilities of the movement (Burrows 1887, 67).

It is evident when looking at her brother's early work that Rossetti was likely to have been inspired by the Catholic look and atmosphere encountered in this church, although his brother, William, noted that Rossetti "was never confirmed, professed no religious faith, and practised no regular religious observances; but he had (more especially two or three years after this) sufficient sympathy with the abstract ideas and the venerable forms of Christianity to go occasionally to an Anglican church—very occasionally, and only as the inclination ruled him" (Rossetti 1895, vol. 1, 115).

It was however the death of his wife and muse, Lizzie Siddal, in 1862, that could be seen as drawing together many of Rossetti's complicated beliefs regarding the immortality of the soul. For in his guilt at the part he played in her addiction to the laudanum that was to be the cause of her death, the artist started to feel an urgent need to seek forgiveness and peace. In 1864, hoping for some communication with her spirit, he attended public spiritualist sessions and later organised private séances in his studio.

From the mid-nineteenth century, spiritualism was centred around the belief that the dead could interact with the living. It became a popular craze which was, in part, inspired by a revival in interest in the writings of Swedenborg. In particular, his conception of a future life, and the notion of being able to converse with the spirit of the dead evidently fascinated many such as the poet, Elizabeth Barrett Browning, and writers William and Mary Howitt as well as their daughter, Anna Mary Howitt, who studied art at Sass' school and was "on friendly terms with members of the Pre-Raphaelite Brotherhood" (Marsh and Nunn 1997, 104).

As Maddison states in her thesis, Rossetti "kept a book on Swedenborg's life and works in his library at Cheyne Walk" (2013, 37). Furthermore, she asserts that it was Swedenborg's work *Conjugial Love* that may have directly inspired Rossetti's increasing interest in love and the afterlife (2013, 55). In this book, Swedenborg discusses marriage from a spiritual viewpoint, the ways in which men and women relate to each other while living and in the afterlife. He states that marriages in heaven between true soulmates will continue to grow. He includes his thoughts on sexual relationships in this world, both in and out of the married state, and how the decisions made by human beings affect their spiritual evolution.

It is from Michael Rossetti that we get the clearest statement of Rossetti's spiritual views on life after death. He states: "As to my brother's reported assertion 'I believe in a future life,' this was partially true at all periods of his career, and was entirely true in his closing years. It depended partly upon what we call 'spiritualism,' on many of whose manifestations he relied" (Rossetti 1863, 380–1).

These manifestations may well refer specifically to the appearances recorded by William Rossetti, though initially a sceptic, in his séance diaries between 1865 and 1868, of Lizzie who was "constantly appearing in the séances at Cheyne Walk" (Bullen 2013, 433). At the same time as his interest in attending and hosting seances took hold, Rossetti began work

on what can be described as a spirit painting, *Beata Beatrix*. In fact, Maddison goes further and suggests that the "spiritualistic imagery of the original version of *Beata Beatrix* draws upon those aspects of Victorian spiritualism that Rossetti had a particular interest in, or experience of: the mesmeric trance state, the séance and Swedenborgian ideas about love and the afterlife" (2013, 128).

When Dante Gabriel Rossetti died on Easter Day, 1882, it was decided that he would be buried in the local churchyard of the village of Birchington, Kent, where he had been staying. Fellow artist, and one of his closest friends, Ford Madox Brown, was asked by his brother, William, to design Rossetti's monument for the churchyard. Madox Brown's suggestion of an Irish cross in granite apparently met with approval from Christina and her mother, but caused William to say: "my mother wants a cross and I don't ... I am strongly minded to say that she might have the cross if she liked, but then she herself must order it" (Marsh 1994, 515). However, after a great deal of correspondence between Christina (on behalf of their mother) and William over the form of the tombstone (his preference was for a simple engraved stone such as the one Madox Brown had designed earlier for the burial place of his son, Oliver), William eventually agreed to the Celtic cross (Fig. 8.2).

One can only imagine Madox Brown's discomfort at being in the middle of the family dispute over the design of the monument. It would seem, on the evidence of the tomb stone he erected over his own family burial place in Islington, and which was held up as the ideal by William, that his taste was more agnostic and so corresponded with that of Rossetti's brother, but he was also anxious not to upset the religious sensibilities of Christina and her mother. In the end Madox Brown's use of symbolic motifs, which were both secular as well as Christian, effectively identify Rossetti on a variety of levels and much of the imagery indicates Madox Brown's own understanding of Rossetti's longing to be re-connected to Lizzie, his wife and muse.

The cruciform shape at the top of the cross is set within a circle, which symbolises eternal life, as well as the natural cycle whereby the death of plants and animals provide food for the birth and growth of the next generation. The spaces between the cross and the circle are entwined with pomegranates which were the pagan symbol of rebirth taken from the story of Proserpine, the daughter of the earth Goddess, Ceres.

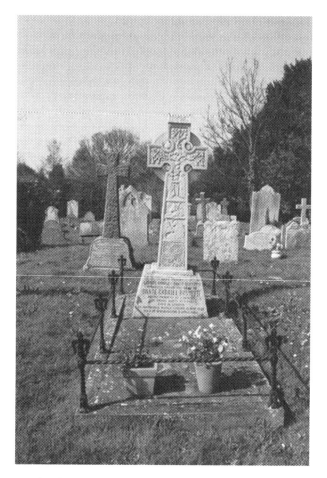

Fig. 8.2 Tomb of Dante Gabriel Rossetti, Birchington on Sea, © Miss Jennie Burgess. Source: Historic England Archive

Within the cruciform is a scene that represents the spiritual marriage between the fourteenth-century Italian poet, Dante Alighieri and his spiritual guide, Beatrice, taking place in front of a haloed figure and a tree with branches that are twisting and sinuous. These tendrils spread out into the shape of the cross. In light of Rossetti's reading of *Conjugial Love*, it is also possible that the figures are Rossetti and his wife, thus indicating the continuation of their marriage after death, and the hope for reconciliation and rediscovery of the joy of their sexual encounters. In his poetry, as well as

his art, it can be seen that Rossetti often promoted a powerful and positive spirituality equating sublime love with immortality. In his poem, "Sudden Light" (1863) Rossetti uses the notion of love that is stronger than death, allowing soulmates to meet again. In the last stanza, he asks,

> Has this been thus before?
> And shall not thus time's eddying flight
> Still with our lives our love restore
> In death's despite,
> And day and night yield one delight once more?[7] (Rossetti 1863, 25)

Evelyn De Morgan (1855–1919) "Sorrow is only of Earth; the life of the Spirit is Joy"

The artist and pacifist, Evelyn De Morgan (1855–1919), like Rossetti, used symbolism throughout her work. However, her paintings were also largely informed by her strongly held spiritual belief in a divine presence that was opposed to the evil in the world, and that it is the duty of human beings to strive towards the light that is God, away from earthly and materialistic desire (Oberhausen 2009, 38–42).

Her marriage in 1887 at the age of 30 to fellow artist William De Morgan surprised family and friends because she had long maintained such a single-minded attitude to her art. William was the son of mathematician Augustus De Morgan and the renowned spiritualist author, Sophia De Morgan. Sophia hosted séances and talks which were regularly advertised in *Light*, a major Spiritualist newspaper which was first published in England in 1881.[8] It was within this environment that Evelyn and her husband were to become immersed in spiritualism and particularly, Swedenborgian spiritualism.

Shortly after the marriage, their mutual faith in an afterlife, and the notion that spiritual evolution is a process of moral growth, prompted them to experiment with automatic writing, a process whereby the subject allows a spirit to guide the pen in his/her hand whilst in a trancelike state. These writings were published anonymously in 1909 as *The Result of an Experiment* and can be seen to form the basis or inspiration for much of Evelyn's work. She believed that a person could only attain spiritual growth by making moral judgments during his/her earthly existence. However, through death, and entering a new spiritual state, it is possible to work towards one's own salvation, or damnation. This evolution from

a physical to a spiritual and finally a celestial plane is symbolised in many of De Morgan's paintings, depicting the earthly physicality which distracts and binds as well as the individual's striving up towards the light that is divine. The writings also exhorted Evelyn to see the earthly work she did as an artist as corresponding to the revelation of spiritual grace as intended by God through creation. Lawton describes this in her book, *Evelyn Pickering De Morgan and The Allegorical Body*: "As repeated in various passages in the *Result of an Experiment*, the morally uplifting nature of symbolic art is dependent on the recognition that a state of spiritual grace is best conveyed through external, physical beauty" (Lawton Smith 2002, 50).

When William died unexpectedly, in January 1917, from trench fever caught from a soldier friend, who had visited them on Christmas Day, Evelyn began work on a funerary monument that would not only mark William's resting place, but also her own. Her sister described this "handiwork" as "the expression of a bitter grief" (Stirling 2012, 382).

Designed as well as carved under the supervision of sculptor, Sir George Frampton, the use of Carrara marble could be seen as symbolic of the De Morgans' love of Italy and a desire to ensure it connected to the past and lasted into the future (Fig. 8.3). (It may also be noted that as it was suitable for any environment, there were a number of marble importers based in both London and Carrara during this period.)[9]

The form of the monument is a rectangular standing stone, with the top pedimented in the style of the Greek stele. On the face of the monument is a bas-relief that has been described by Mrs. Stirling, Evelyn's sister, as consisting of two figures, one a mourning figure and the other, winged (Stirling 2012, 382). It is apparent on close examination of the monument, as well as a study of some of De Morgan's works, that the symbolism of this very personal memorial could be said to not only identify the artist, and her work, but also the beliefs she shared with her husband.[10]

It may be that the figures could have been sourced from two different paintings. The figure on the left, with head bowed and one hand on heart, the other resting on a down turned torch, seems to be referencing the Angel of Death which features in De Morgan's *The Field of the Slain* (1916),[11] a work which was completed for the Red Cross Exhibition held in Kensington. Here the Angel tenderly gathers the souls while leaving the bodies scattered behind on the battlefield. These souls are represented disconcertingly as disembodied heads (which rather pre-figure the photographs of spiritualist Ada Emma Dean taken at the cenotaph on Armistice Day from 1921).[12]

Fig. 8.3 Tomb of William (1839–1917) and Evelyn De Morgan (1855–1919), Brookwood Cemetery (victorianweb.org) Photograph by Robert Friedus

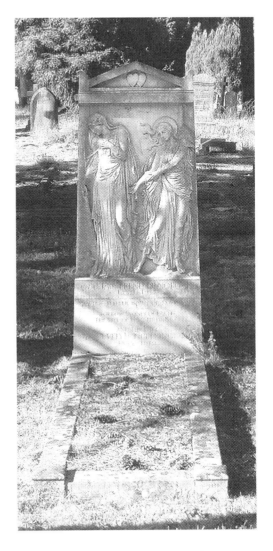

The composition is described by Stirling who states that one figure is "a mourner, bowed with grief" [by implication, Evelyn] and the other, "Psyche, with airy poise and happy gesture, is striving to wean her from her grief" (Stirling 2012, 382). However, it seems quite possible that the inspiration for the composition was a work De Morgan was working on

when William died and did not finish until shortly before her own death. This is entitled *The Passing of the Soul at Death* (1910–19) and depicts a dying woman, also with torch downturned, surrounded by rocks and a serpent. Yet at the moment of death, her soul breaks free, shedding the physical body and passing into the light of the spirit world. The pose and gesture of the second figure closely resembles the "soul" as depicted in this painting.[13]

If we accept that the headstone is inspired by this work, then the figures must be the same person at the moment of death. This reading of the monument is aided by the placement of the right foot of the freed soul over the left of the dying figure, as if sloughing off "the heavy, cumbersome matter of the flesh" (Lawton Smith, 52). Thus the second figure is the soul of the dead person no longer bound by the confines of their earthly physicality, being "led by the light that makes day of the darkness of death" (Lawton Smith, 52). The haloed figure is depicted as if moving away from the other, and the frame of the monument on the left-hand side is placed behind her shoulder and hip as if to emphasise her release from the burden of the flesh. The movement of the figure is also accentuated by her flowing hair and the greater fluidity of her drapery. Despite the gender of the figures, the body and soul could represent William as well as Evelyn. Beneath the image there is a sentence taken from one of the spirit letters transcribed by the De Morgans, which reiterates this Swedenborgian spiritualist reading of the imagery: "Sorrow is only of Earth; the life of the Spirit is Joy" (De Morgan and William 1909).

Finally, mention must also be made of the two hearts that are placed in the pediment of the monument, overlapping slightly. It may be said that their marriage was truly a meeting of soulmates, and their close friend, Georgiana Burne-Jones (wife of Edward Burne-Jones) was to describe it as "one of the blessed marriages" (Stirling 2012, 374). In *Conjugial Love*, Swedenborg describes what happens to those who might enjoy this ideal state after the death of one such soulmate. Those who love each other tenderly on earth are certain they will live together forever. When they think they will be parted by death, they grieve, but then they are revived by the hope of an eternity in heaven (Swedenborg 2009, 254). Those who have lived together in love truly conjugial are not separated by the death of one, for the spirit of the deceased partner continues to dwell with the spirit of the one not yet deceased, and this until the death of the latter. Then, "they meet again and reunite themselves and love even more tenderly than before" because they are in the spiritual world (Swedenborg 2009, 365).

In the exploration of the imagery of each of these funerary monuments placed over or close to the physical remains of the deceased, it is possible to see how Swedenborgian ideas, around the persistence of the soul (and indeed as a signifier of love) beyond death, were deeply attractive to those who sought refuge from the world of rapid scientific and technological change through their artistic endeavours. Even as this progress was heralded by many, for others it created a sense of unease where the only absolute certainty that remained was death. However, what lay after death remained a source of speculation and a frustration that science could not offer up the answers. Swedenborg, with his mix of scientific reasoning and detailed theological philosophies, gave hope to those who wanted to believe in a life after death. For Maria Cosway, Dante Gabriel Rossetti, and Evelyn De Morgan, the belief that they would one day be reunited with their soulmates and live again in this happy state beyond the grave was not just reassuring, it had become almost tangible, and the monuments that were carved in stone were a testament to this hope being fulfilled.

Notes

1. Vasari, regarded as the first art historian, had continued to exert a profound influence on ideas around the theory of art throughout the nineteenth century.
2. Heaven, Purgatory or Hell.
3. "The 1662 Book Of Common Prayer", *Justus.Anglican.Org*, 2018, http://justus.anglican.org/resources/bcp/1662/baskerville.htm. The BCP (Book of Common Prayer) contains the Order for the Burial of the Dead. It references the understanding that the body is left behind and the soul released. For example, "Almighty God, with whom do live the spirits of them that depart hence in the Lord, and with whom the souls of the faithful, after they are delivered from the burden of the flesh, are in joy and felicity."
4. In fact, his son, also named Richard, was commissioned to produce a monument in 1833 for the Rev John Clowes, an Anglican minister who preached the Sweden borgianism doctrine from his pulpit in St John's Manchester.
5. The accompanying epitaph was written by Maria Cosway's brother-in-law William Coombe:

 Art weeps. taste mourns, and genius drops her tear
 o'er him so long they lov'd, who slumbers here.
 while colours last, and time allows to give
 the all resembling grace. his name shall live.

6. *Conjugial Love* was first published in England in 1790.
7. "Sudden Light By Dante Gabriel Rossetti | Poetry Foundation", *Poetry Foundation*, 1863, https://www.poetryfoundation.org/poems/45026/sudden-light
8. Light: A Journal Of Psychical, Occult, And Mystical Research.", *Iapsop.Com*, 1887, http://iapsop.com/archive/materials/light/light_v7_n329_apr_23_1887.pdf
9. "Carrara Marble-Mapping The Practice And Profession Of Sculpture In Britain And Ireland 1851–1951", *Mapping Sculpture - Mapping The Practice And Profession Of Sculpture In Britain And Ireland 1851–1951*, 2021, https://sculpture.gla.ac.uk/
10. Unfortunately, the original, full size drawing that she produced was destroyed by fire in 1991.
11. Evelyn De Morgan, *The Field Of The Slain*, Oil on Canvas (Private Collection, 2016).
12. Giulia Katherine Hoffmann, "Otherworldly Impressions: Female Mediumship In Britain And America In The Nineteenth And Early Twentieth Centuries", (PhD Thesis, UC Riverside, 2014), 128 https://escholarship.org/uc/item/3jd8n56n
13. Evelyn De Morgan, *The Passing Of The Soul At Death*, Oil on Canvas (The Morgan Foundation, 1919).

Works Cited

Becker, Ernest. 1985. *Escape From Evil*. New York: The Free Press.
Bullen, John B. 2013. Raising The Dead: Dante Gabriel Rossetti's 'Willowwood' Sonnets. In *The Oxford Handbook Of Victorian Poetry*, ed. Matthew Bevis, 429–444. Oxford: Oxford University Press.
Burrows, Henry W. 1887. *The Half Century Of Christ Church, St Pancras Albany Street*. London: Skeffington and Sons.
Busco, Marie. 1994. *Sir Richard Westmacott Sculptr*. Cambridge: Cambridge Univ. Press.
Cunningham, Allan. 1842. *The Lives of the Most Eminent British Painters and Sculptors*, 5 volumes. New York: Harper & Brothers.
De Morgan, Evelyn. 1916. *The Field Of The Slain*. Oil on Canvas. Private Collection.
De Morgan, Evelyn, and William. 1909. The Result Of An Experiment—New Acquisition. *The De Morgan Foundation*. https://www.demorgan.org.uk/the-result-of-an-experiment-new-acquisition/.
Freud, Sigmund. 2003. *The Uncanny*. Translated by David McLintock. London: Penguin Modern Classics.

Lawton Smith, Elise. 2002. *Evelyn Pickering De Morgan and the Allegorical Body*. Fairleigh Dickinson Univ Press.

Maddison, Anna. 2013. Conjugial Love And The Afterlife: New Readings Of Selected Works By Dante Gabriel Rossetti In The Context Of Swedenborgian-Spiritualism. https://research.edgehill.ac.uk/ws/portalfiles/portal/20307059/Maddison_Anna_-_Thesis_-_Input_-_Final_-_2013_11.pdf.

Marsh, Jan. 1994. *Christina Rossetti: A Literary Biography*. London: Jonathan Cape.

Marsh, Jan, and Pamela Gerrish Nunn. 1997. *Pre-Raphaelite Women Artists*. Manchester: Manchester City Art Galleries.

McHugh, J. 1910. Catholic Encyclopaedia: Particular Judgment. http://www.newadvent.org/cathen/08550a.htm.

Oberhausen, Judy. 2009. Sisters in Spirit: Alice Kipling Fleming, Evelyn Pickering De Morgan and 19th-century Spiritualism The British Art Journal 9, no. 3, 38–42. Accessed March 7, 2021. http://www.jstor.org/stable/41614839.

Rix, Robert. 2007. *William Blake And The Cultures Of Radical Christianity*. Aldershot: Ashgate.

Rossetti, Dante Gabriel. 1863. Sudden Light. In *Poems, An Offering to Lancashire*. Emily Faithfull, Victoria Press. https://www.poetryfoundation.org/poems/45026/sudden-light.

Rossetti, William. 1895. Dante Gabriel Rossetti. His Family-Letters With A Memoir (Volume One). http://www.rossettiarchive.org/docs/pr5246.a43.rad.html#A.R.14.

Stirling, A.M.W. 2012. *William De Morgan And His Wife*. London: Forgotten Books.

Swedenborg, Emanuel. 2009. *The Delights Of Wisdom As Pertaining To Conjugial Love After Which Follow The Pleasures Of Insanity Pertaining To Promiscuous Love*. Swedenborg Foundation: Pennsylvania. Ebook. https://swedenborg.com/wp-content/uploads/2013/03/swedenborg_foundation_conjugial_love.pdf.

The Result Of An Experiment—New Acquisition. 2015. *The De Morgan Foundation*. https://www.demorgan.org.uk/the-result-of-an-experiment-new-acquisition/.

Thornbury, Walter. 1877. *The Life Of J.M.W. Turner, R.A. Founded On Letters And Papers Furnished By His Friends And Fellow Academicians*. London: Chatto & Windus.

White, William. 1868. *Emanuel Swedenborg: His Life And Writings*. 2nd ed. London: Simpkin Marshall and Company.

Williamson, George C. 1905. *Richard Cosway R A*. London: George Bell and Sons.

CHAPTER 9

"Dancing the American Soul: Secular and Sacred Motifs in the Choreographic American Renaissance"

Adeline Chevrier-Bosseau

Associating dance and the soul in an American context is essentially fraught: from the Calvinist strain equating dancers with madmen and animals[1] to nineteenth-century anti-dance sermons and all the modern avatars of anti-dance prejudice in popular Hollywood movies,[2] dancing has consistently been deemed nefarious and detrimental to the human soul, as Ann Wagner (1997) has amply documented in her study of *Adversaries of Dance, From the Puritans to the Present*. Yet what is striking is how consistently the pioneers of American dance have striven to find and express the American soul in their search for indigenous American movement; whether the term "soul" is understood in a secular sense as the essence, the spirit, the animating principle, or in a more religious sense, all the dance pioneers

A. Chevrier-Bosseau (✉)
Sorbonne University, Paris, France

Institut Universitaire de France, Paris, France
e-mail: adeline.chevrier-bosseau@sorbonne-universite.fr

© The Author(s), under exclusive license to Springer Nature Switzerland AG 2024
D. Louis-Dimitrov, E. Murail (eds.), *The Persistence of the Soul in Literature, Art and Politics*,
https://doi.org/10.1007/978-3-031-40934-9_9

of the first half of the twentieth century have engaged with the American soul in some way or other.

This search for Americanness in dance echoes in many respects the work of the writers of the American Renaissance in their quest for a uniquely American voice and American cultural independence, to the point where it would not seem unreasonable to consider the first half of the twentieth century as the American Renaissance in dance. In his seminal work, F. O. Matthiessen explains: "It may not seem precisely accurate to refer to our mid-nineteenth century as a *re-birth*; but that was how the writers themselves judged it. Not as a re-birth of values that had existed previously in America, but as America's way of producing a renaissance, by coming to its first maturity and affirming its rightful heritage in the whole expanse of art and culture" (Matthiesen 1969, vii). Similarly, the pioneering choreographic experiments of American artists like Isadora Duncan, Ruth Saint Denis, Ted Shawn, Alvin Ailey, Agnes De Mille, Martha Graham, or naturalized Americans such as Balanchine, to name but a few, cannot be considered as the birth of American dance—since there had been American dancers long before them, like John Durang or Augusta Maywood—but it is a re-birth in the same way as the literary American Renaissance, since it too corresponds to what Matthiessen defines as "America's way of producing a renaissance, by coming to its first maturity and affirming its rightful heritage in the whole expanse of art and culture." The choreographic production from the early twentieth century to, roughly, the late 1950s, will therefore be referred to in this chapter as the American Renaissance in dance.

Like Hawthorne, Melville, and their contemporaries, American dance pioneers revisited the history and founding myths of the country in their productions: when these writers worked on creating a uniquely American style of writing that would set them apart from European models and establish an identifiable American voice, they looked toward the American landscape for inspiration, as well as American themes, founding myths, and history. Nathaniel Hawthorne revisited the Puritan past of the early colonies in *The Scarlet Letter*, representing the evolving New England landscape,[3] the wilderness, but also the "Utopia of human virtue and happiness" (Hawthorne 1986, 45) which led the settlers to build villages, then cities, in the New World; similarly, the founders of modern American dance looked to the past to find inspiration and the origins of indigenous American movement. The persistence of American myths and folklore is extremely noticeable in the early works of the pioneers of American dance:

from Graham's *American Document* (1938) to Agnes De Mille's *Rodeo* (1942), an impressive number of choreographic pieces from the 1930s to the 1950s have been inspired by Americana. The first part of this study will therefore be devoted to this quest for the essence of Americanness in the works of early twentieth-century choreographers.

On the less secular side of the spectrum, the American Renaissance choreographers' engagement with the divine soul can be read in the light of their fascination for Eastern philosophy and spirituality, especially Brahmanism. The correspondence, journals, and works of writers like Emerson or Thoreau attest to their familiarity with ancient Indian sacred texts that were being translated and published during the most prolific period of the 1850s.[4] Even writers like Whitman who left no actual record of having widely read these texts developed a relation to the body and the soul, a transcendence of the self toward the supreme self (or Brahman) which had a lasting impact on his "spiritual children," the choreographers of the American Renaissance, in whose works references to Indian philosophy and spirituality abound. The second part will therefore examine the influence of Brahmanism on the artists of the American Renaissance's approach to the body and the soul.

Choreographing the American Soul

The Webster Dictionary first defines the term "soul" as an "immaterial essence," a notion which is matched by the elusiveness of the very concept of the American soul, as well as the process of essentialization which is recurrent in the endeavors of the pioneers of American dance to define it. Among the distinctive motifs that the writers of the American Renaissance developed to make their writing truly American and recognizable as such was the relation to the American landscape, with references to American vegetation and wildlife as well as countless rewritings of the Puritan typology of the wilderness. Another was the creation of typically American characters, like the stern Puritan and its corollary, the victim of merciless Puritanism, the adventurous youth—the pioneer, the man or woman of the Frontier, the explorer, the young man on an initiatory journey aboard the Pequod or a raft on the Mississippi—the colored "Other," either a threatening presence or a figure of suffering, a tortured slave or vanishing Indian. Independence, self-reliance, courage, and persistence pervade the works of the American Renaissance, as well as a sense of boldness—on a diegetic and on a formal level. Like their literary counterparts, the artists

of the American Renaissance in dance modeled choreographic Americanness on these motifs.

In her autobiography, Isadora Duncan delineates several times how "the dance of the America of the future" (Duncan 2013, 223) should be an organic embodiment of the epic vastness of the land:

> I bring you the dance. I bring you the idea that is going to revolutionise our entire epoch. Where have I discovered it? By the Pacific Ocean, by the waving pine-forests of Sierra Nevada. I have seen the ideal figure of youthful America dancing over the top of the Rockies. The supreme poet of our country is Walt Whitman. I have discovered the dance that is worthy of the poem of Walt Whitman. I am indeed the spiritual daughter of Walt Whitman. For the children of America I will create a new dance that will express America. (Duncan 2013, 21–22)[5]

Duncan imagined a dance which "would be like the vibration of the American soul striving upward, through labour to harmonious life" (Duncan 2013, 304)—an embodiment of the American pioneer spirit. Similarly, Ted Shawn also compared this new modern American dance to Whitman's poetry and sees it as the embodiment of the American spirit of democracy, freedom, and forward movement:

> The dance of America will be as seemingly formless as the poetry of Walt Whitman, and yet like *Leaves of Grass* it will be so big that it will encompass all forms. Its organization will be democratic, its fundamental principles, freedom & progress; its manifestation an institution of art expression through rhythmic, beautiful bodily movement, broader and more elastic than has ever yet been known. (Shawn 1926, foreword)

Further in his manifesto *The American Ballet* (1926), Shawn explains:

> It is our concern that the dance of America shall express the richness, the dignity and mellowness of our national tradition; that it have the bigness of heart and the long-suffering of our Lincoln; the vastness of our plains, the majesty of our mountains, the fertility of our soil. We must release through the American dance that spirit which would bear hardship, poverty and even death rather than submit to mental and spiritual tyranny. Because we are young, it is inevitable that we shall be full-blooded, vigorous, passionate, and joyous in our dancing. But beyond this, because of the tradition of our Anglo-Saxon forefathers, who fought and died to make it possible for us to

have *life, liberty and the pursuit of happiness*, we must in all our activities be a torch to the world, and in the dance most of all. (Shawn 1926, 14)

The founding principles of American society and culture—like the fragment from the Declaration of Independence quoted by Shawn[6]—are profoundly ingrained in the dance pioneers' quest for indigenous American movement, as much as they were for the writers of the American Renaissance. In another manifesto for American dance, Lincoln Kirstein stresses the fundamental importance of American history in the shaping of an American choreographic style: "an American ballet repertory will be built on the twin basis of native historic themes and contemporary traditional choreography to classic music" (Kirstein 1938, 90). Geographical landmarks, founding principles such as freedom and youthful joy, and founding American myths such as the Frontier and Manifest Destiny, as well as the Puritan tradition of the *exemplum* (illustrated in Shawn's injunction to "be a torch to the world") and the unassuming, unpretentious freshness, and boldness of the self-made man have all inspired the creation of American dance. In his manifesto, Kirstein lists all these characteristics in a plea that echoes Emerson's "Self-Reliance":

American style springs or should spring from our own training and environment, which was not in an Imperial School or a Parisian imitation of it. Ours is a style bred also from basket-ball courts, track and swimming meets and junior-proms. Our style springs from the personal atmosphere of recognizable American types as exemplified by the behavior of movie-stars like Ginger Rogers, Carole Lombard, or the late Jean Harlow. It is frank, open, fresh and friendly. ... The Russians keep their audience at arm's length. We almost invite ours to dance with us. (Kirstein 1938, 45)

Among these "recognizable American types," two figures, the pioneer, and the cowboy, recurrently appear in the dance pieces from the 1940s to the 1950s that have helped shape the American style.

Dancing the Frontier: Cowboys and Pioneers

In the European classical repertory, many ballets refer to European themes or places: *La Sylphide*, *Coppelia*, *Le Corsaire*, and *Giselle* are classics of nineteenth-century ballet, they all take place in European settings and are built around a network of European references (a poem by Lord Byron,

the novels of Walter Scott, German folk tales, …). Other classics like *Raymonda* refer to the Crusades, and "Spanish" ballets like *Paquita* or *Don Quixote* are also typically European, in their argument and repertories—in the sense of the "repertoire of the text" as defined by Iser[7]—as well as in the style and the choreography. When classical ballet first appeared in the United States, and until the choreographers of the American Renaissance in dance began to work on American themes for their pieces, most of the dancing done on stage was a European importation, with European settings and themes. Meanwhile, Buffalo Bill's Wild West Shows incarnated Americanness on European stages until the first decades of the twentieth century. Later, with the development and growing worldwide popularity of Hollywood cinema, Westerns and plots featuring cowboys, pioneers, and Native Americans in Wild West settings came to signify America for a lot of Europeans. In his previously mentioned manifesto, Ted Shawn advocated for the "preservation" of the national figure of the cowboy in American dance:

> In the frontier life and early phases of American village life types were developed which had their day and have passed away with the passing of the forces which created them. The cowboy, a picturesque, decorative creature with chaps, big hat, colored neck handkerchief, is now seen only in the movies or rodeos. Let us preserve him in the dance. (Shawn 1926, 24–25)

Taking their cue from the principles of narrative dance delineated by Jean-Georges Noverre in the eighteenth century, American Renaissance choreographers used the Noverrian concept of the "ballet d'action" to tell American stories and contribute to building the history of the American style. For Noverre (1760), dance had to be expressive, and to tell a story; the principles of the "ballet d'action" are the foundations of the *École française*, and of narrative dance in general. Among the entire section of the American repertory based on Americana, three pieces epitomize the representations of cowboys and Frontier life: Agnes De Mille's *Rodeo* (1942), George Balanchine's *Western Symphony* (1954), and Martha Graham's *Appalachian Spring* (1944). Though both take place in the Wild West and feature plots revolving around cowboys and their daily lives, *Rodeo* has a clearer argument than Balanchine's *Western Symphony*: a cowgirl is in love with a boy and tries to win him over and the argument of the ballet follows the unfolding of this love story. The plot is not dramatically different from European classics of the repertory, and the

playfulness of the romantic tribulations of the characters recalls that of Lise and Colas in *La Fille mal gardée*, or Kitri and Basilio's in *Don Quixote*. The technique, however, is vastly different. On the other hand, *Western Symphony* purposely has no argument, as Balanchine explains:

> My idea in this ballet was to make a formal work that would derive its flavor from the informal American West, a ballet that would move within the framework of the classic school but in a new atmosphere. Earlier ballets on American folk themes (*Billy the Kid*, *Rodeo*, et al.) have been based on cowboy lore, but these have been story ballets. I wanted to do a ballet without a story in an unmistakably native American idiom. (Balanchine and Mason 1977, 177)

Yet *Western Symphony* isn't abstract: it can still be considered as "ballet d'action," but the story told by the dance is that of the essence of Americanness itself—or rather, the essence of America as perceived by a Georgian immigrant whose vision of American culture stemmed from jazz music and the American movies he had seen when he still lived in the Soviet Union.[8] The "unmistakably native American idiom" in both pieces expresses itself in the costumes (cowboy and cowgirl outfits, as well as saloon dancers' costumes for some of the ladies), the setting, but also the movement, which blends together classical ballet[9] and what Kirstein called "American character dancing,"[10] popular dances like country line dancing, square dancing, as well as references to jazz and to Broadway musicals. They also offer a typically American take on pantomime—a classic feature of "ballets d'action"—in the roping and riding scenes in *Rodeo*, or in the second movement of *Western Symphony*, when the cowboy exits the stage holding the reins of his "carriage" drawn by four dancers from the corps de ballet. Pantomime is used with an explicitly comical effect in Balanchine's piece (like when these four corps dancers imitate the movements of horses), but *Rodeo* is extremely ingenuous in its Americanization of pantomime, particularly in the riding scenes, where the dance figures the precarious balance, boldness, and effort of a rodeo without ever resorting to literal pantomime. Just like European ballet created an entire pantomimic vocabulary to signify marriage, crying, dancing, swearing, De Mille created a brand-new vocabulary expressing the pantomimic language of cowboys (hopping on the saddle, staying on the horse while it tries to shake off its rider, …).

The music by Aaron Copland and Hershy Kay is also typically American: Copland composed the music for *Rodeo* and *Appalachian Spring*, and he had previously been commissioned by Lincoln Kirstein to compose the music for the ballet *Billy the Kid* (Kirstein 1938). For *Western Symphony*, Balanchine commissioned a score by Hershy Kay; both Kay and Copland made ample use of honky-tonk piano themes in *Rodeo* and *Western Symphony*, for which Kay revisited popular melodies like "Red River Valley," "Rye Whiskey," or "Good Night, Ladies." The music for these two pieces is lively and upbeat for the most part and mellows down for the more intimate, introspective moments.[11] For *Appalachian Spring*, Copland also featured American popular music, using the theme of a traditional shaker song "T'is the gift to be simple."

Graham's *Appalachian Spring* also depicts Frontier life, but not in the same perspective of pure entertainment as the other two pieces. In a letter to Copland, Graham wrote: "it is hard to do American things without either becoming pure folk or else approaching a little like a mural in a middle western railway station or post office" (Graham 1992, 227). Graham wanted to concentrate on the essence of the pioneer experience and show the hopes and dreams of a couple of pioneers in a space that is still a work in progress, in the process of being conquered and built. For Graham, "*Appalachian Spring* is essentially a dance of place. You choose a piece of land, part of the house goes up. You dedicate it. The questioning spirit is there and the sense of establishing roots" (Graham 1992, 231). With sets by Isamu Noguchi, space in *Appalachian Spring* remains resolutely abstract, unfinished, in progress. The progress and forward movement characteristic of the process of representing the Frontier are duplicated in the piece's focus on dancing the pursuit of happiness; the individuality at the core of this American principle is incarnated by the numerous soli in the piece. Like *Rodeo* and *Western Symphony*, the story in Graham's ballet also refers to the past, the pioneers, the first settlers, but because it gives body and movement to timeless American concepts such as the pursuit of happiness, *Appalachian Spring* revisits the tradition of narrative ballet to tell a story which is that of the American spirit itself. The process of actualization, as featured in Graham's piece, is a key component of the American Renaissance—in dance as in literature—and it is also visible in the way American Renaissance artists dealt with classical myths.

The American Renaissance in Dance and Classical Myths

The first section of the 14th chapter of Matthiessen's study of the American Renaissance examines first "The need for mythology," the process of actualization through which writers like Thoreau or Emerson referred to ancient myths to reveal "the inevitable recurrence of the elemental human patterns" (Matthiesen 1969, 631). The reappropriation and Americanization of myths and classical texts is another common point between the American Renaissance in literature and in dance; for American writers and later, choreographers, the connection to Greco-Roman culture was complex and provided the means to historicize the nation as well as to establish difference with the British model.[12] In the Graham repertory, two groups of pieces condense some of her best-known work: on the one hand, the "American" ballets, like *Frontier* (1935), *Appalachian Spring* (1944), *American Document* (1938), *Letter to the World* (1940), or later pieces like *The Scarlet Letter* (1975), and on the other the "Greek" ballets, whose arguments are rewritings of Ancient Greek myths—such as *Cave of the Heart* (1946, inspired by the story of Medea), *Night Journey* (1947, based on the story of Oedipus and Jocasta), *Errand into the Maze* (1947, based on the story of Ariadne and the Minotaur), or *Clytemnestra* (1958). Balanchine also revisited Greek myths in ballets like *Apollo* (1928) or *Orpheus* (1948) and referred to the Greek concept of "Agon" in his 1957 ballet revisiting (and Americanizing) Early Modern European court dances. Graham's reinterpretation of Greek myths could be read in an Emersonian sense, following Emerson's appraisal of myth in essays like "History"—as a way to celebrate the universality and timelessness of the human struggles they feature. It was also an act of feminist re-vision, as defined by Adrienne Rich in her essay "When We Dead Awaken"[13]: in her "Greek" pieces, Graham's choreography focuses on the women's struggles, and draws them out from the shadows of the secondary roles they were confined to in the original myths to put them in the foreground. These pieces are rewritings of ancient myths, but they also interrogate female desire, female sexual and social freedom, and women's quest to live freely and blaze their own trail, much like her "American" pieces on female pioneers did. In that sense, her "Greek" pieces are as much about mythological figures like Medea or Jocasta that they are about the contemporary American woman and about the pioneering spirit of the modern American woman who is more independent and more daring than her Old-World counterparts.[14] Like Balanchine's *Apollo*, which is still part of the

repertory of the New York City Ballet and an audience favorite, Graham's "Greek" pieces also celebrate the American choreographic style through these revisited Ancient myths: albeit in different styles, both choreographers celebrate the streamlined American aesthetic and make ample use of choreographic Americanisms, in a non-verbal retelling of the myths in the American idiom. While they were drawn to the drama and statuesque purity of movement of the Hellenistic style, American Renaissance choreographers were as interested in the philosophical teachings of Ancient Greece and Ancient Rome as their literary counterparts, especially regarding the soul and the principles of democracy. According to V. K. Chari, "Both Emerson and Whitman felt the need for a new, impersonal 'doctrine of the soul'. Hence they were attracted to the German doctrines of Self and Emerson took avidly to the Neo-Platonic conception of the Oversoul and the more strikingly developed doctrine of Self in the Atman-Brahman concept of the *Gita* and the *Katha Upanishad*" (Chari 1959, 292). Chari even calls Emerson's essay "Plato" "the more deeply Indian of his essays, which contains the kernel of Emerson's orientalism" (Chari 1959, 292). In the works of American Renaissance choreographers, a similar affinity or conflation can be noticed between Greek philosophy and Brahmanism, an ancient form of Hinduism.

"The Orient Is in the West" (Emily Dickinson): The Spiritual Frontier—Oriental Philosophy and the New American Soul

For the Transcendentalists as for Whitman and later, the choreographers of the American Renaissance, reading ancient Indian texts was a spiritual revelation. According to Swami Paramananda, "there can be little question that Emerson was strongly imbued with the spirit of the *Upanishads* when he wrote his essay on the Over-Soul. The title itself indicates it, for "Over-Soul" is almost a literal translation of the Sanskrit word "ParamAtman" (Supreme Self)" (Paramananda 1918, 65). Passages of Emerson's essay strongly recall Brahmanic principles, like this excerpt, which echoes the concept of the Atman (the human soul) as being connected to the Brahman, the source of all things, and therefore to the Supreme Soul as one and the same: "within man is the soul of the whole; the wise silence; the universal beauty, to which every part and particle is equally related; the eternal ONE" (Emerson 1939, 160). In the same

paragraph, Emerson mentions the "transcendent simplicity and energy of the Highest Law." Associating spirituality and the soul with circulating energies is also at the core of many Eastern philosophies, whether this life force is called *prāna* (in the *Upanishads*) or *qi* in ancient Chinese philosophy. Thoreau, whom Emerson called "Our Spartan-Buddhist Henry" (Emerson 1939, 455), wrote in *Walden* of the profound impact Ancient Indian principles had on him: "In the morning I bathe my intellect in the stupendous and cosmogonal philosophy of the *Bhagvat Geeta*" (Thoreau 1894, 459). For Thoreau (and, arguably, for Emerson), the Puritan streak in Christianity had corrupted our connection to the Divine, and reverting to a more organic spirituality inspired by Brahmanism would "restore mankind."[15] Many American Renaissance choreographers embraced this notion of the Supreme Soul and incorporated Brahmanic and yogic principles in their technique, while denouncing the mortiferous and stifling influence of Puritanism.

Ruth Saint Denis, Martha Graham, and the Supreme Soul

While the first influences in her career were certainly Delsartism and the "Greek" dancing and Delsarte-inspired aesthetics of Genevieve Stebbins, Ruth Saint Denis quickly developed a deep fascination for Indian mysticism; her 1906 piece *Radha*[16] is named after the Hindu goddess who in ancient Sanskrit texts is represented as Krishna's lover. While the piece is more of an Orientalist fantasia than an in-depth study of ancient Indian wisdom, the appeal of such a sacred figure to Ruth Saint Denis is obvious in light of her later career and her autobiography and miscellaneous notes preserved at the University of California Los Angeles (UCLA) library: Rādhā's union with Krishna is adulterous, since she is married to another, but according to David M. Wulff, Rādhā's love for Krishna symbolizes "parakīyā, love free from the constraints of marriage" (Hawley & Wulff 1984, 41). Because Rādhā's love for Krishna knows no bounds and overcomes obstacles, it is absolute, and akin to a union with the ātman or Brahman, the supreme life force. For Wulff, "Rādhā, as love embodied, is thus the supreme avenue of religious realization" (Hawley & Wulff 1984, 41). In her autobiography, Ruth Saint Denis recalls initially considering living with her partner Ted Shawn without being married, but the persistent moral stigma attached to female performers and her desire to found a legitimate dance school with a strong spiritual component convinced her otherwise[17] (they got married a year before the official creation of the

Denishawn School in Los Angeles, in 1915, which did not prevent them from each freely exploring their sexuality[18]). In some ancient texts, the sexual union between Krishna and Rādhā is emphasized and presented as a form of prayer, a spiritual and physical union with the divine. The body as a vehicle for prayer and the site of the union with the divine is a recurrent theme in Ruth Saint Denis' reflections about dance. In a 1949 essay she wrote for Jacob's Pillow, she defines "the religious dance" as such:

> The dance of Life of Joy of Truth of Love
> What is the Religious Dance
> But these elements of the Self
> Unfolded in gesture and rhythm, strength and grace
> What is the Religious Dance but these
> In its deepest sense all movement in rhythm is religious in the manner if it's revealing by the body of the cosmic eternal rhythms of the universe.[19]

On the next page, she encourages the dancers of Jacob's Pillow to "dance only our joy and the releasing of our limitless Brahmanic selfhood." In a March 1950 essay entitled "I am Brahman,"[20] Saint Denis dreams of a "supreme divine dance," a mystical expression of the soul through dance. Dance is compared to a form of worship in several texts, like the aforementioned 1949 essay which longs for a "Church of the Divine Dance" (called a "temple-theatre of the dance" in a 1938 radio interview in Philadelphia) or in the essays "A Theatre of Philosophy" and "Creative Arts Colony."[21] The latter substitutes the stern Puritan communities of the early settlers for a spiritual community inspired by Brahmanism and Buddhism whose purpose would be "to free the frustrated energies of inspired artists in America in all fields" and which would function as "a semi-monastic order" fostering artistic creation and collaboration.

For Saint Denis and even more so for her former student, Martha Graham, the female dancer often appears as a high priestess whose ecstatic dance connects to the divine, and the body is the locus of mystical experience. According to Chari, "Yoga, in the words of the *Gita*, is the endeavor to 'lift the self by the self'" (Chari 1959, 298).[22] A fervent believer of that endeavor to find transcendence in the self, Saint Denis was introduced to yoga early on in her career, and she was inspired by this practice for the creation of her piece called *The Yogi* (1908). Graham developed a taste for Oriental philosophy when her family moved to California when she was a teenager (Graham, 44), and even more so when she became a student at

the Denishawn school, where her training was inspired by her mentor's mysticism. She was initiated to Zen Buddhism (Graham, 161) and she was well-versed in several types of yoga. Like her literary predecessors of the American Renaissance, Graham evokes the transcendent spiritual experience of the circulation of energy—or *prāna*—inside the body, which elevates the human soul and connects it to the Supreme Soul: "movement never lies. The body is a very strange business. The chakras awake the centers of energy in the body, as in kundalini yoga. The awakening starts in the feet and goes up. Through the torso, the neck, up, up, through the head, all the while releasing energy" (Graham, 122). Her school, referred to as the "house of the Pelvic Truth" by some of her students, taught dancers to connect to this inner flow of energy: Graham mentions several times the need for female dancers to "move from [their] vagina" (Graham, 211–212). Indeed, in kundalini yoga, the "root" chakra is located in the pelvis, and it is the source of the *prāna* in the body, the life spring of sexual energy, which should remain unlocked at all times, especially for women, since it connects them to the earth and the essence of femininity—creative, generative power. This emphasis on female generative, creative power is a common point for all the female choreographers of the American Renaissance: in her abstract dances, Loïe Fuller concealed the female form underneath billowing fabric and the stage lighting of her own invention. In her dances, the female body wasn't displayed for the male gaze, but condensed to an essence, an abstraction—the essence of the dance, pure movement. The shapes made by the dancing body on stage recall blooming flowers, dancing flames or butterflies coming out of their cocoon. The recurrence of the flower metaphor in Fuller's work can be read as a representation of the female genitalia, and in that sense, the abstract dancing body is condensed to the essence of femininity and represents a powerful feminine force that engenders herself, free from the constraints of the male gaze that weighed so heavily on female dancers in the nineteenth century and in the early twentieth century.[23] Duncan also dreamed of a "dancer of the future" who would dance female divine selfhood:

> The dancer of the future will be one whose body and soul have grown so harmoniously together that the natural language of that soul will have become the movement of the body. The dancer will not belong to a nation but to all humanity. She will dance not in the form of nymph, nor fairy, nor coquette, but in the form of woman in her greatest and purest expression. She will realize the mission of woman's body and the holiness of all its parts.

> She will dance the changing life of nature, showing how each part is transformed into the other. From all parts of her body shall shine radiant intelligence, bringing to the world the message of the thoughts and aspirations of thousands of women. She shall dance the freedom of woman. (Duncan 1928, 63)

This strong, self-generative, and creative womanhood is repeatedly represented in the works of Martha Graham, whose heroines are strong women grappling with the constraints of a patriarchal society and fighting to liberate themselves: this is visible in her "Greek" ballets representing the power of female desire, as well as in pieces like *Appalachian Spring* or *Letter to the World*, where the bride and the "dancing Emily" dance soli that express their longing for freedom and try to vanquish their nemesis, the figure of the Ancestress, who embodies the Puritan spirit, the mortification of the flesh, physical, and creative constraint. For these female choreographers of the American Renaissance, the union with the supreme soul can be achieved through the holy dance of the woman whose body and soul have transcended the disconnect that the Puritan mindset had drilled into women's psyche, and who is perfectly attuned with the divine flow of energy in herself, and with the creative power of the earth. This connection to the ground and its energies is central in Eastern practices like meditation or yoga as well as in Modern dance (both Duncan and Graham notoriously danced barefoot and used the floor) and it also has a special resonance in the context of the American Renaissance in Dance, since it recalls Whitman's barefoot meanderings and the lyric self's organic bond to the land in *Leaves of Grass*.

The Spiritual Children of Walt Whitman

For Graham, as it was for Isadora Duncan, it is from the organic connection between the body of the dancer and the life force, the energy of the land, that true American movement will spring—as she writes in her "Affirmations" collected by Merle Armitage:

> The modern American dance is characterized, like the true dance of any period of world history, by a simplicity of idea, an economy of means, a focus directly upon movement, and behind and above and around all, an awareness, a direct relationship to the blood flow of the time and country that nourishes it. To have an American dance we must take these character-

istics as a starting point, then from a cognizance of old forms we shall build a new order. (1932, Armitage, 100–101)[24]

The legacy both of Duncan's spirituality and the lessons in Brahmanism she learned from Ruth Saint Denis are perceptible in this "affirmation." In Duncan's essay "The Dancer of the Future," Duncan sees the dance as the spiritual union of Atman and Brahman, of the individual self with the supreme one: "The movement of the universe concentrating in an individual becomes what is termed the will … The dance should simply be, then, the natural gravitation of this will of the individual, which in the end is no more nor less than a human translation of the gravitation of the universe" (Duncan 1928, 55). A similar flow of lyric energy, of forward drive, of epic Americanness and of Brahmanic union of the body and the soul courses throughout the written and choreographic works of the artists of the American Renaissance in dance, most of whom professed their admiration and creative debt to their "spiritual father," Walt Whitman, and his groundbreaking *Leaves of Grass*. Whitman is hailed as Isadora Duncan's spiritual father,[25] as a major source of inspiration for Ted Shawn or Martha Graham, and several pieces like Graham's *American Document* (1938), Agnes De Mille's *The Harvest According* (1952), or Helen Tamiris' *Walt Whitman Suite* (1936) pay tribute to the poet's work and incorporate fragments from *Leaves of Grass*. These choreographers were not only inspired by the Americanness and artistic innovations of Whitman's poetry, but also by his association of the body and the soul on a spiritual level. The self-proclaimed "poet of the body, poet of the soul" ("Song of Myself")[26] hadn't studied ancient Indian texts[27] when he wrote *Leaves of Grass*, but the affinities between his conception of the self and the soul and Indian thought were immediately perceptible by his peers who had studied them. In his article on "Hindu Mysticism and Whitman's 'Song of Myself,'" Malcolm Cowley explains that a year after Whitman's opus was published, Thoreau came to him and immediately pointed out the resemblance to "the Orientals" (Cowley, 919–920). In his paper on "Whitman and Indian Thought," V. K. Chari concurs and adds that Emerson compared *Leaves of Grass* to the *Bhagavad-Gita* (Chari 1959, 291). According to Cowley:

> He believed that the Self (or atman, to use a Sanskrit word), is of the same essence as the universal spirit … He believed that true knowledge is to be acquired not through the sense or the intellect, but through union with the Self. … This true knowledge is available to every man and woman, since

each conceals a divine Self. Moreover, the divinity of all implies the perfect equality of all, the immortality of all, and the universal duty of loving one another. (Cowley 1973, 922)

Chari attributes Whitman's cultivation of harmony between the body and the transcendent soul to "a species of Yoga or meditative discipline" (297–298) and underlines the resemblance between the transcendent exultation in Whitman's poems and the teachings of the *Upanishads* (298). Dance appears several times in *Leaves of Grass* and is usually associated to physical and spiritual exultation: in an Orientalist conflation (also present in Ruth Saint Denis' or Loïe Fuller's Orientalism), the 4th section of "Proud Music of the Storm" brings together the "religious dances old and new" of "dervishes," "Persian," and "Arab" sacred dances as well as "Greek" dancing in an ecstatic whirl where the self experiences a spiritual fusion with the supreme self:

> Fill me with all the voices of the universe,
> Endow me with their throbbings, Nature's also,
> The tempests, waters, winds, operas and chants, marches and dances,
> Utter, pour in, for I would take them all! ("Proud Music of the Storm", end of section 5)

For the choreographers as well as the writers of the American Renaissance, "The Orient is in the West," as Emily Dickinson put it in a March 1885 letter to Mabel Loomis Todd: it represents progress, a movement away from the Puritan past toward a future system which rehabilitates the body and doesn't disconnect it from the soul. Equating the Orient with the Frontier and westward movement is extremely significant, since it moves away from a Eurocentric perspective to an American perspective in which the Orient is indeed in the West and Europe in the East, but it also reinforces the American dichotomy between the Puritan East, symbolizing the history and the past of the country and the West as its future.

For Whitman, dance is certainly not the way to the Devil and the damnation of the soul, as Mather, Calvin, and numerous other writers would have it: it is on the contrary a mystical experience, where the healthy movement of the body leads the soul to spiritual ecstasy. Emily Dickinson herself represented dance as an escape, a way for the soul to play and free

itself. In her poem "I cannot dance upon my Toes" (F381) the fantasized Romantic ballet embodies the way the spirit can move and deploy itself beyond social, mental, and physical limitations. Poem F360 "The Soul has Bandaged moments" features a shackled soul breaking free and dancing "like a Bomb, abroad" (third stanza) in an ecstatic release that allows her to get closer to "Paradise" (4th stanza). Writing or dancing the American soul, for the artists of the American Renaissance, is a spiritual quest for their own identity as American artists, a way to transcend the European codes imposed on them and to invent a new language.

Notes

1. John Calvin, sermon 79: "to hoppe and daûnce like stray beasts" is seen in this sermon as the work of the devil, and an "inticement to whoredome" (*Sermons of Maister John Calvin upon the Booke of Job*, trans. Arthur Golding, London: Thomas Woodcocke, 1584, 373–374). This comparison is also present in Nathaniel Hawthorne's short story "The May-Pole of Merry Mount," *Twice-Told Tales*, NY: Th. Y. Cromwell, 1902, 42–53.
2. Wagner mentions *Footloose* and *Dirty Dancing*, but the association between dance and moral corruption is present in many TV and film productions, as exemplified by recent American TV series such as *Flesh and Bone* (2015) and *Tiny Pretty Things* (2020).
3. The opening chapter "The Prison-Door" alludes to the expansion of the city of Boston, for example.
4. V. K. Chari writes, "In the years during which the *Leaves* were in the making there was a considerable vogue in America for Hindu religious ideas, particularly through the enthusiasm of the New Englanders. And the English and American periodicals of the time contained much Vedantic material" (Chari, 291).
5. This organic association between indigenous movement and the American landscape can be found several times throughout her autobiography: "All these movements—where have they come from? They have sprung from the great Nature of America, from the Sierra Nevada, from the Pacific Ocean, as it washes the coast of California; from the great spaces of the Rocky Mountains—from the Yosemite Valley—from the Niagara Falls" (Duncan, 223).
6. Graham also incorporated passages from the Declaration of Independence in her ballet *American Document*.
7. Iser defines the "repertoire" of the text as "all the familiar territory within the text. This may be in the form of references to earlier works, or to social

and historical norms, or to the whole culture from which the text has emerged" (Iser 1978, 69).
8. As Sally Banes notes, Balanchine "was fascinated with popular images of the 'Wild West', with white square dancing" (Banes 1994, 56).
9. *Rodeo* was initially choreographed for the Ballets de Monte-Carlo, and *Western Symphony* is danced on pointe in the neo-classical Balanchine style.
10. "Popular vaudeville, revue-dance, and popular jazz or swing music; that is what we could call American character dancing—our parallel to the national dances of Spain, Italy or Russia" (Kirstein, 90). Both *Rodeo* and *Western Symphony* feature classical idioms, like the *pas de deux*, or dancing on pointe in the case of Balanchine's ballet, as well as choreographic Americanisms—parallel turns, steps substituting hitting the floor with the toes by the heel of the flexed foot as in country dance, as well as the alignment of the body which is often tilted or off-center.
11. Even in these quieter passages, the music continues to differ from what would normally be expected of *pas de deux* music in European ballets and maintains its core Americanness, as in the *grand pas de deux* in the first movement of *Western Symphony*, which is danced to honky-tonk piano instead of a string orchestra for example.
12. For further discussion of the persistence of ancient models in American culture, see the introduction by Ronan Ludot-Vlasak to the special issue of *Transatlantica*, "The Poetics and Politics of Antiquity in the Long Nineteenth Century," n° 2, 2015, https://journals.openedition.org/transatlantica/7830
13. "Re-vision—the act of looking back, of seeing with fresh eyes, of entering an old text from a new critical direction—is for us more than a chapter in cultural history: it is an act of survival. Until we can understand the assumptions in which we are drenched we cannot know ourselves. And this drive to self-knowledge, for woman, is more than a search for identity" (Rich 1972, 18).
14. When Fuller and Duncan first appeared on French stages, their daring innovations were "excused" and accepted by the public—who would have been unmitigatingly shocked otherwise—because they were American. Journalist Jules Huret recalled in *La Patrie* and in his 1908 essay "L'École de danse de Grünewald" that Duncan's unorthodox choice of music was attributed to her "barbaric American ways" ("danser sur du Schumann! C'est bien un goût barbare de Yankee!" quoted by Allard 1997, 18). Fuller was also characterized by her fearlessness, her individuality, and her bold experimental streak; see Cappelle (ed) (2020, 159–171).
15. "Our manners have been corrupted by communication with the saints. Our hymn-books resound with a melodious cursing of God and enduring him forever. One would say that even the prophets and redeemers had

rather consoled the fears than confirmed the hopes of man. There is nowhere recorded a simple and irrepressible satisfaction with the gift of life, any memorable praise of God. All health and success does me good, however far off and withdrawn it may appear; all disease and failure helps to make me sad and does me evil, however much sympathy it may have with me or I with it. If, then, we would indeed restore mankind by truly Indian, botanic, magnetic, or natural means, let us first be as simple and well as Nature ourselves, dispel the clouds which hang over our own brows, and take up a little life into our pores. Do not stay to be an overseer of the poor, but endeavor to become one of the worthies of the world" (Thoreau, 125).

16. The final movement of the piece is available in Jacob's Pillow digital archives: https://danceinteractive.jacobspillow.org/ruth-st-denis/the-delirium-of-senses-from-radha/
17. Saint Denis (1939, 165–167). Graham married her partner Erick Hawkins at his request, after 8 years of living together (Graham, 174).
18. In her autobiography, Graham recalls that Shawn was quite open about his relationships with his various boyfriends (Graham, 70) although Saint Denis and Shawn remained devoted to each other.
19. "What is the religious dance?" The Ruth Saint Denis Papers, UCLA library, Special Collections, box 64, folder 3.
20. The Ruth Saint Denis Papers, UCLA library, Special Collections, box 65, folder 5.
21. Ibid.
22. Chari also underlines the fact that Thoreau practiced Yoga and refers to it in *Walden* (298).
23. Fuller was a queer artist, and her life partner and herself frequented the lesbian *salons* of Paris, where Gab Sorère routinely appeared dressed as a man.
24. She reiterated this imperative in 1936: "To the American dancer I say 'Know your country'. When its vitality, its freshness, its exuberance, its overabundance of youth and vigor, its contrasts of plenitude and barrenness are made manifest in movement on the stage, we begin to see the American dance" (Armitage 1968, 105). "We must look to America to bring forth an art as powerful as the country itself. We look to the dance to evoke and offer life" (Armitage 1968, 107).
25. "I am indeed the spiritual daughter of Walt Whitman" (Duncan, 21).
26. Section 21 famously opens with "I am the poet of the Body and I am the poet of the Soul."
27. Chari however argues that although there are no records in Whitman's notes of a careful study of these texts, Whitman would still have been familiar with Vedantic principles due to their popularity at the time: "Whitman,

who read almost everything that came his way, could not have escaped some contact with these ideas ... Whitman's knowledge of the Vedanta, if he possessed any knowledge of it at all, may have been indirect, derived through the Transcendentalists, and mainly through the writings of Emerson, which surely influenced him during his formative years" (Chari, 292).

WORKS CITED

Allard, Odette. 1997. *Isadora, La danseuse aux pieds nus, ou La révolution Isadorienne, d'Isadora Duncan à Malkovsky*. Paris: Éditions des Écrivains Associés.

Armitage, Merle. 1968. *Martha Graham, The Early Years*. New York: Dance Horizons.

Balanchine, Georges, and Francis Mason. 1977. *Balanchine's Complete Stories of the Great Ballets*. New York: Doubleday.

Banes, Sally. 1994. *Writing Dancing in the Age of Postmodernism*. Hanover & London: Wesleyan UP.

Cappelle, Laura, ed. 2020. *Nouvelle Histoire de la Danse en Occident, De la Préhistoire à nos Jours*. Paris: Seuil.

Chari, V.K. 1959. Whitman and Indian Thought. *Western Humanities Review* 13: 291–297.

Cowley, Malcolm. 1973. Hindu Mysticism and Whitman's 'Song of Myself'. In *Walt Whitman, Leaves of Grass*, ed. Sculley Bradly and Harold W. Blodgett, 918–926. New York: W. W. Norton & Company.

Dickinson, Emily. 1958. In *The Letters of Emily Dickinson*, ed. Thomas H. Johnson and Theodora Ward. Cambridge: The Belknap Press of Harvard University Press.

———. 1998. *The Poems of Emily Dickinson*, edited by Ralph W. Franklin, Variorum Edition, 3 volumes. Cambridge: The Belknap Press of Harvard University Press.

Duncan, Isadora. 1928. *The Art of the Dance*. New York: Theatre Art Books.

———. 2013. *My Life*. New York & London: Liveright Publishing.

Emerson, Ralph Waldo. 1939. In *The Letters of Ralph Waldo Emerson*, ed. Ralph L. Rusk. New York.

———. 1971. In *The Collected Works of Ralph Waldo Emerson*, ed. Robert E. Spiller, vol. 3. Cambridge.

Graham, Martha. July 1943. *Script for Appalachian Spring*. Copland Collection, The Library of Congress.

———. 1992. *Blood Memory, An Autobiography*. London: Macmillan.

Hawley, John Stratton, and Donna Marie Wulff, eds. 1984. *The Divine Consort, Rādhā and the Goddesses of India*. Delhi, Varanasi, Patna: Motilal Banarsidass.

Hawthorne, Nathaniel. 1986. *The Scarlet Letter (1850)*. London and New York: Penguin.

Iser, Wolfgang. 1978. *The Act of Reading, a Theory of Aesthetic Response (1976)*. Baltimore and London: The Johns Hopkins University Press.
Kirstein, Lincoln. 1938. *Blast at Ballet, A Corrective for the American Audience*. New York City: Martin's Press.
Ludot-Vlasak, Ronan. 2015. The Poetics and Politics of Antiquity in the Long Nineteenth Century. *Transatlantica* 2. https://journals.openedition.org/transatlantica/7830.
Matthiesen, Francis Otto. 1969. *American Renaissance: Art and Expression in the Age of Whitman and Emerson (1941)*. London, Toronto: Oxford University Press.
Noverre, Jean-Georges. 1760. *Lettres sur la danse et les ballets*. Available in its original edition at http://obvil.sorbonne-universite.site/corpus///danse/noverre_lettres-danse_1760_orig#lettre-11.
Paramananda, Swami. 1918. *Emerson and Vedanta*. Boston: The Vedanta Centre.
Rich, Adrienne. October 1972. When We Dead Awaken: Writing as Re-vision. *College English* 34(1):18–30.
Saint Denis, Ruth. 1939. *An Unfinished Life: An Autobiography*. New York: Harper and Brothers.
Shawn, Ted. 1926. *The American Ballet*. Henry Holt & Co.
Thoreau, Henry David. 1894. *Walden, or, Life in the Woods*. Boston & New York: Houghton Mifflin.
Wagner, Ann Louise. 1997. *Adversaries of Dance from the Puritans to the Present*. Urbana & Chicago: University of Illinois Press.
Whitman, Walt. 2002. In *Leaves of Grass and Other Writings*, ed. Michael Moon. New York: Norton.

CHAPTER 10

Casting the Soul: Antony Gormley's Sculptures

Coralie Griffon

[...] One cannot touch the body without considering the soul [...].
Antony Gormley, "Body and Soul," 1990

In contemporary English, the word "soul" may be used to refer to "a work of art which possesses an emotional or intellectual energy or intensity" (Oxford English Dictionary), but this definition remains somewhat vague. The English noun "soul" comes from the German *Seele* meaning "seabed" while in French, the noun *âme* comes from the Latin word *anima* meaning breath, life, air. The latter may be associated with the origin of the word *spirit* whose etymology also evokes air and breath. The references to the classical elements of air and water seem to allude to the universe as a whole,[1] while also pointing to something literally *ungraspable*.

The soul has long been understood and explained through dichotomies: body versus soul, materiality versus immateriality, interiority versus exteriority. Greek philosopher Plato thought the body was the "tomb" or

C. Griffon (✉)
Compiègne University of Technology, Compiegne, France

© The Author(s), under exclusive license to Springer Nature Switzerland AG 2024
D. Louis-Dimitrov, E. Murail (eds.), *The Persistence of the Soul in Literature, Art and Politics*,
https://doi.org/10.1007/978-3-031-40934-9_10

prison of the soul (1999, n. p.), while French philosopher Michel Foucault made the reverse statement, stating that "the soul is a prison for the body" (1975, 38), because it is subjected to political and social powers.

Contemporary British artist Antony Gormley does not seem to think about the soul or the body in terms of hierarchy or even in term of tensions. On the contrary, according to him, they are intimately interwoven and cannot be separated, as shown by the use of "and" in the title of a series of prints *Body and Soul* (1990) (Fig. 10.1).

He uses ancient techniques in order to go beyond the materiality of the body and the artwork. In the first part of his book entitled *L'Art et L'Âme* (which translates as *Art and the Soul*), René Huyghe examines the use of chiaroscuro and *sfumato* (a technique consisting in blurring the contour of an object) to show how Renaissance artists endeavoured to show the invisible to the "mind's eyes" which were constructed in opposition to the "body's eyes" (1960, 96). Gormley too uses chiaroscuro to blur the limit

Fig. 10.1 Antony Gormley, *Body and Soul I*, 1990. Etching on 300 gsm Somerset TP textured paper. 50 × 58.1 cm. © the artist

between the inside and outside of the body. His work is also reminiscent of negatives and positives in photography. On the one hand, there are four white prints with black imprints of Gormley's hands, knees, forehead, and spine. The positive images of real body parts are nonetheless quite difficult to identify as such since they look like abstract forms floating on white paper. Moreover, the contour of each form is not well defined, which shows the role of chance in the making of those imprints. Indeed, each form could have been slightly different since they come from the position the body had on the paper at a certain moment in time. They are, therefore, *traces* of the body that are *registered* on paper. It seems that Antony Gormley wants viewers to reassess what they think they know about their body. This impression is also conveyed in the five other prints which are all black with white marks representing the five main orifices of the body. The five prints function as negative images of the orifices since the use of black may suggest that we are looking through the orifices from the inside of the body while the colour white attracts the eye, like a spot of light in darkness. Gormley invites viewers to observe what they normally ignore, the emptiness left by the absence of skin, the materiality of the orifice. This interior space is not used to map the inside of the body with its veins, muscles, and organs but to reveal what is ungraspable about the being, the principle of life. The series of prints can be linked to a statue entitled *Learning to See* (1993) which represents a man standing with his eyes closed (Fig. 10.2).

The title surprisingly stipulates that the statue is learning to *see*, so viewers would expect it to have open eyes. Because the statue seems to be aware of its own posture with its arms and legs straight and stiff, the statue seems to be actively looking at its own self, at the inside of its own body without paying much attention to its environment. The artist acknowledges that "Sculpture, in stillness, can transmit what may not be seen" (Hutchinson et al. 2010, 118). He considers that there is something to look at *inside* the body which does not pertain to anatomy. Antony Gormley describes the series as follows: "The idea of *Body and Soul* is […] to think about the portals of the body as literally being windows of the soul, but windows seen from the inside and not from the outside" (Barbero and Moszynska 2010, 28). The word "window" is interesting since it involves the issue of perception, which is about both seeing and understanding, about both the senses and the mind. It seems that Gormley considers the soul to be part of the body, or embodied, and according to him, the body is the medium which enables man to connect his inner

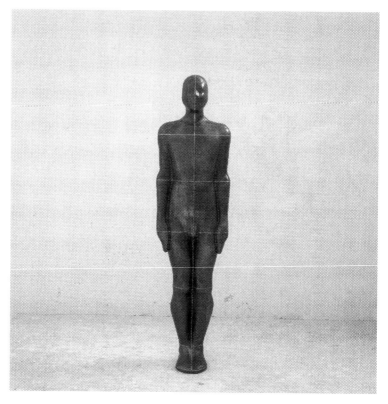

Fig. 10.2 Antony Gormley, *Learning to See*, 1993. Lead, fibreglass, plaster, and air. 197 × 53 × 36 cm. © the artist

space with his environment. The soul—that essence contained within the body—is not visible, but it can be *perceived*, as suggested by *Body and Soul* and *Learning to See*.

This article examines how the tensions between the visible and the invisible, the inside and the outside, are poetically intertwined in Gormley's works to breathe life into his statues. How can these statues, which do not mimetically represent man, convey emotions and humanity? We will examine how both the materiality of the body and of the sculptures are directly related to the question of perception.

Representing the Soul

In his essay *Laocoon* first published in 1766, Gotthold Ephraim Lessing (1729–1781) begins by quoting Johann Joachim Winckelmann (1717–1768), who notices that the statue of *Laocoon*, although suffering a lot as shown by its contorted body, is not screaming. That very fact, according to Winckelmann, conveys greatness of soul (Lessing 2011, 9–13). It was indeed commonly believed that the face, and especially the eyes, were the residence of the soul. Roland Barthes commented on it: "the Western eye is subject to a whole mythology of the soul, central and secret, whose fire, sheltered in the orbital cavity, radiates toward a fleshy, sensuous, passional exterior" (1982, 102). It was also thought that the brain, and notably the pineal gland, was the place where the soul might reside since it was at the centre of the brain and at the top of the body. More recently, science has played a central part in the quest to understand our emotions. However, some artists have shown a particular attachment to the idea that the eye may have a particular role to play for the soul. In the twentieth century, Alberto Giacometti thought that an artist had to focus on the eyes to represent a person since what truly brought them to life was their gaze (Bonafoux 2004, 88). Ernst H. Gombrich points out that beholders gazing at a contemporary work of art representing eyes will often assimilate the perceived object to a person, hence the continuous significance of eyes in the art world,[2] as is the case in Gormley's installation *Field for the British Isles* (see Fig. 10.3). The piece consists of 40,000 small terracotta figurines all staring back at the beholders. It is interesting to note that the figurines were handmade by 100 volunteers from Merseyside—by a community rather than by a single artist. The figurines occupy the whole space, preventing viewers from entering the space they occupy. Each figurine has two holes for eyes which are looking directly at the audience. The installation creates a mirror effect since both viewers and figurines are staring straight at each other. The eyes imagined by Gormley are simple big holes—they are endowed with depth and yet, they do not copy reality. They both reveal and obscure each figurine's interiority. The figurines seem quite vulnerable: they are tiny and bear the fingerprints of their makers, a form of memory. However, the sheer size of the installation makes it an imposing presence and requires a huge exhibition space. The installation was described by the artist as a "soul garden" (Gormley 1993), acknowledging the role of the eyes in representing life. Yet, at the same time, the tensions which stem out of the installation

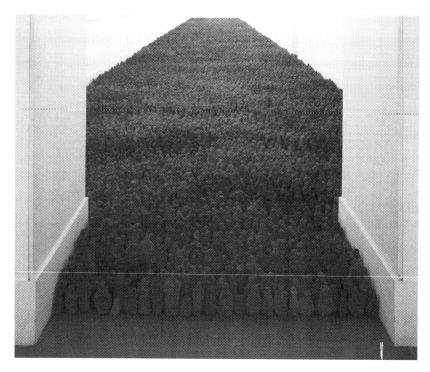

Fig. 10.3 Antony Gormley, *Field for the British Isles,* 1993. Terracotta. Variable size: approx. 40,000 elements, each 8–26 cm tall. Arts Council Collection, Southbank Centre, London, England. Installation view, Irish Museum of Modern Art, Dublin, Ireland. © the artist

highlight that the soul, or the life principle, may be conveyed not just through eyes, but also through other means.

Besides, most of Gormley's statues have very few details and marks on their surface, apart from their exposed soldered joints. The faces of his lead body cases only bear faint marks of eyes, noses, or mouths. This is the case for the 100 statues which make up *Another Place* (see Fig. 10.4), a permanent installation displayed in Crosby near Liverpool since 2005. The figures are staring at the horizon, lost in contemplation. Their bodies are stiff and still, engrossed by contemplation. The seeming absence that is conveyed by their gaze is coupled with physical absence as well. Indeed, depending on the ebb and flow of the tides, statues may be revealed or

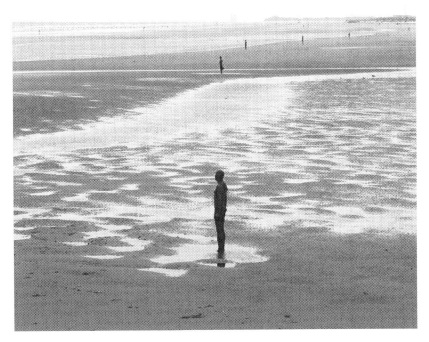

Fig. 10.4 Antony Gormley, *Another Place*, 1997. Cast iron. 189 × 53 × 29 cm (100 elements). Permanent installation, Crosby Beach, Merseyside, England. © the artist. Photography by Stephen White & Co.

submerged. Similarly, some of them are progressively buried in the sand blown by the strong winds. Chance and nature are continuously transforming the piece, thereby endowing it with poetic undertones. These constant transformations remind us of the vulnerability of the human body and turn the piece into a kind of memento mori. To translate emotions and emphasize the depth of human interiority, Gormley pays attention to the *whole* body and not just to the face.

Furthermore, although the 100 statues of the installation are replicas of Gormley's bodies, they do not bear any of Gormley's distinctive facial features. What seems to be particularly surprising and paradoxical with Gormley's statues is that they convey emotions and depth through very few details. Antony Gormley uses casting to make them as resemblant as possible to the human body, but at the same time gives them this quite

vague, somewhat unfinished air. Gormley explains: "[In this piece], I have been interested in asking what is the nature of the space a human being inhabits. What I try to show is the space where the body was, not to represent the body itself" (Wroe 2005). The quotation directly refers to the notion of *trace* which is left by the absence of a body in the mould. The trace appears after the body leaves and shows where the body was. It illustrates the fact that Gormley is more interested in the trace of the body rather than in a physical, mimetic body. And his body cases, which refer to his statues made of lead, or to his statues of the installation *Another Place*, epitomise the paradox of the imprint that has been explored by French philosopher Georges Didi-Huberman in *La Ressemblance par Contact*. According to him, the paradox of cast objects is that they are both very close to and distant from the object they come from. The cast object is the result of direct *contact* with the original object but at the same time, it is difficult to identify the cast object with its referent. Gormley's body cases paradoxically seem to mark the presence of an absent body; they are the markers of something which was there, to echo Roland Barthes's phrase about photography.[3] It seems that Gormley's statues are both physical objects and abstract traces. The artist acknowledges that his statues are "physical objects"—cases—but "also a case as in an argument made with forensic evidence. [...] They deny their present-ness" (Gormley 2002). This impression is reinforced by the fact that they are grey, achromatic, bearing no colour. Moreover, they are described by Gormley as being "tools for carrying nothing, nothing else than emptiness, shadow, darkness, carrying the condition of embodiment" (Gormley 2008, 52). On the one hand, the body cases can be negative images of the bodies whose contours stand out from the bright space surrounding them. On the other hand, the lead body cases can be seen as three-dimensional shadows that would be both Gormley's and the viewer's shadow. Georges Didi-Huberman writes about the "physical shape of shadow,"[4] which also refers to the materiality of the shadow (2001, 100). W.J.T. Mitchell states that: "His mechanically reproduced "corpographs" are already *non-sites* in themselves, like three-dimensional photographs that refer to the absent space of a body" (Hutchinson et al. 2010, 179). They *record* man's presence more than they *show* something. The images of the negative and of the shadow helping us describe Gormley's lead body cases take us back to photography as illustrated by Alfred Stieglitz's *Shadows on the Lake* (1916) for example, and to the origin of painting described by Pliny the Elder. In *Natural History*, he describes how the daughter of the potter Butades of

Sicyon outlined her lover's shadow upon a wall to make up for his absence (Stoichita 2000, 15). Butades then used this outline to model the face of her lover in clay, which brings us back to sculpture. Moreover, the use of casting inscribes Gormley in a long history since that process has been used since prehistoric times, as acknowledged by Didi-Huberman (2008, 40). Gormley's body cases seem to represent those bodies' souls rather than just bodies. That possibility for sculpture to represent the soul is not new and dates back to Ancient Egypt where statues used to represent either the departed or gods. Those statues were thought to have a soul, the *Ka*, which was believed to be a shadow (Stoichita 2000, 19). Sculpture enables the artist to deal with the immateriality of the body, with something absent, evanescent, and uncertain, which the weight and the volume of some of his works also convey. Besides, Gormley seems to ask questions about the very soul of sculpture itself by emphasizing the immateriality rather than the materiality of the body.

THE EMPTINESS AND LIGHTNESS OF GORMLEY'S BODIES: PERCEIVING THE IMPERCEPTIBLE

To associate his sculptures with lightness, Gormley plays with gravity, placing some statues on the wall (as in *Lock I*, 1994), or suspending some statues to the ceiling or to another statue as exemplified by the piece *Dawn* (1988). What is most striking in *Lock I* (see Fig. 10.5) is the disconnection between the statue and the floor. Antony Gormley's works are by-products of the loss of the plinth, notably triggered by Auguste Rodin, who was the first artist to question the link between the statue and the floor through the plinth. As for the work *Dawn* (see Fig. 10.6), it lies directly on the floor and is therefore quite vulnerable to damage. The vulnerable nature of humans is hinted at through the vulnerability of the statue. This piece too, through its associations with death, may be seen as a kind of memento mori. This sculpture is composed of a supine lead body over which a prone fibreglass and plaster figure with outstretched arms seems to be floating. The three-dimensional shadow in that piece seems to be the fibreglass figure. This floating body is quite ambivalent, being both light and heavy. Indeed, it is suspended over the lead body and affixed to the lead phallus: viewers are uncertain whether the body hovering on top is leaving the supine lead figure on the floor, or descending into this lead figure, which is reminiscent of a case, a coffin, or a sarcophagus. *Dawn* materialises the

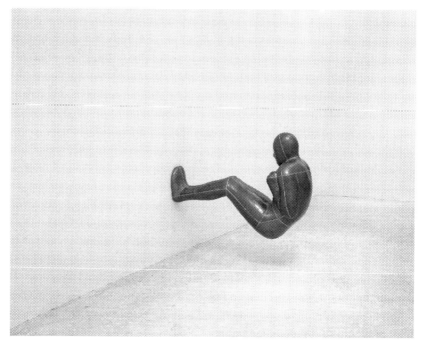

Fig. 10.5 Antony Gormley, *Lock I*, 1994. Lead, fibreglass, plaster, steel, and air. 92 × 59 × 127 cm. Museum Voorlinden, Wassenaar, the Netherlands. © the artist. Photograph by Stephen White & Co

complex reality of human nature, showing both its materiality and immateriality. The piece recalls the rich iconography of Christian images depicting the soul leaving its body and elevating itself toward the sky or toward God—which is emphasized by its cross-shaped appearance. Moreover, the fibreglass and plaster body—which is an intermediary layer in the process of making—could echo the intermediary process of the soul leaving its mortal "case." Yet, the title, *Dawn*, evokes daylight as if the plaster figure had descended to meet and bring light to the lead figure. If the piece hints at a Catholic motif, the ambivalence of the suspension makes it uncertain and unclear. Is the cross-shaped figure a kind of soul or spirit? Can it be separated from the body? Is it immortal as stated in the fifth council of the Lateran which took place between 1512 and 1517? Gormley, who comes

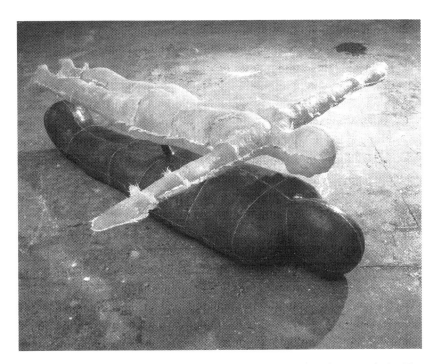

Fig. 10.6 Antony Gormley, *Dawn*, 1988. Lead, fibreglass, plaster, and air. 65 × 194 × 210 cm. © the artist

from a Catholic background, perceptibly acknowledges some of these ideas, yet he also gestures towards the mystery of the life principle.

This piece also evokes this passage from the *Bible*: "And the LORD God formed man of the dust of the ground, and breathed into his nostrils the breath of life; and man became a living soul" (Genesis 2:7 KJV). This takes us back to the very origin of the noun "soul," *anima* in Latin. Interestingly, Antony Gormley mentions air in the list of materials next to lead, and fibreglass. Admitting that there is air is to give it some *material* existence and thus to give the soul a palpable existence too. Air is mentioned as a material to make man in the Bible and it is also a material used by Gormley to make lead statues. In both cases, air is contained *inside* the body. Considering the lead body case, air can be considered to be cast inside it. The presence of air in the list of materials is also interesting because it cannot be seen. It may remind viewers of Marcel Duchamp's

Air de Paris, a ready-made[5] originally created in 1919. It shows a glass container on which Duchamp wrote "air de Paris" and which was signed by the artist. Similarly, the title asserts the presence of air. Italian artist Penone described Duchamp's work as being a sculpture of air (Busine 2012, 23). Many of Penone's sculptures themselves are about breathed and blown air. Interestingly, Antony Gormley asserts that he is using his body as a ready-made (Gormley et al. 2011, 57), which draws us back to Duchamp. In addition, Gormley's statement shows his aim to take the body as it really is to turn it into a work of art. It also means that, according to Gormley, air is part and parcel of the human body. Yet, if artists acknowledge the presence of air in the room and in the environment and try to *reveal* it such as Duchamp's *Air de Paris*, Gormley deals with the air as circulating in and out of the body through breath. It is less about *revealing* the air than becoming aware of its presence everywhere. The connection between the body and the environment through breath is illustrated in the following quotation about *Another Place* (see Fig. 10.4) and seems to show how difficult breathing may be in an inappropriate environment:

> This sculpture exposes to light and time the nakedness of a particular and peculiar body: no hero, no ideal, just the industrially reproduced body of a middle-aged man trying to remain standing and trying to breathe, facing a horizon busy with ships moving blocks of coloured containers around the planet. (Hutchinson et al. 2010, 158)

As for John Hutchinson, he asserts that the whole body of work breathes (2010, 84). Moreover, Gormley explains that the use of air and breath comes from his willingness to reflect about being alive:

> I think that the abstract body was really invented in Mathura, India in the fifth century AD during the Gupta period. In this tradition, life does not have to be expressed through action […] but through breath, through an implied inner potency expressed in the compound curves of an invented body […]. (Gormley 2015, 76)

As a matter of fact, Gormley's body is covered by different layers of materials so that it can be cast. During the process, if Gormley's torso is inflated because of breathing, that will be seen from the outside, through the curve of the torso. As a consequence, Gormley's lead body cases are the products of a living moment that is frozen in time. The "implied inner potency" mentioned by the artist could well have been replaced with the

noun "soul" because of the association with air and breath. Furthermore, Gormley's interpretation shows the continuous interest in breath as a life principle which may be found, not only in the Bible and art, but also in Greek myths. The myth of Prometheus and Athena also refers to breathing and life together since Prometheus's figures were given the breath of life by Athena (De Samosate 2015, 1024). Therefore, air as a synonym for life seems to be a topos that has *survived* throughout history. The idea of survival draws us back to Aby Warburg who questioned motifs that were paradoxically both evolving and resisting evolution (Warburg 2012, 2–3; Didi-Huberman 2002, 53). The motifs of both shadow and air seem to be means to show that the soul is an *immortal* or *persisting* subject.

Not only do some of Gormley's statues contain air, but some of his statues are barely visible. In 2019, a Gormley exhibition was organised on Delos, a Cycladic uninhabited island. It displayed some of his works in the midst of remarkable archaeological sites. Some of his statues were sometimes barely distinguishable. The statue *Connect* (2015) (see Fig. 10.7) was placed near an architectural element which echoed its motif: *Connect*

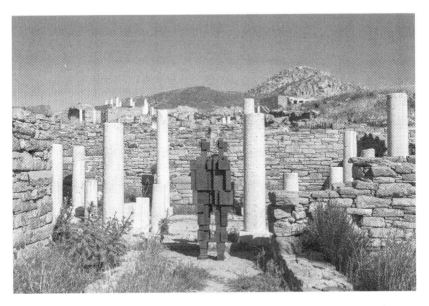

Fig. 10.7 Antony Gormley, *Connect*, 2015. Cast iron. 192.5 × 70 × 51 cm. Installation view, "Sight," Delos, Greece, 2019. © the artist. Photograph by Oak Taylor Smith

is composed of cubes reminding the viewer of the stones of the wall in the background. Statues like *Signal II* (2018), *Chute II* (2018), and *Station XIX* (2014) were literally made to disappear in the landscape.[6] These statues are made of cast-iron rods, which creates a very thin outline mostly characterised by emptiness as if the statues were haunting the place. Made mostly of air, they look like ghosts of what was once a living body. According to Didi-Huberman, ghost-like statues maintain a reciprocal relationship with the place where they are found (2001, 136). Reciprocity is found in Gormley's works too. Indeed, on the one hand, the statues frame the landscape and, on the other hand, the landscape endows them with a specific background, so with some kind of physicality. Yet, it necessarily dwarfs these statues and makes them quite difficult to spot since they are nearly *transparent*, which brings out the issue of perception (Figs. 10.8 and 10.9).

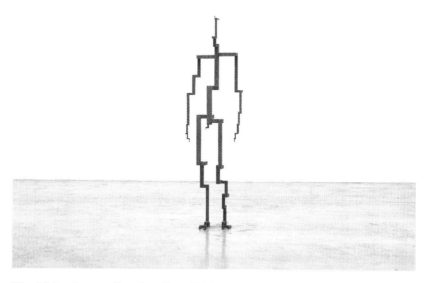

Fig. 10.8 Antony Gormley, *Signal II*, 2018. Cast iron. 189 × 51.8 × 35.5 cm. © the artist. Photograph by Stephen White & Co.

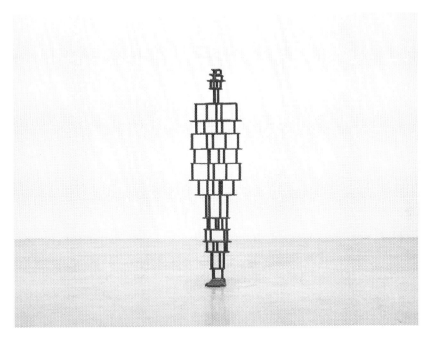

Fig. 10.9 Antony Gormley, *Station XIX*, 2014. Cast iron. 193.8 × 48.9 × 35.5 cm. © the artist. Photograph by Stephen White & Co.

The statue *Station XIX* is constituted of a grid which is reminiscent of the invention of perspective in the Renaissance, the aim of which was to reproduce reality as artists saw it from a specific place (Damisch 1997, 120–1). Yet the pattern of the grid here does not help the artist to reproduce a body realistically. On the contrary, it makes it more abstract because viewers may gaze through the grid which opens onto the landscape. The grid seems to cut the landscape metaphorically as if there was an invisible canvas, the statue acting as a frame or window through which the painter is looking (Stoichita 2017, 29 and 64). Therefore, the body may be seen as a *window*, enabling the viewer to observe or at least to focus on something he may not have paid attention to otherwise. This interpretation reminds us of Rosalind Krauss's theory about the grid. For her, the grid triggers a centrifugal movement which enables viewers to focus on the space around rather than on the object (1985, 102–3). Gormley's body is here a *medium* which helps viewers see better. Yet, Krauss also argues that

the grid sets off another opposite movement which focuses on the surface of the work of art and on its physical characteristics (1985, 94). Paradoxically, the grid both enhances the presence of the work but also eclipses it. Therefore, the materiality of sculpture may not be an inherent characteristic of contemporary sculpture. Indeed, for Rosalind Krauss, the very nature of sculpture in the twentieth century has become "increasingly problematic," (1981, 2), in part because the limits between different artistic domains have become quite blurred. As a matter of fact, some sculptural works have been said to be *drawings* in space. The use of wire by Walter Bodmer (1903–1973) and Alexander Calder (1898–1976) created linear statues rather than works with volume. Other artists from different generations, such as Ibram Lassaw (1913–2003), also used wire to compose statues with voids and lines. Antony Gormley may be the successor of these artists: Anna Moszynska states that Gormley *draws* the body in space with some of his works (Barbero and Moszynska 2010, 49). Statues like *Signal II* (see Fig. 10.8) or *Chute II* can therefore be seen as three-dimensional drawings or two-dimensional sculptures. This paradox may also confirm the link between drawing and sculpture since many notorious sculptors practised both drawing and sculpture as complementary activities.[7] In addition, Gormley stated that "[drawings] are literally the foundation of [his] sculpture" (Barbero and Moszynska 2010, 6). The ambivalent nature of sculpture here may echo the ungraspable nature of human beings. Gormley declared that "[his] return to the body in sculpture is to ask, 'what is a body?'. It starts from the notion of being uncertain about what a human body is and what it might mean. A human being is a place of becoming, it isn't an already known object" (Daskalopoulos et al. 2019, 90). The idea of "becoming" mentioned by the artist is reflected in the shape of some statues which seem to be quite blurred, *in the making*. To give but an example, the series *Feeling Material* (see Fig. 10.10) shows a body which is trapped in the midst of.[8] It is a dynamic sculpture illustrating the state of becoming. It is also becoming in the beholder's eyes since the body's contours appear progressively to the viewers and are not easy to make out. Sculpture is paradoxically used by Gormley to show what is difficult to perceive. By questioning the materiality of sculpture, he manages to question the materiality of the body as well. Through sculpture, he questions what we think we know or what we take for granted.

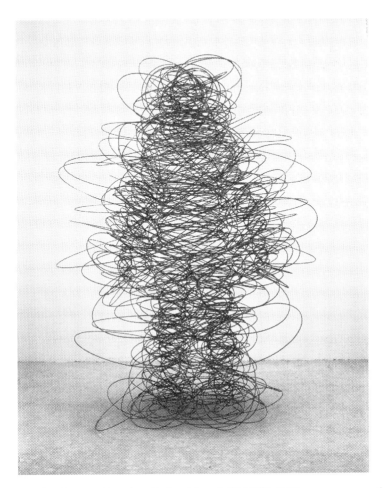

Fig. 10.10 Antony Gormley, *Feeling Material I*, 2003. 3.25 mm square section rolled mild steel hoops of various diameters. 205 × 154 × 128 cm. The SCHAUWERK Sindelfingen Collection, Sindelfingen, Germany. © the artist. Photograph by Stephen White & Co.

It is not easy to use the noun "soul" correctly as its referent seems to always escape us. The word "soul" may often be replaced by others such as "spirit" or "mind," as they are originally linked. Scholars may employ a different terminology: Georges Vigarello states that "interiority" has

replaced the soul (2016, 255) while Gaston Bachelard talks about "intimate immensity" (1964, 184). Gormley refers to "an implied inner potency" when speaking about what makes people *human*. Yet, the idea of the soul being *inside* the body persists, hence the constant exploration of the inside of the body, be it through art or science. The ungraspable characteristic of the soul and of human nature seems to have motivated Gormley to be a sculptor. In an interview with Ernst H. Gombrich, he declared: "I want to start where language ends" (Hutchinson et al. 2010, 12). French philosopher Michel Serres remarked that statues came before language (2014, 49). Sculpture may be a means to articulate ideas that language cannot express. Yet, one should not forget that the power of language resides in its very limits, since it reflects man's own limitations. Both the limits of language and Gormley's works may illustrate why the soul persists in today's world: probing the depth of human nature remains one of the great challenges we face.

Notes

1. "Having the four classical elements symbolically encoded in the meaning of this very simple word, soul, may seem somewhat puerile and vain." (My translation. Original quotation in French: "On trouvera peut-être puérile et vaine cette symbolique des quatre éléments inscrite dans la langue de ce mot si simple, l'âme.") In Jean Clair (dir.), *L'Âme au Corps. Art et Sciences. 1793–1993* (Paris: Réunion des musées nationaux/Gallimard, 1993), 57–58.
2. See chapter 3 "Pygmalion's power" in Ernst H. Gombrich, *Art and Illusion, a Study in the Psychology of Pictorial Representation* (London: Phaidon Press Limited, 1960).
3. The phrase "*ça a été*" used by the French philosopher about photography in Roland Barthes, *La chambre claire. Note sur la photographie* (Paris: Gallimard, 1980), 119–22.
4. Personal translation.
5. A ready-made is a manufactured object which is designated as a piece of art by the artist. The object was not originally made for an artistic use and its appearance is often not modified by the artist who just signs it. Marcel Duchamp produced the most famous ready-mades, such as *Fountain* (1917).
6. See photographs of the works in Dimitris Daskalopoulos et al., *Sight. Antony Gormley on Delos. Archaeological Site and Museum* (Athens: NEON, 2019).
7. As an example, an exhibition was organised by the Musée Rodin in Paris entitled "Rodin—cut-out drawing" from 6 November 2018 to 24 February

2019. The museum possesses 7500 drawings by Auguste Rodin. For scholars, focusing on his drawings is essential to understand Rodin's sculptures.
8. Gombrich studied how whirls and rivers can create forms. See Ernst H. Gombrich, "The Form of Movement in Water and Air," in *The Heritage of Apelles. Studies in the Art of Renaissance* (Londres: Phaidon Press Limited, 1976), 39–56.

Works Cited

Bachelard, Gaston. 1964. *The Poetics of Space* [1958]. Translated by Maria Jolas. New York: The Orion Press.
Barbero, Luca Massimo, and Anna Moszynska. 2010. *Antony Gormley. Drawing space*. Milan: MACRO/Electa.
Barthes, Roland. 1980. *La Chambre claire. Note sur la photographie*. Paris: Gallimard.
———. 1982. *Empire of Signs*. New York: Hill and Wang, Farrar, Straus and Giroux, Inc.. https://monoskop.org/images/1/10/Barthes_roland_Empire_of_Signs_1983.pdf.
Bonafoux, Pascal. 2004. *L'Autoportrait au XXe siècle. Moi je, par soi-même*. Paris: Diane de Selliers.
Busine (dir.), Laurent. 2012. *Giuseppe Penone*. Arles: Actes Sud.
Clair (dir.), Jean. 1993. *L'Âme au corps. Art et sciences. 1793-1993*. Paris: Réunion des musées nationaux/Gallimard.
Damisch, Hubert. 1997. *L'Origine de la Perspective*. Paris: Flammarion.
Daskalopoulos, Dimitris, Demetris Athanasoulis, Elina Kountouri, Iwona Blazwick, Emily Riddle, and Fanis Kafantaris. 2019. *Sight. Antony Gormley on Delos. Archaeological Site and Museum*. Athènes: NEON.
De Samosate, Lucien. 2015. *Œuvres complètes*. Paris: Editions Robert Laffont.
Didi-Huberman, Georges. 2001. *Génie du non-lieu. Air, Poussière, Empreinte, Hantise*. Paris: Les Éditions de Minuit.
———. 2002. *L'Image Survivante. Histoire de l'Art et Temps des Fantômes selon Aby Warburg*. Paris: Les Éditions de Minuit.
———. 2008. *La Ressemblance par contact. Archéologie, anachronisme et modernité de l'empreinte*. Paris: Les Éditions de Minuit.
Foucault, Michel. 1975. *Surveiller et punir*. Paris: Gallimard.
Gombrich, Ernst H. 1960. *Art and Illusion, a Study in the Psychology of Pictorial Representation*. London: Phaidon Press Limited.
———. 1976. The Form of Movement in Water and Air. In *The Heritage of Apelles. Studies in the Art of Renaissance*. London: Phaidon Press Limited.
Gormley, Antony. 1993. Antony Gormley interview with Declan McGonable. In *Antony Gormley*, exh. cat., Malmö Konsthall, Malmö, Sweden/Tate Gallery, Liverpool, England/Irish Museum of Modern Art, Dublin, Ireland. London:

Tate Gallery Publications. Accessed November 9, 2017. http://www.antony-gormley.com/resources/interview-item/id/132.

———. 2002. Silence and Stillness, Antony Gormley interviewed by Enrique Juncosa. In *Centro Galego de Arte Contemporanea, Santiago de Compostela, Spain*, ed. Lisa Jardine, Michael Tarantino, and Antony Gormley. Accessed March 25, 2018. http://www.antonygormley.com/resources/interview-item/id/137.

———. 2008. Interview with Pierre Tillet. In *Between You and Me*, ed. Rod Mengham, Fernando Huici March, Pierre Tillet, and Antony Gormley. Paris; Salzburg: Galerie Thaddaeus Ropac.

———. 2015. *On Sculpture*. London: Thames & Hudson.

Gormley, Antony, Mikhail Piotrovsky, Margaret Iversen, Dimitri Ozerkov, and Anna Trofimova. 2011. *Antony Gormley. Still Standing*. London: Fontanka Publications.

Hutchinson, John, Ernst H. Gombrich, Lela B. Njatin, and Willam J.T. Mitchell. 2010. *Antony Gormley*. London: Phaidon Press Limited.

Huyghe, René. 1960. *L'Art et l'âme*. Paris: Flammarion.

Krauss, Rosalind. 1981. *Passages in Modern Sculpture*. Cambridge & London: The MIT Press.

———. 1985. *The Originality of the Avant-Garde and Other Modernist Myths*. Cambridge: The MIT Press.

Lessing, Gotthold Ephraim. 2011. *Laocoon*. Paris: Klincksieck.

Oxford English Dictionary. 2nd ed. http://www.oed.com/.

Plato. 1999. Cratylus, Translated by Benjamin Jowett. Accessed 21/02/20. https://www.gutenberg.org/files/1616/1616-h/1616-h.htm.

Serres, Michel. 2014. *Statues*. Paris: Flammarion.

Stoichita, Victor. 2000. *Brève Histoire de l'ombre*. Genève: Librairie Droz.

———. 2017. *L'Instauration du tableau*. Genève: Librairie Droz.

Vigarello, Georges. 2016. *Le Sentiment de soi. Histoire de la perception du corps. XVI-XXe siècle*. Paris: Éditions du Seuil.

Warburg, Aby. 2012. *L'Atlas. Mnémosyne*. Paris: L'Écarquillé.

Wroe, Nicholas. 2005. "Leader of the Pack." *The Guardian*, June 25, 2005. https://www.theguardian.com/artanddesign/2005/jun/25/art

CHAPTER 11

Sweet Soul Music

Adrian Grafe

Do you like good music?
That sweet soul music
Help me get the feeling
I want to get the feeling
Otis Redding's got the feeling

Last lines of Arthur Conley's "Sweet Soul Music" (1967)

INTRODUCTION

According to Jacques Arènes in *Nos vies à créer*, the soul is not something that just exists, that is merely there; he writes of the powers and activities of the soul (Arènes 2014). If the soul has powers and activities, one of the things it does, according to Hegel's *Aesthetics* (III, ii; as quoted by Liszt 1855), is speak, and speak through music. "Music is [...] the language of the soul." It is language produced by the soul and addressed to the soul. The soul? Whose soul or souls? The soul of the musician or composer on the one hand, and the soul of the listener on the other. The point is that it

A. Grafe (✉)
Artois University, Arras, France

© The Author(s), under exclusive license to Springer Nature Switzerland AG 2024
D. Louis-Dimitrov, E. Murail (eds.), *The Persistence of the Soul in Literature, Art and Politics*,
https://doi.org/10.1007/978-3-031-40934-9_11

does not involve one soul but at least two souls. The fact that music is the language of the soul guarantees its persistence, since music-making is an inherent activity of all peoples. This is a Romantic view of the nature of music, but it is well epitomized by soul music. Soul music seen or rather heard in this light is a tautology: all music is soul music. If all music is soul music, then soul music is doubly soulful. Soul music accords primacy to feeling—witness the repetition of the word in the lines from Conley's song quoted in the epigraph—and this naturally reflects the idea that the soul is an organ, not only of a moral and intellectual nature but also, and perhaps above all, of feeling. In response to T.S. Eliot's remark in his Nobel speech, "the expression of one's feelings calls for resources which language cannot supply," Christopher Ricks has written: "Eliot's thought has the amplitude to accommodate the ways in which voice and music, for instance, are evidently resources which language cannot supply—but with which language is then happy co-operatively to achieve compound interest in the art of song" (Ricks 2020, 197). This is once again doubly true—borrowing Ricks's expression, we might say interest on compound interest—when the song is a soul song, because feeling (emotion) and feelings lie so saliently at the core of soul music.

Origins and Features: Soul Music as Palimpsest

Rather than use the perhaps facile (and probably dead) metaphor of the idea of roots, or think of soul music as having a monolithic identity, one might rather consider it as a palimpsest, and a living or ongoing one at that. (Be it said in passing that, while the term "roots" appears in his book title, philosopher Joel Rudinow tends to use a geneticist terminology, writing of the "birth" of soul music, from "the union of gospel music with rhythm & blues" (Rudinow 2010, 17)). Adèle (to take but one contemporary example, though atypical because Adèle is both white and British) is in herself a one-woman history of foremothers (the geneticist language is hard to avoid) and godmothers (just as James Brown was nicknamed "the godfather of soul"). Adèle's soul voice incorporates Etta James's, just as Etta James's does Bessie Smith's. Beneath soul lies rhythm and blues, beneath rhythm and blues, jazz and blues, beneath blues, work songs and songs sung by slaves working on cotton plantations in the American South, and ballads. In tension with blues, one finds gospel, beneath gospel, hymns and sacred songs dating back several centuries. Soul in turn lies beneath more recent forms of musical expression. Beneath hip-hop lies

rap, and beneath rap, soul. This is the strength and persistence of the soul: the soul of soul music travels through these other musical forms. That means that there is no distinct boundary between them, which is indeed Peter Guralnick's argument in his classic study *Sweet Soul Music* (1999).

One might have recourse to images other than the palimpsest: call soul music a dialogue with other musical genres; or a polyphony, encapsulating several musical genres to form a new one. This explains why Ray Charles (1930–2004) is often deemed the originator of soul music, as he blended, from the 1950s on, gospel, jazz and blues, developing a new sound out of these various styles (see Unterberger n.d.). Though the origin of the term as applied to a style of music is hard to determine—OED (1989) quotes one author, S. Henderson, as saying that it "surfaced" in the "musical community" and the wider Black Community in the late 1950s—an article in the BBC magazine *Radio Times* on 19 July 1979, also cited by the OED, claims: "The word 'soul' probably originated with Ray Charles." This is probably as unprovable as it is plausible.

But if music is the language of the soul, then in the case of soul music, it is trilingual. There are three strands that go to make up soul music. Some of the best soul singers are thus trilingual; and "soul music places emphasis on singing" (Macmillan Dictionary). It can mediate faith, sensuous and sometimes sensual love, and powerful protest. Because of this triple dimension, soul music is arguably protreptic.[1] This metamorphic, self-transformative dimension of soul music chimes with archetypal symbolism for the soul such as the cocoon, the chrysalis, and the butterfly. A live version of Marvin Gaye singing the jazzy, gentle "God is Love" has him introduce the song by saying (presumably he had just finished a harsher or more up-tempo song): "I'm now going to chameleonise myself in order to get into the mood of the song" (Gaye 2013).

Souls in Faith

Soul music comes out of church, gospel music. British critic Clive Anderson writes:

> Soul music is made by black Americans and elevates "feeling" above all else. It began in the late fifties, secularized gospel embracing blues profanity, and dealt exclusively with that most important subject, the vagaries of love. The sound remains in church. More often than not soul is in ballad form and employs certain gospel and blues techniques—call and response patterns,

hip argot and inflection, melismatic delivery. It is a completely vocal art....
Soul assumes a shared experience, a relationship with the listener, as in blues, where the singer confirms and works out the feelings of the audience. In this sense it remains sacramental. (quoted by Guralnick 1999, 3)

The biographies of at least three of the most outstanding exponents of soul music—Sam Cooke, often regarded as the inventor of soul; Aretha Franklin, the mother of soul along with foremothers like Billie Holiday and Etta James; and Marvin Gaye—reveal that their fathers were all ministers of the gospel, and that they all started singing in church.

Marvin Gaye's "Let's Get It On" (Gaye 1973) is a joyful love song; the spiritual power of love is here emphasized by the use at the end of the song of gospel idioms unsuspected in the intimately erotic opening of the song:

> I've been really tryin', baby
> Tryin' to hold back this feeling for so long
> And if you feel like I feel, baby
> Then, c'mon, oh, c'mon
>
> Let's get it on
> Ah, baby, let's get it on
> Let's love, baby

And then towards the end, just as the handclaps come in, so reminiscent of gospel celebrations:

> C'mon, baby
> Do you know the meaning?
> I've been sanctified
> Girl, you give me good feeling
> I've been sanctified

It took the genius of Marvin Gaye explicitly to bring out the transcendent dimension within soul music when it was at its most erotic.

SOULS IN LOVE

Soul's second language is love, love songs. They express joy, sadness and sweetness in different combinations. Article 79 of Descartes's Passions of the Soul says: "Love is an excitation of the soul [...], mobilizing it to join with the objects of its love" (Descartes 1989, 62; translation modified). Soul music is the language of love, or at least a language of love.

Let us consider one love song. Taking a good look at "The Tracks of My Tears" (Robinson 1965), it is easy to trace the singer's argument. His manner, what he shows the world, his social persona, is just that: show, performance. The song is a performance of a performance. The persona is the type of clown hiding his sadness with a cheerful veneer, the universal trope of the human being using a social mask to conceal his true emotions. He turns the cliché of crocodile tears on its head: his grief has turned his social behaviour, his smile, the girl on his arm, into simulacra. The only real thing about him is his tears; even though he acts cheerful, and does not cry in public, the tracks of his tears cannot be washed away: the point of the lyric is to offer something of the singer's soul, a representation of the real person, that is, precisely the one that society does not see. This topic was clearly something of an obsession with Smokey Robinson. In 1967, he released "Tears of a Clown," and in the same year, "The Love I Saw in You Was Just a Mirage."

One can detect the hint of melancholy, and even shyness, in Marvin Tarplin's simple three-chord electric guitar introduction. Throughout the song, the grounding of its being remains the discreet guitar pattern. The Miracles' harmonies interplay with Robinson's swooping falsetto, at first a low falsetto, then rising higher and higher as the song progresses, from the second couplet onwards. Note how well the idea of the falsetto fits the song, the false—artificial—surface as opposed to the soul depth. The Funk Brothers rhythm section interacts with the Detroit Symphony Orchestra, and one discerns the way in which the syncopated descending trumpet riff is picked up at the climax of the song with the repeated A major chord in the line "my smile is my makeup I wear since my breakup with you." One could also wonder at how sometimes Robinson sings the same thing as the Miracles, and at others he stops short, momentarily breaks off, just as the girl he loves has broken the relationship off.

Manuel Garcia in his *New Compendious Treatise on the Art of Singing* (1857) says that what counts is not "the literal sense of the words, but the emotion of the soul from which they spring" (Garcia 1857, 69). Like

Hegel, Manuel Garcia also uses the phrase "the language of the soul", though for him, it is not music itself which is that language: "The series of expressive accents obtained from changes of respiration, and the employment of different timbres form an inarticulate language made up of tears, interjections, cries, sighs etc, which may be termed the language of the soul" (Garcia 1857, 71). The soul then expresses itself through language, both verbal and non-verbal. A transcript of the vocal which included non-verbal sounds (and the semi-slang "yeahs") not appearing in any version of the lyrics might look like this (last eight lines):

> **Hey, hey-yeah**, outside I'm masquerading
> Inside my hope is fading
> I'm just a clown **ooh yeah** since you put me down
> My smile is my make-up I wear since my break-up with you
> Baby, take a good look at my face, **oh-ah-ah**
> You'll see my smile looks out of place
> **Yeah**, just look closer, it's easy to trace
> **Oh**, the tracks of my tears, baby, baby, baby **Ooh yeah, Ooh**

The song's soulfulness finally arises from far more than the sum of its lyric and non-lyric parts, of course, and Robinson uses the resources of his voice to underline the persona's sadness, but these sounds also naturally express the singer's enthusiasm for his art.

SOULS IN HOPE OF CHANGE: SOCIAL POLITICAL, AND ECOLOGICAL CONSCIOUSNESS

Clive Anderson's definition of soul music does not take into account a third dimension. This is a particular source and motive of persistence: soul is a vehicle for expressing political and social consciousness, and therefore a call to political and social change and progress. This is the Civil Rights aspect of soul music. Soul music in its first heyday was a creative force and an agent for consciousness-raising, for social change, being taken up by the Civil Rights movement in the case of Sam Cooke's "A change is gonna come" or written directly to bear witness to, and take part in, necessary social change, as with Marvin Gaye's song and album *What's Goin' On* (1971).

Gaye, as it were, took the link between earlier soul music and the Civil Rights movement, and extended it so that his new music—his new soul—expressed his protest at social conditions in the early seventies. Gaye

wrought a specific aspect of the persistence of soul music, when he shifted it single-handedly from a Civil-Rights ethos to a human-rights one: "Human rights…that's the theme," he said of the album (*Rolling Stone*, 2012). Gaye said in an interview: "I realized that I had to put my own fantasies behind me if I wanted to write songs that would reach the souls of people" (*Rolling Stone*, 2012). He also said: "I felt the strong urge to write music and to write lyrics that would touch the souls of men" (Robinson 2001). To describe his approach to *What's Going On*, Gaye constantly uses the word "soul" not to describe the music itself but in terms of his communicative aim. Soul music at its best—which *What's Going On* is—is not first and foremost a musical style originating in a specific ethnic group, although it is that. It is soulful because it consciously intends to reach the audience's souls.

The song "What's Going On" shares features of Smokey Robinson's "The Tracks of My Tears," but is more innovative, showing how Motown soul could integrate social consciousness, something that Motown's executives initially refused to contemplate precisely because it was not the kind of love-song material they were used to and that had worked so well commercially for them. Gaye extends the language of soul in several ways in the song: he introduces unusual chords, which the ear might more readily associate with jazz (thus nodding, perhaps, to soul's origins and Ray Charles), and changes key several times. He complicates the song's emotion by creating a party atmosphere from the beginning, with the speech of the male voices greeting one another over the semi-improvised soprano saxophone introduction: "What's happening! Nice to see you!…" This is arguably a version of social—albeit all-male—solidarity. The handclaps and the return of the male party voices confirm the joyfulness which the song expresses. It is also a joyfulness that the song aims for, since the actual lyrics, protesting the Viet Nam war and social conflict, are mournful. Like Smokey Robinson in "The Tracks of My Tears," Gaye goes off-script (or rather off-lyric-sheet) with much non-verbal singing, including scat-singing, which arguably suits the musical context extremely well, and does not sound like an allusion to the scat style of singers like Ella Fitzgerald. Gaye thus manages to bring together layers of conflicting emotions and ideas, reflected in his extension of the musical style. Gaye's overdubbed lead vocals combine a smooth-sounding tone with his trademark rough-edged style familiar from "I heard it through the grapevine"; he was to alternate these two styles—bitter on the verse, sweet on the chorus—in

"Let's Get It On." Incidentally, Gaye's raw, rougher style was not so far removed from that of Arthur Conley, who was not a Motown artist.

Hegel suggests that the creation of art is "a liberation of the soul, which music carries to the most extreme heights" (quoted by Eldridge 2007, 120). Soul music is at once the liberation of souls—both artist's and audience's—and a call for the liberation of souls.

Marvin Gaye persisted in getting it on as one can see from his song "Keep Gettin' It On" from the *Let's Get It On* album. In this variant on "Let's Get It On", he combined all three languages—love, religion and social awareness—in one song: "Oh, wouldn't you rather make love, children? / As opposed to war/Like ya know ya should" And then later in the song,

"Oh, Jesus is trying to get the people to come on/To get it on/Yes, Lord, oh, get it on (get it on, got to get it on)."

As said above, then, some of the best soul singers are thus trilingual, having a strong feeling for the expression of faith, are sensuous and sometimes sensual lovers in song, and have a social conscience. The story of sweet soul music is in part the—sometimes fraught—story of Afro-Americans seeking integration into American society, reaching out to jazz and classical musicians to play with them, irrespective of ethnicity or skin colour; wanting to make money and take care of their own business affairs; and opening doors for other Afro-American artists and beyond them for the whole Afro-American community.

Among many others, Aretha Franklin, for example, with the proto-#METOO anthem "R-E-S-P-E-C-T," Sam Cooke and Marvin Gaye, three of the most outstanding musicians and singers of all time, were all on the side of social and political change and expressed it in their music. Franklin, Cooke and Gaye combine, then, the drive to express the need for societal change in ways consonant with their Christian spiritual heritage and beginnings as mentioned above. Such music goes beyond ethnic labels, to touch people whatever their ethnic background or indeed language. Hence, when necessary, Motown artists would not hesitate to bring in white musicians. Their music was about inclusiveness, porosity and change.

However, historically, Tamla Motown record label productions, like the records of Marvin Gaye, Smokey Robinson and many others, have always been seen as having a crossover intention: in other words, the ambition of

aiming music made by Afro-American artists at a white audience, thus giving them increased exposure and earning more money. But this cynical, if realistic, view does not tell the whole story. Soul music wasn't just a bi-ethnic art form. It was inclusive, designed to appeal to non-black audiences (which did not therefore mean just white audiences). Motown founder Berry Gordy said, as quoted by Smokey Robinson (2001) and Jim Wright (2018): "We're not just going to make black music. We're going to make music for the world." Soul music, Motown above all, is the ultimate in inclusive music. In an Instagram post, Smokey Robinson wrote (quoted by Mail Online 2019): "The beauty of Motown is that we're a family made up of Black, White, Hispanic and Asian women and men." Hence soul music contributes to the creation of one world. Soul music was black and urban. But some of the musicians who made it did not, or at least not always, see it from such a limited perspective. This explicitly goes beyond the much-touted idea that Motown and other major soul music producers were aiming solely at black-white integration. Gordy's statement shows that his ambitions for Motown were global, and in this he and his roster of artists were successful. But one can also consider soul music as lying at the origin of the whole notion of world music which has come to the fore only relatively recently. Moreover, while Rob Bowman's excellent entry on soul music in the *Continuum Encyclopedia of Popular Music of the World* suggests that "[j]ust as the soul is understood to represent the essence of a given individual, soul music was understood, implicitly by some, explicitly by others, to represent in some sense the very essence of black culture" (2012, 439), it would also be tenable to broaden the definition to include not only essence but also transcendence on one hand, and understandings of the soul referred to above on the other, understandings that deem the soul to be the seat of the emotions, an observation which complements Jacques Arènes's idea of the soul already quoted.

Soul Music as Universal: And Pluriversal

In his One World Anthropology, Tim Ingold says that the soul is not an "object-in-itself." He says, "It is, more fundamentally, a movement, which takes the grammatical form not of the noun or pronoun, but of the verb.

And the most outstanding characteristic of this movement is that it carries on, or keeps on going?" (Ingold 2018, 159). In a word, it persists.

If music is the language of the soul, and the soul is movement, then one of the best means of expressing the soul, if not of representing it, is music, since music by definition is dynamic, constantly moving forward. Hence we are not surprised when Tim Ingold draws on the language of music to convey his notion of the soul. However, by the soul, Ingold does not want us to understand just the soul of an individual, but rather what he refers to as "soul-life" (Ingold 2018, 159), a larger entity of which individuals are a part but which is not the sum of individual souls. Ingold sets up the analogy between "soul-life" and

> polyphonic music, in which every voice, or every instrument, carries on along its own melodic line. In music the relation between parts and whole is not summative—neither additive nor multiplicative—but contrapuntal. Think of the tenor part in the chorus or the cello part in the symphony. I want to think of the life of every particular soul, likewise, as a line of counterpoint that, even as it issues forth, is continually attentive and responsive to each and every other. (Ingold 2018, 160)

Souls, then "co-respond." But this is not a relationship of give and take. It is souls going side by side, Ingold says, "like companions walking together or playing music together." No instrument is lost or drowned in the mass, but plays alongside the others and co-responds to them. Precisely because souls go along together "soul-life is a whole that cannot be decomposed without causing grief if not destruction to the lives of its parts" (Ingold 2018, 160).

Conclusion: SZA, Sheeran and the Persistence of Soul

Tim Ingold argues that the soul persists as souls and in souls, not primarily as *the* soul. Soul music as a palimpsest and as a malleable, inclusive, metamorphic genre persists to this day in avatars with an undoubtedly less spiritual dimension than the soul music of the last century. Soul is (only) a musical category and as such some of its greatest artists have consciously gone beyond the limits imposed by categorization (and record companies with an eye to a fast buck). Once again, Marvin Gaye is the best example of an artist wilfully bucking trends, and in somewhat contradictory

fashion, too. The author-performer of "Let's Get It On" could say: "I never wanted to sing the hot stuff. [...] I wanted to be a pop singer," and sing "pop ballads." And Gerri Hirshey praises what she calls Gaye's "counterpoint of finesse and funk" (Hirshey 1984, 217).

A US singer like SZA has adapted a soul singing style to contemporary electronic hip-hop rhythms and diction to produce a twenty-first-century definition of soul. British artist Ed Sheeran had, in 2021, three ongoing court cases around accusations of plagiarism that he ripped off "Let's Get It On" for his song "Thinking Out Loud" (2014). The upside of Sheeran's court-cases for music-lovers is that it will, one hopes, have introduced the vastly talented Sheeran's younger generation of fans to the unalloyed genius and originality of Marvin Gaye. As has been argued throughout this chapter, if soul originated in black consciousness, it is universal—and pluriversal—in outlook, and this point was never in doubt among the artists themselves, and was even made casually, as in this retort by Otis Redding to a neighbourhood boy who somehow managed to gatecrash his way into Redding's session on the day he happened to be writing and recording one of his future classics, "Dock of the Bay," and had said he liked Redding's singing of the song and would like to be a singer himself: "If you got the feelin', you can sing soul. You just sing from the heart, and—there's no difference between nobody's heart" (Booth 1995, 323). Or their soul, he might have added for, as Arthur Conley pointed out in the only way possible, that is, in song, Otis Redding's "got the feeling." But among the attributes that finally give soul music its soul, in the best instances, along with the qualities of musicianship, rhythm and melody that are as inimitable as they are indefinable, is both the quality and intensity of feeling the singer brings to their vocal performance, the feeling the accompanists bring to theirs, and the performers' desire, so eloquently articulated by Marvin Gaye, to touch the souls of the performer's listeners.

Notes

1. From the noun protrepsis: a call to a new way of life.
2. All quotations from Ingold are in Tim Ingold, "One World Anthropology," *HAU: Journal of Ethnographic Theory* 8 (1/2), 2018, 158–171.

WORKS CITED

Arènes, Jacques. 2014. *Nos vies à créer*. Paris: Cerf. Kindle.
Booth, Stanley. 1995. 1967: The Memphis Soul Sound. In *The Faber Book of Pop*, ed. Hanif Kureishi and Jon Savage, 320–324. London: Faber and Faber.
Conley, Arthur. 1967. *Sweet Soul Music*. USA: Atco. Single.
Descartes, René. 1989. *The Passions of the Soul*. Translated by Stephen Voss. Indianapolis/Cambridge: Hackett.
Eldridge, Richard Thomas. 2007. Hegel On Music. *Hegel And The Arts* 119–145. Accessed May 4, 2021. https://works.swarthmore.edu/fac-philosophy/106.
Garcia, Manuel. 1857. *New Compendious Treatise on the Art of Singing*. Boston: Oliver Ditson Company. Accessed May 4, 2021. https://archive.org/stream/agq3849.0001.001.umich.edu/agq3849.0001.001.umich.edu_djvu.txt.
Gaye, Marvin. 1971. *What's Going On*. USA: Tamla Motown. Album.
———. 1973. *Let's Get it On*. Youtube audio. Accessed May 4, 2021. https://www.youtube.com/watch?v=P-1b2xght_U.
———. 2013. *God is Love*. Youtube audio. Accessed May 4, 2021. https://www.youtube.com/watch?v=ztqHHpkgo8w.
Guralnick, Peter. 1999 [1986]. *Sweet Soul Music: Rhythm and Blues and the Southern Dream of Freedom*. Boston: Little Brown and Company.
Hirshey, Gerri. 1984. *Nowhere to Run: The Story of Soul Music*. London: Macmillan.
Ingold, Tim. 2018. One World Anthropology. *HAU: Journal of Ethnographic Theory* 8 (1/2): 158–171.
Liszt, Franz. 1855. *Berlioz and his 'Harald' Symphony*. Accessed May 4, 2021. https://is.muni.cz/el/1421/podzim2008/VH_751/liszt.html.
Mail Online (n.a.). 2019. Smokey Robinson defends Jennifer Lopez amid criticism of her Motown tribute performance at the Grammys: 'Kids of all races grew up loving the music of Motown'. February 19. Accessed May 4, 2021. https://www.dailymail.co.uk/tvshowbiz/article-6698073/Smokey-Robinson-defends-Jennifer-Lopez-amid-criticism-Motown-tribute-performance.html.
Oxford English Dictionary (OED). 1989. (second edition). Entry on "soul". Accessed May 4, 2021. https://www.oed.com/oed2/00231475.
Ricks, Christopher. 2020. Dylan's Resources. In *21st-Century Dylan: Late and Timely*, ed. Laurence Estanove, Adrian Grafe, Andrew McKeown, and Claire Hélie, 197–202. New York, London: Bloomsbury Academic.
Robinson, Smokey, and the Miracles. 1965. *The Tracks of My Tears*. USA: Tamla Motown. Single. Accessed May 4, 2021. https://www.youtube.com/watch?v=rNS6D4hSQdA.
———. 2001. Liner note to deluxe edition of Marvin Gaye's album *What's Going On*. Accessed May 4, 2001. http://www.bignoisenow.com/christina/whatsgoingon.html.

Rolling, Stone. 2012. Best Albums of All Time: Number One: Marvin Gaye, *What's Going On.* https://www.rollingstone.com/music/music-lists/best-albums-of-all-time-1062063/marvin-gaye-whats-going-on-4-1063232/.

Rudinow, Joel. 2010. *Soul Music: Tracking the Spiritual Roots of Pop from Plato to Motown.* Ann Arbor: The University of Michigan Press.

Unterberger, Richie. n.d. *Biography of Ray Charles.* Accessed May 4, 2021. https://www.allmusic.com/artist/ray-charles-mn0000046861/biography.

Wright, Jim. 2018. *Smokey Robinson Reflects on Motown's Birth.* November 28. Accessed May 4, 2021. https://www.aarp.org/entertainment/music/info-2018/smokey-robinson-motown-interview.html.

PART III

The Ethics and Politics of the Soul

CHAPTER 12

Colliding Circles: Ralph Waldo Emerson's Concept of the Soul Between Spiritual Self-Realization and Materialistic Expansion

Olga Thierbach-McLean

The beginning of the new decade has confronted us with the abrupt end of an era. As the world has been grappling with a pandemic of historic proportions, people across the globe have been forced to rethink taken-for-granted aspects of their private and public lives. This humanitarian crisis came at a moment when the global community was also facing a surge in anti-democratic ideologies, the erosion of trust in political and economic institutions, and the existential ecological challenge of climate change. Particularly in such times of societal upheaval and shifting paradigms, we are impelled to reevaluate who we are and who we aspire to be, individually as well as collectively.

In the U.S., this national reckoning has taken a particularly exigent form as the pandemic has struck in an election year during the most turbulent and controversial presidency in recent history, exacerbating the

O. Thierbach-McLean (✉)
Independent Scholar, Hamburg, Germany
e-mail: olgatmclean@gmail.com

© The Author(s), under exclusive license to Springer Nature Switzerland AG 2024
D. Louis-Dimitrov, E. Murail (eds.), *The Persistence of the Soul in Literature, Art and Politics*,
https://doi.org/10.1007/978-3-031-40934-9_12

frictions in a society already deeply polarized with respect to wealth distribution, racial equity, and political attitudes. So intensely felt is this rift that both conservative and progressive camps cast the 2020 election as a referendum on the country's very spiritual identity. While Joseph Biden adopted the phrase "Battle for the Soul of the Nation" as his campaign slogan, election ads for Donald Trump called on voters to "Save America's Soul." This dramatic rhetoric invites a fundamental inquiry: What defines this collective soul? Which values, tenets, and sensibilities shape national character, a concept so elusive and so persistent at the same time?

In a U.S. context, it is difficult to think of a better place to investigate this question than in the work of Ralph Waldo Emerson (1803–1882). Although he is often thought of as being one of the more unwieldy canonized writers, his ideas have resonated so widely that he has been credited with being "America's most revered prophet" (Gougeon 2008, 173), the "source of American wisdom" (Mitchell 1997, 69), and the "founding father of nearly everything we think of as American in the modern world" (Donoghue 1988, 37). While these may sound like ambitious claims to make about one single voice, Emerson's cultural impact can hardly be overstated. During his lifetime, he was already considered the quintessential American intellectual. Thus, in 1838 eminent British writer and social theorist Harriet Martineau stressed that "without knowing Emerson it is not too much to say that the United States cannot be fully known" (Martineau 1838, 228). By the same token, when the U.S. showcased itself at the 1867 Paris Universal Exposition, visitors to the American exhibit were presented with a portrait of Emerson alongside paintings of the Rocky Mountains and Niagara Falls. Evidently Emerson's contemporaries already felt that his philosophy was as central to the American iconography as the country's most spectacular natural sites. Indeed, he would leave a lasting imprint on the landscape of U.S. intellectual history as the figurehead of the American Renaissance and the trailblazer of pragmatism, the only philosophical school to originate in the U.S.

The galvanizing effect of his ideas derived from their capacity to capture the national mood of his time, blending the celebration of individual freedom, can-do optimism, and freewheeling spirituality. But what continues to make them so relevant to the present moment is that they provided the framework for modern-day discourses on social reform, civic rights, and the relationship between self and society. In a country that has traditionally conceived of itself as the land of boundless possibilities, Emerson's 1841 essay "Self-Reliance" still stands as the central manifesto of American

individualism, the ultimate ode to what he hailed as "the infinitude of the private man" (*Journals* 7:342). As historian Robert D. Richardson has remarked, it is "the single best place to see how the self-rule of classical Stoicism, the *Bildung* of Goethe, the subjective theology of Schleiermacher, and the revolution of Kant and his successors come to be translated into accessible language [...] and—what is much more important—shown to have a constant bearing on everyday life" (Richardson 1995, 322). It is not least due to the strong resonance of Emersonian creeds in U.S. culture that, to borrow Stanley Cavell's words, Americans are a "half-Transcendental, half-pragmatic people" (qtd. in Mudge 2016, xix). The evidence for this collective capability to simultaneously embrace spirituality and materialism, traditional values and scientific innovation, lofty ideals and unsentimental practicality are literally everywhere; in the motto "In God We Trust" imprinted on the national currency; the mega churches and jet-setting televangelists; and in the persuasion of roughly half the electorate that it takes a real estate tycoon to boost the country's morale.

Needless to say, the coexistence of such diverging tendencies is ripe with ideological tensions and discontents. Most recently, the classic Emersonian dilemma of how to reconcile the claim to uninhibited self-determination with collective interest has erupted in a fierce controversy over the legitimacy of public measures to contain the spread of Covid-19. While similar protests have sprung up all over the Western world fueled by social media, the U.S. with its powerful individualist and non-conformist tradition remains a hotspot of anti-government activism.[1] Concurrently, the country has seen some of the most intense ideological clashes over how to balance humanitarian ideals with the demands of the capitalist marketplace.

This chapter investigates these cultural phenomena against the background of Emerson's powerful intellectual legacy. By specifically focusing on his concept of the soul, it explores the very cornerstone of his individualistic philosophy, and at the same time the most fundamental way in which humans have constructed their sense of self and their relationship with the world. In keeping with Percy Bysshe Shelley's famous dictum that "poets are the *unacknowledged legislators of the world*," I thus seek to highlight the intersections between literature and politics by contributing to the body of research that situates Emerson's transcendentalist ideas in a political context. In doing so, I not only continue on the critical path of "de-transcendentalizing" Emerson, but even suggest that it is in his most esoteric moments of metaphysical speculation about the nature of our

spiritual essence that he has left the strongest imprint on political realities in present-day America.

The Nomadic Soul

"The one thing in the world, of value, is the active soul," declared Emerson in "The American Scholar" (*Collected Works* 1:56). In this momentous address, delivered in 1837 to the Phi Beta Kappa Society at Cambridge, he famously urged for America's intellectual self-actuation through emancipation from European models. Although on that occasion Emerson's audience was comprised of the country's educational elite, his message was deeply egalitarian in nature. It was a call to Americans from all walks of life to turn their attention inward, not only towards their young society's unique promise but also their own personal potential. Just when the industrial age was underway and the U.S. was about to embrace Taylorism and Fordism, Emerson proposed a radically different model of human productivity. As a counter-concept to the progressing division of labor with a view to maximum material output, he advocated for the diversification of individual activity with the goal of broadening the range of personal experience:

> Man is not a farmer, or a professor, or an engineer, but he is all. Man is priest, and scholar, and statesman, and producer, and soldier. In the divided or social state, these functions are parcelled out to individuals, each of whom aims to do his stint of the joint work, whilst each other performs his. […] The state of society is one in which the members have suffered amputation from the trunk, and strut about so many walking monsters,—a good finger, a neck, a stomach, an elbow, but never a man. (*Collected Works* 1:53)[2]

Preceding the publication of Karl Marx's *Das Kapital* by three decades, Emerson thus offered a pioneering critique of the dehumanizing and alienating effects of the capitalist mode of production by pointing to the mechanisms of fragmentation and commodification that left human beings "metamorphosed into a thing, into many things" (ibid.). He deplored that

> The planter, who is Man sent out into the field to gather food, is seldom cheered by any idea of the true dignity of his ministry. He sees his bushel and his cart, and nothing beyond, and sinks into the farmer, instead of Man on the farm. The tradesman scarcely ever gives an ideal worth to his work,

but is ridden by the routine of his craft, and the soul is subject to dollars. (ibid.)

Rejecting what he perceived as "vulgar prosperity" (*Collected Works* 1:62), Emerson decidedly uncoupled the value of work from the profit principle and instead declared the pursuit of spiritual wholeness to be the true purpose of all human agency. This idealistic assertion rested on his religious belief in a benevolent power which appears in his writings under various names such as "Universal Spirit," "Supreme Being," "eternal ONE," or "the All." His master term for this supernatural force, however, is the "Soul." While he also uses the generic word "God," his explorative terminology indicates a conceptual shift from the traditional Christian view of a personified ruler of the universe to the deistic notion of an *anima mundi* manifesting itself in its own creation. Descriptions of this aboriginal energy abound with metaphors of flowing, surging, and permeating, with the individual human soul often being described as a vessel or channel for the divine pneuma. In a line of reasoning that heavily draws on the Scottish Enlightenment with its theory of the moral sense, Emerson argues that genuine self-possession can only be achieved through submission to a universal spiritual law.[3] As he expounds in his 1841 essay "The Over-Soul," it is this act of inner surrender that allows humans to come into contact with their higher selves and rise above prosaic materiality:

> What we commonly call man, the eating, drinking, planting, counting man, does not, as we know him, represent himself, but misrepresents himself. Him we do not respect, but the soul, whose organ he is, would he let it appear through his action, would make our knees bend. When it breathes through his intellect, it is genius; when it breathes through his will, it is virtue; when it flows through his affection, it is love. And the blindness of the intellect begins, when it would be something of itself. The weakness of the will begins, when the individual would be something of himself. All reform aims, in some one particular, to let the soul have its way through us; in other words, to engage us to obey. (*Collected Works* 2:161)

Emerson thus reissues the Platonic doctrine that the core fiber of reality is metaphysical, and at the same time clarifies that his advocacy for unfettered personal autonomy is by no means an endorsement of unrestrained egotism or anarchy. To the contrary, he believes that radical introspection is the only way to establish that theurgic connection, which ultimately

allows the individual to transcend myopic preoccupation with personal interest and experience unity with all of creation. "We live in succession, in division, in parts, in particles," he observes. "Meantime within man is the soul of the whole; the wise silence; the universal beauty, to which every part and particle is equally related; the eternal ONE" (*Collected Works* 2:160). To tap into this pool of divine consciousness and allow the Over-Soul to shape us in its own image so that we may thrive as individuals, we need to become "receivers of its truth and organs of its activity" (*Collected Works* 2:37). To Emerson, truth and activity are twin aspects because engaging authentically with an ever-changing world requires an agile mind that is always ready to adjust its position in light of new information. "Not in his goals but in his transition man is great. [...] The truest state of mind rested in, becomes false," he infers (*Early Lectures* 2:158).

Accordingly, in order to avoid slipping into mental ossification, we need to accept "that the soul *becomes*" (*Collected Works* 2:40) as it "looketh steadily forwards, creating a world before her, leaving worlds behind her" (*Collected Works* 2:163) on ceaseless nomadic wanderings. Transience thus being the natural leitmotif of our existence, self-realization can never be pinned to a fixed status but must be conceived of as an open-ended process of self-cultivation, an "ascension, or the passage of the soul into higher forms" (*Collected Works* 3:14). By thus prompting his readers to lead their lives as "an apprenticeship to the truth, that around every circle another one can be drawn; that there is no end in nature, but every end is a beginning" (*Collected Works* 2:179), Emerson promotes a society in which all people are motivated by spiritual and intellectual growth, and lead explorative lives in ever-widening circles of experience, skill, and knowledge. It would be thanks to such a collective shift in emphasis from financial gain to mental enrichment, he predicted, that America would come into its own and take a leading role among the world's societies. As he envisioned in the closing line of "The American Scholar," "[a] nation of men will for the first time exist, because each believes himself inspired by the Divine Soul which also inspires all men" (*Collected Works* 1:70).

From today's historical perspective, as we look back on the nineteenth century as the ignition point that sent the U.S. on the trajectory to becoming the epicenter of global capitalism, this forecast seems painfully quixotic. But then again, in many respects, Emerson's vision has actually come to pass. After all, the cultural reverence for commerce and entrepreneurship in the U.S. rarely takes the form of sheer money idolatry but is typically lined with the moral approval of the dynamic, resourceful, and freely

experimenting self. Even as the capitalist alliance with spirituality is not an exclusively American phenomenon—Max Weber's *The Protestant Ethic and the Spirit of Capitalism* inevitably comes to mind—it has taken a particularly pronounced form in the U.S., where the idiom "from rags to riches" has become shorthand for a life well lived, synonymous with the American Dream itself. Far from being a mere sign of unabashed materialism, it is evidence of the cultural echo of Emerson's verdict that "[t]he powers that make the capitalist are metaphysical" (*Later Lectures* 1:141). In conspicuous contrast to Europe, where the term "capitalism" never fully shed its exploitative ring, a large portion of U.S. citizens has consistently upheld the capitalist system as the economic expression of individualist values, a wholesome ideological ecosystem that incentivizes individuals to experiment, explore, and expand. Thus, American society has cultivated a capitalist narrative which derives its very meaning and momentum from a metaphysical underpinning of which Emerson is the chief architect.

Spiritual Capital and Capitalist Spirit

As a romantic idealist, Emerson was convinced that spiritual laws, not material circumstances, are the determining factors that shape reality. But at the same time, he insisted that the soul is not just an otherworldly essence but a decidedly practical force that calls for real-world application. If "action is the essential attribute of the Soul's life" (Bishop 1964, 36), then Emerson certainly wished to see it unfold not only in the mental, but also in the physical realm. He recurrently praised hands-on vigor and business acumen as the mark of a dynamic personality, submitting that without action "thought can never ripen into truth. […] The preamble of thought, the transition through which it passes from the unconscious to the conscious, is action" (*Collected Works* 1:59). Just like an artist with their medium, the soul needs to connect directly with the external world to find an outlet for its creative impulse and realize its intrinsic nature.

And so, for all his spiritualization of the human condition, Emerson draws the portrait of a soul that is perfectly suited for a secular, performance-oriented society. In fact, he explicitly cites material autonomy as a salient attribute of the spirited, self-reliant individual. "Man was born to be rich," he proclaims with characteristic optimism (*Collected Works* 4:53). This may seem like a surprising statement to come from the same thinker who also warns that "[t]here is nothing more important in the culture of man than to resist the dangers of commerce" (*Early Lectures* 3:191). But here

it is crucial to understand that, despite his ardently idealistic outlook, Emerson is neither an ascetic nor a recluse. In his eyes, there is no fundamental conflict between mind and matter, metaphysics and mundanity, and inner and outer worlds. Rather, he thinks of these spheres as harmoniously joined in obedience to the primal principle of constant productivity, which ultimately ensures that internal vitality and external affluence become mirror images of each other. This accord between spiritual and material domains is not least reflected in his language as he habitually draws on terms from physics, biology, and finance to describe spiritual experiences. Reversely, he frequently invokes the organic imagery of growing, blossoming, and germinating to describe the forces he perceives to be at work in the pecuniary realm. "Money, which represents the prose of life, and which is hardly spoken of in parlors without apology, is, in its effects and laws, as beautiful as roses," he muses. "Property keeps the accounts of the world, and is always moral. The property will be found where the labor, the wisdom, and the virtue has been in nations, in classes, and [...] in the individual also" (*Collected Works* 3:136).

But even as he applauds the concrete results of spiritual truths, he also points to them as potential moral pitfalls that threaten to distract the soul from its true vocation. Consequently, the Emersonian soul has to master a delicate balancing act; it has to remain true to its origin by adhering to the imperative of perpetual productivity while at the same time withstanding the siren song of materialism:

> What a man does, that he has. [...] Let him regard no good as solid, but that which is in his nature, and which must grow out of him as long as he exists. The goods of fortune may come and go like summer leaves; let him scatter them on every wind as the momentary signs of his infinite productiveness. (*Collected Works* 2:83–84)

In other words, the soul is summoned to keenly strive for things it is supposed to have no interest in. By all indications, this is a highly unrealistic demand on the human psyche. Especially if virtue and voracity look so much alike, distinguishing between them becomes all but impossible. And so, despite his sharp censuring of crude acquisitiveness and repeated admonitions to think of material gains as incidental side products and never as prime objectives of human endeavor, the compatibility of Emerson's philosophy with the hyper-capitalist mindset is obvious. "As a principle of a restless activity that seizes and discharges all existing things

in a process of continuous expansion, the soul turns out to be a capitalist," finds Dieter Schulz in his analysis of what he calls "Emerson's enterprising soul" (Schulz 1997, 70, 57).[4] This understanding of individual fulfillment as a permanent ambition for more has visibly shaped American life:

> The famous American pragmatism and 'can do' optimism were given their most ardent and elegant expression by Emerson; his encouragements have their trace elements in the magnificent sprawl we see on all sides—the parking lots and skyscrapers, the voracious tracts of single-family homes, the heaped supermarket aisles and crowded ribbons of highway: the architectural manifestations of a nation of individuals, of wagons each hitched, in his famous phrase, to its own star. (Updike 1991, 161)

These are the words of John Updike who saw in Emerson the epitome of both the auspicious and the adverse idiosyncrasies of U.S. culture. From the present vantage point, Emerson's praise of unremitting advancement and ingestion seems to fall under the latter category. His enthusiastic welcoming of industrial capitalism under the banner of "Machinery and Transcendentalism agree well" (*Journals* 8:397) often seems jarring to the modern reader. In contrast to contemporaries like Henry David Thoreau or Mark Twain, who were alarmed by the economic transformations they were witnessing all around them, he failed to see any conflict between human appetites and the environment, technological progress and the natural world. For instance, while Thoreau denounced the newly constructed railroad as a violent disruptor of tranquil country life, Emerson relished it as an enhancement of the natural scenery. "Railroad iron is a magician's rod, in its power to evoke the sleeping energies of land and water," he rhapsodized (*Collected Works* 1:226). Based on his "industrialized version of the pastoral ideal" (Marx 1973, 222), it is fully consistent for him to celebrate the natural landscape as an expression of the divine and at the same time call for its transformation and exploitation through human industriousness. "Nature is thoroughly mediate. It is made to serve. […] It offers all its kingdoms to man as the raw material which he may mould into what is useful," he postulates in his seminal work *Nature* (*Collected Works* 1:25).

Today, as we are confronted with dwindling resources, overpopulation, and ecological catastrophe brought on by the rapacious commodification of our natural environment, such starry-eyed cheerfulness seems outdated at best and offensive at worst. Unlike Emerson, we no longer have the

luxury of imagining that nature is inexhaustible and will always proffer sufficient space and materials for an insatiable human drive to appropriate, create, and consume. Considering the ubiquitous clashes between a mentality of abundance and the fact of a finite planet, the need for remodeling collective behavior is becoming ever more pressing. "Mainstream economics views endless economic growth as a must, but nothing in nature grows forever," writes for example economist Kate Raworth (Raworth 2017, 26). Similar to Emerson, she refers to natural processes as benchmarks for constructive economic behavior, albeit arriving at a markedly different conclusion. A prominent voice among a growing number of economics experts, she urges for replacing the paradigm of infinity and upward movement with that of containment and balance. In her 2017 book *Doughnut Economics,* she specifically underlines the key role of imagery for how we frame reality, arguing that in order to be able to reimagine our economic system for our own time, we first need to discard "mistaken metaphors" (Raworth 2017, 10) that trap our minds into obsolete patterns of thinking. The question arises whether Emerson's expanding circles should be counted among these.

The Limitations of Expansiveness

Political theorist George Kateb has somewhat provocatively suggested that "it may be rather wasteful to study Emerson unless one shares his religiousness" (Kateb 2002, 65). Given that Emerson's staunch confidence in the positive potential of unbridled individuality rests entirely on the premise of a transcendental authority, any challenge to this metaphysical axiom at once puts into question his entire individualistic worldview. Of course, the very quality of religious dogmas is such that they can neither be conclusively falsified nor be proven, but from a purely empirical standpoint, it is safe to say that Emerson's anticipations regarding basic human nature and its outward effects erred strongly on the side of optimism. Whatever the hypothetical reason for this collective failure to live up to Emerson's high hopes, in actuality we are experiencing the fallout from solipsistic notions of truth and aggressively expansive conceptions of selfhood. Particularly in the wake of the Trump presidency, the Emersonian message that individual self-absorption will ultimately lead to social consensus and that materialism is but a different form of idealism rings awkwardly hollow.

The glaring discrepancy between theory and practice invites the question of how useful the Emersonian concept of the soul still is to us, even as such a utilitarian approach to an essentially ontological and epistemological problem may seem misplaced. After all, the enquiry into who we are at the deepest level of being is quite separate from the issue of who we should preferably be. But at least in Emerson's case, he himself invites such a practical litmus test by emphasizing that his "metaphysics are to the end of use" (*Complete Works* 12:13). That is, his spiritual guidelines are not meant to remain abstract mysticism but must be appraised and adjusted based on actual results. "Pure doctrine always bears fruit in pure benefits," as he puts it (*Complete Works* 11:480).

Approached from this angle, the fruits of his doctrine of the soul appear to be of mixed quality. On the one hand, his passionate plea for every individual's right to maximum self-realization has provided an apt language for promoting lifelong personal development and advancing civic liberties, which ultimately secured him a place among the most influential figures of the liberal tradition. But on the other hand, a model of personhood that idolizes relentless advancement as the hallmark of a vibrant personality has been given to validating conduct patterns that are, to stay with Emerson's circle metaphor, questionably self-centered.[5] A sense of unrestrained personal entitlement is not only unlikely to make for mutually satisfying relationships with fellow human beings but is also fundamentally at odds with the democratic ethos. In a social body organized around constant negotiation and compromise, one's own circles regularly collide with those of others, and learning to respect these boundaries is a vital part of the cultural toolbox that enables us to live and work together.

Seldom has that been more obvious than in the struggle with the coronavirus. Now that our well-being and even survival depends on being able to practice personal restraint in various ways—by putting our work on hold, suspending our daily routines, reducing our physical movements and interactions, and not least by psychologically coping with living in an indefinite stand-by mode—we unexpectedly find ourselves in need of a completely different psychocultural skillset than the one Emerson has to offer.[6] And it seems more than just a coincidence that the U.S., a society that has traditionally subscribed to more bold interpretations of personal liberty than any other Western nation, has seen the most widespread opposition to anti-contagion policies. Especially conservative Americans, who tend to identify strongly with ideals of privatism and self-reliance, have been resolutely contesting lockdowns, mask wearing, and vaccine

mandates as illegitimate intrusions into their private sphere. And while the intensity of this ideological dispute has been habitually attributed to the polarizing and inconsistent messaging of the Trump administration, it is also bolstered by the broader intellectual current of individualism. As evidence of this, conservative arguments against restrictive measures are typically rendered in the classic liberal language of personal conscience and the right to choose, from top-level officials like Attorney General William Barr who equated stay-at-home mandates with slavery to street-level protests dotted with signs declaring "My Body, My Choice" next to crossed-out face mask pictograms. In a cultural climate that prizes unobstructed personal freedom as the universal formula for the common good, any constraint to one's expanding circle by normative collective power is easily framed as morally corrupt—even if this constraint is a guardrail meant to protect one's own life.

As a concomitant phenomenon, the American articulation of anti-restriction sentiments has taken a distinctly capitalist twist. Naturally, all countries hit by the pandemic have been faced with the difficult task of weighing economic against public health aspects. However, in the U.S., the clash between the logic of humanitarianism and capitalism has been particularly blunt as many high-profile commentators have espoused a predominantly economic reading of the crisis. As a case in point, Lieutenant Governor of Texas Dan Patrick exhorted his fellow citizens to risk their own lives to keep the national economy running. "As a senior citizen, are you willing to take a chance on your survival in exchange for keeping the America that America loves for your children and grandchildren?" he asked in a *Fox News* interview on March 24, 2020, subsequently concluding that "if that's the exchange, I'm all in" (Sonmez 2020). Some weeks later, he pressed on that "there are more important things than living. And that's saving this country for my children and my grandchildren and saving this country for all of us" (Madani 2020). In the same vein, conservative radio host Glenn Beck proclaimed that economic aspects should be the main priority, and "[e]ven if we all get sick, I'd rather die than kill the country" (Shepherd 2020).

On the face of it, such extolments of self-sacrifice in the name of the collective economic system may seem utterly irreconcilable with individualistic values. But in a cultural ambiance steeped in amalgamated individualistic-capitalist precepts, it is not at all implausible to suggest that saving the soul of the nation, and by implication also the individual soul, entails sustaining by all means the capitalist marketplace as its natural

habitat. There we have it, the scenario Emerson was cautioning against: the soul losing sight of itself amidst "the momentary signs of [its] infinite productiveness."

A Soul for the Twenty-First Century

Emerson, the seeker of timeless truths, has once admitted that "[n]o man can quite emancipate himself from his age and country, or produce a model in which the education, the religion, the politics, usages, and arts, of his times shall have no share" (*Collected Works* 2:210). His own concept of the soul is a distinct product of his place in history, reflecting his country's preoccupation with personal autonomy, industrialization, and the advancement of the Frontier. But nearly two centuries after his emergence as a leading public intellectual, his optimism regarding the alliance of free-running individualism and capitalism fails to tally with reality as we find it. We are experiencing how easily self-referential notions of truth and knowledge can be translated into "alternative facts" that corrode the very foundation for social dialogue and cohesion. We are witnessing increasing material inequality produced by the workings of a market that is far from being the unerringly fair "very intellectual force" (*Collected Works* 1:233) described by Emerson. And we are agonizingly slow to curb our predatory consumption of nature even as the warning signs are everywhere. Apparently, our collective soul has become an egocentric workaholic ignoring the symptoms of an impending heart attack.

And so, as with all idealists, we read Emerson at our own risk. He may speak to what is best in us, but he also sets us up for being disaffected with reality if we take him all too literally. Purist ideologies are prone to turning into their opposites, and Emerson's philosophy is no exception; his ardently idealistic notion of self-cultivation has simultaneously exposed him to the charge of being a "seer of *laisser-faire* capitalism and the rampant individual" (Aaron 1961, 8).[7] On the one hand, he invites us to explore the full range of human possibilities and look at the world with an unprejudiced mind that is able to see beyond the status quo. In our time of fast-paced change and unprecedented intercultural contact, these faculties may be more valuable than ever. But on the other hand, Emerson sends us on our way with a map that often shows paved roads where there is just uncertain terrain, particularly when it comes to the presumed causal connection between ideational assets and external expansion, as well as the equation of activity with productivity. These are features of his thought

that call for critical reevaluation in the light of new experience. For as it turns out, the compulsion to incessantly push limits can also become a prison, so that our future may well depend on the understanding that progress is not just made by breaching boundaries, but just as often by learning to observe them.

Notes

1. Sociologists and political scientists have long been expressing alarm over the culturally encouraged political mistrust in the U.S. (cf. Bellah; Eliasoph).
2. Emerson's gendered language reflects the norms of his time, indicating that he conceived of self-reliance as a predominantly male project. However, by stressing the worth of individual personality and arguing that personal experiences form the basis for pondering social questions, he also provided an important stepping stone for the articulation of women's rights.
3. Introduced by Francis Hutcheson (1694–1746), the term *moral sentiment* denotes an innate ethical consciousness that promotes altruistic behavior. Even as individuals have free will and therefore the option of disobeying divine law, they can always gauge the moral quality of their actions by the degree of harmony perceived within their soul.
4. Translated by the author from German.
5. For an in-depth discussion of individualist values as a decisive factor for Donald Trump's political appeal, see Thierbach-McLean.
6. In Germany, the government-sponsored campaign *Besondere Helden* ('Special Heroes') has addressed this sudden change in priorities in a humorous manner, casting slackers and couch-dwellers as the new saviors of the nation.
7. Tellingly, Henry Ford was known as a great admirer of Emerson and routinely gave out copies of his works as presents.

Works Cited

Aaron, Daniel. 1961. *Men of Good Hope: A Story of American Progressiveness.* New York: Oxford University Press.
Bellah, Robert. 1996. *Habits of the Heart: Individualism and Commitment in American Life.* Berkeley: University of California Press.
Bishop, Jonathan. 1964. *Emerson on the Soul.* Cambridge: Harvard University Press.
Donoghue, Denis. 1988. *Reading America: Essays on American Literature.* Berkeley: University of California Press.
Eliasoph, Nina. 1998. *Avoiding Politics: How Americans Produce Apathy in Everyday Life.* Cambridge: Cambridge University Press.

Emerson, Ralph Waldo. 1904a. In *The Complete Works of Ralph Waldo Emerson*, ed. Edward Waldo Emerson, vol. 11. New York: Houghton Mifflin.
———. 1904b. In *The Complete Works of Ralph Waldo Emerson*, ed. Edward Waldo Emerson, vol. 12. New York: Houghton Mifflin.
———. 1964. In *The Early Lectures of Ralph Waldo Emerson, Volume 2: 1836–1836*, ed. Stephen E. Whicher et al. Cambridge: Belknap Press of Harvard University Press.
———. 1969. In *The Journals and Miscellaneous Notebooks of Ralph Waldo Emerson, Volume 7: 1838–1842*, ed. A.W. Plumstead and Harrison Hayford. Cambridge: Belknap Press of Harvard University Press.
———. 1970. In *The Journals and Miscellaneous Notebooks of Ralph Waldo Emerson, Volume 8: 1841–1843*, ed. William H. Gilman and J.E. Parsons. Cambridge: Belknap Press of Harvard University Press.
———. 1971. In *The Collected Works of Ralph Waldo Emerson*, ed. Robert E. Spiller and Alfred R. Ferguson, vol. 1. Cambridge: Belknap Press of Harvard University Press.
———. 1972. In *The Early Lectures of Ralph Waldo Emerson, Volume 3: 1838–1842*, ed. Robert E. Spiller and Wallace E. Williams. Cambridge: Belknap Press of Harvard University Press.
———. 1980. In *The Collected Works of Ralph Waldo Emerson*, ed. Joseph Slater et al., vol. 2. Cambridge: Belknap Press of Harvard University Press.
———. 1984. In *The Collected Works of Ralph Waldo Emerson*, ed. Joseph Slater et al., vol. 3. Cambridge: Belknap Press of Harvard University Press.
———. 1987. In *The Collected Works of Ralph Waldo Emerson*, ed. Wallace E. Williams and Douglas E. Wilson, vol. 4. Cambridge: Belknap Press of Harvard University Press.
———. 2001. In *The Later Lectures of Ralph Waldo Emerson, Volume 1: 1843–1854*, ed. Ronald A. Bosco and Joel Myerson. Athens: University of Georgia Press.
Gougeon, Len. 2008. Emerson and the Reinvention of Democracy. In *New Morning: Emerson in the Twenty-First Century*, ed. Arthur S. Lothstein and Michael Brodrick, 162–178. Albany: State University of New York Press.
Kateb, George. 2002. *Emerson and Self-Reliance*. Lanham: Rowman & Littlefield Publishers.
Madani, Doha. 21 April 2020. Dan Patrick on coronavirus: 'More important things than living.' *NBC News*. https://www.nbcnews.com/news/us-news/texas-lt-gov-dan-patrick-reopening-economy-more-important-things-n1188911.
Martineau, Harriet. 1838. *Retrospect of Western Travel*. Vol. 3. London: Saunders and Otley.
Marx, Leo. 1973. *The Machine in the Garden. Technology and the Pastoral Ideal in America*. London: Oxford University Press.

Mitchell, Charles E. 1997. *Individualism and Its Discontents*. Amherst: University of Massachusetts Press.

Mudge, Jean McClure, ed. 2016. *Mr. Emerson's Revolution*. Cambridge: Open Book Publishers.

Raworth, Kate. 2017. *Doughnut Economics: 7 Ways to Think Like a 21st Century Economist*. White River Junction: Chelsea Green Publishing.

Richardson, Robert D. 1995. *Emerson: The Mind on Fire*. Berkeley: University of California Press.

Schulz, Dieter. 1997. *Amerikanischer Transzendentalismus: Ralph Waldo Emerson, Henry David Thoreau, Margaret Fuller*. Darmstadt: Wissenschaftliche Buchgesellschaft.

Shepherd, Katie. 25 March 2020. 'I would rather die than kill the country': The conservative chorus pushing Trump to end social distancing. *The Washington Post*. https://www.washingtonpost.com/nation/2020/03/25/coronavirus-glenn-beck-trump/.

Sonmez, Felicia. 24 March 2020. Texas Lt. Gov. Dan Patrick comes under fire for saying seniors should 'take a chance' on their own lives for sake of grandchildren during coronavirus crisis. *The Washington Post*. https://www.washingtonpost.com/politics/texas-lt-gov-dan-patrick-comes-under-fire-for-saying-seniors-should-take-a-chance-on-their-own-lives-for-sake-of-grandchildren-during-coronavirus-crisis/2020/03/24/e6f64858-6de6-11ea-b148-e4ce3fbd85b5_story.html.

Thierbach-McLean, Olga. 2018. From Emerson to Trump: Capitalism, Meritocracy, and the Virtue of Money. *Amerikastudien/American Studies*, No. 64. Heidelberg: Universitätsverlag Winter.

Updike, John. 1991. *Odd Jobs*. New York: Knopf.

CHAPTER 13

"Souls on Board": A Counter-History of Modern Mobility

Susan Zieger

Of the myriad ways to map the world, perhaps the ghostliest is by shipwreck. Sunken ships cling to the fringes of continents: Roman and Carthaginian quinqueremes line the Mediterranean, convict ships lurk in Botany Bay, submarines dot Pacific island shores. In the arctic and in the tropics, in waters shallow and deep, lies every kind of vessel, barque and brigantine, canoe and ketch, destroyer and dhow. By a widely circulated estimate, more than three million wrecks litter the ocean floor. Treasure hunters have explored them for decades, a ghoulish habit of mining graves for plundered silver and gold. Yet, wrecks are not sealed coffins: the sea gently sweeps flesh from bone, ribs float free of spines, and marrow dissolves, until not a trace remains. Of haunted places, shipwrecks are special. They are neither the family attic, nor the battlefield, nor the village cemetery. To be "buried at sea" is to be buried nowhere. Their revenants were once people on the move: emigrants, crewmen, pirates, and slaves. People whom life brought together as strangers, and only for the duration of an

S. Zieger (✉)
University of California, Riverside, Riverside, CA, USA
e-mail: susanz@ucr.edu

© The Author(s), under exclusive license to Springer Nature Switzerland AG 2024
D. Louis-Dimitrov, E. Murail (eds.), *The Persistence of the Soul in Literature, Art and Politics*, https://doi.org/10.1007/978-3-031-40934-9_13

unfinished journey. There is no way to count them now, but when their ships were whole, they were tallied as "souls on board." Simply by embarking on a journey, the phrase implied, you had already become a sort of ghost. The shipwreck is a hidden, disintegrating tombstone for these vanished souls.

The expression "souls on board" resounds through the grim account books of maritime disaster. In 1835, the *Neva*, deporting 150 Irish women convicts and 55 of their infant children to Sydney, manned by a crew of 26, plus a ship's surgeon, and bringing nine free immigrants along for the ride, struck a reef off the coast of Tasmania and sank. Three passengers succumbing to disease and being buried at sea, and one baby being born in the passage, "the total number of souls on board, as the vessel sailed the last quarter of her journey, was two hundred and forty-two" (Layson 1882, 254).[1] Ten years earlier, the East Indiaman *Kent* had left England for Bengal and China, carrying soldiers, their wives, and children. When a crew member accidentally ignited a cask of spirits and set lower decks on fire, efforts to extinguish it waterlogged the ship, which began to slowly sink—at the same time that a gale sprang up. A desperate evacuation ensued, as women and children were lowered by ropes into lifeboats; only some of them made it aboard the nearby *Cambria*. As one of its historians reports, "The numbers lost by the destruction of the *Kent* were: 55 soldiers, 1 seaman, 5 marine boys, 15 women, and 20 children,—in all 96 souls, out of a total of 651" (Hoare 1885, 50). The premature ghostliness of the passenger lurks in their very countability: that which makes them one of many, ready to be listed by sex, age, and occupation in such reports. Drawing on its use in the King James version of the Bible, the phrase's force derives from the spiritual courage required to undertake a risky voyage in the age of sail.[2] Before steam navigation and the calculation of longitude made long sea journeys more predictable and safer, a ship leaving port entered a wrathful and capricious ocean. Risking one's life to cross it could strip everything from you but your spirit, and your bare facts. What ethics and values drove the practice of counting souls who departed their bodies while on the move?

Counting souls became an international practice, for reasons of clarity and speed in handling emergencies. Ship captains needed to know how many people were on board, so that in the event of a disaster, all might be found. For the same reason, today airline pilots are required to state the number of passengers on a flight to air traffic control. One aviation enthusiast who enjoys listening to such exchanges on a headset channel, notes

that although "souls on board" is customary terminology, "when you hear it said out loud by a controller it's usually a bad sign. It fills me with dread" (Fallows 2013). In fact, the transition from "souls" to "persons" as the international standard is the subject of controversy on internet aviation forums.[3] Aviation aficionados debate who and what it has included, historically and in the present. Possible confusion over whether "souls on board" covers human remains being returned home for burial may have led the Federal Aviation Association to revise its "Inflight Emergency Checklist and Record." Not to mention the unfortunate abbreviation of the phrase to "SOB"—"sons of bitches" in American slang. "Persons on Board" and "POB" are now understood to mean every living human on the aircraft, a number that differs from that of seats sold or occupied, as it includes lap infants and aviation personnel occupying jump seats. Travel with companion animals has become a common practice, but I have yet to find evidence of their being included in any emergency count. For the present, "person" has the benefit of clarity, but the disadvantage of light weight, sliding easily through news reports' citations of numbers dead, whether by transportation accident or terrorist design. Lacking the gravitas of "soul," "person" reflects the banality of increased and speedier modern mobility, which now requires far less spiritual fortitude than in the age of sail (Cresswell 2010, 19). The purpose and general practice of counting those on board, whether souls or persons, have not significantly changed, but the politics of mobility surrounding them have.

Referring to passengers as souls is a remnant of a premodern time, in which people stayed put until they died, and then their souls departed their bodies, and the earth. Under the modern norms of increasing and constant personal mobility, this fantasy of stillness, groundedness, and landedness acquires the air of nostalgia—and of conservatism. Within this ideology, to be mobile is to be superficial: mobility is synonymous with the jet-setter's frivolity, the gallivant's audacity, and the globetrotter's outsize carbon footprint. David Morley coins the term "sedentarism" to describe this fetishization of place as "crucial to the preservation of properly 'rooted,' moral, and authentic forms of life," and corollary suspicion of travel (Morley 2017, 60). In the common parlance of geographers, to inhabit anonymous "space" rather than specific "places," is to live in a neoliberal nowhere, to be soulless. Marc Augé, describing airports, hotels, and highways as the interchangeable zones of "supermodernity," claims that there, one loses one's identity in "solitude, and similitude. There is no room for history unless it has been transformed into an element of

spectacle..." (Augé 1995, 103). Transcendent mobility is granted to the soul upon death; to seize it in life is blasphemy. By establishing the ship or the plane as places of human life, practices and discourses of counting travelers challenge this view. If history is to remain the narrative of human doings, then it should not discount those that happen in constantly changing settings. Or, if history requires place, then perhaps telling stories of humans in transit requires counter-history (Benjamin 2019, 257).[4]

Thanks to the increased fluidity of capital, millions of people of all classes, races, and genders now live their lives on the move. Filipinos *en route* to Qatar to construct buildings, El Salvadoreans traveling to Las Vegas to clean hotel rooms, and Syrian refugees arriving and surviving in cities throughout Europe. They are the descendants of the women like those transported on the *Neva*, soldiers like those on board the *Kent*, and migrating workers throughout the nineteenth-century world. This chapter's discussion, of counting and memorializing those who died in transit, contests the "non-places" paradigm, contributing to a larger counter-history of modern mobility. I focus on the Middle Passage as a crucial origin of this counter-history.[5] Within Black studies, the question of counting the kidnapped, enslaved people on voyages has opened up new methods and politics. Beginning here, in the slave ship hold, and moving to the slave shipwreck, we gain a clearer view of the ethical stakes of counting souls lost in modern transit.

THE MIDDLE PASSAGE

The mass involuntary migration of the Atlantic slave trade was, to those who experienced it, suffering upon suffering. The most well-documented of it was extreme physical experience: cramped quarters, disease, beatings, rape, murder, suicide. Less described was its social, psychological, and cultural toll: an enslaved African person was kidnapped from their home, chained to someone who spoke a different language, and renamed by a number, "designating their inclusion among a vessel's cargo" (Mustakeem 2016). An often-overlooked dimension was spiritual. Many traditional African belief systems mingled the spiritual and the earthly, the material and the immaterial. To die in the Middle Passage, as befell so many, was to be buried at sea, and so to lack the proper funerary rites that the soul required to journey to the afterlife. As Stephanie Smallwood asks, writing of Akan people kidnapped in the seventeenth century, "With no food and drink to sustain the deceased in the domain of the ancestors, neither

clothing nor tools with which to continue the activities of earthly life in the new realm, and no earth to receive the dead bodies, how were the deceased to find their way out of the watery realm to the land of the ancestors?" (Smallwood 2007, 140). Moreover, these trapped souls would torment the living on the ship. Slave ships were haunted places on African terms, and with a cultural and religious specificity that can only be gestured toward here. Slave ships were not haunted only because many people perished on them, nor because those deaths were a vicious effect of racial capitalism; rather, they are also haunted because their occupants remained between two worlds.[6] "[E]ven the African dead were enslaved and commodified, trapped in a time-space regime in which they were unable fully to die" (Smallwood 2007, 152). This liminal realm sounds like a non-place *avant la lettre*. But unlike Augé's later concept, it is a mobile space of Black death at an earlier stage of capitalism, not a place of implicitly white, privileged mobility in a more recent one. Such African beliefs stood counter to the logistical and financial frameworks within which the traders calculated the preservation and loss of their cargo. Enslaved people's sense of being trapped in a space of injury resisted the discourse of "souls on board" and the context of high-risk, high-profit venture that made it a useful metric.[7]

Did the enslaved count as "souls on board" for the white shipmasters who kidnapped and tortured them? Yes and no. From the seventeenth century, Portuguese and Spanish slavers baptized enslaved people before they embarked, a soul-making practice that also imposed new names upon them.[8] However, the evidence of enslaved people taken from Angola and Upper Guinea to Cartagena shows that they did not adopt Christian beliefs. Rather, they thought baptism was to prevent them from rebelling or having sex on the Middle Passage, or that it meant their captors were planning to make powder out of them, and eat them (Newson 2007, 102). Protestant Dutch, British, and French slavers, who began trading after 1620, were uninterested in baptizing their human cargo (Schmieder et al. 2011, 55).[9] And, as Ian Baucom demonstrates, by the end of the eighteenth century, in a secularizing enlightenment, the rise of maritime insurance replaced what Christian soul-making there was, turning the enslaved into commodities represented by numbers on balance sheets, and motivating the murderous calculations of the crew responsible for the massacre on the *Zong* (Baucom 2005). Nonetheless, enslaved people would have been counted as "souls on board" for the same practical reasons that motivated the procedure on the voyages of free people: in a case

of emergency, the total number of humans needed to be known to recover everyone. "Recovery" here takes on a financial connotation: as assets, purchased and ensured for a price, enslaved people lost at sea "counted" as a financial loss that could not be recouped. Thus the enumeration of "souls on board" a slave ship pivoted between an older model of religious accounting, and a newer, financial one.

Against the financial context of counting, historians of the Middle Passage have developed non-quantitative methods. Katherine McKittrick writes, "The slave's status as object-commodity, or purely economic cargo, reveals that a black archival presence not only enumerates the dead and dying, but also acts as an origin story. This is where we begin, this is where historic blackness comes from: the list, the breathless numbers, the absolutely economic, the mathematics of the unliving" (McKittrick 2014, 17). McKittrick's critique is partly about the construction of the archive: scholars of the Middle Passage must approach that history through evidence—bills of lading, logbooks, account ledgers—that is implicated in the violence. Along with her, Saidiya Hartman, Sowande' Mustakeem, and others have called on scholars to stop citing the numbers—of enslaved, of deaths on the translantic voyage, of different causes of death—because it reinscribes material, epistemic, and phenomenological violence. Fred Moten pursues this objective in his recent trilogy. *Black and Blur, Stolen Life,* and *The Universal Machine* (2018) are united under the unofficial title "consent not to be a single being." This refusal of singularity is, in part, a refusal of the individualized sovereignty that makes counting people possible. Moten stands against the addictive "logistics and logic of racial capitalism and its ends" savored by "the sovereign junkie" (Moten 2018, 194). Moten's and others' turn to the non-quantifiable zone of affect and feeling partakes of W.E.B. Du Bois' language of the soul as spiritual, intellectual, and political striving. But Du Bois traded in the currency of sovereignty: "[T]here must come a loftier respect for the sovereign human soul that seeks to know itself and the world about it; that seeks a freedom for expansion and self-development; that will love and hate and labor in its own way, untrammeled alike by old and new." Du Bois was writing in an earlier period, when the term "soul" could broker the inclusion of Black people within liberal individualism (Du Bois 1903). Moten, writing within the later Black radical tradition, resists the quantification of Black life that begins with such acts of enumeration.

One way that scholars have avoided re-inscribing the violence of counting is to view the Middle Passage as a source of Black culture. Numbers close things down, but the ship as a place also affords, according to Hortense Spillers, "a wild and unclaimed richness of *possibility* that is not … 'counted' / 'accounted,' or differentiated…" (Spillers 1987, 72). Paul Gilroy suggests, "[Ships] need to be thought of as cultural and political units rather than abstract embodiments of the triangular trade. They were something more—a means to conduct political dissent and possibly a distinct mode of cultural production" (Gilroy 1993, 16–7). The delicate task is to restore Black agency to the scene of coerced mobility, in the register of culture, without aestheticizing it as the silver-lining of massive tragedy, and thus excusing the inhumanity of the Atlantic trade. Or as David Lloyd asks, "if the historian celebrates the vitality of [Black] culture, does the representation of vitality itself represent a mitigation of the unremitting violence of the order of slavery?" (Lloyd 2020, 81). No less a thinker than Du Bois himself risks this effect when he writes of Black music's transformation from its African origins, in terms tinged with sentimentality: "it was adapted, changed, and intensified by the tragic soul-life of the slave, until, under the stress of law and whip, it became the one true expression of a people's sorrow, despair, and hope" (Du Bois 1903). In Du Bois' prose, the "soul-life" of the individual, almost allegorical enslaved person transmogrifies pre-existing forms, but racist violence completes the process, creating a unified cultural expression. The Black radical tradition, though it cannot help but draw on Du Bois, nonetheless questions the link between the soul and the individual that can lead to static theorizations of personhood and culture. Moten and Stefano Harney, in *The Undercommons*, imagine life in the slave ship hold as an alternative to the corrosive individualism of the western tradition: "To have been shipped is to have been moved by others, with others. It is to feel at home with the homeless, at ease with the fugitive, at peace with the pursued, at rest with the ones who consent not to be one." This mode of "hapticality" is neither individual nor collective; it could perhaps be called intersubjective, as it is "a way of feeling through others, a feel for feeling others feeling you" (Harney and Moten 2013, 98). In their way of reimagining the Middle Passage, counting becomes irrelevant, and the accent falls not on individual Black deaths, but on collective Black lives.

Slave Shipwrecks

Of the myriad shipwrecks that map modern global trade, perhaps the ghostliest is the slave shipwreck, and perhaps the most fascinating work of historical recovery is its salvage. Their locations—on the southeastern coast of the U.S., in the Caribbean, in Brazil, along the Gold Coast and that of Angola—are not hard to predict. Of the estimated three million wrecks, 590 engaged in the slave trade have been documented between the sixteenth and nineteenth centuries.[10] Only four have been excavated. In the 1980s, treasure hunters looted the *Henrietta Marie*, wrecked near Key West in 1700, and the *Whydah*, sunk near Wellfleet in 1717. Academic teams using professional standards recovered the *Fredensborg*, sunk in 1767 near Arendal, Norway, and the *James Matthews*, wrecked near Perth in 1841. Though these were slave ships, none of them sank with enslaved people on board. Yet the historical record tells us that many slavers wrecked as the result of enslaved people's rebellions.[11] Recovering such wrecks is one way to document the history of enslavement, pay respect to Black suffering, and emphasize Black collective agency and struggle. This final section turns to maritime archeology and its intersection with Black studies, to ask how literally "diving into the wreck," to paraphrase Adrienne Rich, is tensed between the quantitative method, with its proximity to financial calculation, and attempts at Moten and Harney's hapticality, a feeling for and with history. This sensual and proprioceptive feeling of history also generates scholarship tying slave shipwrecks to their natural submarine environment. As one interpreter suggests, "These approaches to slavery and its shipwrecks, focused less on grand narratives than on survival, embodiment, the lower ranges of confidence, invoke a language of water and a view shifted both to the submarine and to the south" (Lavery 2020, 13). As we shall see, the shift to such methods nonetheless holds fast to calculation and counting, especially of souls on board.

Only one ship that wrecked with enslaved people aboard has been discovered and professionally excavated: that of the Portuguese slaver, the *São José Paquete Africa*, in 2015 (Cooper 2015).[12] The *São José* left Mozambique in December 1794, bound for Brazil with 512 captive people on board. Its owners and captain attempted this 7000-mile voyage in their effort to find a source of cheap, plentiful slaves: by the end of the eighteenth century, the intensity of the trade along the west coast had depleted the supply of Africans there. Rounding the Cape of Good Hope, the ship struck rocks about 300 feet from the shore. A barque approached,

rescuing some of the enslaved; the captain and crew also survived. But more than half the enslaved people drowned, most likely in their iron shackles. The survivors were sold in the Cape Colony. Thus the disaster and emergency of the wreck of the *São José* reflect the ongoing disaster and emergency of slave ships' successful landings.

I have reproduced these numbers—512, 7000, 300—in part because that is one strategy of the principal archeologists and historians who set out to locate and excavate the sunken ship. They are part of the Slave Wrecks Project, a consortium of academics, museum directors, and Black scuba divers in the U.S. and South Africa, who seek "to bring the immensity of that history [of the Middle Passage] to a human scale, voyage by voyage." (Slave Wrecks Project 2008).[13] Their book about the *São José*, titled *From No Return: The 221-Year Journey of the Slave Ship São José* (2016), embraces quantification. The book's title references the exact number of years that passed between the ship's wreck and its recovery. Its dedication, "For the 512 aboard the São José who are no longer forgotten, and for the many millions more" reaches for precise numbers even when they cannot be stated. And pages between the book's essays graphically accentuate numbers: "512: Number of Africans in Mozambique captured and held aboard the São José as cargo" (n.p.); and "120: Approximate number of days the enslaved would have spent in the dark in the ship's hold, had it not sunk on its journey to Maranhão, Brazil" (Boshoff et al. 2016, 70–71). The authors note that 11 enslaved people who survived the wreck died of their injuries before they could be sold (60). At the same time, the book's authors express a desire to "personalize the statistics" (74); and a discomfort with the "crass calculation" of the *São José*'s archival records, in which "tidy columns" tallied the enslaved alongside mundane goods (61). Speculating that the bodies of those who perished would have washed ashore, the authors imagine they would have been buried quickly nearby, and thus repose "under one or more of the luxury residences that crowd every valuable inch of real estate right up to the beach" in the privileged community of Clifton in Cape Town—another way in which racial capitalism has erased even their remains (65).

At the same time that they use numbers to count the cost, the authors of *From No Return* also accentuate feeling as a historical method. This takes the form of identification with the perished. For example, noting the characteristic turbulence of the water, which dashes even experienced divers against a nearby reef, Stephen C. Lubkemann and Jaco Jacques Boshoff write, "We have all bled on this site Our dive tanks and computers, our

fins and our masks, render us at best only marginally less helpless than those who found themselves on the distressed and disintegrating São José on that December eve so long ago" (53). And Lonnie G. Bunch III writes of walking down the "Ramp of No Return" in Mossuril, where captives would have boarded the ship: "The ramp was graded at an awkward angle, making it difficult to walk—and this was without shackles. Like so many who had gone before me, I looked at what was ahead of me, and realized that I could not see anything behind me. For the captives, it would have been as if all they had known had simply vanished" (79). Finally, Paul Gardullo writes that Kamau Sadiki, a member of his Black scuba diving group, Diving With a Purpose (DWP), said "that upon touching a timber he felt as if he could feel the souls of those who had died there" (14). In each of these examples, it is a haptic and proprioceptive sense—of the force of underwater currents, of a steep ramp and awkward walk, of the texture of wood worn by tides—that conjures proximity to the dead. The last example is the most directly relevant to the question of counting souls on board: in the moment he touches the timber, Sadiki feels them, a physical and perhaps spiritual experience that does not quantify.

The documentary television series *Enslaved* (Jakobovici, 2020), which combines DWP's exploration of slave shipwrecks with historical reenactments of the Middle Passage, and interviews with historians and maritime archeologists, expresses a similar sense of feeling history. For example, in the episode "Rationalization," the scuba divers investigate the wreck of "35F," an unnamed ship that sank in the English Channel in the 1680s, most likely returning a handful of enslaved people, ivory, and gold from west Africa. Divers Kramer Wimberley, Joshua Williams and Alannah Vellacott speak emotionally about their efforts to rescue an intact elephant tusk as the only recoverable relic related to the enslaved passengers' lives. "If it's the final resting place of some of my ancestors, then it's a burial ground. But it's also a crime scene, because they were taken," says Wimberley. Interviews with historians and other divers explain that the tusk, as well as the small metal and glass objects known as manillas and aggry, functioned as currency in the trade. "A shudder went through me," says director Simcha Jacobovici, as he handles a manilla, the equivalent of one enslaved person. The series inculcates such feelings of awe and horror in its confrontation with the recovered material culture of chattel slavery. Yet these emotional effects do not resonate without the contextualization of the calculation of value. In the play between abstraction and sensuous materiality—the 350-year-old coral growing on the tusk, the divers'

elaborate decompression measures after a 300-foot dive, the reminiscence of thousands of manillas piled on the sea floor—*Enslaved* mediates between the two methods to offer its version of popular history.

Poetry and sculpture have long held space for the counter-history of the Middle Passage. For example, Derek Walcott's "The Sea is History" observes "but the ocean kept turning blank pages / looking for History" which only comes "in the salt chuckle of rocks / with their sea pools" (Walcott 2007, 137–9). In Robert Hayden's "Middle Passage," "Shuttles in the rocking loom of history, / the dark ships move, the dark ships move"—weaving an elusive history as they go. M. NourBese Philip's book-length poem *Zong!*, which excavates the massacre of enslaved people thrown overboard the eponymous ship in 1781, utilizes and then abandons a numbering system for its fragmented cantos. "Zong! #" mocks the effort to count: "150sixtyfortytwoandahalfeleventhreesevenfiftythirty-seven eighteen seventeenonesix / weeks / months / weeks / days / months / days / weeks / months / weeks / months / weeks / negroes / was the bad made measure" (Philip 2011, 51). Perhaps Jason de Caires Taylor's underwater sculpture "Vicissitudes" (2006) comes closest to illustrating how not to count the lost souls of the Middle Passage. The piece, which represents children of different ethnicities holding hands and facing outward in a circle, was immediately interpreted as a comment on enslaved community during the Middle Passage. However, the concrete forms, which dynamically change as coral and underwater plants grow upon them, also speak to human-environmental interdependency. "Finding ways to celebrate the genesis of cultures and affective communities created by collective trauma without obscuring their tragic origin is difficult. 'Vicissitudes' manages to do precisely that, taking figures that in one sense represent death and turning them into the medium for new life," writes one scholar (Carozza).

The "souls on board" discourse registers the emergency and the tragedy of mass loss of human life through numbers. But there are other, sometimes intertwined paths toward remembrance and understanding than counting souls. Moten's "consent not to be one," a joining with others, provides a respite from the fallacious dream of individualized rational sovereignty. Diving With a Purpose recovers the material history of slave shipwrecks while promoting an affective relationship to history. Looking forward, we can stop speaking and writing about non-places: there are none. The slave shipwreck confounds the ideologies of sedentarism, rootedness, place, and property. It suggests that the soul might persist most

intensively neither in a living individual, nor in a landed place, but in the interstices—between past and present, between life and death, between reader and writer.[14]

NOTES

1. Layson's math is wrong: by his count there should have been 239.
2. The phrase appears in Acts 27, when Luke records being shipwrecked on Malta with the Apostle Paul: "And we were all in the ship two hundred three score and sixteen souls." Acts 27:37, KJV.
3. See for example the National Air Traffic Controllers' Association: https://www.natca.org/index.php/insider-articles/1572-nov-4-2016-the-mystery-of-souls-on-board; and the Professional Pilots' Rumor Network: https://www.pprune.org/atc-issues/359490-term-souls-board.html
4. Walter Benjamin, *Illuminations* ed. Hannah Arendt. New York: Mariner, 2019: 196–209.
5. On histories of the Middle Passage, and involuntary Black travel as counter-history, see Saidiya Hartman, "Venus in Two Acts" *Small Axe* 12:22 (June 2008), 1–14; and Paul Gilroy, *The Black Atlantic: Modernity and Double Consciousness.* (London: Verso, 1993).
6. On racial capitalism, see Cedric J. Robinson, *Black Marxism: The Making of the Black Radical Tradition.* [1983]. Chapel Hill: University of North Carolina Press, 2000.
7. On the enslaved person's persistence in a state of injury, see Achille Mbmebe, "Necropolitics" *Public Culture* 15:1 (2003), 11–40: 21.
8. Much of the critical discussion deals with the politics of baptism after landing in the New World. Hamilton reports that before a 1667 law declaring that Christians could hold other Christians in bondage, enslaved people were not baptized. On soul-making in postcolonial theory, see Gayatri Spivak, "Three Women's Texts and a Critique of Imperialism" *Critical Inquiry* 12:1 (Autumn 1985), 243–261.
9. Ulrike Schmieder, Katja Füllberg-Stolberg, and Michael Zueske, eds. *The End of Slavery in the Americas: A Comparative Approach* Berlin: LIT Verlag, 2011: 55.
10. https://slavewrecksproject.org/about-swp/slave-wreck-heritage/
11. Jaco Jacques Boshoff, et al. *From No Return: The 221-Year Journey of the Slave Ship São José.* Washington, D.C.: Smithsonian National Museum of African American History and Culture, 2016: 64. Further citations are to this edition and appear in the text in parentheses.
12. Though, by publication, more may have come to light.

13. Slave Wrecks Project, "Our Mission." https://nmaahc.si.edu/explore/initiatives/slave-wrecks-project. See also the ePix series "Enslaved," in which the actor Samuel L. Jackson joins Diving With A Purpose to excavate the wreck of the *Guerrero*.
14. On the notion of "between" as entanglement, blur, and "difference without separation," see Fred Moten, *Black and Blur* (Durham: Duke University Press, 2017), 313.

Works Cited

Augé, Marc. 1995. *Non-Places: Introduction to the Anthropology of Supermodernity*. London: Verso.
Baucom, Ian. 2005. *Specters of the Atlantic: Finance Capital, Slavery, and the Philosophy of History*. Durham: Duke University Press.
Benjamin, Walter. 2019. In *Illuminations*, ed. Hannah Arendt. New York: Mariner.
Boshoff, Jaco Jacques, et al. 2016. *From No Return: The 221-Year Journey of the Slave Ship São José*. Washington, DC: Smithsonian National Museum of African American History and Culture.
Carozza, Davide. Jason de Caires Taylor, "Vicissitudes". *Deeps*. The Black Atlantic, Duke University. Accessed on 1.26.21. http://sites.duke.edu/blackatlantic/.
Cooper, Helene. 2015. Grim History Traced in Sunken Slave Ship Found Off South Africa. *The New York Times*, 31 May 2015.
Cresswell, Tim. 2010. Towards a Politics of Mobility. *Environment and Planning D: Society and Space* 28: 17–31.
Du Bois, W.E.B. 1903. *The Souls of Black Folk*. Project Gutenberg edition. https://www.gutenberg.org/files/408/408-h/408-h.htm.
Fallows, Deborah. 2013. Say 'Souls on Board,' and Other Secrets of the Skies. *The Atlantic* 16 September 2013. https://www.theatlantic.com/national/archive/2013/09/say-souls-on-board-and-other-secrets-of-the-skies/279694/.
Gilroy, Paul. 1993. *The Black Atlantic: Modernity and Double Consciousness*. London: Verso.
Hamilton, Peter J. 1904. *Colonization of the South*. Philadelphia: George Barrie's Sons.
Harney, Stefano, and Fred Moten. 2013. *The Undercommons: Fugitive Planning & Black Study*. Autonomedia.
Hartman, Saidiya. 2008. Venus in Two Acts. *Small Axe* 12:22 (June).
Hoare, Edward Newenham. 1885. *Perils of the Deep. Being an Account of Some of the Memorable Shipwrecks and Disasters at Sea During the Last One Hundred Years*. London: Society for the Promoting of Christian Knowledge.
King, James. Bible. https://www.biblegateway.com/.

Lavery, Charne. 2020. Diving into the Slave Wreck: The São José Paquete d'Africa Yvette Christiansë's Imprendehora" *Eastern African Literary and Cultural Studies* 6(4): 269–283.

Layson, J.F. 1882. *Memorable Shipwrecks and Seafaring Adventures of the Nineteenth Century*. London: Tyne.

Lloyd, David. 2020. The Social Life of Black Things. *Radical Philosophy* 20.7 (Spring), 79–92:81.

Mbmebe, Achille. 2003. Necropolitics. *Public Culture* 15 (1): 11–40.

McKittrick, Katherine. 2014. Mathematics Black Life. *The Black Scholar* 44:2 (Summer), 16–28.

Morley, David. 2017. *Communications and Mobility: The Migrant, the Mobile Phone, and the Container Box*. Chichester: Wiley-Blackwell.

Moten, Fred. 2017. *Black and Blur*. Durham: Duke University Press.

———. 2018. *Stolen Life*. Durham: Duke University Press.

Mustakeem, Sowande' M. 2016. *Slavery at Sea: Terror, Sex, and Sickness in the Middle Passage*. Urbana: University of Illinois Press. Kindle edition.

Newson, Linda A. 2007. And Susie Minchin. *From Capture to Sale: The Portuguese Slave Trade to Spanish South American in the Early Seventeenth Century*. Leiden: Brill.

Philip, M. NourbeSe. 2011. *Zong!* 51. Middletown: Wesleyan University Press.

Robinson, Cedric J. 2000. *Black Marxism: The Making of the Black Radical Tradition* [1983]. Chapel Hill: University of North Carolina Press.

Schmieder, Ulrike, Katja Füllberg-Stolberg, and Michael Zueske, eds. 2011. *The End of Slavery in the Americas: A Comparative Approach*. Berlin: LIT Verlag.

Slave Wrecks Project. 2008. *Our Mission*. Accessed May 11, 2021. https://nmaahc.si.edu/explore/initiatives/slave-wrecks-project.

Smallwood, Stephanie. 2007. *Saltwater Slavery: A Middle Passage from Africa to American Diaspora*. Cambridge: Harvard University Press.

Spillers, Hortense J. 1987. Mama's Baby, Papa's Maybe: An American Grammar Book. *Diacritics* 17 (2): 65–81.

Spivak, Gayatri. 1985. Three Women's Texts and a Critique of Imperialism. *Critical Inquiry* 12:1 (Autumn), 243–261.

Walcott, Derek. 2007. The Sea is History. In *Selected Poems*, 137–139. New York: Farrar, Straus, Giroux.

CHAPTER 14

African American Women's Literary Renaissance: A Template for Spiritual Fiction in the Twenty-First Century?

Claude Le Fustec

INTRODUCTION: THE SPIRITUAL TURN IN AFRICAN AMERICAN FICTION BY WOMEN

Still rather undocumented, the 1970s and 1980s were a special time in African American letters, one in which an unprecedented number of African American women fiction writers were published. Beyond a mere issue of number, however, the period is characterized by a shaping spirit best encapsulated in Akasha Gloria Hull's 2001 *Soul Talk: The New Spirituality of African American Women*, where she states in her chapter "The Third Revolution: A New Spirituality Arises":

> Around 1980 an outburst of spirituality concomitantly erupted among African American women, just when the civil rights movement and the early ferment of the feminist movement were subsiding. [...]

C. Le Fustec (✉)
Rennes 2 University, Rennes, France

© The Author(s), under exclusive license to Springer Nature Switzerland AG 2024
D. Louis-Dimitrov, E. Murail (eds.), *The Persistence of the Soul in Literature, Art and Politics*,
https://doi.org/10.1007/978-3-031-40934-9_14

Black women embraced practices associated with the New Age [...] and laid them alongside more traditional, culturally derived religious and spiritual foundations. The results could be seen in [...] the remarkable outpouring of creative writing by authors such as Toni Morrison, Toni Cade Bambara, and Alice Walker [...]. What African American women were creating added political dimension to the generally apolitical spiritual movement and contributed immensely to a higher collective spiritual consciousness. (Hull 2001, 23–4)

As the comment suggests, in the wake of the ebullient sixties, the time was ripe for the flowering of a spiritual kind of African American fiction after a period of intense political activism had opened up new channels of expression. Furthermore, as Akasha Gloria Hull is also at pains to demonstrate throughout her book, this type of spirituality went hand in hand with a heightened political awareness that it both drew from and nourished in return. Finally, in this context, the word "spirituality" covers a variety of practices and beliefs that inevitably take very different fictional forms, which this essay is all about.

Based on Dr. Hull's own experience as well as on interviews with nine African American women having earned influential reputations notably as writers and artists, *Soul Talk* remains a rare achievement in the field of African American studies with its explicit focus on spirituality as central to the lives and craft of African American women.[1] A deadly foe in secular academic circles, spirituality is either opposed to sane, rational reasoning and charged with religious bigotry if not fanaticism or made into a rather fuzzy and abstract notion. As Hull puts it, explaining the process she went through to write her book: "Oriented as I had been toward a spirituality that was predominantly intellectual and 'heady,' I also had to fall to the knees of my heart" (Hull 2001, 253).

In other words, spirituality should first and foremost be considered as experiential. Indeed, as Hull defines and explores it in her book, spirituality is not just inseparable from African American women's daily lives; it also fuels their political-cum-artistic commitments:

Soul Talk investigates this new spirituality that is taking shape among many progressive African American women at this turning of the twenty-first century. Arising around 1980, it brings together three interlocking dimensions: (1) the heightened political and social awareness of the civil rights and feminist movements, (2) a spiritual consciousness that melds black American traditions such as Christian prayer and ancestral reverence with New Age

modalities such as crystal work and self-help metaphysics, and (3) enhanced creativity, especially as represented by the outburst of literature by Toni Morrison, Toni Cade Bambara, Alice Walker, Lucille Clifton, Octavia Butler, Audre Lorde, Ntozake Shange, Paule Marshall, Sonia Sanchez, Gayle (sic) Jones […]. (Hull 2001, 1–2)

As it happens, Dr. Hull's analysis is perfectly congruent with my own 1993 PhD dissertation on Toni Cade Bambara's and Toni Morrison's fiction. Entitled "Crisis and Regeneration: The Quest for Unity in the Fiction by Toni Cade Bambara and Toni Morrison," it examined the way the two authors reach out for a sense of individual and collective coherence beyond the physical, mental, and spiritual alienation plaguing their lives, a move very much echoed, as Hull shows, by all the African American women writers of the seventies and eighties.

Toni Morrison's Emancipatory Fiction: Revisiting Christian Experience

To discuss this spiritual resilience in African American women's fiction, specifically as expressed in the decades immediately following the Civil Rights Movement, I would like to start by focusing on the writer who, as an editor in the prestigious Random publishing house, facilitated this literary renaissance[2]: Toni Morrison.

On top of arguably being the leader of this renaissance, as, notably, the 1993 Nobel Laureate, Toni Morrison deserves special attention in this discussion because her spiritual stance is very specific. For hers is a non-dogmatic yet deeply Christian sensitivity.[3] The scope and impact on her fiction of such a sensitivity have long been underestimated.[4] Now, even more so, as I will argue, the specifically spiritual character of Morrison's imagination remains to be examined.

The first obvious reason for such an omission in the impressive volume of critical thinking on Morrison is the difficulty encountered in differentiating between the overlapping categories of the religious and the spiritual. One of the rare academic endeavors in that direction, the transdisciplinary and international network *Theorias* published in 2015 a first collection of essays clearly all pointing in a direction suggesting the experiential nature of the spiritual beyond religious affiliations (Le Fustec et al. 2015), while its latest publication advocates the creation of "spiritual studies" (Le Fustec et al. 2022). Taking this inner, experiential orientation as the

hallmark of the spiritual will serve as a basis to assess the nature of Morrison's writing project.

In her 1993 Nobel lecture, Morrison created a dialogue between a wise old woman and inexperienced youngsters who have come to challenge her wisdom, where she has them eventually implore her guidance in the following terms: "You, old woman, blessed with blindness, can speak the language that tells us what only language can: how to see without pictures. Language alone protects us from the scariness of things with no names. Language alone is meditation" (Morrison 1993). An allegorical meditation on language, this dialogue is probably one of Morrison's clearest assessments of the spiritual nature of writing for her, especially when she points out that language can never "pin down" life because "[i]ts force, its felicity is in its reach toward the ineffable" (Morrison 1993).

Both inward bound and aimed at the invisible and ineffable, language is clearly a privileged medium for Morrison to attain knowledge, particularly self-knowledge, the aim of spiritual striving. In her 2012 Harvard Ingersoll lecture, she stated:

> Allowing goodness its own speech does not annihilate evil, but it does allow me to signify my own understanding of goodness: the acquisition of self-knowledge. A satisfactory or good ending for me is when the protagonist learns something vital and morally insightful that she or he did not know at the beginning. (Carrasco et al. 2019, 19)

Interestingly, Morrison conflates a moral ("goodness") and spiritual vocabulary ("self-knowledge")—thereby ruling out potential moral judgment since goodness ceases to be a moral category—to designate the end of fiction writing for her: the acquisition of self-knowledge.

This pronouncement sums up to perfection what can be seen on a larger scale as a clear move in her fiction from a moral type of concern to a more spiritual one. Indeed, as I showed in a preceding publication (Le Fustec 2011), while her first four novels could be read as exposing and questioning the Manichean moral thinking derived from a deeply Puritan ideology of sin,[5] the three novels making up her subsequent trilogy (*Beloved*, *Jazz* and *Paradise*) seem constructed as explorations of the three coordinates of human life, respectively appearing as final words in each novel: "me," "now," "here."

As I demonstrated, the moral concern of the first four novels can be seen on a symbolic level in the recurrence of the theme of the Fall, the

biblical myth of alienation from Paradise and the common structuring principle in the first four novels, which are pointed responses to the moral dualism characteristic of its usual interpretation.[6] In deconstructing the ideological underpinnings behind the reading of the Fall, these novels question the symbolic equation constructed between Blacks and evil.

The trilogy, by contrast, reads more like a three-part meditation on what a human being is all about (when a moral/religious ideology ceases to prevail), through plots that focus on three specific periods in African American history. Indicating herself the larger scope of these historical novels, Morrison said that each novel in the trilogy represents one aspect of love: maternal (*Beloved*), erotic (*Jazz*) and spiritual (*Paradise*). Finally, as if propelled by this spiritual anchor in self-awareness as a response to the obliterating power of slavery and racism, the four novels following the trilogy (*Love*, *A Mercy*, *Home* and *God help the child*) have titles sounding like invitations to read them as secular meditations on traditionally Christian concepts (Redemption, Mercy, The Promised Land/Eden, Salvation respectively) that shaped the American Nation.

The ending of *A Mercy* is a case in point. Told from the young narrator's mother's viewpoint describing her maternal relief and gratitude for Jacob when he agrees to take her daughter as a servant and thus save her from their owner's inevitable sexual harassment, the passage conjures up the traditionally divine attribute, often called upon by European settlers on their arriving in the New World: Mercy.[7]

> I said you. Take you, my daughter. Because I saw the tall man see you as a human child, not pieces of eight. I knelt before him. Hoping for a miracle. He said yes.
> It was not a miracle. Bestowed by God. It was a mercy. Offered by a human. (Morrison 2008, 164–5)

Coming at the end of the narrative, the passage reads like the solution to the riddle of the title all the while silently commenting on the relativity and precariousness of human interpretation since what comes out as an act of mercy and love had been consistently understood as abandonment and betrayal through the narrative eyes of the daughter. From a larger perspective, in the context of this novel's rewriting of the colonial period, this hermeneutic deficiency is an implicit comment on the early Puritan settlers' constant reading of what they took to be signs to guide them in their

colonial enterprise, which later generated the national founding myths (such as Manifest Destiny).

To return to Morrison's fiction as a whole, there is a narrative sign supporting reading her novels as evolving from a moral to a spiritual concern. For one unquestionable fact is the evolution (as from *Jazz*) away from a relatively classical type of narration, with either a first-person narrator (as in *The Bluest Eye*) or an omniscient one (as in *Beloved*), toward a form of stream of consciousness. This is in keeping with the spiritual turn (inward bound) of her fiction as from the trilogy, with *Beloved* arguably a transition work with its meandering—though still omniscient—type of narration, modeled after the way memory works according to the author.

This being said, what remains a hallmark of Morrison's spiritual engagement is its Christian character. Even in *Jazz*, dedicated to exploring erotic love through an adulterous affair taking place in Harlem, at the apex of the story, when the young girl, whom her lover Joe has just shot, refuses to unveil her murderer's identity, Morrison has her resort to a mysterious image, resonant with Christian echoes, in her final, dying words reported by her friend Felice:

> It was the last thing she said. [...] Everybody was screaming, "Who shot you, who did it?" She said, "Leave me alone. I'll tell you tomorrow." [...] Then she called my name. [...] She was sweating, and whispering to herself. Couldn't keep her eyes open. Then she opened them wide and said real loud: "There's only one apple." "Just one. Tell Joe." (Morrison 1992, 213)

Seemingly uttered out of the blue, at the crucial moment of death, the image cannot but recall the biblical symbol of the Fall from Paradise sentencing humankind to death and guilt. However, usually a symbol of severance from Eden and hence of disunity, the image interestingly appears here in the context of a refusal to assign guilt and with a strong focus on "one." "There's only one apple. [...] Just one."

No interpretation is provided, leaving the potentially symbolic significance in abeyance, in keeping with Morrison's avoidance of fixed meanings. Nevertheless, relating it to the gnostic epigraph, extracted from a text that is all about the conjunction of opposites,[8] might suggest an interesting interpretive track. If, indeed, the symbolically laden fruit of the Fall be turned into a signifier of unity/uniqueness devoid of predefined moral significance, the whole edifice of divisive and exclusionary moralism crumbles, which appears to be the underlying pursuit in Morrison's fiction from

the start. As it happens, while progressing along that path, her narration naturally encounters the opposite—Charity, or Love, the leading thread of her trilogy. It is worth pondering that this three-fold narrative meditation on Love in the trilogy should result in greater self-awareness ("Me," "Now," "Here") and precede plots, in the next novels, with titles focusing on core Christian values. The overall feeling is that Morrison's Christian sensitivity comes out in her fiction as experiential[9] and results in an individuating process becoming apparent in the trilogy and subsequently enabling a greater depth of narrative/allegorical exploration of the ways Christian ontological values may have been distorted in/by African American (hi)stories.

Toni Cade Bambara's Esoteric Holism

Should one feel doubtful about the actuality and importance of the Christian influence on Morrison's creativity, one only need turn to a fellow writer, who was also a friend: Toni Cade Bambara. It is interesting to compare the way the two writers incorporated the myth of the Flying African into their creative output. For Morrison, the myth is central to her third novel, *Song of Solomon*, while it appears in Bambara's fiction in one of the short stories of her second collection as a topic of conversation producing a metaphor then used as the title of her 1980 novel: *The Salt Eaters*.

The first remark is that one need not be very perceptive to realize that Morrison's title echoes the biblical "Song of Songs" while Bambara's metaphor is more of her own. In fact, the image of the "salt eaters," later to become the title of her first and only novel published in her lifetime, appears in her short story "Broken Field Running" as a metaphor of the vicious circle of oppression in which African American people have been caught:

> "All I'm saying is we got grounded. [...] We sure as hell got to rise above this here mess. We got to fly."
> "The salt trails of a people," Sanderson resumes [...].
> "You got to talk plain, Sand. Your metaphors always so damn falutin. Talk plain, man." [...]
> "I'm talking plain, sister. I'm tellin ya how it was and how it is. We get our sweat sold back to us so we can sweat some more. Sweat dripping in the white man's pails. [...] We salt eaters." (Bambara 1984, 55–6)

A testimony to Bambara's scientific training, the title of the short story refers to the electromagnetic field at the center of which Black people supposedly were in balance when they "came to Africa [and] could fly" (Bambara 1984, 556). The legend of the Flying African(s) is here taken up in a pseudo-scientific way, conflating folk culture with sophisticated Western knowledge, a conjunction Bambara fully explores in *The Salt Eaters*, as she explains in her essay with the explicitly spiritual title, "Salvation is the Issue":

> The setup in *The Salt Eaters* is as close as I have come at this stage in my development to coaxing the "design" of the world I intuit and attempt to signify/communicate come through. Intimations of what I'm striving for—to work at the point of interface between the political/artistic/metaphysical, that meeting place where all seeming contradictions and polarities melt, that bicameral mind membrane (jamming at the juncture doo ahh) can be explored more sense-ably in some language other than what I've been using prompts me of late to [...] pick up another kind of pencil—the camera. (Evans 1985, 43)

Clearly, if Morrison's approach to writing is meditative, Bambara's is not. As she readily admitted, "I'm inclined to be a self-indulgent blabbermouth rather than a disciplined and tight-reined 'listener'" (Evans 1985, 44), which accounts for a rather speedy narrative style, requiring that she resort to specific types of paper and ink "to slow [her] down" (Evans 1985, 44). "Raised by family and community to be a combatant," she lists "mystics" alongside "linguists, physicists, and cinematographers" as sources of inspiration "steering [her] toward new language possibilities" (Evans 1985, 45). This is to say that Bambara's spiritual sensitivity is of an intuitive and improvisational kind, based on no specific religious tradition but rather striving to bring all areas of knowledge together. A definitely holistic thinker, she worked from intuition and her spirituality is of an esoteric kind. It is noteworthy that after the spiritual peak that *The Salt Eaters* arguably was, and contrary to Morrison who seems to have been drawn to increasingly more introspective fiction, Bambara should have turned to a more documentary type of creation, whether in her long novel *These Bones Are Not My Child*, posthumously shortened and published by Toni Morrison, or in the films she shot at the Philadelphia Scribe Video Center.

Alice Walker's Pantheism

It is likely that the documentary vein was more satisfactory to the activist fiber in Bambara, an open activism that is a common point she shares with another renowned African American writer: Alice Walker. A more strident feminist with, notably, open bisexual positions, Walker shares Bambara's holistic vision with a specificity of her own: what has been termed her "pantheism" (Smith 1998).

As demonstrated by *The Color Purple*, Alice Walker's most acclaimed novel, notably on account of Spielberg's film adaptation, Walker's pantheism is a feminine and feminist response to a patriarchal vision and practice of religion. Described by the author herself as "the theological work examining the journey from the religious back to the spiritual that I spent much of my adult life, prior to writing it, seeking to avoid,"[10] *The Color Purple* occupies a special place in Walker's career. In Nagueyalti Warren's words, "more than in any of her previous works, *The Color Purple* […] is her paean to Spirit, [where she] lays the theological groundwork for ideas that she expands and clarifies in her later work" (Warren 2019, 81). Warren even goes so far as to say that "*The Color Purple* mirrors the passion of Jesus of Nazareth and his transformation into the Christ" (Warren 2019, 98).

Warren's analysis of the link between *The Color Purple* and Christian theology is interesting albeit disconcerting considering the overall pantheistic message of the book, largely conveyed by Shug, who very much acts as the main narrator's spiritual guide. Indeed for Shug, "God ain't a he or a she, but a It. […] God is everything […] that is or ever was or ever will be," a certainty derived from her sudden experience of feeling "part of everything, not separate at all" (Walker 1982, 190–1). A clear indictment of the usual patriarchal reading of the Christian God and its attending oppressive ideology, the novel may indeed be read, as Warren suggests, as both signifying upon certain passages of the Bible and exemplifying the Christic journey.[11] However, should one try to assess Walker's spiritual specificity as compared to Bambara's or Morrison's, the word "mystic" with its suggestions of oneness with the whole of Creation comes up alongside "pantheistic" (as it does in Warren's analysis). Indeed, Walker herself speaks of *The Color Purple* as "the book in which I was able to express a new spiritual awareness, a rebirth into strong feelings of Oneness I realized I had experienced and taken for granted as a child."[12] In Warren's words: "Alice Walker is a present-day mystic. If, as Margaret Furse claims,

the mystic experiences Spirit as immediate and present in all things, then mysticism is a worldview that aligns with Walker's writings" (Warren 2019, xiii).

This is probably where Bambara and Walker part in terms of their spiritual sensitivity: where Walker's spirituality seems first and foremost corporeal, Bambara's would be more intellectual, a matter of intuitive and illuminating understanding. Indeed, whereas Shug's connection to nature is the basis of her mystic conversion,[13] the central epiphany in *The Salt Eaters* comes to one of the characters, Campbell, as the intuition of "universal knowledge":

> What came to Campbell [...] was a flash in the brain pan, and he knew he'd struck gold. Knew in a glowing moment that all systems were the same at base—voodoo, thermodynamics, I Ching, astrology, numerology, alchemy, metaphysics, everybody's ancient myths—they were interchangeable, not at all separate much less conflicting. (Bambara 1982, 210)

This is not to say that *The Salt Eaters* lacks a physical basis, for the narrative is framed by the healing scene between Velma and Minnie, symbolically placed in a hospital as the meeting point between rational and non-rational systems of knowledge. Yet again, Bambara's focus is less on the sensual per se than on the inner energy whose flow Minnie helps to restore. "No need of Minnie's hands now. That is clear. Velma's glow aglow and two yards wide of clear and unstreaked white and yellow. Her eyes scanning the air surrounding Minnie, then examining her own hands, fingers stretched and radiant" (Bambara 1982, 295). Different as they are, Walker's and Bambara's spiritual sensitivities, as expressed through their fiction, still evidence a common holistic experience which seems to ground them.

Still, another point of enquiry would be their respective stances to the religious. As opposed to Walker's explicit conversion away from the religious back to the spiritual reflected in Shug's militant pantheism, institutional religion does not seem part of Bambara's concerns. Nor does her writing appear shaped by a religious imagination of the type that seems to inform Morrison's whereas the epistolary form chosen for *The Color Purple* signals more ambiguity. Indeed, even if Celie's letters to God are gradually addressed to her sister Nettie before the final pantheistic address "Dear God. Dear stars, dear trees, dear sky, dear peoples. Dear Everything.

Dear God.," the last word of the book is "Amen," which seems to suggest an attempted reconciliation between institutional ritual and "the Spirit":

> Without whose assistance
> Neither this book
> Nor I
> Would have been
> Written[14]

This must also have been Spielberg's understanding of the novel, considering the climactic scene of Shug's reconciliation with her father, a priest, into whose service she bursts, dropping the 'sinful' blues she had been singing in a juke joint to take up the gospel sung by the church choir ("God's trying to tell you something") and fall into her father's arms, to the lyrics: "Speak to me Lord, right now, right now, right now." Even if this scene is absent from the novel, it is faithful to the novel's spiritual though slightly didactic (and sentimentalized) message of universal reconciliation.

MAGIC REALISM IN GLORIA NAYLOR'S FICTION

Even if only briefly, another writer of the renaissance deserves mentioning for the totally specific narrative modality taken up by the spiritual in her fiction: indeed, contrary to what generally happens when authors are asked about the topic, Gloria Naylor readily admits her use of magic realism as narrative mode in an interview with Kay Bonnetti:

> KB: Another thing that comes up a lot in literature is the question of magical realism. And I wondered what your thoughts were.
> GN: [...] You know, I needed to find a way structurally to tell the story of George and Cocoa, so what I was doing was walking a thin line between that which is real and that which is not real, in an odd kind of way. So, I read Gabriel García Márquez ages ago. [...] And so I don't have any problem with it. I enjoy reading some of the magical realists and I've even used them. (Montgomery 2004, 61)

Recognizing magic realism as a central narrative device in *Mama Day* in those terms, Naylor shows her allegiance to a western, rational type of thinking dividing up reality into "that which is real" (i.e. ordinary reality) and "that which is not real" (magic, the supernatural), contrary to

practitioners of the mode who, usually raised in non-western environments taking the non-rational for granted, balk at being called "magic realists" as both components of reality implied by the phrase seem to them just as much real the one as the other. In that sense, according to Elizabeth Hayes, magic realism would be more "programmatic" in Naylor's fiction and a militant way to "interrogate rationalist ideology by dramatically illustrating its limitation" (Felton and Loris 1997, 186). In other words, Naylor's magic realism would be deliberately postcolonial at heart. This notwithstanding, magic realism in *Mama Day* is not just a way of bringing together two opposed worldviews so as to question the imperialism of one of the two. It is also the underlying mechanism in the central romance between George and Cocoa, wedding not just two universes but two hearts. As the author herself has suggested, there is something redemptive in their coming together and crossing over to Cocoa's family world of magic, the island called Willow Springs, all the more as she explicitly thought of George as "a Christ figure":

> GN: In *Mama Day* George is a Christ figure. He sacrifices himself for love and he dies at thirty-three years old.
> ML: So your Christ figure is born in *Bailey's Cafe*?
> GN: Yes, because *Bailey's Cafe* predates *Mama Day*. George saved Cocoa and in that way he saved the whole line of the Days, all the women. (Felton and Loris 1997, 143)

There is thus no missing the biblical intertext in Naylor's fiction, a student of Morrison's, who discovered African American fiction thanks to *The Bluest Eye*. However, contrary to the way it operates in Morrison—very much shaping her religious imagination and leading her into meditative probings as to the essence of humanity—with Naylor, the Bible remains more of a surface allegory with which her fiction engages in dialogue. Still, this takes nothing away from the actual redemptive gesture that her narration seeks to be, situating her clearly within the holistic logic at work in the spiritual fiction characterizing the renaissance.

> In all of our education, whether it's in institutions or not, in homes or streets or wherever, whether it's scholarly or whether it's experiential, there is a kind of a progression. We move from data to information to knowledge to wisdom. And separating one from the other, being able to distinguish among and between them, that is, knowing the limitations and the danger of exercising one without the others, while respecting each category of intelligence, is generally what serious education is about. (Morrison 2019, 307)

I would argue that the specifically spiritual dimension that appears to be the salient feature of the post-Civil Rights African American women's literary renaissance pursued precisely that goal: moving from data to wisdom in an educating spirit striving to substitute unity consciousness to the reigning conflictual divisiveness. Accordingly, back in the early nineties, my enquiry into Bambara and Morrison's fiction was less geared toward militant political action than animated by a concern with the way African American writers might chart a path toward a higher global spiritual consciousness (with the potential to impact political action). I thus read with some elation Hull's following words: "More universally, the question becomes: How does spirituality make a place for itself in a materially limited and materialistic world?" (Hull 2001, 229–30).

Three decades ago, the issue could still be dismissed as secondary and a matter for idle academic musings. But today, with the global sanitary and ecological crisis calling for urgent transformation, poet Sonia Sanchez's words might be heeded with greater care:

"As African people, we have moved people spiritually in this country: This country is sustained through the spirituality, I think, of African people." Via music, humor, how we walk or hit a ball, helping people to feel good about themselves so they are less prone to render hurt—Sonia says—"we are in a sense humanizing the world." (Hull 2001, 242)

Notes

1. Another notable exception is Baker's 1991 *Workings of the Spirit. The Poetics of Afro-American Women's Writing*, which grants theoretical attention to the spiritual dimension of African American writing, or Alice Walker's own poetic collection of essays *In Search of Our Mothers' Gardens* (1983). To the best of our knowledge, there has been so far no such critical endeavor in academic circles.
2. The phrase "African American Women's Literary Renaissance" is used by Akasha Gloria Hull in *Soul Talk: The New Spirituality of African American Women*, page 5.
3. "Toni Morrison's writing name, Toni, was birthed out of her own religious experience of converting to Catholicism. Raised in an African Methodist Episcopal church, Morrison converted to the Catholic faith at the age of 12, taking the confirmation name St. Anthony" (Meagan Jordan, "The

Religious Dimensions of Toni Morrison's Literature," *Sojourners*, Aug 23, 2019).
4. Not until 2006 was a whole book dedicated to the link between Morrison's fiction and the Bible: *Toni Morrison and the Bible. Contested Intertextualities* (Shirley Stave A, ed., New York: P. Lang). The other major title about her "moral and religious vision" was published the year of her death: David Carrasco, ed., *Toni Morrison. Goodness and Literary Imagination: Toni Morrison Harvard Divinity School's 95th Ingersoll Lecture with essays on Morrison's moral and religious vision* (Charlottesville: University of Virginia Press, 2019). Finally, in his *Longing for an Absent God. Faith and Doubt in Great American Fiction* (Fortress Press, 2020), Nick Ripatrazone examines Morrison as a "storyteller shaped by a catholic faith based in visceral narrative" (Ripatrazone, "On the Paradoxes of Toni Morrison's Catholicism," *Literary Hub*, March 2, 2020).
5. TULIP is the acronym of the Puritan doctrine that reads man's innate nature as "totally depraved."
6. In this respect, I find Nick Ripatrazone's assertion that "Morrison's Catholic faith [...] offers a theological structure for her worldview" ("On the Paradoxes of Toni Morrison's Catholicism") quite illuminating.
7. One famous instance is Winthrop's "Model of Christian Charity."
8. Epigraph in *Jazz*:

"I am the name of the sound
 and the sound of the name
I am the sign of the letter
 and the designation of the division.
"Thunder, Perfect Mind,"
The Nag Hammadi

9. As the "bad one," for instance, Sula exposes the sheer cruelty with which her community casts her into the role of the evil one and thus questions the neat division between good and evil upon which that community is built. This same division between righteousness and wrong is very much the structuring principle in the first four novels as my study of the parable of the Fall in these novels tried to show.
10. In Walker's own introduction to the tenth anniversary of the publication of her novel.
11. Warren does suggest that "purple, used within the context of Christian liturgy, often during Lent season and for Easter, signifies pain and suffering and the royal resurrection" (Warren, *Alice Walker's Metaphysics*, 95).
12. Introduction to the tenth anniversary edition.

13. "[Shug] say, My first step from the old white man was trees. Then air. Then birds. Then other people. But one day […], it come to me: that feeling of being part of everything […]. I knew that if I cut a tree, my arm would bleed" (Walker, *The Color Purple*, 190–1).
14. Dedication in *The Color Purple*.

Works Cited

Baker, Houston A. 1991. Jr. *Workings of the Spirit. The Poetics of Afro-American Women's Writing*. Chicago and London: The University of Chicago Press.

Bambara, Toni Cade. 1982. *The Salt Eaters*. London: The Women's Press.

———. 1984. Broken Field Running. *The Sea Birds Are Still Alive* [1982]. London: The Women's Press.

Carrasco, Davíd, Stephanie Paulsell, and Mara Willard, eds. 2019. *Toni Morrison. Goodness: Altruism and the Literary Imagination, Harvard Divinity School's 95th Ingersoll Lecture with essays on Morrison's Moral and Religious Vision*. University of Virginia Press.

Evans, Mari, ed. 1985. *Black Women Writers. Arguments and Interviews*. London and Sydney: Pluto Press.

Felton, Sharon, and Michelle C. Loris, eds. 1997. *The Critical Response to Gloria Naylor*. Westport: Greenwood Press.

Hull, Akasha Gloria. 2001. *Soul Talk. The New Spirituality of African American Women*. Rochester: Inner Traditions.

Le Fustec, Claude. 2011. 'Never break them in two. Never put one over the other. Eve is Mary's mother. Mary is the daughter of Eve'. Toni Morrison's Womanist Gospel of Self-Knowledge. *E-rea* 8, no. 2 (March). http://journals.openedition.org/erea/1680.

Le Fustec, Claude, Françoise, and Jeff Storey, eds. 2015. *Théoriser le spirituel? Approches transdisciplinaires de la spiritualité dans les Arts et les Sciences*. Bruxelles, Belgique: Editions Modulaires Européennes, coll. Esthétique et Spiritualité.

Le Fustec, Claude, Myriam Watthee-Delmotte, Eric Vinson, and Xavier Gravend-Tirole, eds. 2022. *Le spirituel: un concept opératoire en sciences humaines et sociales*. Louvain: Presses Universitaires de Louvain.

Montgomery, Maxine Lavon, ed. 2004. *Conversations with Gloria Naylor*. Jackson: University Press of Mississippi.

Morrison, Toni. 1992. *Jazz*. London: Chatto and Windus.

———. 1993. Nobel Lecture, December 7. https://www.nobelprize.org/prizes/literature/1993/morrison/lecture/.

———. 2008. *A Mercy*. London: Chatto and Windus.

———. 2019. *The Source of Self-Regard. Mouth Full of Blood: Essays, Speeches, Meditations*. London: Chatto and Windus.

Smith, Pamela A. 1998/1999. Green Lap, Brown Embrace, Blue Body: The Ecospirituality of Alice Walker. (Winter) *Cross Currents* 48(4): 471–487.

Stave, Shirley A. 2006. *Toni Morrison and the Bible. Contested Intertextualities*. New York: P. Lang.

Walker, Alice. 1982. *The Color Purple*. New York: Harcourt Brace Jovanovich.

———. 1983. *In Search of Our Mothers' Gardens. Womanist Prose*. San Diego: Harvest/HBJ.

Warren, Nagueyalti. 2019. *Alice Walker's Metaphysics. Literature of Spirit*. Lanham: Rowman and Littlefield.

CHAPTER 15

Persisting Souls in a Persisting Myth: Appropriation and Transmigration in Ahmed Saadawi's *Frankenstein in Baghdad* (2013)

Claire Wrobel

Introduction: From Ingolstadt to Baghdad

As is well known, Mary Shelley's tale of a medicine student putting together a body from corpses and bringing the creature thus assembled to life in the Bavarian town of Ingolstadt has undergone countless adaptations across all possible media, a phenomenon which has led to the coining of the phrase "Frankenpheme" in cultural studies. The word is drawn from "phonemes" and "graphemes"—sonic and visual elements—and refers to elements of culture derived from Shelley's work (Morton 2002). *Frankenstein in Baghdad*—penned by Ahmed Saadawi, an Iraqi poet and novelist born in 1973—confirms the work's presence in world cultures. The book was published in 2013, rewarded with the International Prize for Arabic Literature in 2014, and translated into English in 2018, on the

C. Wrobel (✉)
Paris-Panthéon-Assas University, Paris, France
e-mail: claire.wrobel@u-paris2.fr

© The Author(s), under exclusive license to Springer Nature Switzerland AG 2024
D. Louis-Dimitrov, E. Murail (eds.), *The Persistence of the Soul in Literature, Art and Politics*, https://doi.org/10.1007/978-3-031-40934-9_15

bicentenary of the first publication of Shelley's work. Here, Shelley's tale transmigrates to contemporary Baghdad, a "death machine" in which daily attacks leave mangled corpses lying about (Saadawi 2018, 118). Saadawi is well aware of his novel's inscription in a long series of transmutations, as shown by his explicit reference to Kenneth Branagh's 1994 film with Robert de Niro as the Creature (132).

A focus on the soul in the original and its adaptation makes it possible to understand how Saadawi appropriates and rewrites Shelley's myth, and maybe also to grasp the soul of this modern myth—"soul" being taken here in the sense of enduring, "essential part, element, or feature" (*OED*) or "true substance" (Baldick 1987, 2) of a literary work. The notion of transmigration, as the "passage or removal from one place to another" (*OED*) but also as metempsychosis—a phenomenon which is staged in Saadawi's version—may be useful in order to study the intertextual relationship between the two works. The 2013 rewriting explores the political potentialities of the concept of the soul, raising the question of how national unity and a collective destiny may emerge out of a fragmented body politic, for which the Creature—referred to in Saadawi's novel as the "Whatsitsname"—provides figuration. If the soul is the factor which turns a country into a nation, Shelley's myth provides Saadawi with the imaginative means to express anxiety as to its existence or even possibility.

The first section of the paper discusses the limited importance granted to the soul in Shelley's tale, and locates Victor Frankenstein's quest for the "principle of life"—the obsolete meaning of "soul"—in the scientific context of the time, with the emergence of biology and discoveries on electricity. By contrast, the soul in its theological sense is given more importance in Saadawi's rewriting. The second section seeks to highlight the impact of the Islamic and, more broadly, multi-faith context on the treatment of the soul, but also shows that the soul becomes a character in its own right, and a narrative spring which sends the creature on avenging missions. However, as the third part explains, because these missions multiply, both the Whatsitsname and the text are threatened by fragmentation, reflecting on a fictional and metatextual level the centrifugal forces within the Iraqi political body.

Soul, Spirit and Principle of Life in Mary Shelley's Frankenstein

If we turn to the original *Frankenstein*, what is striking is how relatively rarely the word "soul" itself is used. When it is, it seems to be in the third sense

provided by the *Oxford English Dictionary*, that is, "the seat of the emotions, feelings, or sentiments; the emotional part of man's nature" as well as "intellectual or spiritual power" (Simpson and Wiener 2002). For instance, in the opening chapters, Captain Walton, when discussing the force that draws him to "the wild sea and unvisited regions [he is] about to explore", notes: "There is something at work in my soul, which I do not understand" (Shelley 2003, 22). He also refers to "the burning ardour of [his] soul" (Shelley 2003, 29). The soul is certainly akin to spirituality, as when Walton notes that "the starry sky, the sea, and every sight afforded by these wonderful regions, seem still to have the power of elevating [Frankenstein's] soul from earth" (Shelley 2003, 30). Later on, Frankenstein himself evokes the "unusual tranquillity and gladness of soul" he experiences when he turns away from natural history and embraces mathematics instead (Shelley 2003, 43).

But when it comes to the origin of life and the act of creation, the soul is not mentioned. In fact, as Chris Baldick notes, *Frankenstein* is a godless story, a "disturbing and impiously secular tale" (Shelley 2003, 4). Only in the 1831 introduction to the 1818 novel do references to "a God whose creative monopoly Frankenstein has infringed" appear, and Baldick suggests that such "interpolations" were only added as a "way of accommodating" the tale "into [...] Christian culture" (Shelley 2003, 4). Shelley uses words which are derived from the Latin for soul—*anima*—as well as phrases such as "vital warmth" which may bring to mind the breathing of a soul into the original clay: "Perhaps a corpse would be *re-animated*; galvanism had given token of such things: perhaps the component parts of a creature might be manufactured, brought together, and endued with *vital warmth*" (Shelley 2003, 8; emphasis added). And yet, Shelley steers clear of references to the soul or to a life-imparting God.

Similarly, the question of whether the monster possesses one is given surprisingly little attention, be it by Frankenstein or by the Creature, despite the fact that the latter is prone to metaphysical questioning. Thus, the beginning of volume two, chapter VII depicts him wondering "What did this mean? Who was I? What was I? Whence did I come? What was my destination?" (Shelley 2003, 131). Never in his attempts to locate himself on the chain of being does the Creature refer to the soul. Once Victor Frankenstein has rejected the Creature as a monster, the question of his possessing a soul or not is given no consideration. Postcolonial readings of the novel have seen in the monster an image of the colonized subject—after all, the Creature is compared to "a savage inhabitant of some undiscovered island" by Captain Walton (Shelley 2003, 26)—but the question

of whether this particular "savage" has a soul is not asked.[1] Martin Willis's claim that "[w]hether or not the monster (with the aid of Victor's electrical discoveries) *was* imbued with a conscious soul is at the centre of the narrative" thus seems exaggerated (Willis 1995, 30).

What Frankenstein is looking for is "the principle of life", which is the first, obsolete sense of the word "soul" provided by the *OED*: "Whence, I often asked myself, did the principle of life proceed?" (Shelley 2003, 52). The nature of the principle of life was one of the "various philosophical doctrines" discussed by Lord Byron and Percy Bysshe Shelley at the villa where *Frankenstein* was conceived. Such discussions were anchored in the contemporary scientific debate on the nature of life, which Ralf Haekel presents in *The Soul in British Romanticism*. For Haekel, the monster is a product of vitalist thought, according to which the body needs to be animated by a vivifying principle which is however not understood in theological, but rather in scientific terms (Haekel 2014, 40–41). For someone like John Hunter, the vital principle is a form of heat, an idea which is echoed in Shelley's abovementioned remark, while for John Thelwall, the vital principle is electricity.

Shelley's time was marked by the scientific discoveries on electricity by Galvani (who discovered animal electricity), Volta (who discovered electric power) and Davy (who developed the battery). The "elixir of life" sought by the natural philosophers whom Frankenstein initially turned to thus becomes the "spark of life" (Shelley 2003, 42, 9). Mary Shelley attended public demonstrations of the effect of electricity on animal and human bodies. Humphry Davy, a pioneer of electrochemistry, was a visitor to the Godwin household and Mary Shelley was reading his books in 1816 (Hindle 1990, 31). Shelley's awareness of the most recent discoveries in the field of science is transposed in the scene where Frankenstein witnesses a thunderstorm and sees an oak reduced to a "blasted stump" by lightning (Shelley 2003, 42). The scene convinces him of the power of electricity and diverts the course of his studies. What gives life to the monster in Shelley's novel is an electrical shock. In this context, the Creature is "an effect of contemporary scientific discourse", which explains why, as Baldick puts it, "the problem of the monster's soul simply does not arise" (Baldick 1987, 4):

> The question of whether the monster has a soul is irrelevant to the novel, because a soul is able to establish a connection to transcendence that Frankenstein, not being God, cannot create. [...] In fact, the creature is the

consequence of the theoretical assumption that life without a soul is deemed to be possible in the first place. To conceive of human life and consciousness as imaginable without a transcendental soul in the early decades of the nineteenth century is the outcome of eighteenth-century scientific and epistemological discourses. The creature is therefore an expression of the contemporary scientific—and especially vitalist—debates and thus a reflection of the rivalling concepts and theories of human life at the threshold of the modern scientific world. (Haekel 2014, 41)

By transmigrating to contemporary Baghdad, *Frankenstein* is of course severed from this very specific context which heralds the emergence of biology in Western science around the year 1800.

Bodyless Souls and Soulless Bodies in the City of Demons

In *Frankenstein in Baghdad*, the act of creation is a response to the impossibility of mourning for the dead. The Iraqi capital is a Gothic space, "a troubled city where the demons had broken out of their dungeons and come to the surface all at once" (Saadawi 2018, 61), in which daily explosions make countless victims. The fictional primal scene on which the novel is based depicts Saadawi's variation on Victor Frankenstein—Hadi—going to the mortuary to collect the body of his friend Nahem, who was killed in an explosion: "Hadi was shocked to see that the bodies of explosion victims were all mixed up together and to hear the mortuary worker tell him to put a body together and carry it off—take this leg and this arm and so on" (Saadawi 2018, 214). The central character of the scene is confirmed by the author's statement that it was his experience of such a situation which prompted him to write the novel (Muller 2017). The question raised by Hadi's story is that of the possibility of mourning for a person whose body has been mutilated to the point of being unidentifiable. A related question is raised through the character of Elishva, an old woman who refuses to accept that her son, who has been missing for 20 years after he was sent to war by the Baathists, is dead: how can one mourn a person whose coffin is empty? Indeed, her son's body has never been brought home and only a few personal objects have been buried in the coffin. Finally, the death of a guard called Hasib, whose body is blown into pieces by yet another explosion, raises the question of the fate of the soul which was lodged in a body which has been pulverized. The reintroduction of a religious dimension in Shelley's tale goes along with an ethical

questioning regarding the origin of the body parts the monster is made of—a question that never crosses Victor Frankenstein's mind.

The stories of these three characters, which are stitched together in Saadawi's version of Shelley's tale, are very much anchored in the recent, and not-so-recent political history of Iraq. *Frankenstein in Baghdad*, like other "Iraqi postcolonial novels", documents the consequences of the 2003 invasion, one of which is deadly sectarian violence, which was heralded in 2006 by the explosion of a Shia shrine in Samarra (Hamedawi 2017). A survey conducted by an American and Iraqi team of public health researchers found that approximately 600,000 people have been killed due to the war which followed the US invasion (Burnham et al. 2007). But the history of violence which Saadawi retraces goes further back: the disappearances under the Baathist dictatorship established in 1958 and under Saddam Hussein's presidency which started in 1979, the war with Iran (1980–1988) and the Gulf War (1990–1991). The novel, having been published in 2013, does not register the emergence of ISIS and the invasion of Mosul in 2014. Thus, the city described by Saadawi is not only ripped apart by explosions, but it is also haunted by the ghosts of those who have gone missing in earlier crises. In this context, Elishva's refusal to accept the idea that her son is dead does not seem so ludicrous: "It wasn't hard for her new relatives to believe that Daniel might come back one day. There were many missing people, and some of them were bound to come back. That kept happening. […] Many prisoners came home after the war over Kuwait and in the middle of the 1990s" (Saadawi 2018, 60). This is confirmed later, towards the end of the novel, when Elishva is reunited not with her son, but with her grandson: "Over the last three years the local people had heard many stories that were no more believable. Dead people had emerged from the dungeons of security services and non-existent people appeared out of nowhere outside the doors of their relatives' humble houses" (Saadawi 2018, 227).

The three questions and three stories identified above are brought together and combined in the creature which is put together by Hadi, the local junk dealer and an expert at collecting and assembling. Always on the lookout for drink cans which he then sells to peddlers, he makes a living by collecting and refurbishing discarded objects and lives in a precarious ruin which he has partially restored himself. The debris with which Baghdadi streets are strewn provides him with material out of which he creates new things. He precisely refuses for body parts to be treated like such "rubbish" and decides to stich disconnected members together so

that the resulting corpse "would be respected like other dead people and given a proper burial" (Saadawi 2018, 25). As the novel opens, he has just found the last piece he needed to complete a corpse—a nose. But when the corpse is put together, Hadi does not know what to do with it. Moreover, the recomposed body lacks both a soul and an identity, which will be provided by other characters—the soul by Hasib, and the identity by Daniel.

The third chapter is entitled "A Lost Soul" and focuses on Hasib, the guard killed in the explosion. Little is left of his body; his coffin is said to be a "token". As a consequence, his soul is lost and cannot find rest. His relatives remember him in their dreams, but without a body his soul is doomed to wander:

> Exhausted, every member of the family went to sleep dreaming of Hasib walking home with a cloth bag over his shoulder. They all dreamed something about Hasib. Parts of one dream made up for parts missing in another. A little dream filled a gap in a big one, and the threads stitched together to recreate a dream body for Hasib, to go with his soul, which was still hovering over all their heads and seeking the rest it could not find. Where was the body to which it should return in order to take its place among those who live in a state of limbo? (Saadawi 2018, 34)

Through a process of metempsychosis or transmigration, this bodyless soul lodges itself in the soulless body assembled by Hadi, which now needs an identity. This last element is provided by Elishva, the old woman who is desperately waiting for her son to come back. When she comes across the body, she shouts "Get up, Daniel", in a humorous rewriting of the Lazarus episode, and brings the body back to life: "With her words the old woman had animated this extraordinary composite—made up of disparate body parts and the soul of the hotel guard who had lost his life. The old woman brought him out of anonymity with the name she gave him: Daniel" (Saadawi 2018, 51). For Hadi, however, the "composite" is nameless, and becomes the "Whatsitsname" in his narration, a reminder of the fact that Mary Shelley never gave her own invention a name. The description of the creature thereby assembled does not contradict common representations of the monster: "the big mouth like a gash right across the jaw, the horrible face, the stitches across the forehead and down the cheeks, the big nose" (Saadawi 2018, 83). One may also see in the Whatsitsname's ability to jump over the roofs of Baghdad (Saadawi 2018,

82) an echo of the Creature's ability to climb up mountains at superhuman speed (Shelley 2003, 78).

Although the Quran does not have any specific term to refer to the "soul" as a spiritual principle distinct from the body, it is possible to find the image of the divine spirit (*rûh*) breathing into the clay of the first man. The term *nafs* might be the closest concept to soul. Interestingly, the *nafs* may be called by God when people die, but also when they dream (Michon and Moreau 2013, 120). Thus, death and dreams are similar in that the soul leaves the body, a point which is made by the boy whom Hasib meets in the cemetery: "Maybe you haven't really died and you're dreaming. Or your soul has left your body to go for a stroll and will come back later" (Saadawi 2018, 36).

The dream episode quoted above points to the anchorage of *Frankenstein in Baghdad* in a Muslim context. In the Islamic tradition, dreams are indeed the privileged means by which the dead can communicate with the living, who are often asked to improve the post-mortem fate of a dead relative (Lory 2015, 109). Many of the 350 dream narratives collected in his *Book of Dreams* by Ibn-Abî al-Dunyâ, who died in Baghdad in 894, illustrate the fundamental idea that salvation may be reached through faith and practice, which is why special attention is paid to the moments that immediately follow physical death—the preparation of the corpse, the prayers (Lory 2015, 105–109). Sometimes, the deceased ask for favours from the dreamers; more generally, the living can do something to improve the post-mortem fate of their relatives. In some dreams, the deceased give indications on the funerary rites and insist on their importance, whether it be the cleaning of the body, the shroud, the procession, or the prayers. As Lory puts it, "dreams create in this way a complementarity between those who know but cannot act and those who can act but do not know" (Lory 2015, 113–114; my translation).

The soul is normally tied to a particular place. Thus the boy whom Hasib meets in the cemetery points to his grave, stating that his body is "lying underneath" (Saadawi 2018, 36). In Lory's account the Prophet stated that when a believer walks by a grave and salutes the dead, the soul of the dead person salutes him back, pointing to an "invisible solidarity" which binds the believers together and which is manifested through religious rites (Lory 2015, 114). The political violence—in particular the mutilation of bodies—and the impossibility to conduct funeral rites properly severs the link of solidarity between the dead and the living. This impossible mourning lends a melancholy tone to the novel. And yet,

humour blends in, as in the boy's description of the soul as "the fuel in a car":

> Sometimes the soul leaves the body and you die, but then the Angel of Death changes his mind or corrects the mistake he has made, and the soul goes back inside its body. Then God commands the body to rise from the dead. In other words, the soul is like the fuel in a car. It takes a spark to ignite it. (Saadawi 2018, 37)

In this passage, Saadawi is providing a humorous rewriting of the "spark of life" which Victor Frankenstein sought to impart to the body he had assembled. The vital "fluid" referred to in the 1818 text becomes "fuel" in the incongruous car metaphor. Similarly, the description of a character one may assume is guarding the gates of heaven is marked by fantasy and humour: "He saw a man in a white vest and white shorts floating face-up in [the river]. What bliss! He must be looking at the stars, clear in the night sky. He was drifting slowly with the current. Hasib moved towards him and looked into his face. 'Why are you looking at me, my son?' the man said. 'Go and find out what happened to your body. Don't stay here'" (Saadawi 2018, 35).

Moreover, a lot of importance is given to Elishva, who is not a Muslim but a Christian who believes God is speaking to her through her picture of St George. The saint "really" speaks to her, imbuing the novel with magic realism. Through Elishva, the author gives us an idea of the many religions present in the city. Indeed, she maximizes her chances of getting her son back by making vows at "the Saint Qardagh Church in Akad al-Nasara in Sheikh Omar", "the Anglican Church of Saint George in Bab al-Sharqi", "the Syriac Orthodox church", "the abandoned Jewish synagogue", "the Orfali mosque near the start of Saadoun Street" and "the Church of Saint Odisho" (Saadawi 2018, 90). Her vows may be read as a form of rite in a place where the mourning rite has become much harder to fulfil.

The scientific context which explained the soullessness of Shelley's *Frankenstein* has completely vanished in the contemporary Iraqi version. The soul, unsurprisingly, seems to be best understood from within an Islamic context—its connections with dreams, its link with a particular place, the insistence on rituals and on the solidarity between the dead and the living. While the question of whether the Creature has a soul is not asked in Shelley's tale, in *Frankenstein in Baghdad*, by a sort of reversal, the fact that the Whatsitsname needs a soul goes unquestioned. Similarly,

the idea that life springs from the combination between a body, a soul and an identity does not give rise to any questions or explanations. Rather, Hasib's soul seems to become a character in its own right and, after it combines with Daniel's identity, it becomes a narrative spring that sets the Whatsitsname on its revenge course.

Restless Souls, Endless Revenge and the Dislocation of Meaning

Frankenstein in Baghdad effects a hybridization between Shelley's tale and the conventional spring of many ghost stories in which a wandering soul cannot find rest because the deceased has not been properly buried or needs to be avenged. While, as we discussed above, the idea that the living can help the deceased is present in the Islamic tradition, it is also, more generally, part of a Gothic literary tradition to which *Frankenstein* is related. The Whatsitsname goes on a killing spree against those responsible for Daniel's death so he can find peace. However, what is first presented as a linear quest comes undone and unravels before the reader's very eyes.

The Whatsitsname's first logical victim is the Baathist who sent Daniel off to war, whose murder appears perfectly rational: "[H]e wasn't short of enemies […]. It clearly wasn't random" (Saadawi 2018, 78–79). As murders multiply, the governmental department in charge of finding their author identifies a pattern: "all signs pointed to one perpetrator. […] one person was behind all these crimes" (Saadawi 2018, 106). The key to understanding the murders is the revenge story, which the Department does not know about. They can still, however, try and make sense of the deaths by seeking for a pattern and its underlying rationality.

When given a voice, the Whatsitsname provides a rather eloquent, almost messianic statement of his mission:

> I'm the answer to the call of the poor. I'm a savior, the one they were waiting for and hoped for in some sense. […] I am the answer to their call for an end to injustice and for revenge on the guilty.
>
> With the help of God and of heaven, I will take revenge on all the criminals. I will finally bring about justice on earth, and there will no longer be a need to wait in agony for justice to come, in heaven or after death. (Saadawi 2018, 136–137)

But this interpretation, which stands until the middle of the novel, is later challenged and threatened by dislocation, due to the multiplication of missions and the moral quandaries associated with them. When the Whatsitsname seeks to avenge the dead guard whose soul it possesses, identifying who "the real killer" is proves rather complicated. The immediate cause, a Sudanese suicide bomber, is by definition already dead. Should it be then, as Hadi suggests, the hotel management that placed the guard at the entrance of the Novotel building? Should it be the company that ran the hotel? Are not suicide attacks the result of complex chains of causation? How far up those chains should the Whatsitsname go?

Secondly, since the Whatsitsname is "a composite of victims seeking to avenge their deaths so they could rest in peace", the process is potentially endless (Saadawi 2018, 125). It is not just Daniel and Hasib that the Whatsitsname has to avenge, but all the victims he is made of. In that respect, the soul is no different from an arm or a leg, and the dichotomy between body and soul does not seem to hold. To complicate matters further, as body parts tend to fall off, the monster constantly needs "new flesh from new victims", giving him more avenging missions to fulfil, in a seemingly endless cycle: "My list of people to seek revenge on grew longer as my old body parts fell off and my assistants added parts from my new victims, until one night I realized that under these circumstances I would face an open-ended list of targets that would never end" (Saadawi 2018, 129, 146–147). The monster thus provides a fictional embodiment of the endless cycle of violence plaguing the city.

Thirdly, it soon appears that the distinction between criminals and innocent people is not that clear-cut. They are "entangled" and the Whatsitsname realizes that "'[t]here are no innocents who are completely innocent or criminals who are completely criminal' […]. [E]very criminal he had killed was also a victim" (Saadawi 2018, 207). The monster wants to make sure he is not equipped with the flesh of criminals but the boundary between victims and criminals is not easy to draw: "[W]ho's to say how criminal someone is?" (Saadawi 2018, 149). When he starts losing his eyesight, he kills an innocent to take his eyes in order to avoid having a criminal's eyes grafted onto his body, but in doing so, he precisely becomes a criminal himself and does not know on whom to exact revenge for this particular victim. He thus finds himself torn by "conflicting ideas" (Saadawi 2018, 154). The climax of absurdity is reached when the killing becomes an end unto itself. By the end of the novel, the avenging mission finds itself entirely stripped of meaning: "My face changes all the time

[…]. Nothing in me lasts long, other than my desire to keep going. I kill in order to keep going" (Saadawi 2018, 259). The Whatsitsname provides a means to expose the cycle of violence which has been tearing Baghdad apart for years.

To go a step further, the significance of the Whatsitsname also starts falling apart. The monster does not seem to have any intrinsic meaning, but rather to derive its sense from what is projected onto it. This is particularly apparent in Saadawi's variation on the mirror scene. In Shelley's version, the mirror scene is located in the fourth chapter of the second volume and constitutes a moment of realization for the Creature who becomes aware of his own ugliness—by contrast with the "perfect form" of the cottagers whom he has been admiring—and who becomes "fully convinced that [he is] in reality the monster that [he is]" (Shelley 2003, 116–117).

In Saadawi's version, the Whatsitsname, whom Elishva has named Daniel, sees his own reflection as he is studying the picture of the "original" Daniel: "Daniel moved closer to study this picture. It must have been taken twenty years earlier. He noticed the reflection of his own face in the glass. It rather surprised him—this was the first time he had seen himself. He ran his finger over the stitches on his face and neck. He looked very ugly. How come the old woman didn't seem startled by his dreadful appearance?" (Saadawi 2018, 53). But contrary to Shelley's monster, the "new version" of Daniel is not rejected. Rather he is embraced as the projection of a wilful illusion. Elishva has him wear her dead son's clothes and avoids wearing glasses so that "when she came back into the sitting room she would see only what she wanted to see", that is, her son (Saadawi 2018, 53). Elishva is well aware of the fact that the monster is not her son, but her pain is such that she is ready to stage a convincing enough illusion.

The scene is central, as other characters will project so many meanings onto the Whatsitsname that he will be on the brink of dislocation. To some, he is "the model citizen that the Iraqi state has failed to produce", a claim which he himself makes: "Because I'm made up of body parts of people from diverse backgrounds—ethnicities, tribes, races, and social classes—I represent the impossible mix that never was achieved in the past. I'm the first true Iraqi citizen". To others, he is "an instrument of mass destruction that presages the coming of the savior that all the world's religions have predicted" (Saadawi 2018, 141). For Brigadier Majid, the Whatsitsname is a criminal, "a useless, despicable, lowly person who had made himself into a myth by exploiting people's ignorance and fear and

the chaos around them", and whose arrest could be a major step to promote his career (Saadawi 2018, 163). As the Creature keeps killing more and more people, he becomes known as "Criminal X" to journalists and even becomes "a television star" (Saadawi 2018, 202).

By the end of the novel, interpretations of the monster keep on proliferating: "Fear of the Whatsitsname continued to spread. In Sadr City they spoke of him as a Wahhabi, in Adamiya as a Shiite extremist. The Iraqi government described him as an agent of foreign powers, while the spokesman for the US State Department said he was an ingenious man whose aim was to undermine the American project in Iraq" (Saadawi 2018, 260). The narrative voice confirms that in the final analysis, the Whatsitsname is shaped by people's projections: "The definitive image of him was whatever lurked in people's heads, fed by fear and despair. It was an image that had as many forms as there were people to conjure it" (Saadawi 2018, 260).

The mirror scene is given another twist at the end of the novel when Hadi, who has been disfigured in an explosion, looks at his reflection, only to realize that his face is that of the monster:

> He was a horrible creature, and even if he made a full recovery he would never look the same as before. In shock, he wiped his hand along the surface of the mirror to make sure it was really a mirror and leaned in to examine his disfigurement. He wanted to cry, but all he could do was stare. As he looked closer, he detected something deeper: this wasn't the face of Hadi the junk dealer; it was the face of someone he had convinced himself was merely a figment of his fertile imagination. It was the face of the Whatsitsname. (Saadawi 2018, 258–259)

It is Hadi that the authorities will later arrest as the criminal they have been chasing for so long, by a process of assimilation between creator and creature which echoes the Doppelganger motif in the original *Frankenstein*.

Ultimately, the traditional plot of revenge to free a soul so that it can rest in peace—which initially provided meaning to the Whatsitsname's existence—comes undone as the novel unfolds, giving Saadawi an opportunity to expose the absurdity of the cycle of violence, the wounds of Iraqi society and the threat of political and religious chaos.

The political commentary is reflected metatextually in the novel's somewhat chaotic structure. Saadawi's rewriting of Shelley's myth is indeed constantly bursting at the seams and ends on a rather threatening note, with the Whatsitsname looking down on the city. The book starts

from the end, opening with a final report written by the chairman of a special committee of inquiry into the Tracking and Pursuit Department which, as readers will discover, was set up by American forces to get hold of the Whatsitsname, but this particular frame has no equivalent at the end of the novel. Moreover, the story is told many times, by several narrators, on different media. The first time the journalist who is called Mahmoud and stands in for Captain Walton hears the story, it is already a repetition: he is listening to the story for the second or third time "to see if Hadi would contradict himself" (Saadawi 2018, 19). He starts taping Hadi's tale on his new Panasonic recorder, and then leaves his device with Hadi, for him to record an interview with the Whatsitsname, as he wants evidence that "a mythical creature of this kind" exists (Saadawi 2018, 115). The central part of the novel is, as in Shelley's novel, the tale of the monster—transcribed in chapter ten, which is simply entitled "The Whatsitsname". However, the symmetrical structure of Shelley's tale is not repeated, as the following chapter resumes third-person narration where a parallel structure with that of Shelley's novel would have led to Hadi/Victor Frankenstein continuing the tale.

The break introduced in the Chinese box structure of Shelley's tale is just one example of textual imbalance in a novel that relies on intertextuality, unreliable narrators, open-endedness, repetitions without originals and metafictional gestures to convey the sense of chaos and the threat of political fragmentation.

Conclusion: The Persistence of Shelley's Myth

Critics agree on the fact that *Frankenstein* does not fit the strict anthropological definition of a myth. Chris Baldick for instance points out that actual myths are "defined by their exclusive anteriority to literate and especially to modern culture" (Baldick 1987, 1). Moreover, to paraphrase some of the points made by Jean-Jacques Lecercle in *Frankenstein, mythe et philosophie*, myths usually relate the emergence of the cosmos out of primitive chaos (whereas here the monster brings an ambiguous chaos, not the cosmos) and myths describe an arbitrary creation out of nothing (whereas here the monster is not made out of nothing) (Lecercle 1988, 24). Yet *Frankenstein* has been identified as a modern myth, along with other examples such as Faust, Don Quixote, Robinson Crusoe, Jekyll, or Dracula (Baldick 1987, 2). Lecercle lists several "symptoms" of myth around *Frankenstein*—the fact that the textual origin, the author and the

time in which *Frankenstein* was created have been forgotten; that the creature, like Dracula or Sherlock Holmes, has obliterated its creator; and that there have been numerous adaptations (he focuses on theatre plays and films especially) attesting to ongoing fascination (Lecercle 1988, 6). The latest literary rewriting in the English language seems to be Jeanette Winterson's *Frankissstein; A Love Story*, which was published in 2019.

As Lecercle and others have shown, it is difficult to understand Shelley's novel without taking the context of the French revolution into account. The story may be read as that of violent political forces let loose on the world, illustrating how a myth can provide an imaginary solution to a real contradiction. Indeed, while for conservatives, the monster, who stood for the revolutionary crowd, was unambiguously evil and needed to be destroyed, for Shelley, it embodied an event which was liberating but also dangerous and unstoppable. The myth's "vitality"—its "capacity for change", "adaptability and openness to new combinations of meaning"—has enabled it to transmigrate to Iraq and offer a shape—albeit a shifting one—to political chaos (Baldick 1987, 4). The monster represents a necessary quest for justice, for souls to be laid to rest, for wounds to be healed, for unity to be achieved but, like Frankenstein's creature, it is also deadly and uncontrollable.

At this point, it may be useful to go back to Mary Shelley's words in her introduction to the 1831 edition: "Invention [...] does not consist in creating out of void, but out of chaos: it can give form to dark, shapeless substances, but cannot bring into being the substance itself", a remark which of course applies both to Frankenstein's scientific enterprise and Mary Shelley's literary endeavour (Shelley 2003, 8). The reason why *Frankenstein* proves a persisting myth may be that it originates in a significant *gesture*, the act of assembling, which can refer to the work of remembrance, to the social fabric, to literary creation; that it offers a striking *trope*, that of the body made up of disconnected parts, which can be read as the "dream body" of the deceased, the body politic and the textual body; and that it provides a potent *metaphor* to try and produce sense out of chaos, which proves operative on the spiritual, political and aesthetic levels.

Note

1. Spivak suggests that while Frankenstein "does not display the axiomatics of imperialism", the "discourse of imperialism"—or an "imperialist sentiment"—does surface incidentally in the novel (Spivak 1985, 255–256).

Works Cited

Baldick, Chris. 1987. *In Frankenstein's Shadow: Myth, Monstrosity and Nineteenth-Century Writing.* Oxford: Clarendon Press.

Burnham, Gilbert, Shannon Doocy, Elizabeth Dzeng, et al. 2007. *The Human Cost of the War in Iraq: A Mortality Study, 2002–2006.* MIT Center for International Studies. http://web.mit.edu/CIS/pdf/Human_Cost_of_War.pdf.

Haekel, Ralf. 2014. *The Soul in British Romanticism: Negotiating Human Nature in Philosophy, Science and Poetry.* Trier: Wissenschaftlicher Verlag Trier.

Hamedawi, Shayma. 2017. The Postcolonial Iraqi Novel: Themes and Sources of Inspiration. *Babel* 36: 211.

Hindle, Maurice. 1990. Vital Matters: Mary Shelley's Frankenstein and Romantic Science. *Critical Survey* 2 (1): 29–35.

Lecercle, Jean-Jacques. 1988. *Frankenstein: Mythe et philosophie.* Presses Universitaires de France.

Lory, Pierre. 2015. *Le Rêve et ses interprétations en Islam.* [2003]. Paris: Albin Michel.

Michon, Cyrille, and Denis Moreau, eds. 2013. *Dictionnaire des monothéismes.* Paris: Seuil.

Morton, Timothy, ed. 2002. *Routledge Literary Sourcebook on Frankenstein.* New York: Routledge.

Muller, Quentin. 2017. Le 'Frankenstein à Bagdad' d'Ahmed Saadawi bientôt au cinéma?. *Les Inrocks.* https://www.lesinrocks.com/2017/12/23/livres/cinema/le-frankenstein-bagdad-dahmed-saadawi-bientot-au-cinema/.

Saadawi, Ahmed. 2018. *Frankenstein in Baghdad* [2013]. Translated by Jonathan Wright. Oneworld Publications.

Shelley, Mary. 2003. *Frankenstein; or, the Modern Prometheus* [1818]. Edited with an introduction and notes by Maurice Hindle. Penguin Classics.

Simpson, J.A. and E.S.C. Wiener, ed. 2002. *The Oxford English Dictionary.* Second Edition. 20 vols. Oxford: Clarendon Press.

Spivak, Gayatri Chakravorty. 1985. Three Women's Texts and a Critique of Imperialism. *Critical Inquiry* 12 (1): 235–61.

Willis, Martin. 1995. *Frankenstein* and the soul. *Essays in Criticism* 45 (1): 24–35.

Index[1]

A

Absence, 7, 83–86, 88, 90, 91, 94–98, 179, 182, 184, 185
Adèle, 198
Air, 38, 43, 129, 177, 180, 184, 186–190, 230, 231, 252
Alchemy, 122, 132, 133, 252
Âme, 108, 177
Americana, 19, 157, 160
American Renaissance, 19, 155–171, 214
Anima, 2, 108, 119–135, 177, 187, 261
Arènes, Jacques, 7, 8, 197, 205
Aristotle, 4–6, 58
 De Anima, 4, 5
Atman/Brahman, 13, 157, 164–166, 169

B

Ba, 15, 29
Baathist, 263, 264, 268
Bachelard, Gaston, 194
Baghdad, 259–272
Balanchine, George, 19, 156, 160–163, 172n9, 172n10
Bambara, Toni Cade, 12, 22, 244, 245, 249–252, 255
 The Salt Eaters, 249, 250, 252
Barthes, Roland, 60, 181, 184
Bernheim, Hippolyte, 9
Bible, 13, 75, 132, 187, 189, 230, 251, 254
Bildungsroman, 74–77
Blackwood, Algernon, 15, 31, 41–45
 The Wave, 15, 31, 41, 42, 44
Blake, William, 13

[1] Note: Page numbers followed by 'n' refer to notes.

© The Author(s), under exclusive license to Springer Nature Switzerland AG 2024
D. Louis-Dimitrov, E. Murail (eds.), *The Persistence of the Soul in Literature, Art and Politics*, https://doi.org/10.1007/978-3-031-40934-9

276 INDEX

Bodmer, Walter, 192
Body, 1, 29, 49, 71, 84, 101, 140, 157, 177, 215, 230, 259, 260
Body politic, 22, 260, 273
Boothby, Guy, 38
Brahmanism, 19, 157, 164–166, 169
Branagh, Kenneth, 260
Brantlinger, Patrick, 30, 36, 46n7
Breath/breathe, 2, 19, 38, 108, 177, 180, 187–189, 217
Butades of Sicyon, 184–185
Byron, George Gordon, Lord, 159, 262

C
Calder, Alexander, 192
Capitalism, 218, 219, 221, 224, 225, 233, 234, 237
Catholic/Catholicism, 8, 17, 18, 102, 127, 135n3, 139, 140, 143, 186, 187, 255n3, 256n4, 256n6
Cavell, Stanley, 20, 215
Chaos, 23, 271–273
Cheng, François, 1, 6, 107, 108
Choreography, 159, 160, 163
Christ, 18, 23n3, 93, 121, 122, 127, 129, 130, 132, 251, 254
Christian/Christianity, 5, 7, 9, 10, 12, 13, 15, 17, 30, 75, 76, 80n7, 93, 107, 123, 129, 138, 143, 145, 165, 186, 204, 217, 233, 244–249, 251, 256n11, 261, 267
Colonisation, 35–40
Commemoration, 18, 137–151
Consciousness, 2, 15, 16, 20, 22, 32, 42, 43, 45, 49, 50, 52, 53, 55, 57–60, 62, 63, 67–73, 75, 78, 79, 108, 109, 202–205, 207, 218, 226n3, 244, 248, 255, 263
Cooke, Sam, 20, 200, 202, 204

Cosmos, 272
Cosway, Richard, 18, 137–151
Counter-history, 21, 229–240
COVID-19 pandemic, 215

D
Dallas, Eneas Sweetland, 15, 16, 49–65
Dance, 14, 17, 19, 155–171, 171n2, 172n10
Darkness, 73, 150, 179, 184
Davy, Humphry, 262
De Morgan, Evelyn, 18, 137–151
De Niro, Robert, 260
De Quincey, Thomas, 44
Death, 3, 6, 10, 14, 19, 30, 32–34, 83–85, 89, 91, 96, 97, 103, 105, 106, 110, 138–141, 143–147, 150, 151, 158, 185, 232–235, 239, 240, 248, 260, 263, 266, 268, 269
Derrida, Jacques, 83–86
 Specters of Marx, 84
Descartes, René, 6, 106, 201
Didi-Huberman, Georges, 184, 185, 190
 La Ressemblance par Contact, 184
Don Quixote, 160, 161, 272
Doppelgänger, 271
Drawings, 17, 71, 75, 94, 144, 192, 195n7, 230
Dream, 16, 41–43, 46n8, 50, 54, 61, 65, 69, 74, 91, 162, 166, 239, 265–267, 273
Du Bois, William Edward Burghardt, 21, 234, 235
Dualism, 3, 20, 106, 107, 247
Duchamp, Marcel, 188, 194n5
 Air de Paris, 187, 188
Duncan, Isadora, 19, 156, 158, 168, 169

E
Eastern philosophy, 19, 157, 165
Edwardian, 15, 30, 41
Egypt/Egyptian, 3, 4, 12, 15, 29–45, 46n1, 46n3, 46n4, 46n5, 46n6, 46n7, 138
Egyptology, 15, 30
Electricity, 260, 262
Emblems, 17, 18, 119–123, 125–127, 129, 130, 132–134, 134n1
Emerson, Ralph Waldo, 20, 21, 157, 159, 163–165, 169, 174n27, 213–226, 226n2, 226n7
Empedocles, 4
Eyes, 41, 44, 55, 102, 105, 124, 125, 127, 129, 135n4, 172n13, 178, 179, 181, 182, 192, 206, 220, 247, 248, 252, 268, 269

F
Faith, 5, 6, 8, 36, 72, 123, 126, 129, 130, 135n3, 139, 140, 143, 147, 199–200, 204, 255n3, 256n4, 256n6, 266
Faust, 272
Foucault, Michel, 9, 178
Frampton, George, 148
Frankenpheme, 259
Franklin, Aretha, 200, 204
French revolution, 273
Freud, Sigmund, 6–10, 12, 40, 41, 43, 68–70, 72–74, 79n1, 107, 138

G
Galen, 5
Galvani, Luigi, 262
Garcia, Manuel, 201, 202
Gauchet, Marcel, 7
 The Disenchantment of the World: A Political History of Religion, 7

Gaye, Marvin, 199, 200, 202–204, 206, 207
 "Keep Gettin' It On," 204
 "Let's Get it On," 200, 204, 207
 "*What's Goin' On,*" 202
Ghost, 17, 85, 86, 88, 91, 97, 104–107, 109, 112n8, 190, 230, 264, 268
Giacometti, Alberto, 181
Goetz, Stewart, 1, 4–6
Gombrich, Ernst H., 181, 194
Gormley, Antony, 19
 "implied inner potency," 188, 194
 "soul garden," 181
Graham, Martha, 19, 156, 157, 160, 162–169, 171n6, 173n17, 173n18
Grid, 191, 192
Guralnick, Peter, 199, 200

H
Habermas, Jürgen, 12
Haggard, Henry Rider, 15, 30–32, 35, 36, 39, 44, 46n2
 The Ancient Allan, 31–33
 She, 31, 39, 43
 "Smith and the Pharaohs," 15, 30–33, 35, 39, 43, 44
Hartmann, Eduard von, 10
Harvey, Christopher, 18, 119–135
Hawthorne, Nathaniel, 8, 156
Heart, 5–7, 11, 18, 22, 30, 50, 55, 90, 102, 108, 121–125, 127–130, 132–134, 134n1, 148, 150, 158, 207, 225, 244, 254
Hegel, Georg Wilhelm Friedrich, 75, 197, 202, 204
 Aesthetics, 64, 197
Hull, Akasha Gloria, 22, 243–245, 255
Hungerford, Amy, 13

H

Hunter, John, 262
Hutchinson, John, 179, 184, 188, 194
Huyghe, René, 178
 L'Art et l'Âme, 178
Hypnotism, 9, 11, 50

I

Ibn-Abî al-Dunyâ, 266
Ibsen, Henrik Johan, 8
Idealism, 68, 79n4, 222
Imperial Gothic, 30, 31, 36, 39, 45, 46n7
Individualism/individuality, 2, 3, 6, 10, 16, 29, 33, 78, 79, 162, 172n14, 215, 222, 224, 225, 234, 235
Ingold, Tim, 205, 206
 "One World Anthropology," 205
Interiority, 6, 8, 10, 14, 121, 177, 181, 183, 193
Invisible, 14, 18, 19, 86, 94, 95, 122, 178, 180, 191, 246, 266
ISIS, 264
Islamic, 22, 260, 266–268

J

James, Etta, 20, 198, 200
James, William, 7, 9, 23n2, 68, 103
Jewish, 267
Joyce, James, 17, 101, 108–110
 Portrait of the Artist as a Young Man, 17, 101
Jung, Carl Gustav, 7, 10, 16, 68, 69, 71–73

K

Ka, 15, 29–45, 185
Krauss, Rosalind, 191, 192

L

Lacan, Jacques, 17, 109, 110, 113n13
 The Sinthome, 109, 110, 113n13
Language, 13, 20, 53, 54, 57–59, 70, 102, 108–110, 134, 161, 167, 171, 194, 197–199, 201–204, 206, 215, 220, 223, 224, 226n2, 232, 234, 236, 246, 250, 273
Lassaw, Ibram, 192
Lessing, Gotthold Ephraim, 181
 Laocoon, 181
Lincoln, Abraham, 16, 85, 90, 94–96, 98
Logistics, 234
Lukács, György, 2

M

Madox Brown, Ford, 145
Materiality/immateriality, 19, 34, 78, 134, 177–180, 184–186, 192, 217, 238
McClure, John A., 12, 13
Meditation, 109, 168, 246, 247, 249
Memento mori, 105, 183, 185
Metaphysics/metaphysical, 2–7, 10, 16, 19, 20, 49, 64, 102, 104, 215, 217, 219, 220, 222, 223, 245, 250, 252, 261
Metempsychosis, 2, 4, 260, 265
Mind, 1, 6, 8–10, 14, 15, 19, 29–45, 49–59, 61–64, 69–71, 76, 79, 86, 98, 103, 106–110, 121, 124, 127, 179, 193, 218–220, 222, 225, 250, 261, 264, 267
Mitchell, W. J. T., 184
Mobility, 229–240
Modernism/modernist, 13, 68, 74, 77–79, 101, 108
Morrison, Toni, 12, 22, 244–252, 254, 255, 255n3, 256n4, 256n6
Mosul, 264

Moszynska, Anna, 179, 192
Mourning, 83, 85, 90, 94, 95, 148, 263, 266, 267
Music, 14, 17, 19, 20, 54, 59, 78, 159, 161, 162, 172n10, 172n11, 172n14, 197–207, 235, 255
Muslim, 266, 267
Myth, 12, 19, 22, 106, 156, 159, 162–164, 189, 247–249, 252, 259–273

N
Nafs, 266
Nation, 3, 17, 19, 21, 23, 43, 45, 97, 110, 163, 167, 218, 220, 221, 223, 224, 226n6, 260
Naylor, Gloria, 12, 253–255
 Mama Day, 253, 254
Negro spiritual, 21

O
Orphism, Orphic, 3, 4
Over-Soul, 20, 164, 217, 218

P
Painting, 7, 17, 41, 145, 147, 148, 150, 184, 214
Penone, Giuseppe, 188
Pfister, Oskar, 8
Photography (positives & negatives), 179
Plato, 4, 5, 104, 106, 164, 177
Pliny the Elder, 184
 Natural History, 184
Polytheistic, 12
Portrait, 113n13, 141, 142, 214, 219
Postmodernism/postmodern/postmodernity, 12, 13, 16, 101–110

Pre-Raphaelite, 143, 144
Presence, 2, 3, 10, 17, 19, 41, 57–59, 83–86, 88, 90, 91, 93–98, 125, 126, 147, 157, 181, 184, 187, 188, 192, 234, 259
Presocratic, 3, 4
Principle of life, 2, 4, 19, 22, 179, 260–263
Prometheus and Athena, 189
Protestanism/protestant, 8, 135n3
Psyche, 2, 4, 6, 7, 9–11, 15, 16, 31, 40–45, 67–79, 149, 168, 220
Psychic, 6–11, 69, 72, 73, 105
Psychoanalysis, 8–11, 45, 68
Psychology/psychological/psychologization, 2, 3, 7–11, 15, 16, 49, 51, 64, 65, 68, 70, 72, 79
Psychotherapy, 7, 9, 11, 14
Pythagoras, 4

Q
Quran, 266

R
Redding, Otis, 207
Reincarnation, 2, 4, 30–35, 39, 42, 44, 45, 46n2
Religion/religious, 2–7, 9–11, 13, 16–18, 22, 23n2, 36, 49, 73, 74, 91–94, 102, 104, 121, 132, 138, 139, 143, 145, 155, 165, 166, 170, 171n4, 173n19, 204, 217, 222, 225, 233, 234, 244, 245, 247, 250–252, 254, 255n3, 256n4, 263, 266, 267, 270, 271
Rembrandt van Rijn, 7, 23n3
Renan, Ernest, 17
Resilience, 20–23, 245
Rites, 14, 232, 266, 267
Robinson Crusoe, 272

280 INDEX

Robinson, Smokey, 201–205
 and the Miracles, 201
Rodin, Auguste, 185, 195n7
Rohmer, Sax, 34
Rossetti, Dante Gabriel, 18, 137–151
Royal Academy of Arts, 137
Rúh, 266

S

Saadawi, Ahmed, 22, 259–273
Sacred, 14, 36, 103, 132,
 155–171, 198
St. Augustine, 5, 7, 130
Saint Denis, Ruth, 19, 156, 165–170,
 173n17, 173n18
St. Thomas Aquinas, 5–7, 17, 109
Saunders, George, 16, 17, 83–98
 Lincoln in the Bardo, 16, 83–98
Sculpture, 14, 17, 19, 195n7, 239
Secular/secularize/postsecular, 6, 8,
 10–14, 17, 49, 105, 145,
 155–171, 219, 244, 247, 261
Seele, 7, 69, 177
Serres, Michel, 194
Shadow, 30, 107, 108, 163, 184,
 185, 189
Shawn, Ted, 19, 156, 158–160, 165,
 169, 173n18
Sheeran, Ed, 206–207
Shelley, Mary, 259–268, 270–273
 Frankenstein, 260–263, 267,
 268, 271–273
Shelley, Percy Bysshe, 22, 76, 215
Sherlock Holmes, 273
Shipwreck, 229, 230, 232, 236–240
Simmel, Georg, 7, 23n3
Sinclair, May, 16, 67–79, 79n1, 79n2,
 79n3, 80n5, 80n6, 80n7
 Mary Olivier: A Life, 74
Sisko, John, 3, 4
Slavery, 22, 224, 235, 236, 238, 247
Social consciousness, 20, 202–204

Social reform, 214
Socrates/Socratic, 4, 104
 Phaedo, 4
Spectre/spectral, 84–86, 88,
 90, 94–98
Spirit/spiritual, 2, 30, 49, 84, 102,
 121, 140, 155, 177, 186, 204,
 213–226, 230,
 243–255, 260–263
Spiritualism, 10, 13, 18, 50, 137–151
Stieglitz, Alfred, 184
 Shadows on the Lake, 184
Stoker, Bram, 15, 29–33, 37–39,
 46n3, 46n8
 Dracula, 39, 272, 273
 The Jewel of Seven Stars, 15, 29–33,
 35, 37, 39, 40
 *Strange Case of Dr. Jekyll and Mr.
 Hyde*, 61, 63
Subjectivity, 3, 7, 12, 14, 104
Swedenborg, Emanuel, 140, 141, 143,
 144, 150, 151

T

Taine, Hippolyte, 10
Taliaferro, Charles, 1, 4–6
Tamla Motown, 204
Thelwall, John, 262
Theology, 1, 11, 23, 103, 104,
 215, 251
Trace(s), 44, 83, 85, 88, 94, 96–98,
 138, 179, 184, 201, 221, 229
Transcendentalism, 221
Transmigration, 4, 15,
 29–45, 259–273
Tuke, Daniel Hack, 9

U

Uncanny (Freud), 138
Unconscious, 10, 12, 16, 39, 41, 42,
 50–58, 60–64, 69, 219

V
Victorian, 14, 15, 19, 29–45, 51, 145
Vigarello, Georges, 193
Vitalist, 10, 262, 263
Volta, Alessandro, count, 262
Von Schubert, Gotthilf Heinrich, 10

W
Walker, Alice, 12, 22, 244, 245, 251–253, 255n1, 256n10, 257n13
The Color Purple, 251, 252, 257n13
Wallace, David Foster, 17, 101–110, 111n4, 112n10, 112n11
"The Soul is Not a Smithy," 17, 101, 108, 109
This is Water, 102, 108
War, 204, 263, 264, 268
Warburg, Aby, 189
Westmacott, Richard, 141
Whitman, Walt, 157, 158, 164, 168–171, 173–174n27
Winckelmann, Johann Joachim, 181
Winterson, Jeanette, 273
Frankissstein: A Love Story, 273